MARY ELLEN MILLER is Sterling Professor of the
History of Art at Yale University, where she also
served as Dean of Yale College and Master of Saybrook
College. Miller is the author of *The Gods and Symbols of
Ancient Mexico and the Maya* (with Karl Taube), *The Art
of Mesoamerica* (now in its fifth edition), and, with
Linda Schele, *The Blood of Kings*. Her major work on
Bonampak, *The Spectacle of the Late Maya Court*,
co-authored with Claudia Brittenham, has been
recently published. A member of the American
Academy of Arts and Sciences, she curated the highly
acclaimed 2004 exhibition, *The Courtly Art of the Ancient
Maya*. A native of New York State, Miller earned her
AB degree from Princeton and her PhD from Yale.

MEGAN E. O'NEIL is Assistant Professor of Art
History at Barnard College and Columbia University.
Her research focuses primarily on Maya sculpture in
Chiapas and the Peten. Her book, *Engaging Ancient
Maya Sculpture at Piedras Negras, Guatemala*, was
published in 2012. A new project, *The Lives of Ancient
Maya Sculptures*, is in progress. She has received
fellowships from Dumbarton Oaks, Fulbright, and
the National Gallery of Art, and has published essays
in journals and museum publications. She studied at
Yale University and the University of Texas at Austin,
receiving her doctorate from Yale in 2005.

Thames & Hudson world of art

This famous series provides the widest available range of
illustrated books on art in all its aspects.

To find out about all our publications, including
other titles in the World of Art series, please visit
thamesandhudsonusa.com.

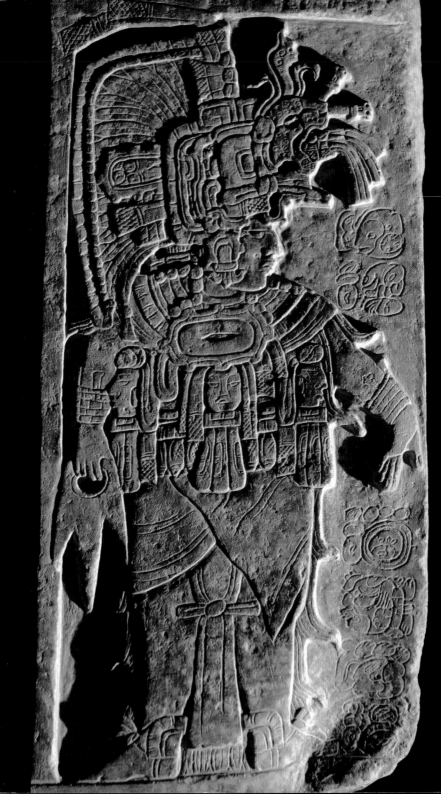

Mary Ellen Miller
and Megan E. O'Neil

Maya Art and Architecture

Second edition

254 illustrations, 191 in color

 Thames & Hudson world of art

To the memory of Linda Schele, 1942–1998

Pronunciation and spelling of Mayan and other Mesoamerican words require some attention. In the sixteenth century, the letter x in the Spanish alphabet was pronounced like the phoneme sh in English today. In general, names in native Mesoamerican languages with this consonant require the sh sound – as in Iximche, for example. In most Mayan words, the c, regardless of the following vowel, is hard. The letter j is pronounced like a hard "h" or the Spanish jota. The use of an apostrophe after vowels and consonants in Mayan words indicates a glottal stop. Spanish words ordinarily have a stress on the penultimate syllable unless they end in a vowel, n, or s, and accent marks are used to indicate stress on another syllable. Accents are generally used in this work only on names in Spanish (e.g. José). In general, place names used here are the standard ones found on maps published by national governments, although accents have been dropped for names derived from Mayan and other native languages. Following accepted conventions, the adjective "Maya" is used, except for matters related to language or writing, when "Mayan" is used. Correlations of Maya dates with the Christian calendar use Simon Martin and Joel Skidmore's Modified GMT (Goodman-Martínez-Thompson) correlation constant of 584286 (GMT+3) and are given in the Julian calendar.

Maya Art and Architecture © 1999 and 2014 Thames & Hudson Ltd, London

First published in 1999 in paperback in the United States of America by Thames & Hudson Inc., 500 Fifth Avenue, New York, New York 10110

thamesandhudsonusa.com

Second edition 2014

Library of Congress Catalog Card Number 2013948282

ISBN 978-0-500-20422-1

Printed and bound in China by Everbest Printing Co. Ltd

1 (Frontispiece). Using exquisite fine limestone and working at a small scale, La Corona artists depicted local lords who paid allegiance to the powerful Kaan-dynasty kings at Calakmul. Panel 1a features Ajaw K'inich Yook at the time of Yuknoom Ch'een II's consolidation of regional power. The panel was installed on small exterior risers along with others, whose imagery and text frequently continue across panels.

Contents

Preface

Fifteen years ago, when I first wrote this book, I hoped that the study of Maya art and architecture would be a swiftly changing field. My wish has more than come true, making it possible to rethink, reorganize, and expand the purview of the second edition.

New readings of Mayan hieroglyphics continue to inform thinking. To the factionalism that led eighth-century Maya city-states to desperate warfare, Simon Martin has offered political nuance, including betrayal and intrigue. Stephen Houston, David Stuart, and Karl Taube have given greater meaning to emotion and sensory experience embedded in Maya art and materiality, from the desire to convey flash and sparkle to the nature of humiliation portrayed in representation. New narratives have been uncovered at Palenque, and documentation by Barbara Fash, Ian Graham, and Justin Kerr has helped studies to flourish.

But the greatest change has come to the corpus itself. In 2001, William Saturno stepped into a looter's trench and happened upon the now-famous paintings of San Bartolo, revealing the most coherent Maya painting of the late first millennium BC [208, 209]; a few years later, Saturno, then with more intention, discovered the latest Maya paintings of the southern lowlands at Xultun [220]. At Calakmul, Ramón Carrasco has excavated extraordinary and massive paintings and friezes [213, 214]. While so many new Maya paintings have made their entry into this study, others have made an exit: Claudia Brittenham has convinced me that the paintings at Cacaxtla, in Central Mexico, are not Maya but in a style unto themselves. Early architecture masked with huge heads of both deities and humans has come to light across the Maya world, from El Zotz [43] to Balamku; fascinating architectural programs at Ek' Balam [71] have quickly become destinations for travelers and scholars as the extraordinary arc of Maya discovery widens. Deep and systematic archaeology has made meaning at La Corona out of a looted corpus of carved panels [1], even as bulldozers are caught on video demolishing pyramids in Belize. New discoveries of stucco walls at Holmul [4] provide

extraordinary works from 590, often thought of as a time of little artistic production.

Like its predecessor, this new edition of *Maya Art and Architecture* focuses on understanding the traditions of Maya art. Unlike any other book in print, it addresses a series of questions fundamental to art history. How did the Maya artist exploit the materials at hand? What are the synthetic ways to assess both the subjects of Maya art and the focus on the human figure? What is the nature of Maya sculptural development? How did the regional schools of sculpture and painting emerge, and what can be made of them – and how can this be understood in chapters that transcend individual city-states while providing focused readings of individual works?

In 2004, with Simon Martin and Kathleen Berrin, I curated *Courtly Art of the Ancient Maya*, which gave me opportunity to study hundreds of works in depth. Other exhibitions, especially *Lords of Creation* (2004–2005) and *Fiery Pool* (2011), brought many new discoveries and previously unpublished works together; specialized exhibitions – *Dancing Through Dreams* (2012), *Maya 2012* (2012), and *Rostros de la Divinidad* (2011) – have also provided fresh ways of thinking about Maya art, as have the studies of facture and materials that Diana Magaloni Kerpel has both led and inspired. Such studies have made the inclusion of richer illustration and more color imperative: I am grateful for the continuing support from Yale's History of Art to make that possible in this book.

When *Maya Art and Architecture* was first written, Megan O'Neil had recently graduated from Yale and was taking her first steps toward becoming a Mayanist. I'm delighted to welcome her as co-author of the second edition. We both had the opportunity to work closely with Linda Schele – Megan was her student at the time of her death in 1998 – and we renew the dedication of this book to her.

Mary Ellen Miller

Chapter 1 Introduction

In their texts, the ancient Maya gave names to the things they made. They identified the ceramic vessels they painted, distinguishing a low bowl, or *lak*, from a cylinder vessel for drinking, *uk'ib* [194]. They named their buildings, calling, for example, the most sacred royal palace structure at Palenque the *sak nuk naah*, the "white skin house," or the most important funerary pyramid at Piedras Negras the *muknal*, or "burial hill." They honored the day when they would set a new stone monument, a *lakamtuun*, or "banner stone," at Copan.

Not only did the Maya have names for these ancient art forms, but they also knew who had commissioned a work of art and who, in turn, had made it. A painter at Naranjo signed his pots [195], and a sculptor from Yaxchilan signed Stela 1 at Bonampak; at Yaxchilan, they called attention to the wealthy royal woman who commissioned a series of carved stone lintels and the building that contained them, *yotoot*, "her house."

The Maya speak of writing and carving in the surviving texts, but like most ancient civilizations, they had no single encompassing word for art in their lexicon. And perhaps they had no need for such a word, for every surface – whether a textile or a thatched roof – could be transformed by paint and stucco and turned into a remarkable thing, ornamented with designs or figures that were characteristically Maya. These works were all around them, at dozens of Maya cities, and although the cherished objects of perishable materials may have disappeared, many were made to last. The ancient Maya world was a world of Maya art.

Maya art and civilization

The opportunity to revise this book is timely on many fronts, but one of them is the understanding of Maya chronology: in 2013, Takeshi Inomata revealed that under 18 m (60 ft) of later construction at Ceibal in Guatemala were remains demonstrating that the site was founded circa 1000 BC [2], with significant architecture that established the pattern for later buildings. This new, secure dating is part of a constant revision of

the chronology of Maya cities and sanctuaries in the tropical and subtropical rainforests of southern Mexico, Guatemala, Belize, and Honduras, where new foundational projects of early date are continuously coming to light alongside many extraordinary works of art and buildings of all periods. Additionally, new data have shed light on the vexed question of dating at Chichen Itza, where a Late and Terminal Classic presence in what has been called "Old Chichen" is now secure. Although this book will emphasize the art of the southern lowlands, with periodic inclusion of works from adjacent mountainous terrain, it cannot pretend to be comprehensive, not even in regard to the years from AD 250 to 900, or what is called the "Classic" period, and especially given the rapidly expanding corpus. At dozens of cities, large and small, Maya art and architecture thrived, with local styles and traditions evolving over time.

The Maya were not the only peoples to achieve high civilization in Mesoamerica, the ancient cultural region that encompassed most of Mexico and northern Central America: greatness was achieved by the Olmecs of the Gulf Coast, who established ceremonial precincts and carved monumental heads and other sculptures in the first millennium BC. And when the Spanish arrived on Mesoamerica's shore early in the sixteenth century, the invaders quickly sized up the Aztecs as the most powerful civilization at hand. Even during their own apogee, the Maya may well have suffered political and military defeats at the hands of more powerful neighbors, especially the Teotihuacanos [119], who built their capital near modern-day Mexico City. Cultures making complex art surrounded the Maya on all sides, and the Maya sometimes adopted the imagery and style of "foreign" forms to serve their own political agenda.

Some early works of Maya art were no doubt ephemeral, as are many works that the Maya make today (for the Maya survive into the present, as our final chapter makes clear). When the ancient Maya placed an unusual rock in a spring or cut flowers for an offering, they may have perceived these acts to be as much art-making as the carving of a sculpture or the shaping of a ceramic vessel. They studied landforms, wind, rain, and the heavens and then built an environment that captured the natural world, enhancing its experience through their monuments and buildings. They imbued certain materials, particularly rare greenstones, and especially jade, with great value. During the Late Preclassic, Maya populations grew

2. Discovered at Ceibal by Takeshi Inomata's archaeological project, this greenstone head, carved in a distinctly Olmec style, provides one of several indications of lowland Maya connections with the Gulf Coast Olmec during the Middle Preclassic period.

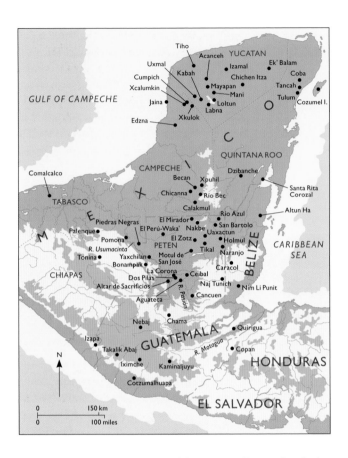

3. Map of the Maya region, showing sites mentioned in the text.

exponentially, and by the reign of Augustus in Rome, they had built one of their largest cities, El Mirador, in the northern Peten, but by AD 250, long before Rome's collapse, it had fallen into disrepair and decline.

Millions of Maya people speaking related languages inhabited the Maya lowlands, many of them living in or near substantial cities, some of them quite large, including Tikal, Copan, Calakmul, and Uaxactun, where settlement was ancient and where the inhabitants initiated monumental construction no later than 100 BC and sometimes much earlier. Others, among them Palenque, Dos Pilas, Uxmal, and Xpuhil, flourished later, especially from AD 600 to 900. Particular Maya practices took root almost everywhere during the first millennium AD, including the carving of tall stone shafts, or stelae, and their placement with low cylindrical stones called altars today. The cessation of this monument-making has served as one of the sharpest

markers of the Maya "collapse," often posed as among the great unsolved cultural declines of the past. What is clear is that this collapse – and perhaps earlier episodes of decline – was one of resources, as well as cultural production: the Maya drew on the rainforest, and over the course of the first millennium AD, they may well have harvested most of it, so that by the late eighth century they inhabited a degraded environment, one unable to support the population. Yet despite the collapse of civilization that followed the stressful eighth century, this century is also the richest source of Maya art, with large populations able to lay claim to elegant ceramics, and with kings eager to record their contentious relationships with neighbors and competing lineages prior to utter decline and abandonment.

But Maya civilization was not washed away in a single wave. During the ninth century, Maya culture and art-making continued apace in the north, first in the Puuc region, particularly at Uxmal and neighboring sites, and then expanding at Chichen Itza [77], a place that in the tenth century was the most powerful city of Mesoamerica. Even with Chichen's decline by AD 1100, Maya culture did not falter altogether, for other places such as Mayapan thrived, and the finely painted books of the Maya that survive [227, 228] were created within about a hundred years of the Spanish arrival in Yucatan in 1511. But in large part, once Chichen Itza had become only a place of pilgrimage, rather than a vibrant urban center, only a few materials that survive today – jade, bone, shell, fine-grained limestone – took a permanent form whose meaning and life as a work of art can still be recovered.

Living in the rainforest, the Maya struggled against rot and decay; new works and repaintings were constantly required. Very little of what was once made survives, and yet the corpus demonstrates a greater range of subject matter than any other New World tradition. What does survive in excellent condition usually comes from deep within burial chambers or caves, or under dense later construction: the Maya themselves were constantly curating their world and making decisions about what to display, and what to secrete.

Discovery continues to show that much Maya art is site-specific, both in the current sense of being designed for a particular architectural space, but also in the sense of being made within a particular regional school. Thus the three-dimensional qualities of single-figure Copan sculptures [159]

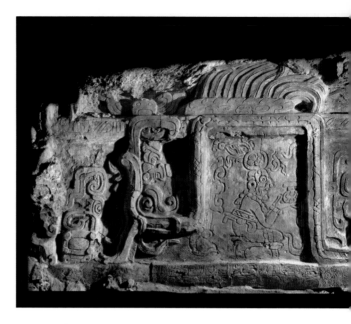

4. In 2013, archaeologists uncovered a vast 8 x 2-m (26 x 7-ft) stucco wall at Holmul that dates to 590, when the Kaan dynasty expanded power to the Holmul-Naranjo region, part of the long power struggle between Tikal and the Kaan lords. At center, where the face has been ritually defaced, is the Holmul ruler, Och Chan Yopaat, figured richly in three dimensions, and sitting in a cleft *witz*, like the Maize God.

lasted for generations; Palenque sculptors sorted out problems of two-dimensional group compositions, all the while designing works for interior rather than exterior display. Even so, despite the absence of a central authority, the facture of one site is intelligible in light of another, with recognizable styles conveying subject and writing that would have made sense to any educated Maya man or woman.

In its complexity, subtlety, and innovation, Maya art is the greatest of New World styles [1, 4]. No other tradition survived through so many generations or across such a geographical range. Indeed, black and white chocolate pots of the American Southwest now reveal the impact Maya art had at distance, and Taino vomit spoons in Belize caves indicate far-flung maritime connections. Moreover, Mayan texts tell their own stories and allow ancient narratives to be read and spoken today. This book attempts to put the incomparable material wealth of Maya art in context, and to frame its impact in both the past and present.

Discovering Maya art

From the beginning of the nineteenth century, explorers of the Mexican rainforest sensed they had seen ancient traces that they recognized as art and, contrary to experience with many

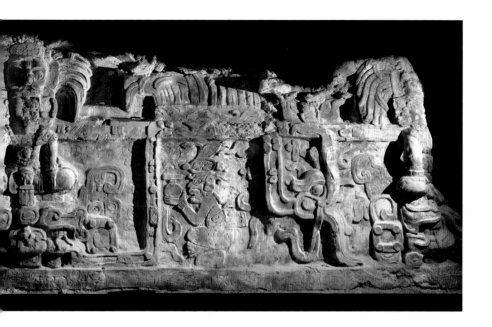

other cultures of ancient Mexico, they liked what they saw. When a colleague sent Alexander von Humboldt a sketch of a Palenque wall panel, he immediately published it in his vast compendium of geological wonders of the New World. A fellow German scholar who saw the sketch then republished it in the first comprehensive study of world art, and marveled at the ability of its makers to render the human form proportionally, unlike the Aztecs. However, he used the term *Ausartung*, "degeneracy," to characterize this work, his perspective marked by a Neoclassical disdain for the complexity of Maya sculpture.

With the voyages of John Lloyd Stephens and Frederick Catherwood to the tropical rainforests of Honduras, Guatemala, what is now called Belize, and the southern states of Mexico, the vast range of ancient Maya art and architecture suddenly came to the attention of the modern world. Starting at Copan in 1839, Stephens commented with infectious enthusiasm that still leaps off the page and charms new readers. By analogy with the Old World, where he had traveled extensively and written an important study of Egypt, Palestine, and Petra, Stephens called monuments "sculptures" and recognized Mayan writing for what it would ultimately prove to be, when deciphered 120 years later: a script that could replicate speech, a writing system that had been used

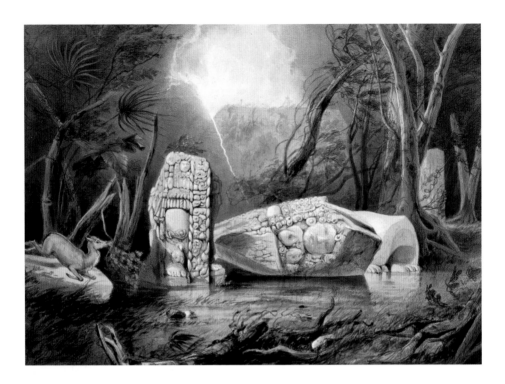

extensively on public monuments to glorify subject and patron. Stephens called the architectural wonders that he saw "temples" and "palaces," terminology that has survived attempts at reclassification as "structures" or "range-type buildings," and in general he was right, spotting royal dwellings and shrines for worship of gods and ancestors long before archaeology could prove them to be so.

Furthermore, Stephens can be seen as the first serious student of Maya art. He called attention to regional differences, noting the rich, near three-dimensionality of Copan sculpture [5] and a gray militaristic uniformity at Chichen Itza that he likened to the Aztecs, a sculptural expression of his sense of decadent society. But while he identified such local characteristics, he also saw the unifying parameters of Maya art and writing. He linked the texts from the Dresden Codex [228], a Conquest-era Maya book published in 1810 by Lord Kingsborough, with the writings he had seen all across the Maya region, simultaneously distinguishing them from writings in Oaxaca or Central Mexico. Furthermore, by his connection of the ancient art with the living people, Stephens defied racist

zealots. But in an era when the age of the planet itself could not be known, there were many things Stephens could not guess, including the age of Maya antiquities. Not until the end of the nineteenth century would scholars figure out that the Maya ruins of the southern lowlands, from Copan to Palenque to Tikal, had preceded the Aztec, rather than co-existed.

Other nineteenth-century writers and explorers made claims about the Maya that ranged from frivolous to scholarly. Despite spurious claims that the Maya civilization was the intellectual wreckage of the sunken continent Atlantis, C.E. Brasseur de Bourbourg rediscovered and published key documents, none more important than the first account of Yucatan written down by its bishop, Diego de Landa. Brasseur recognized that Landa's "alphabet" of Mayan writing might some day hold a useful key. Meanwhile, some early anthropologists, in the belief that race constrained the potential for achievement, could not accept the very idea of civilization among indigenous Americans, and soberly argued that at best, the Maya were "barbarous" as opposed to "savage." Even so, the giant casts of Maya sculptures and buildings at the Chicago World's Columbian Exposition in 1893 told instead a story of cultural marvels that captured public attention [6].

The presence of a complex writing system distinguished the Maya from all other New World peoples, and at the beginning of the twentieth century scholars came to place the Maya at

6. A devotee of Atlantis as an explanatory theory of Maya civilization, explorer Edward H. Thompson prepared the huge casts of building facades from Labna and other Puuc cities that amazed visitors to the World's Columbian Exposition in Chicago, 1893.

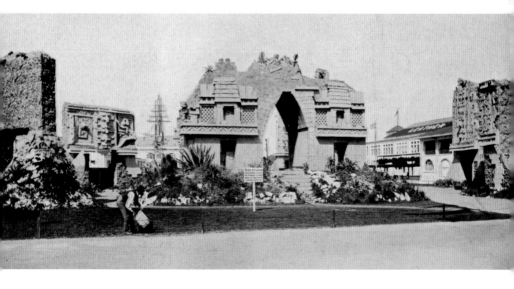

the apex of New World cultural development. When Alfred P. Maudslay began to study Maya art, he systematically retraced the steps of Stephens, and, like his predecessor, he looked for patterns. Identifying analogous inscriptions and iconography from various sites, he set the stage for the pursuit of Mayan hieroglyphic decipherment, and the quest Stephens had once prophesied for a Mayan Rosetta Stone began. With Maudslay's careful publication of Mayan texts in hand, other scholars applied themselves to the decipherment. The texts laid out by Maudslay allowed scholars to understand their rich calendrical framework and discern that the Maya had thrived in the first millennium AD, even while most of the hieroglyphs remained undeciphered. Almost immediately the Maya were proclaimed the Greeks of the New World, the originators, the masters, with the Aztecs only recognized as their "Roman" followers.

As an antidote to studies of calendar and writing – and wisely sidestepping the bombast of "Greeks" and "Romans" – Herbert Spinden wrote A Study of Maya Art for his 1908 doctorate in anthropology at Harvard, a work that opened new ways of thinking about Maya art [7]. Although Spinden was searching for a unifying religious principle – he believed that it would be the serpent and its transformation – in all Maya art, the result was the first systematic study of Maya iconography, or what we might think of as the building blocks of religion. Using Paul Schellhas's study of Maya god representations in the Dresden Codex, Spinden dramatically connected the names of Maya gods to their monumental counterparts, and much of the common Schellhas nomenclature is still used today, including, for example, God A, a skeletal death god. Spinden drew on the collections of the Peabody Museum and recognized the value of studying Maya ceramics, even those without archaeological provenience.

And then Spinden did what no previous student of Maya art had done: he argued that both style and stylistic evolution were intrinsically present in Maya art, and that based on dated monuments, undated or unprovenienced monuments could be convincingly placed in sequence. Spinden wrote in the age of Bernard Berenson and Sigmund Freud; across the surfaces of carved stones he saw the traces of an unconscious to be recognized by outsiders, and in so doing, removed the Maya from consideration as a non-western people whose art would be timeless and unchanging, as Europeans and Anglo-Americans

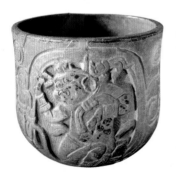

7. Herbert Spinden studied objects in Harvard's Peabody Museum, such as this carved vessel from Peto, Yucatan, juxtaposing figures like this jaguar with depictions on monuments and in codices to understand Maya religion. This vessel is now assigned to the Chochola style (see ill. 205).

have often perceived artistic traditions they do not understand. In other words, Spinden's work made Maya chronology as inexorable and inescapable as the spiral of Frank Lloyd Wright's Guggenheim Museum.

While World War I raged, Spinden proposed that the sculptural program at Piedras Negras [138–143] presented first an image of accession to the throne, followed, normally five years later, by that of a warrior. He noted isolated groupings of sculptures, and saw in them lineage and dynasty. Although Spinden never discussed his theory in relation to the politics of his time, he cannot but have thought about the European kings and princes who had donned the warrior's armor.

But Spinden's efforts to study art, and particularly its meaning, were not heard. One way or another, whatever scholars have thought about Mayan writing has determined how not only the art but indeed, the entire culture, was interpreted. Reading into the inscriptions the machinations of calendar priests, scholars decided that these priests also were the subjects of the art: anonymous, self-effacing, and uniformly male, even when they had large hips or were wearing skirts. Dedicated to a life of stargazing, such priests eschewed war. Spinden's identification of warrior kings fell into disrepute, and for a generation, from World War I to World War II, scholars seem to have stopped looking carefully at Maya art, in order to convince themselves of the truth of their dogma. Studies of the Maya simply eliminated most considerations of Maya art.

This is not to say that Maya art was not admired and collected, nor the world that had made it not extolled. Highland Guatemala, at Nebaj and Chama, had yielded painted ceramics with elegant scenes at court [203, 204]; archaeologists at Uaxactun pulled from the ground painted pots of previously unknown caliber, and they puzzled over the imagery and texts before deducing that illiterate artisans had painted Maya pots, thus reducing them to little more than potsherds of chronology.

When Sylvanus G. Morley, the dean of Maya studies between the wars, looked at Maya art, he knew that he recognized great art when he saw it. In his 1946 magnum opus, *The Ancient Maya*, Morley unhesitatingly (and undoubtedly to the embarrassment of some of his more intellectual colleagues) named his "Fifty Maya Superlatives," enumerating (#27) the "most beautiful example of stone sculpture" (Wall Panel 3, Piedras Negras [142]) and (#30) the "most beautiful example

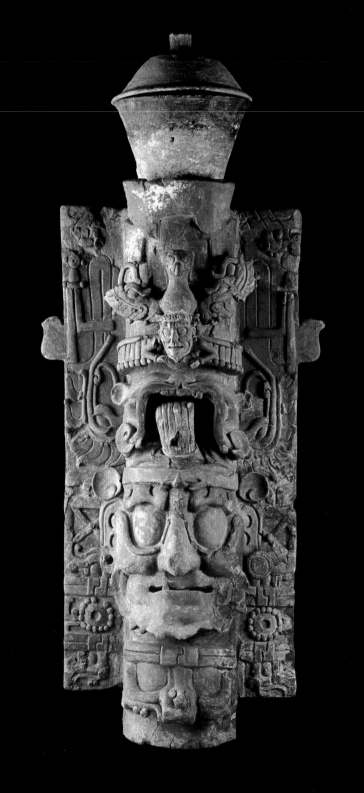

8. Towering stands from Palenque once held incense burners atop their stacked images of deities, as reconstructed in this example. Here the principal visage is that of the Jaguar God of the Underworld, an aged solar deity, also seen on the Palenque Tablet of the Sun (ill. 131).

9. Quirigua Stela C records the Long Count date 13.0.0.0.0, the foundation of the Maya era in 3114 BC, when the bak'tun count began anew. Another turning of the bak'tun count in 2012 was misunderstood in popular culture as a Maya "apocalypse."

8 Kumk'u K'in 0 Tun 13 Bak'tuns 0 Winal 0 K'atun 4 Ajaw

of sculptured stone door lintel" (Lintel 24, Yaxchilan [145]). Such enthusiasms irritated Tatiana Proskouriakoff, whose landmark book, *A Study of Classic Maya Sculpture* (1950), began with an assault on Morley's unscientific thinking. "In its crudest form [his] thesis maintains that the 'better' a monument is the later it is, until the development reaches a peak of perfection and a period of decadence sets in," she wrote. For the first time in several generations, a scholar once again began to look at Maya art carefully and ask the works what they could say to the modern viewer.

And of Maya art and its nature? Proskouriakoff focused on the presence of what she termed the "Classic motif," referring to works with a "single human figure...at the center of the composition" and made within the chronological framework of the first millennium AD. Adopted for usage to delineate cultural periods throughout Mesoamerica, the Preclassic-Classic-Postclassic classification promulgated by the Carnegie Institution *c.* 1950 carries heavy freight today: wherever possible, this study will simply use modern chronology rather than periodization.

Although the story of Mayan hieroglyphic decipherment since 1960 is best recounted elsewhere, it is worth mentioning here that Proskouriakoff played a key role in terms of both the decipherment and in transferring its implications to Maya art. She recognized that verbal glyphs were associated with appropriate subject matter, sweeping away the veil of anonymity that had cloaked Maya art. In one fell swoop, calendar priests became petty kings of warring states, promoting their cults for personal aggrandizement. Maya art, from painted ceramics to carved monuments to architectural configurations, could be studied anew.

The close of 2012 attracted unprecedented media attention to the Maya calendar, with its convention of five places and the completion of a vast period of thirteen bak'tuns, shifting on the tally from 12.19.19.17.19 to 13.0.0.0.0 overnight: the first day in the new era of the calendar coincided with 24 December, 2012. Apocalyptic hoopla verged on the lunatic as the final day of the thirteenth bak'tun approached (many at the time believing this day to be 20 December), and Aztec solar imagery was widely assumed to be equivalent to Maya calendrics. But the Maya knew best: their calendar had cycled through in the same way before, in 3114 BC, and they made both retrospective reference to the ancient date and prospective notation of an enduring future.

The subject of Maya art

Maya art is an art of the court and its retinue, in large part celebrating royalty, nobles, and wealthy merchants, and the women, musicians, and artists who lived with them or served them. The Maya elites lived well, and their world was one of both perishable and permanent art: works of art could link them to the past by recalling the deeds or forms of ancestors, or they could make room for innovation and imagination in somewhat new formulations [10].

Much Maya art was made to adorn wealthy individuals, from jade and obsidian ear flares tagged *u-tup*, "his or her ear ornament," to elegant mosaic masks that would transform the dead with permanent form [104]. Here, the subject is also the "object," the human body, whose proportions shaped much of Maya facture, from the screenfold book to the stela.

This is most particularly true for the *royal* body, depicted on stone in these adornments, the "Classic motif" Proskouriakoff

10. This Tonina panel was once part of a sculptural assemblage of captives, probably on the Fifth Terrace of the site (ill. 57). The awkward rendering reveals the captive's back, while the twisted cord between the eyes and the jaguar ear mark him as an embodiment of the Jaguar God of the Underworld.

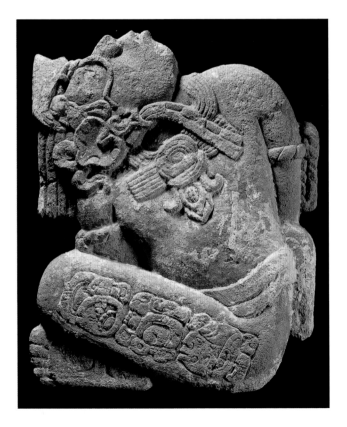

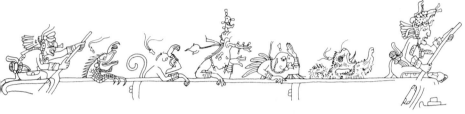

11. Tikal's Burial 116 included at least eighty-nine carved bones, some forming matching sets; many were finely carved and incised and then rubbed with cinnabar. Above, a Chahk concentrates as he grasps a fish in the stern of a canoe; below, deities paddle the Maize God through the Underworld, accompanied by animals who sing, grasp the gunwales, and gesture wildly in mourning.

identified in 1950. At some cities, as Spinden had spotted a century ago, subjects repeat like clockwork, from accession to office to war. But marriages and extended family also figure broadly, as do the communications between humans and the supernatural, vividly conveyed by the "vision" monuments at Yaxchilan. Distinctive forms at different cities notwithstanding, rites of passage, from birth to death to victory to the veneration of gods and ancestors, provide much of the subject matter of Maya monuments. By the eighth century, such subjects more frequently engage the entourage, perhaps nowhere more extravagantly displayed than in the paintings of Bonampak, where a crowded court jostles for visual recognition.

The hand-held work, whether ceramic or bone or shell, more typically depicts Maya gods than does the monumental [11], often in a rich supernatural world whose narratives have increasingly been identified on painted Maya ceramics. Some focus on entities named as *wahy*, companion or "dreaming" spirits, specific to local lineages, often malevolent supernatural figures, and perhaps connected to latter-day concepts of sorcery [202]. Particularly on painted ceramics of the seventh and eighth centuries, the lives and deeds of Maya gods wrap around cylinders, often with scenes relating sequential events. Staffs and scepters figure in elite dances, part of the performance and embodiment that also characterize Maya

21

art forms. And then the Maya sequestered much of what survives, actively depositing works in tombs, caches, or the trash, and sometimes burying architecture so carefully that painted facades remain intact today.

The relationship between Maya art and Mayan writing has long been recognized as an intimate one. Much Mayan writing flows across the surface with calligraphic flair, a signal to the training and skill of artists. But more importantly, Mayan logographs – the "word pictures" of this mixed writing system that uses phonetic syllables and logographs together – both inform and take shape from the larger representational schema. Such a logograph, usually a noun or verb – say, the word for yellow (k'an) or darkness (ak'ab) – may appear in carving or in paint in rich interplay, informing the viewer that something depicted is yellow or dark, or, metaphorically, ripe or nocturnal. When a local lord carved a memorial to grieve the passing of a Palenque king, K'inich Kan Bahlam, in the late seventh century, he represented the taking of a boar's tooth in hand and the carving of a k'an tuun, "yellow stone," a reference to the yellowish limestone of the region and also perhaps to the "ripeness" of the king, who had died seven days before [12]. He made a carving of a yellow stone: it is that act, and that material, whose reflexivity is captured on the monument, with signs that call out to be spoken. In looking at Maya representations, we are always seeing texts and hearing words, perhaps a signal that works may have been experienced with spoken, chanted, performed or sung accompaniment.

Few narratives that might further explicate traditional Maya elite material culture survived the era of the Spanish invasion. Bishop Landa's own account has proved to be of great value, even as he was responsible for the collection and burning of many Maya books. In the mid-sixteenth century, K'iche' lords in highland Guatemala wrote "a council book," or Popol Vuh, in European script, transcribing, according to the preface, an earlier book that needed to be hidden. Following a preamble describing the earth's creation, the Popol Vuh tells the story of the Hero Twins, recounting their adventures in Xibalba, an underworld "place of fright," where they played the ballgame against gods of death and brought their father, the Maize God, back to life. These stories figure keenly in Maya art [87, 201, 208, 219], but the Popol Vuh is only a fragment of what must have been

a vast account of the deeds of supernatural beings; additional narratives can only be teased out from the works themselves.

The story of Maya art that unfolds in these pages will focus on the works of fine craft that were imbued with meaning by their makers, and wherever possible, will draw attention to recently discovered works or to newly interpreted ones. We begin with the materials that the Maya exploited so effectively and follow with the built environment, before turning to the way Maya artists represented the human form. Subsequent chapters address the great traditions and regional styles of Maya sculpture, ceramics, and painting, from origins to the Spanish invasion. But no one can anticipate the next work of Maya art to be uncovered: the discovery of elegant carved panels at Palenque in 1999 and 2002 revealed historical narratives and artistic achievements that were entirely unforeseen [133–135]. These new Palenque panels attest that in the world of Maya art, it was possible both to follow a traditional recipe and to make a work of stunning imagination. What we can predict is that new discoveries will continue to change the very terrain of Maya art.

12. As David Stuart has shown, the Emiliano Zapata Panel records the carving of a yellow stone, glyphically named in the third column, second glyph. This is the very object that a regional lord – visible in profile at right – shapes with a boar's tooth, in memorial to a Palenque king.

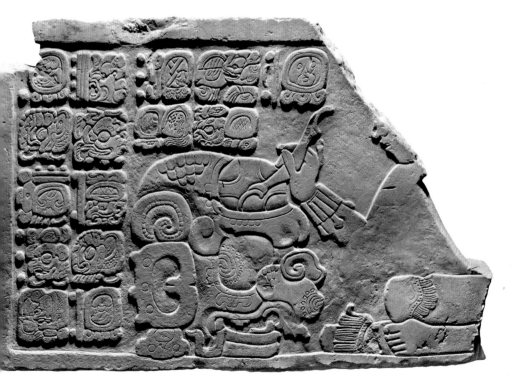

Chapter 2 Precious and Plain: The Materials of Maya Art and Architecture

The rainforest offered the Maya a world of abundance. From the sea to the forest canopy, wild or grown by humans, the natural environment supplied a wealth of materials to fashion into perishable and permanent works of fine quality. The land and waterways were materials too, for pyramids were built onto hills, and rivers and coasts provided strategic locations for cities. Classic Maya cities clustered in the Maya lowlands, with the modern Guatemala department of Peten at the center, a region of stable, non-volcanic karst limestone foundation, cut by a few large rivers, primarily the Usumacinta and its tributaries, the Pasión and Lacanha, in the west, the Hondo, New, and Belize rivers in the east, and in the south, the Motagua, which rises in the Guatemala highlands and courses east, near the Guatemala–Honduras border. In the north, the limestone yields to sinkholes that open to underground water. Many of these cenotes were holy places to the Maya, among them the Sacred Cenote at Chichen Itza, and valued objects were given to the water.

Throughout the Maya region, natural caves were treated with reverence, with carving and painting inside some, particularly at Naj Tunich [219], and the occasional removal of a stalagmite for carving, as at Yaxchilan. Other speleothems were deposited in burials and caches, and the Maya used tecali, or cave onyx, for carved vessels. Clouds and rain emerged from caves: in one San Bartolo painting, a zoomorphic cave maw, its large upper fang rendered as a stalactite, is the source from which the Maize God receives tamales and a flowering gourd, fruits of the earth [209]. Every cave may have been perceived as an entry point into another world. When the Maya dug into bedrock, as they frequently did in making burial chambers, they may have had the sense that they were making a cave – and archaeologists find that the ancient Maya made offerings inside caves, a practice that continues today.

Materials such as rock, clay, and wood were available to Maya artisans everywhere, but others, including jade, seashells, and obsidian, were found only in certain areas, and the Maya traded with people near and far via land, coastal, and riverine trade networks. The history of the materials of Maya art

changes according to the pulses of expansion and contraction of these networks, affected both by the desire for acquisition of materials and limitations to access driven by politics, warfare, or environmental pressure.

Jade and turquoise

Two materials valued for their color were jade and turquoise [13, 14]. The Maya used a single word, *yax*, to express the colors we distinguish as blue and green. They may have seen all things *yax* as analogous – a tropical bird feather, a jade bead, a young ear of maize sprouting from the stalk. To the south, Quirigua and Copan lie near rich sources of jade, and offerings dating to 900 BC at Copan reveal early exploitation of the precious material. The hardest rock of North America apart from emery, jadeite occurs in rock and boulder form in and near the middle Motagua River, and it was worked with jade tools, string saws, leather strops, and abrasives. Both nephrite and jadeite are true jades and depend for their names on the fact that the Aztecs told the Spanish that the stone cured ailments of the liver (Spanish *hígado*, corrupted to jade) and kidney (in Latin, *nephrus*, leading to the term nephrite for most Asian jade). The Maya most admired an apple-green jade, and carvers frequently adapted imagery to veins of color in the stone, which could range from white to black.

13. The preciousness of jade is made manifest by this commemoration of Piedras Negras Ruler 3, made in the eighth century and later taken from its original context (likely a tomb), transported to Chichen Itza, and offered to the Sacred Cenote.

14. This early sixth-century offering from the Copan Acropolis features a jade Maize God in a spondylus shell with cinnabar (mercuric sulfide).

15. Using string saws, the Maya cut a thin piece of jade for this carved plaque from Nebaj, in the Guatemala highlands. Here the enthroned Maize God sits among foliage, attended by a dwarf.

Maya artisans cut jade stones and boulders into distinct shapes [15], some mass-produced for jewelry. Sacred to earlier cultures, jade may also have connoted antiquity, and the Maya collected ancient treasures and buried them centuries later in graves and offering caches. Devoted attendants placed a jade bead in the mouth of a dead loved one, to serve either as a receptacle for the soul, or as an endlessly replenished maize kernel. To the Maya, like the Chinese and Japanese, a jade bead was the symbol of preciousness, but objects in jade could range from the thinnest tessera to a 4.42-kg (9.75-lb) carved cobble [16], the latter, from an Altun Ha tomb, representing the head of an avian Jester God, a deity associated with Maya rulership.

16. Weighing nearly 4.5 kg (10 lb), the Altun Ha jade head, the largest known work of Maya jade, was found at the pelvis of a Maya king interred early in the seventh century.

When K'inich Janaab Pakal – the great ruler of Palenque – died in 683, his heirs assembled a jade mask on his face [110]. The small flat jade tesserae yielded to large, specialized jade pieces for the nose and mouth, including reworked heirloom pieces. In his open mouth is a T-shaped tooth, which both symbolizes wind or breath and connects him to the Sun God. The dead, masked Pakal thus must have taken on both the guise of the Sun God and the Maize God, two divine images of renewal, forever young and firm of face, even though he died at eighty years of age. During the Classic period, the Maya also used other greenstones, including fuchsite, serpentine, and malachite. The female buried in Palenque's Temple 13, likely Pakal's wife, wore a mask of malachite tesserae, an analogue to Pakal's jade mask.

Starting around the year 900 and into the Postclassic era, Central Mexican Toltec traders made a new blue-green

material, turquoise, available to the Maya. Turquoise comes from the southwest United States and northern Mexico, and the Toltecs, Mixtecs, and Aztecs treasured it for their mosaics. Most turquoise mosaics found in the Maya area were probably assembled elsewhere, but the Maya certainly incorporated the material into new objects when it was available. Several *tezcacuitlapilli*, round mirrored ornaments worn on the backs of Toltec lords, were found at Chichen Itza. One intact example [17], its mosaic creating a pattern of Central Mexican fire serpents radiating from the center, was set into the seat of the Red Jaguar Throne of the interior Castillo, the four serpent heads oriented to the cardinal directions. Before the building was sealed, Chichen lords placed three large jade beads on top of the mosaic, thereby setting the three stones of their creation hearth, perhaps to initiate a new era that merged traditional Maya and new Central Mexican concepts. Wooden objects with turquoise mosaics were dredged from the Sacred Cenote at Chichen Itza, and at Santa Rita Corozal, ear flares made of gold and turquoise, probably imported from Central Mexico or Oaxaca, were found in a tomb [18]. These artifacts are among the material evidence of expanding Postclassic exchange

17. Brought to Chichen Itza from distant New Mexico by Toltec traders, turquoise was fractured into tiny tesserae and assembled onto a wooden frame to create this round ornament. Three similar examples were recovered at the site; the center of this one, found on the back of the Red Jaguar Throne (ill. 181), probably once held an iron pyrite mirror.

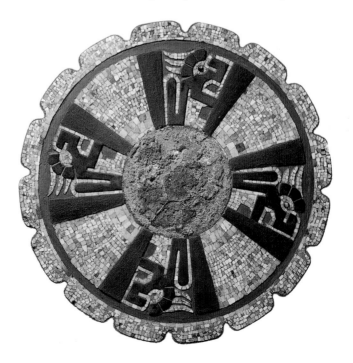

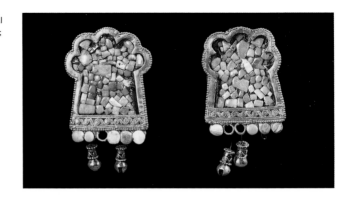

18. Postclassic Santa Rita Corozal was a place of astonishing wealth; a well-preserved tomb included these ear flares of gold and turquoise. The tiny bells were cast using the lost-wax process.

19. These three thin, cut pieces of gold foil were recovered from Chichen Itza's Sacred Cenote; they form a mask that was also depicted in painting and sculpture at the site.

networks, through which Maya people imported turquoise, gold, and copper and exported materials such as salt, cacao, and palygorskite clay (for making Maya blue pigment).

Gold

Gold made a late entry into Mesoamerica from South America, where metallurgy had begun in Peru by 3000 BC. Two broken legs, hollow, and therefore cast by the lost-wax method, of a Lower Central American figure, were found in a cache under Copan Stela H, which could not have been sealed later than AD 731, making it the earliest securely dated gold of Mesoamerica. Well into the early Postclassic era, Central America remained the main source of finished and partly finished metals. By no later than AD 900, the ability to manipulate raw lumps of gold had arrived in Mesoamerica, and gold began to be identified with the sun, cherished and revered for its luminosity. Still, at the time of the Spanish Conquest of Mexico, most indigenous peoples favored greenstones over gold, a preference quickly exploited by Spaniards; but Spanish conquerors seeking Maya gold went away largely empty-handed, since the material remained rare in this part of Mesoamerica.

By no later than the tenth century, Maya lords at Chichen Itza were importing quantities of metal, particularly sheet gold, from Lower Central America. Some sheet gold may have been delivered in disk form, which the Maya then worked using a repoussé technique. The hammered imagery reveals sophisticated compositions [178], usually featuring multiple zones, with Chichen Itza lords in the middle zone, framed by sky gods above and underworld gods below. Slightly convex,

the gold disks were probably affixed to wooden backings and worn by warriors.

In the last few Precolumbian centuries, the Maya came to know and work other metals, including tin, silver, and copper, although most of these were imported from Central Mexico. The Maya at Mayapan and Lamanai made ornaments using the lost-wax process, like the craftsmen of Central Mexico, even melting down copper trade items to make new works. The Chichen Itza cenote yielded a matching set of six copper bowls, all covered with gold foil, or what truly would have been a table setting fit for a king. In the sixteenth century, Bishop Landa would write of the cenote: "they also threw into it a great many other things, like precious stones and things which they prized. And so if this country had possessed gold, it would be this well that would have the greater part of it...." Such lines inspired divers and dredgers to dream of what might lie at the cenote's bottom, and in 1904, Edward Thompson recovered the first rich offerings from the murky sinkhole. These included the precious metals Landa had predicted, for into the cenote people had thrown gold and copper bells, disks, bowls, face masks, and other items, often crushing them before tossing them into the water to transform them into offerings [19].

Fruits of the sea

Across the Maya realm, and from early times onward, the Maya collected materials from the sea, seeking shells, pearls, and sea animals, particularly turtles and manatees. The Maya prized two shells over others: spondylus [14] and oliva. Various spondylus, or thorny oyster, species are found in the Caribbean, Gulf of Mexico, and Pacific Ocean; broken but useable spondylus shells wash up on reefs, but the best examples with intact spines are found at depths that tax the limits of the unaided diver. The spondylus also yields a delicious high-protein food as its first prize, and the occasional pearl as its second. The Maya prized pearls, and adorned themselves with them. On Yaxchilan Lintel 24 [145], Lady K'abal Xook's dress billows and drapes, revealing tiny sewn pearls on the selvage. But pearls are only occasionally found in archaeological contexts, as at Tikal or Palenque, where rulers' tombs contained jade jewelry studded with pearls. To prepare the spondylus shell itself, they scraped off exterior spines and interior white nacre, reducing the weight and

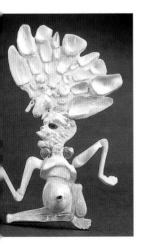

20. Assembled of delicate nacre (mother-of-pearl) and jade beads, this small death god mosaic, with skeletal body and distended belly, may have been part of a headdress assemblage. It was found in a rich tomb on the island of Topoxte, where there was little other elite activity.

29

revealing a brilliant orange interior. Modified spondylus shells trimmed lords' mantles, formed headdress ornaments, and girded women's loins. Workers also cut spondylus shells into mosaic tesserae to create tunics, seen on Piedras Negras Panel 15 and recovered in Burial 5 from the same site. The Maya also valued whole shells and often deposited them in tombs and caches, with the shells' spines intact.

By comparison, other shells received simple treatment. Simple surgery turned conchs into trumpets, and the Maya also incised designs onto their surfaces, carved portions into figural shapes for ear or chest ornaments, or sliced cross-sections to create spiral pectorals. Maya lords also wore multiple strands of single-valve oliva that hung from the hip or edged their kilts, a noisy costume for dance or war. Pecten shells – from the scallop, or saltwater clam – held their greatest value during the fourth century, when Teotihuacanos introduced them to the Maya [117, 119]. Like the Aztecs, who collected brain and other corals and interred them in their principal temple, the Maya valued unusual sea material and added it to cache deposits and tombs. From coral reefs, the Maya also obtained spines from stingrays for bloodletting. Finally, shells of many types were combined with materials such as jade and turquoise to create mosaic images on shells or wood backing [20].

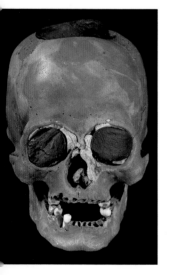

21. With the cranium cut open, the eye cavities filled, and a wooden lid fitted into the opening, this human skull formed an incense burner in which copal was burned.

Bone

Artists worked bones of all sorts, human and animal [22]. They carved bones into shapes of deities [36], using the natural nodules of the medium as faces, eyes, or headdress elements. Bones also were used as surfaces for incised images and texts. At Tikal, Jasaw Chan K'awiil departed the mortal world with a bag of some ninety carved bones, a number of them worked with delicate incision and rubbed with brilliant vermilion [11, 103, 107]. Some human bones may have been relics of revered ancestors, or trophies from the bodies of vanquished captives. A glance at burials from Early Classic Tikal reveals opportunities for both: the primary skeleton of Burial 48, believed to be the ruler Sihyaj Chan K'awiil, lacked femurs, a hand, and a skull, whereas his companions, presumably sacrificial victims, were interred with skeletons intact. If the king's bones had formed a secondary burial, made after the flesh rotted away or was boiled off, the heirs may have claimed relics. Or, if the lord had

22. Found in the early seventh-century Tomb I with another peccary skull and bone needles, this striking skull depicts a legendary scene from the time of Copan's founding: two rulers, sitting within a supernatural portal, face a stela that is wrapped with cloth, prepared for its dedication.

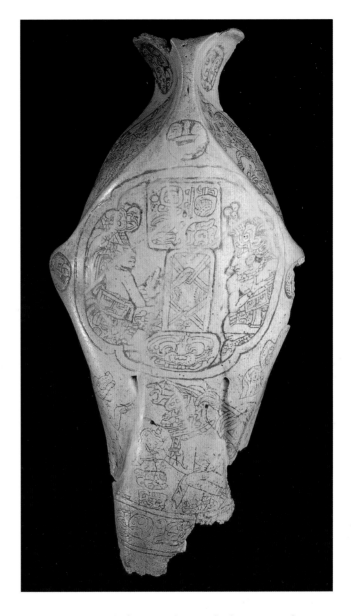

been killed by hostile forces, only some body parts may have been returned. Human skulls were collected and modified too. Excavators retrieved an elaborately carved skull from a Kaminaljuyu grave, and at Chichen Itza, a skull was converted to an incense burner, used to burn rubber, and offered to the Sacred Cenote [21]. Either might have been a relic or trophy.

Wood

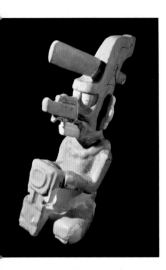

The Maya had a number of extremely hard tropical woods to carve, many more resistant to carving than stone but unfortunately perishable – and thus constituting a body of Maya art largely lost. Undoubtedly the Maya used mahogany and rosewood (the latter with its pungent, sweet smell) for sculpting, and three-dimensional wooden sculptures were probably common, although only the tiniest sample remains [24]. Surviving examples come from caves, cenotes, and tombs; in one case, complete imprints of wooden sculpture survived at Tikal, where a flooded tomb encased works that subsequently rotted away but retained their painted stucco coating [23]. Additionally, sculptors carved hewn boards of tropical hard woods (particularly sapodilla) to form figural and hieroglyphic lintels, and lintels spanning doorways of Tikal's towering temples have survived *in situ* [156].

23. Quick-thinking archaeologists at Tikal injected cavities in Burial 195 left by long-rotted wood covered with stucco, capturing the brilliant Maya blue paint and revealing a stunning set of four K'awiil deities from the early seventh century.

24. Carved of durable tropical wood, this seated dwarf may once have supported a mirror, part of a ruler's palace furniture.

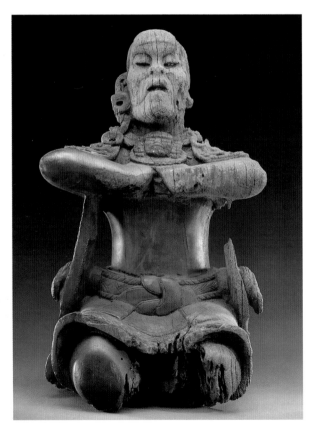

Limestone and other stone

Maya stone sculpture emerged as a well-developed tradition, likely with origins in the sculpture of wood. At most sites, the Maya quarried limestone for their monuments, and at Calakmul, partly quarried shafts remain *in situ*. Using chisels made of chert, some of which have been found in ancient quarries, workmen freed stone blocks on all sides until the prism could be released, leaving only a small "quarry stump" of the sort visible on some stela butts. The quality of stone varied drastically from site to site: at Coba, for example, the gray-white limestone is full of fossilized seashells, which erode fairly quickly, leaving a nearly unintelligible monumental record; Tikal had access to a wide variety of limestone rock, ranging from the fine-grained limestone of Stela 31 to the porous rock of Stela 11 [118, 157].

Sculptors used chert chisels, flakes, picks, and bifaces, some hafted onto wooden handles, to carve these stones, and then abrasives for polishing. In general, freshly quarried limestone yields easily to stone tools and hardens over time, and in the west, sculptors carved fine-grained limestone as fluently as if it were butter. Particularly at Palenque (where the stone has a lovely golden tone) [28], the chisel worked almost like a paintbrush, whether in bas relief or incision, and sculptors crafted designs in stone that, at other sites, could only be achieved in paint [136]. Palenque's painters and carvers may have been one and the same, in fact, grafting both whiplash and pushed paintbrush lines onto the chiseled surface.

On the southern margins of the Maya realm, other rock types dominated sculpture. The volcanic tuff quarried at Copan ranges from brown to pink to green in tonality and was particularly malleable after quarrying, subsequently hardening after exposure to microflora. In contrast to bedded limestone, volcanic tuff lent itself to the greater three-dimensionality characteristic of Copanec sculpture and provided material for massive mosaic facades [159, 160]. Most works were covered with at least a thin wash of stucco, unifying tonalities, but today the colorful and varied underlying stone once again prevails. Tonina sculptors used local sandstone to craft three-dimensional sculptures of standing rulers with fantastic headdresses of stacked deity heads [126], and to carve panels portraying ballplayers or bound captives [26]. At Quirigua, the brownish-red sandstone is a particularly hard and resistant red rock that defied sculptors' attempts to transpose the

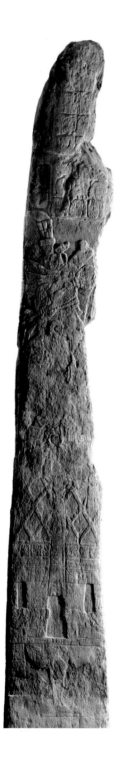

three-dimensionality of Copan, but, with its great strength and little predilection to shear off or fracture, enabled Quirigua lords to erect the tallest freestanding monuments of the Western hemisphere [165].

Local stone was the rule, but exceptions occurred. Calakmul Stela 9 [25] is made of black slate imported from the Maya Mountains, at least 320 km (200 miles) away – and perhaps evidence of political fealty conceded to that powerhouse by Caracol or a nearby polity, either as gift or tribute in AD 662, when Calakmul was at the height of its power. At Tonina, a variety of stones – some of which may have been delivered as tribute payment – depict captives. Completed stone monuments (or parts of them) also were moved. Simon Martin suggests that several stelae from small sites near Tikal, including Xultun and Uolantun, were originally at Tikal but were sent away, or exiled, and adopted by smaller sites. Miller and Houston demonstrated that stone steps celebrating victory were erected at defeated sites but later dispersed to other, subsequently defeated sites, especially blocks involving Calakmul, Caracol, Naranjo, and Ucanal. In this case, moving stone blocks may have been both punitive and humiliating. Such movements of rock may become more apparent as scholars come to understand quarries and their sources better, but the phenomenon occurs elsewhere in Mesoamerica: on the one hand, the Gulf Coast Olmecs of the first millennium BC imported tons of unworked basalt unavailable locally; on the other, the Aztecs at the time of the Spanish invasion demanded tons of imported rock as brutal imperial tribute burdens.

The Maya set their stone stelae in striking configurations, arrayed in stunning order on Copan's Great Plaza or like a receiving line of ancestors along Tikal's North Acropolis [42]. At Piedras Negras, each king initiated a new line of stelae, never exceeding eight. On other occasions, wooden banners or posts may have been placed in stone bases, such as Tonina Monument 8. Some sites, including Tikal and Caracol, that erected stelae in the Early Classic, favored stela-altar pairings [27], and at Copan, altars took fantastic forms of turtles and mythological caimans [159]. Some scholars have sought to replace the term altar in the Maya lexicon, but most of these round, low stones set in front of stelae, as at Tikal, do feature imagery of sacrifice [154].

Despite the general prevalence of the stela, the Maya also adopted other sculptural forms. For example, Palenque artisans

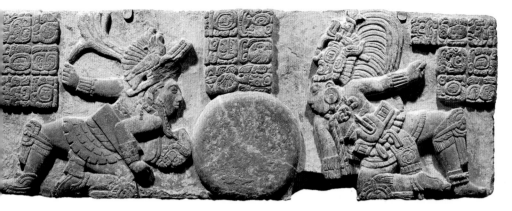

26. (above) Reused and set with the carved side hidden from view, this lintel portraying ballplayers from Tonina is made of the characteristic warm, red sandstone of the site.

27. (right) Stelae and altars of local limestone, here Stela 22 and Altar 10, were consistently paired within the north temples of the Twin Pyramid Groups at Tikal. Lords rule on the upright stone shafts, while altars feature sacrificial victims.

25. (opposite) The slate of Calakmul Stela 9 came from the Maya Mountains, about 150 miles away, obtained either through trade or, more likely, tribute. Made in 662, this side depicts a female in beaded skirt, and the other portrays the ruling dynast.

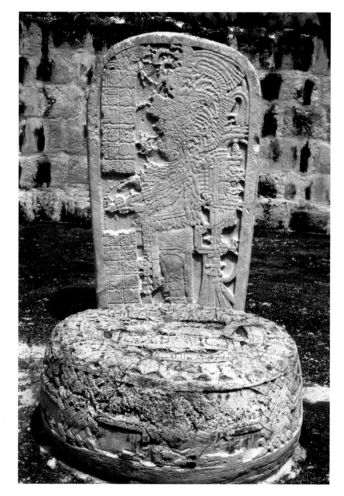

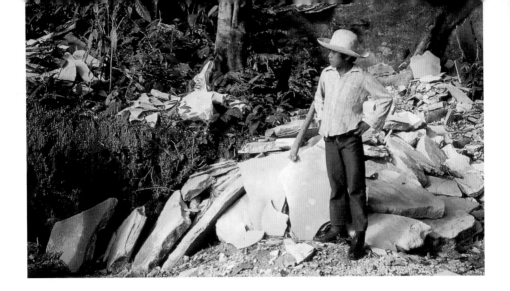

28. As seen in this photograph by Merle Greene Robertson, Palenque quarries yielded large, thin slabs of dense and fine-grained limestone.

assembled thin, carved panels of limestone for large interior installations [28, 132]; Yaxchilan and Petexbatun-region sculptors carved steps with images of captives forming galleries for public intimidation; and Piedras Negras builders incorporated carved panels into building facades [141, 142].

Chert and flint

Chert is a microcrystalline quartz that sparks when struck. Found throughout the Maya lowlands, it was the main material for tools and weapons. Flint, a black chert, held practical and ceremonial value, and the Maya made thousands of flint objects that never saw use as tools. Artisans knapped flint into unusual shapes, ranging from actual weapon forms to simple dogs and turtles, and at their most prized, human forms. Archaeologists call these odd flints "eccentrics" [29]. The knapping of stones was a specialized skill, and some artists were able to achieve the subtlest detail of a pouty mouth or pronounced chin. Eccentric flint figures often sprout multiple human heads, some personifying body parts, particularly the penis.

Eccentric flints in anthropomorphic form usually personify the god K'awiil, whose characteristic torch may signal he was the patron god of flint. These were carried as K'awiil scepters or tucked into headdresses; some may have been hafted onto wooden handles. Other eccentric flints were made explicitly for architectural dedication caches, perhaps to channel the power of lightning into architecture.

29. Sets of flints at Copan retain the shape of the "leaf," the form in which the raw material was transported across the Maya realm.

Obsidian, pyrite, cinnabar, and hematite

Other valuable materials came from farther away, from the Guatemala highlands, or the Maya Mountains of southern Belize. Volcanic flows provided obsidian, a material often considered the "steel" of the New World, used for blades and projectile points, and also worked into art forms, and sometimes incised. Obsidian also was used to create polished mirrors, as was iron pyrite, which was put together to create mosaic mirrors whose tesserae emulated turtle shells [30]. Mirrors, portrayed in images of courtly life painted on ceramic vessels, were used for both personal reflection and spiritual divination.

The Maya found and used cinnabar, or mercuric sulfide, also called vermilion. They knew how to convert the soft ore to quicksilver, first heating the ore to yield the poisonous gas mercuric oxide, and then cooling the gas to yield liquid mercury, dangerous enough but stable, and which archaeologists have found in intact vessels, interred in caches and burials [14]. More characteristically, the Maya preferred the red ore, applying it to sculptures and using it in the

30. Found at the foot of an interred lord at Bonampak, this mirror comprises fifty-nine perfectly polished pyrite tesserae fitted together, forming an idealized turtle carapace.

preparation of bodies for interment. Mountains yielded hematite, a red iron ore pigment, also used to color the deceased, and specular hematite, flecked with mica, used as a painting pigment.

Stucco

Stucco is created by mixing water and vegetal gums with lime. A pliable medium, it was used to shape architectural sculptures, smooth architectural facades, and cover book pages, ceramic vessels, and walls in preparation for painting. The largest of all Maya sculptures are architectural facades made of modeled stucco, like those at El Mirador or El Zotz [43], which represent massive deity heads. Merle Greene Robertson's years of study at Palenque provide the best guide to the materials used: sculptors sketched imagery on plainly finished plastered walls, before building an armature of small stones. Over these stones they applied layers of stucco, completely modeling human body forms before layering on their costumes. Painted stucco is vulnerable to damage by rain and other moisture, and Maya artists repeatedly painted sculptures and buildings to preserve fresh imagery.

To make a good quality lime or cement that will in turn form a supple plaster or stucco, limestone, shells, or *sascab* (decomposed limestone) must be burned, and it usually takes two days of steady burning to reduce limestone to powdered cement. At Tikal archaeologists have found lime kilns, which helped to reduce the amount of wood this process demanded; wood indeed was at times more scarce, and conversion from modeled stucco ornament to cut stone may have been driven by the disappearance of local supplies of fuel. This transition is notable at Copan, particularly in the change from the stuccoed Rosalila building to the stone mosaic Oropendola building discovered by Ricardo Agurcia. This transition, which set the stage for diverse Late Classic facade decoration at Copan, may have occurred out of necessity, or from a desire for more durable materials that did not demand constant maintenance. Stucco ornament flourished longer in areas of richer forest, notably at Tonina and Palenque, although Isabel Villaseñor has shown that later Palenque buildings use a plaster mix with high clay content, perhaps because sufficient lime was unavailable.

The materials of painting

Smooth, plastered walls made ideal surfaces for painting [31], but we do not know the full extent of the monumental painting tradition. Buildings of perishable materials may have had stuccoed and painted facades, roofs, and roofcombs, some of which are depicted in Maya art, clues to a lost tradition. Painters worked on walls of dry or damp stucco; they mixed organic and mineral pigments with water, lime, and vegetal gums (from tree bark or orchid bulbs), which they painted on walls with brushes made of animal hair and plant fibers or quill pens. At Río Azul, Tikal, and Caracol, archaeologists have found Early Classic painted tombs, worked in a limited palette of cream, red, and black. The extent of full polychrome paintings may never be known, but the anomalous preservation of murals at San Bartolo [208], painted around 100 BC, and at Bonampak [217, 218], from AD 791, raises the possibility that such powerful works existed elsewhere also.

The materials of monumental painting ranged from the cheap and common, such as carbon for black, to expensive minerals, such as azurite, which had to be imported, and ones that had to be manufactured, such as Maya blue, created by heating indigo and palygorskite clay to create distinctive and stable blue-green shades. At Bonampak, artists made Maya blue even more precious by blending it with azurite to make the striking blue pigment that dominates the paintings [92]. So valuable and rare was this ancient material that anyone looking at the Bonampak walls may have gazed with the awe of someone seeing the golden mosaics of Ravenna, where lapis lazuli – the azurite of the Old World – studded the walls.

31. Maya painters used consistent recipes for blue and other colors from one wall to another at Bonampak, binding them to stucco walls with agglutinants from trees and orchids. This warrior from Room 2 wears a painted hipcloth that wraps around his body.

Maya codices

Small-scale painting on fig-bark screenfold books [227, 228], called codices today, was a constant endeavor of the Maya scribe over the course of centuries, right up to the Spanish Conquest, although the heyday was probably the first millennium AD. In contemporaneous Europe, paper was unknown and vellum was an expensive commodity: even at the time of the Conquest, Spaniards marveled at the Aztec profligacy with paper, for in addition to painting on it, they used it to adorn themselves, headdresses, and god effigies, they made offerings of blood and rubber on paper, and they burned paper as offerings, as did the

Maya. With fig bark so readily available, the Maya, too, must have considered paper a relatively inexpensive commodity. Although we can only guess what a book from the first millennium looked like, we can imagine that every Maya book was illustrated, with both pictures and text made by trained scribes, and every one what we would today consider a work of art.

Fragile and perishable, some ancient books may have been in circulation when Bishop Landa conducted his *auto da fé*, or "test of faith," in sixteenth-century Yucatan, burning dozens of Maya books in a single conflagration. Four late and fragmentary books survive, as discussed in Chapter 9, and they provide clues to Mayan writing and image-making of earlier times as well. For the Maya, the book may have been one of the most important and precious works. Maya kings were buried surrounded by luxurious goods: included on the chest or somewhere near the body was often a book, as at Altun Ha and Uaxactun, although archaeologists find only their stucco coatings.

Clay and ceramics

Almost every Maya stream bank provides a source of clay. Even today, potters guard good clay mines, and a painter of pots keeps a kit of pigments to blend into clay slip. The Maya created ceramic vessels, figurines, and censers at numerous sites, and at Comalcalco, clay bricks were used to construct buildings [33]. Figurines and censers were made with molds and hand-modeling to create unique sculptural forms of varying sizes [32, 35].

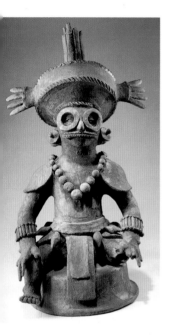

32. One of a set of twelve incensario lids placed outside Ruler 12's tomb at Copan, the "goggles" of this example certainly identify it as the embodiment of Yax K'uk' Mo', the founder of the dynasty.

33. Clay could be put to many uses; at Comalcalco, where stone was scarce, artisans made bricks and marked them with hasty but informed incision. The incised side faced other bricks and remained unseen until archaeologists turned the bricks in the twentieth century.

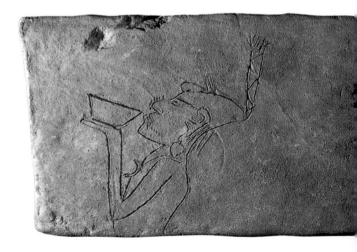

34. Maya artists painted black backgrounds with carbon suspended in slip on this vessel from eighth-century Tikal, reserving unpainted ground for glyphs and figures. Few textiles survive, but the painted gauzy fabric here is one of many renderings that reveal the range and complexity of Maya weaving and embroidery.

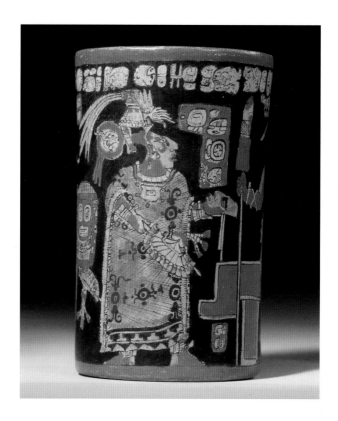

Maya vessels, like all Mesoamerican pottery, were hand-built, without the benefit of a potter's wheel, usually by coiling rolled strips onto a base, or with slab construction, to form the chassis that might then receive feet, a lid, or other additions [34, 190].

Ceramic vessels also became a prime repository of elite imagery. Maya pots were painted with clay slips, blended with colored clays and minerals to yield a range of colors, which bonded permanently to the pot; burnishing increased surface sheen. Although often glossy, no Maya pot was ever glazed, but in the Postclassic, the vitrification of Tohil Plumbate achieved a high gloss [206]. Maya vessels and figurines were fired in open pits and possibly inside larger vessels called saggers, which would have protected finer objects from fire-clouds. Archaeologists have found one possible ceramic kiln in the Maya area, at K'axob, where they also found broken ceramic sherds used as production tools. Most artisans painted with slip before firing; some adopted the Teotihuacan technique of painting fired ceramics with stucco, including pastel pinks and blues [189].

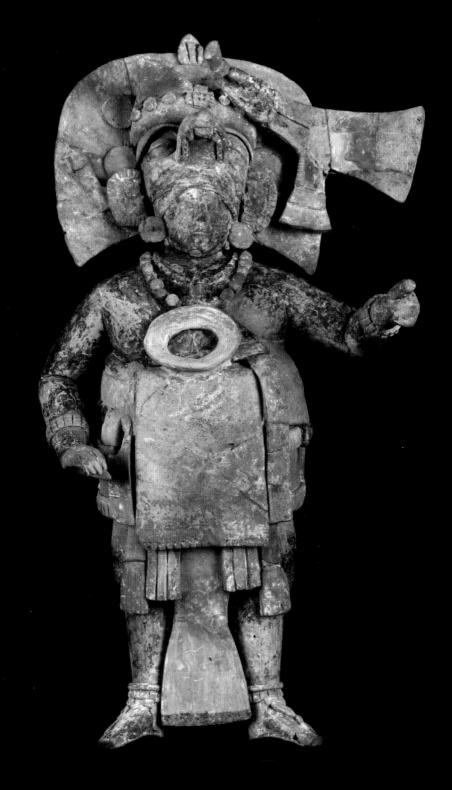

Textiles

35. One of an elaborate set of twenty-three figurines (see ill. 95), for which artists began with mold-made heads and other parts and then built upon the standard chassis, adding matching attire, adornments, and post-fire paint. Thick feet made it possible to nestle figures upright, forming a lasting assemblage.

Among Maya people today, textiles [233] dominate other traditional art forms, with the possible exception of domestic architecture. From town to town across highland Guatemala and Chiapas, traditional weaving has survived and thrived, and weavers and sewers use indigenous and introduced materials to express ethnic and local identity in color and motif. Cloth undoubtedly was an important ancient art form and may have been a means of storing wealth. Outside the Maya area, there is good evidence of the latter: units of cloth bear specific exchange values in the *Codex Mendoza*, a post-Conquest book documenting tribute paid to the Aztecs; a significant part of the *Codex Magliabechiano* depicts mantle patterns, and painted pottery and jade beads are given less weight in these notations. Indeed, these manuscripts suggest that textiles were the most valuable product, as we know them to have been throughout the ancient Andes. What is different in the Andes, however, is preservation: thanks to one of the driest deserts in the world, thousands of Andean textiles from all periods are known.

For the Maya, we have only a few scraps – fragments from cenotes, and cloth impressions left in burials. Archaeologists have described seeing what appeared to be bolts of fabrics turning to dust when they opened the dry tombs deep within ancient pyramids, as happened at Kaminaljuyu, Uaxactun, and Altun Ha, where David Pendergast also found prints from rope left in the tomb. Tools for making textiles also survive [36], including ceramic spindle whorls for spinning cotton, bone needles for sewing, bone picks for weaving, and obsidian blades for cutting thread and trimming fabric.

36. A tomb under Structure 23 at Yaxchilan may have belonged to a royal woman; these carved bones bear the name of Lady K'abal Xook and may have served as weaving picks, hair pins, or simply, as David Stuart has recently suggested, ritual implements, Lady K'abal Xook is known for extraordinary textiles in her depictions.

The only real guide to the role of ancient textiles as an art form is their representation. Seventh-century figurines show Maya women weaving with back-strap looms, as many Maya women still do today. On painted pots, carved stone lintels from Yaxchilan, or painted murals at Bonampak, Maya elite men and women are wrapped in sumptuous clothes, generally fine cottons with elaborate woven and painted designs [34], but also deer hides and jaguar pelts, woven mats, and feathered brocade. The patterning of Maya dress, with bordered selvages and continuous design, is akin to the patterns of painted architecture and painted ceramics, and ancient textile design perhaps was a medium far more influential than most scholars have thought.

Yet the lost textile arts also survive in traces of their structural identity in other materials, such as ceramics, where artists painted designs whose forms derive from embroidery or basketry techniques [37]. Here, the painter turns the

37. Both potter and painter worked to make this painted vessel imitate the perishable form of the basket, from its trim form to painted design that replicates basketry and emphasizes the tapered waist.

perishable basket into a durable ceramic vessel, using paint as the medium for the artifice. Alternatively, a painter may use streaks of brown slip to suggest a ceramic cup is instead made of carved wood [192, 193]. Maya artists seem to have relished such skeuomorphism, which appears in stone too, notably in stone roofs at Palenque and Plan de Ayutla that were made to resemble thatch [38].

Maya representation also offers glimpses into other perishable materials, including tropical bird feathers that were used to create brilliant polychrome headdresses comprising blue-green quetzal feathers [218] and black and white hawk feathers, yet none survives archaeologically. Another important perishable material must have been papier mâché, made of manioc paste, cornstarch, or bark paper to create light sculptural forms for headdresses and the magnificent palanquins used for processions [155].

Despite poor preservation, fragile materials such as wooden bowls, gourds, and textile fragments occasionally survive, and jaguar pelts draped in tombs are evident from the claws left behind. But other items such as assemblages of dough or corn husks do not survive in any form, although we can imagine they might have existed, and they are described in Spanish chronicles about the Aztecs. These materials remain beyond our ken, and what must have been a fantastic world of perishable Maya arts survives only in glimpses.

The human body

The human body, both transitory and permanent, was a canvas for diverse art-making, the skin decorated with paint, tattoos, and cicatrization, the hair tied or cut into distinct shapes, the body adorned with jewelry, clothing, and headdresses [98]. The Maya imagined their gods in human form but with features marking them as supernatural, such as sloping foreheads, crossed eyes, or filed teeth [101, 104, 125]. Maya elite shaped their own bodies to emulate those deities, modifying babies' heads to produce a sloping forehead and filing adult teeth into a T-shape or an *ik'* ("wind")-shaped opening. Even after death, bodies were painted with cinnabar and hematite, wrapped in textiles and feline pelts, and adorned with jade, shells, and other materials, the tomb a fundamental locale for the making and installation of beautiful things to accompany the dead to other worlds.

Chapter 3 Building the Maya World

From the first millennium BC onwards, the Maya built public buildings, creating vast facades against which to stage great spectacles and plazas in which to congregate [39]. Sixteenth-century Spaniards described winding processions that moved from city to shrine across Mesoamerica, in which brightly adorned warriors and supplicants were poised against man-made marvels of roads and pyramids.

With its emphasis on mass and less attention to interior spaces, Maya architecture is composed of a few relatively simple elements: the house, the volume of platform or pyramid, and the path or steps through which people's movements animate the built environment. At its heart lies the one-room house, comparable to Maya houses in Yucatan today, with wattle-and-daub walls, a thatched roof, and a fire at center. Ancient builders replicated vernacular house forms in stone and multiplied them to compose great rambling palaces, or they isolated them atop huge platforms to create temples. Most characteristic of the house is its thatched hip roof; translated into stone, the result is the corbel vault, in which courses of stone approach each other until they are spanned by a single capstone [52]. Despite being inherently unstable, the corbel vault was never challenged by other types of vaulting, perhaps because its relationship to the hip roof gave it inherent value, although the Maya also created flat, trabiated roofs using wooden beams and stucco, and two examples of stuccoed rounded vaults (without keystones) have been found at Calakmul and La Muñeca.

The perishable origins of and counterparts to Maya stone architecture in mud, wood, and thatch seem to have been often in the minds of builders of monumental architecture, who at times engaged with those other materials, as at Palenque, where the edges of the House E roof are shaped to look like thatch, or at Plan de Ayutla, where the upper part of Structure 13, made of stone, looks like an enormous thatched roof, its designs mimicking layers of evenly trimmed thatch descending in steps down either side of a midline [38]. In this way, monumental building at times hewed closely to its perishable

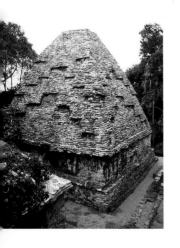

38. The stone roof of a small shrine at Plan de Ayutla masks the corbel vault with a design that probably replicates thatch.

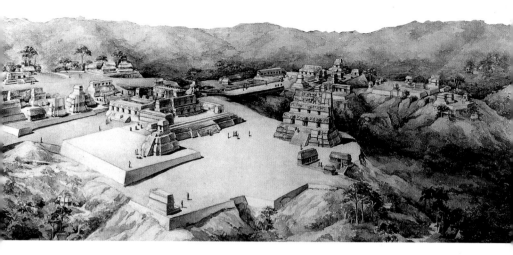

39. Tatiana Proskouriakoff developed this convincing reconstruction of Groups A and B at Uaxactun to demonstrate how elevated roads connected the elegant clusters of buildings separated by ravines and swamp. She called it a city and noted that much of the area was "occupied by residential buildings and minor plazas and courts," but she rendered little human activity. The resulting image probably helped foster the notion of the so-called "vacant ceremonial center."

forebear and counterpart, perhaps for play, as if a visual pun, or to create elite structures that emulated common ones.

The mass of pyramids and platforms is an astounding feat, for builders assembled countless tons of freshly quarried limestone and recycled rubble to construct huge pyramidal structures, both on flat ground and as extensions of hills and other landforms. To create the mass, builders framed sections to fill with rubble; workers carried materials up tier after tier, often scaling a steep, unfinished staircase that later was covered by a more finely finished one [40].

To us the mass appears to be solid, but the ancient Maya may have understood it to be penetrated by hidden hollows – holding caches, tombs, and sealed rooms – that archaeologists uncover as they peel away layers of constructions [54]. The counterweight to mass is void, and the Maya valued the open plazas as much as the volumes. Larger buildings demand larger plazas, and so the largest constructions, whether at Late Preclassic El Mirador or Late Classic Tikal, received the grandest attendant spaces [42]. But there were not fixed proportions; Quirigua's huge plaza seems out of kilter with the modest neighboring buildings. Plazas often overlie hidden efforts, usually drains, to keep them from flooding (although they still did), or to create watery courtyards evoking the underworld entrance. At Tikal, gently sloping plazas delivered water to reservoirs that sustained populations during dry periods [41].

To connect these most important aspects – plaza, house, and platform – the Maya depended on steps and pathways.

Steps move humans vertically, whereas pathways connect horizontally, and the Maya used both with careful thought. Shallow, high, and steep staircases may have limited real movement, but they provided opportunities for visual pageantry, for massive stairways may have been most desirable for performances and rituals. In all periods, the Maya built elevated roads, called *sacbe* (or plural *sacbeob*), "white road," in modern Yucatac Mayan, referring to the gleaming plaster finish of their surfaces. At a city like Uaxactun [39], the white road was a ceremonial road connecting clusters of temples and palaces; in other cases, it connected two cities, between El Mirador and Nakbe in the Preclassic, for example, or Uxmal and Kabah in the Late Classic.

Pyramids, palaces, and ballcourts

From these building blocks, the Maya created diverse building types. The pyramid, used for temples honoring deities and ancestors, had a terraced mass and central staircase for public performance, and single- or multi-roomed superstructures provided intimate spaces for smaller rituals. Palaces were multifunctional spaces where rulers, their families, and court members lived and worked. These comprised "range" structures, multi-room buildings with rooms lined up side-by-side and arranged along terraces or around courtyards, comparable to modest house groups, providing areas for privacy, group work, and socializing. In some, the ruler's throne room and decorated throne survive. Palaces, especially in the Late Classic, were often elevated on platforms built with rubble and on natural landforms [60]. Buildings along the edges of elevated platforms provided beautiful facades and blocked views of palace activities, but elevated buildings within palaces provided vistas through which rulers surveyed their domains. Fasteners for wooden doors and curtains indicate that open spaces and doors were covered with perishable materials to provide additional privacy.

40. A graffito from Tikal Structure 5D-65 (known as Maler's Palace) shows ladders for scaling temples, offering us insight into how such buildings were made, and even occasionally used.

From the earliest times, the Maya built a single axial architectural form, the ballcourt, for a game played with a solid rubber ball [64]. From its simplest form of two parallel mounds with sloping sides, the court evolved more elaborate designs, with steps at one end for seating or sacrificial display, or laid out in the shape of a capital letter I. Frequently found adjacent to

palaces in their most elaborate forms, ballcourts also appear at some distance from ceremonial precincts, usually as simple stone-faced mounds. Sloping sides at southern lowland sites gave way to vertical walls at Uxmal and Chichen Itza [81] before courts vanished from the Postclassic lowlands, although highland Iximche featured multiple courts. What modern scholars know of the game derives from Spanish descriptions and from representations common in Classic art. Opposing sides fielded teams of three to eight players on the court at once, and heavily padded players struck the ball to a goal – a ring, marker, or the end zone – without touching the ball with their hands.

Maya cities and the landscape

For modern observers, one difficulty in comprehending Maya architecture has been simply to see the architectural configurations through the forest, whether the scrub jungle that grows with 70 cm (28 in.) of annual rainfall in northern Yucatan or the high canopy rainforest of Chiapas that results from 3 m (10 ft) of rain a year. Late twentieth-century forest depredations laid bare the Maya countryside, however, for the first time since the eighth century, making it possible to see the larger context of Maya settlement. Also, emerging technologies involving satellite imagery have revealed new sites under the jungle growth, and LIDAR has found dense and extensive settlement surrounding the site of Caracol; there may be far more detail forthcoming.

Unlike their counterparts at Teotihuacan in Central Mexico, the Maya found little or no attraction in rectilinear city streets or the city grid. Rather, most Maya cities grew organically, from the core outward, and from the bottom up, with accretions that expanded the city's radius and took its highest buildings ever upward. Maya architecture accommodated local topography and took advantage of its features: high, solid, limestone outcroppings served best for massive constructions; low, swampy areas were turned into urban reservoirs. The Maya rarely leveled a hill to rationalize topography, but they frequently hauled massive amounts of rough stone and rubble to expand and accentuate local features.

A city without streets has often seemed a confusing agglomeration of structures, but that perspective may be one informed by the modern plan or map. In fact, for a pedestrian

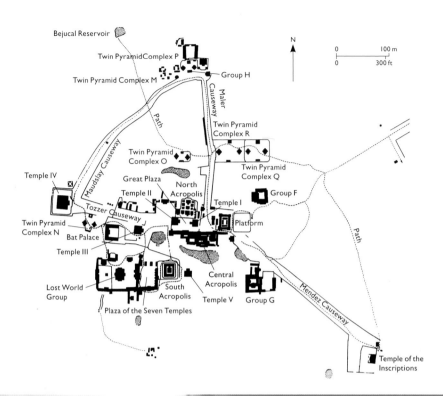

Bejucal Reservoir

Twin PyramidComplex P

Twin Pyramid Complex M

Group H

Maler Causeway

Path

Twin Pyramid Complex R

Twin Pyramid Complex O

Twin Pyramid Complex Q

Temple IV

Maudslay Causeway

Great Plaza

North Acropolis

Temple II

Temple I

Group F

Tozzer Causeway

Twin Pyramid Complex N

Bat Palace

Platform

Path

Temple III

Central Acropolis

Lost World Group

South Acropolis

Temple V

Group G

Plaza of the Seven Temples

Mendez Causeway

Temple of the Inscriptions

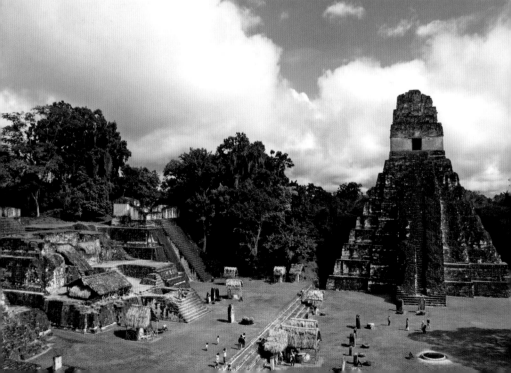

41. Simplified plan of Tikal, showing the causeways connecting the major building groups and the reservoirs (shaded gray) for water storage.

41. Simplified plan of Tikal, showing the causeways connecting the major building groups and the reservoirs (shaded gray) for water storage.

at Tikal, finding one's way around the city might have been straightforward, since the open plazas and huge pyramids created landmarks and vistas for on-the-ground orientation [41]. In contrast, the meticulous grid of Teotihuacan could have seemed labyrinthine, its narrow streets (with the exception of its single great north–south axis) congested and confusing.

Were these great Maya centers "cities"? Not in any twenty-first century sense of the word, but within the context of the premodern world and the ancient New World, they were indeed. John Lloyd Stephens sized up Copan and Palenque as cities in 1839, and although not writing from the perspective of modern sociology or urban studies, the comparison he probably had in mind was his own New York City, where the population was about 300,000. To him a city was a center of social extremes and a place of differentiated architecture: cathedrals and palaces could be distinguished just by appearance; subtler differences separated city hall from financial markets. Stephens did not hesitate to distinguish between a Maya palace and temple, and he had reasonable expectations of what those terms meant. Maya cities provided the greatest social differentiation of the ancient Maya world, for they were home to the richest and the poorest of their times, with populations of 50,000 to 100,000 probably resident at Tikal, Calakmul, or Caracol. Even a population of under 20,000 at Copan or Yaxchilan allowed for sharp separation of social classes. The rich were well off by any standards, and the circle of king and court may have been as much as ten percent (and some scholars might hazard more) of the population. Over time, architectural forms were increasingly differentiated, reaching an apogee at Chichen Itza, where the structures are more diverse than at any lowland site [77]. Chichen Itza may also have had the most heterogeneous population of any Maya city, and that mix may have enhanced the architectural differentiation.

42. A glimpse of Tikal's Great Plaza with Temple I, as seen from Temple II. Ancestral burial shrines and stelae line the North Acropolis to left, where buildings with rounded apron moldings underscore the early date.

Architectural sculpture

The earliest Maya cities of the central region fashioned elaborate exteriors of pliable stucco built over tenoned supports on buildings. The facades of the largest buildings feature huge deity heads, and these may have functioned as idols for adoration or to name buildings or mark them as

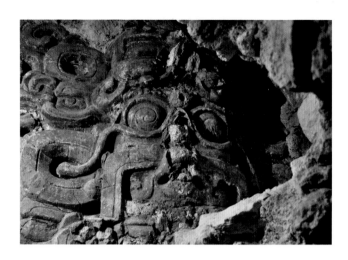

43. A newly discovered facade at El Zotz, 20 km (12 miles) west of Tikal, makes a massive commemoration of the Jaguar God of the Underworld, or the sun at night; characteristic of the jaguar sun is the twisted "cruller" – nicknamed for the pastry – that forms between the eyes.

mythological places. Well-known examples come from Late Preclassic El Mirador, Cerros, and Uaxactun, and this practice continued at Early Classic Tikal, Copan, and El Zotz. Recent excavations have uncovered more Preclassic examples of modeled stucco deity heads at Calakmul and Cival. At El Zotz, a project led by Stephen Houston and Edwin Román uncovered an entire fourth-century AD building with multiple heads of deities, including Chahk and the Sun God in various forms [43].

By the Late Classic period, the scale of facade decoration diminished and may have been replaced by the use of portable braziers and urns installed on pyramid terraces [8], as discovered on Palenque's Cross Group. However, during the Late Classic, massive decoration was set on roofcombs or upper facades, either in modeled stucco crafted over stone tenons, as at Tikal, or in stone mosaics, as at Copan [160]. At Tikal, Temple I's roofcomb held a giant stucco enthroned ruler, although little remains today. Upper facades at Uxmal bear elaborate iconography that offers clues to building function [73].

Scholars long linked the building and rebuilding of Maya cities to Mesoamerican calendar cycles, but excavations have demonstrated connections instead between building campaigns and individual rulers' ambitions, both for their own aggrandizement and to honor deceased ancestors. Even so, some building programs marked major calendar cycles, such as Palenque's Cross Group [55], dedicated on 9.13.0.0.0 (16 March 692), or Tikal's Twin Pyramid Complexes [49], the first dedicated for the same k'atun.

Regional and temporal variations

Because Maya society had no single central authority, individual rulers and ruling families solved architectural problems differently. Although central Peten cities look more like one another than Usumacinta River drainage cities, no template explicates either regional variety, frustrating scholars' attempts to develop a formula that satisfies more than a single center. Yet regional and temporal distinctions can be recognized: Early Classic Piedras Negras resembles Central Peten architecture, whereas its eighth-century flowering follows the pattern established at seventh-century Palenque. On the other hand, one might anticipate that the relatively similar physical environments of Piedras Negras and Yaxchilan, only 40 km (25 miles) apart on the Usumacinta, would have resulted in similar architectural configurations, but they could hardly be more different.

Among the Maya, the agenda of ruling families and individual lords are sharply reflected in architectural programs. An obvious concern was to honor one's ancestors, to enshrine their tombs within huge architectural constructions and make shrines for veneration atop those temples. At some cities these developed into huge ancestor complexes. Yet the city also served as the seat of visceral, mortal power. What may once have been fairly small, simple throne rooms became potent palace chambers, in some cases insulated from the view of the populace, and in others designed to command the public's attention.

Around the Peten: Uaxactun, Tikal, Calakmul, and Aguateca

The first cities of the Classic era arose in the Peten, in northern Guatemala, where Late Preclassic cities had flourished. Some of the largest structures ever built in the Maya area were made in the Late Preclassic Peten, such as El Mirador's Danta structure, measuring 70 m (230 ft) tall. Danta, a tripartite pyramid on a massive platform, was part of a thriving city with temples, residences, and causeways, but despite early success, El Mirador and other Preclassic cities declined and were abandoned in the early centuries AD, possibly because of stress due to environmental degradation, or from disruptions caused by the Ilopango volcanic eruption. This collapse is believed to have been as significant as that of the

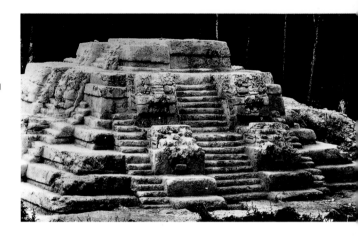

44. Archaeologists stripped away layer after layer of Structure E-VII at Uaxactun during the 1920s, finally reaching an original construction ("sub") that was completed before AD 200. Although modest in comparison with contemporary efforts at El Mirador, E-VII-sub was an important building in its day, a giant chronographic marker that confirmed the movements of the sun.

southern lowland cities in the ninth century AD, yet Maya civilization would continue, and other, more modest Preclassic sites would see vast growth during the third century and beyond.

Most early sites developed around swampy areas, perhaps more favorable for agriculture than lakes and rivers. On most maps today, or even from the air, the Peten looks almost flat, but the broken terrain of karst limestone is in fact rolling and choppy, with underpinnings of solid stone serving best for supporting massive structures. The elevated roads often span swampy areas to link complexes built on solid ground [41]; for comparison, we need think only of New York City, where the rock under Midtown and Lower Manhattan supports massive buildings, connected by New York's avenues.

Early in the first millennium AD, Uaxactun lords constructed a large radial pyramid known today as E-VII-sub, with a staircase on each side, directed toward the four cardinal directions [44]. Massive plaster ornament featured giant Maize God heads borne by the heads of great serpents. E-VII-sub privileged the east facade, where in later phases a stela was placed at the base of the stairs. To the east, the pyramid formed an arrangement with three smaller buildings, creating what has been nicknamed an "E-group," a configuration now widely recognized at sites with a strong Preclassic or Early Classic presence. Functionally, the Uaxactun E-group is a simple observatory: from a point on the eastern stairs, lines of sight can be drawn to the three small buildings aligning with the sunrise on the solstices and equinoxes [45]. These buildings were rebuilt time and again

45. When observed from E-VII, the three small structures facing the larger pyramid marked the equinoxes and solstices, so that the "E-Group" functioned as a giant chronographic marker.

46. At Uaxactun, Group A buildings evolved in eight major stages over at least 500 years, from an open three-temple complex in the Early Classic to dense multi-chamber palaces and galleries in the Late Classic.

throughout the first millennium AD, and although there is debate about whether E-VII's alignment remained intact, these structures were maintained as a significant ritual complex.

Excavations in Group A at Uaxactun revealed a different building program that flourished simultaneously [46]. Before AD 250, lords here razed a perishable longhouse and built a three-temple complex, a triadic grouping even more widespread than the E-groups. As kings died, their successors buried them in rich tombs topped by temples in their honor. But in the seventh century, a new style of building took over the A-V complex: long, ranging palaces first blocked off the main stairs and then turned the old cluster into a sequence of private courts. Royal tombs and the shrines honoring them were subsequently built in other locations, but lesser members of the court – women, children, and retainers – were still buried under these palace floors. From Uaxactun's highest temples, an observer could have seen the roofcombs of Tikal some 24 km (15 miles) to the south.

Tikal shares many architectural characteristics with Preclassic and Early Classic Uaxactun, but on a much grander scale, as with the North Acropolis buildings [42], home to the tombs of early ancestors, which were constructed with characteristic apron moldings and adorned with large stuccoed deity heads. To the southwest, in the so-called Lost World complex, a large Preclassic pyramid forms the focus of an E-group [48]. An adjacent fourth-century structure features the talud-tablero exterior construction and ornament characteristic of distant Teotihuacan and, like other dance

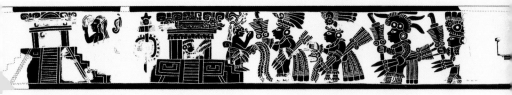

47. A carved blackware vessel from Tikal, in rollout drawing, shows a long procession of lords in Teotihuacan headdresses who carry atlatls and tripod vessels, moving from a Central Mexican shrine at right to a hybrid structure at center. A schematic feathered standard is rendered to the left of the hybrid building.

platforms that dot the site (as in the East Plaza), is architectural testimony to the era's politics, when Teotihuacan lords, through warfare and marriage, appear to have usurped the Tikal throne. Interestingly enough, the workmanship must have been entirely local, for the structure's proportions do not conform to Teotihuacan standards. But the interest in confronting the differences between the two cities' architectural programs was reflected on the small scale as well, evidenced by the image carved on a pot cached at Tikal, where three distinct temple facades seem to show the arrival of lords from Teotihuacan to the Maya city [47].

The North Acropolis at Tikal [42] became a vast ancestral shrine over the 600 years that rulers buried their predecessors within the complex. Early in the fifth century, when Sihyaj Chan K'awiil oversaw the interment of his father, Yax Nuun Ahiin, he ordered a chamber carved into the bedrock at the front of the North Acropolis. Into the tomb went the abundance of Tikal – pots, foodstuffs, a caiman, or *ahiin*, his namesake, and nine young attendants – alongside the dead king, and workmen

48. A Teotihuacan-style building in Tikal's Lost World group (Structure 49). Despite the invasion of Teotihuacan warriors in the fourth century, few Maya buildings took on any foreign characteristics. However, Structure 49, not far from where the Ballcourt Marker (ill. 116) was found, features balustrades virtually unknown in Maya architecture but characteristic of Teotihuacan; it compares with the middle structure depicted on a carved vessel from the site (ill. 47).

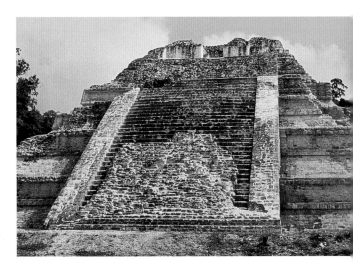

constructed a corbel vault to seal the tomb. Then, a pyramid known today as Structure 34 rose over the tomb, topped by a three-chamber shrine, the rooms linked together from front to back, railroad style. Sihyaj Chan K'awiil completed the shrine to his father, and the building personified the late king.

Eclipsed politically in the sixth century, Tikal experienced sharp economic decline, and no stone monuments were dedicated for 130 years during Tikal's so-called "hiatus," the likely result of defeats by Caracol lords and their allies in 562 and subsequent years. But building continued, for tombs and shrines for deceased kings and other elites were created, and spaces for gathering, performing, and feasting were still built and used.

Freestanding pyramids generally were shrines to powerful ancestors, both at Tikal and throughout the Maya realm: Palenque's Temple of the Inscriptions [54] honored Pakal, and Copan's Temple 16 [65] memorialized K'inich Yax K'uk' Mo'. Descendants paid homage to deceased ancestors, but such constructions clearly reflected on the living as well. At eighth-century Tikal, deceased rulers (and at times their wives) were honored with massive temples whose roofcombs pierce the forest canopy and soar to the sky. Their forms emulate earlier funerary temples of the North Acropolis, comprising terraced pyramids with multi-room superstructures, but their heights – and consequently the labor and resources involved – are much greater. Temples I and II [42], paired on the Great Plaza's east and west sides, the places of the rising and setting sun, were the first major temples dedicated after the hiatus. Temple I housed Jasaw Chan K'awiil, whose death succeeded that of his wife by a few years; she was honored by – if not buried in – Temple II (her portrait lintel spans the shrine doorway, but no tomb has been found).

When Jasaw Chan K'awiil's son Yik'in Chan K'awiil died, his heir and successor – either the short-reigned twenty-eighth ruler, or his successor Yax Nuun Ahiin II – probably entombed him within the huge Temple IV. Two wooden lintels honor Yik'in Chan K'awiil [156], and presumably he is buried inside, although no excavations have pierced the structure. Whether constructing this enormous building was an act of filial piety or derived from a desire to outshine the past, Temple IV, the most massive pyramid constructed anywhere during the eighth century, both outstripped and engaged with Temple I [41]. Temple IV, the highest within sight, also would have impressed

upon neighboring cities Tikal's renewed power, fully recovered from the ashes of their sixth-century humiliation; Temple III may have sought to interpose itself between the father in Temple IV and the grandfather in Temple I. We may never know all the motivations that led eighth-century Tikal kings to build ever higher and grander, but the result, at the end of a century of construction, was a configuration of massive ancestral temples that addressed Temples I and II, which stood in silent dialogue across the Great Plaza, and in turn engaged with the temples to the site's more ancient ancestors in the North Acropolis.

Visible from distant temple tops, the Tikal family pyramids stood like sentinels. These pyramids all face inward, analogous to the way the triangle of Tikal causeways, built or expanded at this time, kept populations moving from one complex to another, without directing energy outward. In its art, too, late Tikal turned inward, reflecting on its great achievements of the past, even while the tallest temples allowed vistas far across the horizon.

During the eighth century, Tikal lords gathered monuments from all over the city and installed them in front of the North Acropolis [42], which held the early kings' tombs and shrines, such that the North Acropolis and Great Plaza were filled with material links to the polity's lengthy history. To the south of the Great Plaza they built a vast palace complex, known today as the Central Acropolis [41], with structures of later generations directly on top of older ones. Galleried buildings facing the plaza, despite their inviting appearance, prevented access to private courtyards within, and the only entrance was carefully controlled by the large eastern palace. Beds and thrones provide evidence that the king and a large retinue lived in the complex, with centralized food preparation facilities on the south slope of the acropolis.

But ancestral shrines and palaces were by no means the only architectural forms built in Late Classic Tikal. Starting in the late seventh century, Tikal kings initiated construction along the causeways of six very similar architectural configurations that today are called Twin Pyramid Complexes [49]. Unlike any other known Maya ceremonial architecture, these were dedicated to celebrate the k'atun, or twenty-year period, and the radial form of their platforms and the identical radial pyramids along the east–west axis may signal a calendrical orientation related to that of Uaxactun's E-VII [45]. The north

59. Tikal's Twin Pyramid complexes compressed aspects of the Great Plaza – pyramids at east and west ends, an ancestral shrine to the north, and a galleried building to the south – and were dedicated on k'atun (twenty-year period) endings.

precinct housed a stela commemorating the king's performance of the k'atun ending [27], while nine plain stelae were installed in a line in front of the eastern pyramid; the western one never features stelae. The entire program may seek to miniaturize the Great Plaza, with an ancestor shrine to the north, matched pyramids east and west, and a simple palace to the south, and then to replicate the form along the causeways.

Tikal's greatest political rival, Calakmul, home to the Kaan ("Snake") dynasty in the seventh and early eighth centuries (and perhaps longer), was another important Classic Maya city. Northwest of Tikal and in the modern Mexican state of Campeche, Calakmul probably suffered depredations in 695, when Tikal won a great clash between the two powers. It may have been occupied by different dynasties over the course of its occupation, but its architectural history extends from the Middle Preclassic to the Late Classic. Its largest building is Structure II, a north-facing pyramid standing 45 m (148 ft) tall. A project directed by Ramón Carrasco discovered Middle and Late Preclassic buildings buried inside that included stuccoed masks and a frieze featuring Chahk, the Rain God. In the Late Preclassic, an enormous pyramid was built to cover these, and the building assumed its present height. In the Early Classic and Late Classic, additions were made on the front, the pyramid's girth was expanded, and new shrines were built on an upper terrace. To the north of Structure II is a long plaza with buildings on either side, and to the southeast is another large pyramid, Structure I. Rulers erected stelae in front of the pyramids and on their terraces [158]. Surrounding this central group are

numerous buildings that include palace complexes, shrines, and probably a market, where a small, painted radial pyramid was found [213]. In the West Group, a ballcourt neighbors an unusual horizontal rock outcrop that features carvings of seven bound, naked captives, perhaps the site of sacrificial ballgame rituals.

In the Petexbatun region in the seventh century, a rogue branch – or its antithesis, the rightful heirs – of the Tikal royal family established rule at Dos Pilas and later at its twin capital Aguateca. Magnificent stelae were carved and dedicated at both sites [127], but much of the architecture appears to have been built hastily, and in desperate – and futile – eighth-century attempts to fight off battle and siege, residents ripped facings off structures to construct defenses. Palisaded walls formed concentric patterns without regard for pre-existing structures [50], and the Dos Pilas royal throne, found smashed, may have been destroyed when the haphazard defenses failed. Both cities fell to their attackers, and at Aguateca, the victors torched the roofs, setting off a fire-storm that consumed the city. No one returned to sift through the ashes until Takeshi Inomata began to work through this Maya equivalent of Pompeii in the 1990s.

50. Dos Pilas in its heyday, above, devolved at the end of the eighth century, when its population ripped facings off buildings in order to throw up hastily made walls and palisades, presumably in a last-ditch defense of the city's center.

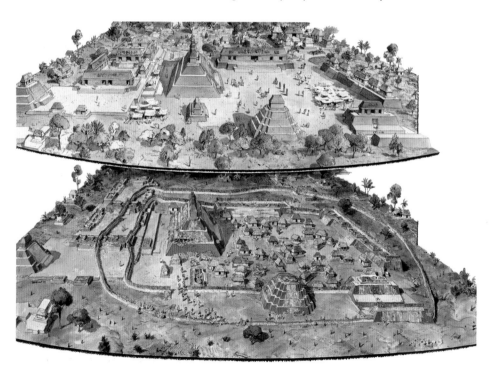

The Maya west: Palenque, Tonina, Yaxchilan, and Piedras Negras

During the Late Classic, the most dynamic architectural innovations took place in the western Maya realm, where dynasties grew wealthy quickly and promoted their reigns with public works. Unlike those of the Peten, the western cities feature obvious strategic siting. Yaxchilan and Piedras Negras perch at key points along the Usumacinta River; set into hillsides, Palenque and Tonina can observe the plains before them as far as the eye can see. Only modest towns during the Early Classic, some with stone monuments and other works, they thrived in the seventh century while Tikal faltered, as if benefiting economically from Tikal's weakness (or their own connections with Calakmul). Perhaps nowhere was this as clear as at Palenque, where one king (K'inich Janaab Pakal) and his descendants built most of what is visible today in about a hundred years, from AD 650 to 750.

At Palenque we know almost nothing of the previous program. Seventh- and eighth-century texts recall ancestors from the fifth and sixth centuries who performed rites at a place called Toktahn. But its archaeological remains have not been found and are buried either beneath Palenque – the Palace itself is atop a vast earlier construction – or at an undiscovered location. Yet we see evidence of earlier landscape modification: before Pakal's reign, engineers built water management systems and canalized the Otulum River. And as Kirk French has shown, there were three additional canalizations from the mountainous backdrop, one of them even pressurized, and literally making of Palenque a "water-mountain," or *altepetl*, known to us best from Aztec practice, with its meaning of "civilized place." Running water came right up to the Palace, and by the eighth century there were three toilets in the Tower court. Additionally, because of the steep slope down to the north, earlier engineers had constructed platforms on the north, in order to place galleries on roughly similar levels.

Pakal first laid out his plan for the Palace [51] with the construction of Houses E, B, and C, probably in that order, atop older structures that were converted into subterranean passages in this phase. The three buildings radiated like spokes from an imaginary point at the northern end of House E. House E became the Palace center, and its distinctive exterior drew attention to its significance even when its principal function as

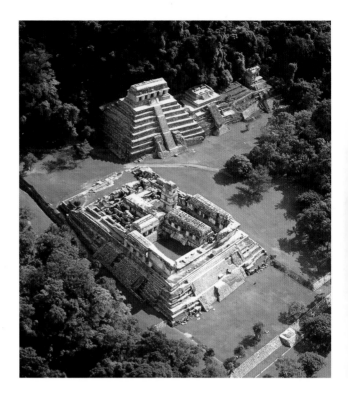

51. (right) Palenque from the air, showing the Palace and the Temple of Inscriptions.

52, 53. (opposite) Architectural innovations at Palenque can be seen in parallel corbel vaults (Palace House F, above) and cut-out keyhole arches (Palace House A, below) to lighten mass.

a throne room was superseded within a generation, for unlike other Palace buildings, it was painted white. Stylized flowers repeat with wallpaper-like regularity across the front facade, and an eighth-century text notes the building was called the *sak nuk naah*, "white skin house," a reference to the smooth white painted surface. As the first major building of Pakal's regime, House E anchored itself in the idiom of perishable architecture: its overhanging eaves are cut to resemble thatch, emphasizing its relationship to more humble architecture. Pakal set his main throne here [128], and other lords may have presided from portable thrones too.

With its open floor plan and the mat motif on its upper story, House B may have at one time been a *popol naah*, a "mat house," or "council house," where Pakal's lords would have gathered. From House B's south side, they could have passed without notice through the back door of House E; they could also have witnessed the actions to the north from their front steps, in what eventually became the Northeast Court. House C's inscribed steps relate the humiliating defeat

Palenque suffered early in the seventh century; these appear amidst statements of its own mid-seventh century political victories and economic renewal.

Perhaps because of the extremely heavy rainfall in the region, Palenque engineers created expansive interior spaces, a feat not achieved at earlier Maya sites. By building side-by-side corbel vaults [52], they stabilized the central load-bearing wall. Relatively light roofcombs [56] rested over this wall, enhancing stability and allowing the width and height of interior chambers to grow. The sloping mansard roof may have also been invented at Palenque, and its profile diminished the mass at cornice level and above, further enhancing stability. By the time Pakal died, his designers were cutting keyhole niches into the interiors of corbel vaults, reducing their mass [53]; in House C, they added a staircase to the roof, where stargazers could gaze upwards at night and watchmen could study the plain for movements during the day.

In the eighth century, K'inich K'an Joy Chitam dramatically changed the open, radial palace by commissioning long galleries that created a rough rectangle around the central spokes. He set his throne in House AD, commanding a view of the entire plain to the north. House AD probably became the main entrance to the Palace, but despite the open and engaging appearance of the long post-and-lintel arcade, the continuous interior wall meant that no further approach to interior chambers could be made from the north side. Rather, visitors were channeled around to the east and west. On the east side, visitors proceeded through the plain post-and-lintel entrance only to find that the interior doorway to the Northeast Court was an ogee-trefoil corbel vault that, equally invisible from inside the courtyard, was elaborated with such curving shape and finish that modern observers have called it "Moorish." Reaching to the top of the vault, such a cross-corbel construction achieved an interior space rare in ancient Mesoamerica.

But the visitor entering the Northeast Court unawares would receive an additional shock: flanking the stairs leading down into the courtyard were nine huge, gross sculptures of captives [53] similar to those chiseled onto the Calakmul outcropping. Moving along the front of the building, one could dance along their foreheads to emphasize their humiliation. Opposite, along the House C lower story, tribute-paying lords from Pomona kneel, facing toward the central stair. The

message was clear: yield to Palenque and pay tribute, or become a humiliated captive. The private courtyard may have been a place to impress neighboring lords with Palenque's prowess.

This kind of enclosed architecture became fortress-like without active aggression, guaranteeing privacy to those within its walls. Its iconography suggests that court business was devoted to war, taxation, and political machinations. The final Palace building was the three-story Tower, a unique survival in Mesoamerican architecture (one at Copan may have been washed away in the nineteenth century). Narrow staircases winding around a central core take the viewer to an ideal point for observation of the plain to the north, Palenque's vulnerable side. Meanwhile, elegant palace compounds were built to the northeast, where the Otulum River gave way to waterfalls and private pools. Probably the homes of wealthy nobles and some members of the royal family, such palaces more effortlessly accommodated women and children, dogs and turkeys, and may have been the sites of weaving, cooking, and an easy domesticity.

Pakal is the only king we know to have constructed his ancestral shrine during his own lifetime – perhaps as an extension of his conviction in his own divine kingship. Some years before his death in 683, architects set the nine-level Temple of Inscriptions directly on a hill, using the natural elevation for much of the pyramid's height. Until archaeologist Alberto Ruz lifted the floor slabs at the rear of the uppermost chambers, cleared the hidden interior staircase, and, in 1952, found the remarkable tomb of Pakal at the pyramid's base, no modern observer had a clue as to the motivation that lay behind the building's construction [54].

The Temple of Inscriptions tomb chamber was designed for eternity, in ways different from any known Maya construction: instead of the usual wood, the superstructure's cross-ties are stone (a material without the tensile strength wooden cross-ties provide), and a small stone tube, the so-called "psychoduct," connects the tomb to the shrine at the top, following carefully along the staircase edge, and allowing communication between Pakal's tomb and worshipers above. As a recently discovered stone panel demonstrates, Pakal's descendants actively maintained his memory and looked to him for political authority. For generations after his interment, people certainly would have known that Pakal was hidden within its secret compartment.

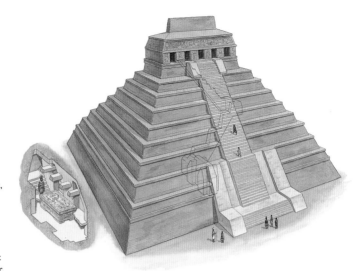

54. After archaeologist Alberto Ruz had located a hidden entry in the rear chamber at the top of the Temple of Inscriptions, he slowly emptied the rubble-filled staircase over several years, zigging and zagging until he came upon a great tomb at its base, on axis with the exterior stairs. The detail (left) shows the interior of the tomb, with K'inich Janaab Pakal's magnificent sarcophagus (ill. 129) at its center.

Like Tikal's Temple I, the Temple of Inscriptions [54] rises in nine distinct levels. Both pyramids probably refer to the nine levels of the Mesoamerican underworld, where a king would descend to its nadir, only to rise up once again. Most Mesoamerican cosmic schemes feature thirteen levels of the heavens in which the surface of the earth is the first layer. Thirteen distinct corbels connect the tomb to the upper galleries, thus fulfilling both schemes in a single structure. Despite Pakal's remarkable success in promulgating his own persona, his son Kan Bahlam apparently had the last word, for the stuccoes on the front facade of the temple show him to have been a god even as a child, his image united with that of K'awiil.

Modern viewers have often found the Temple of Inscriptions and the Palace to be among the most sympathetic of ancient Maya buildings. In large part, their attraction probably lies in their unusually large interior spaces. But another characteristic that makes these buildings so appealing is their proportional system, which promoted the square and rectangle in proportions, known as the golden section in Classical Greece. When a rectangle with the proportions of the golden section has a square removed from one end, the result is a rectangle of the original proportions. The piers and voids of the front facade of the Temple of Inscriptions would suggest that at least at Palenque, the Maya recognized the playful potential and aesthetic effects of such a system.

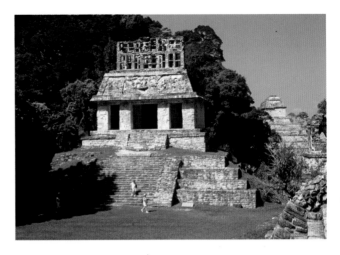

55. Pakal's oldest son, Kan Bahlam, dedicated the three buildings of the Cross Group in 692, nine years after the death of his father. Each building houses a rear shrine that functioned as a symbolic sweatbath for one of Palenque's patron deities. The Temple of the Sun honors trade and war.

East of the Otulum River, the three temples of the Cross Group [55] are set apart from the rest of Palenque: in fact, from the top of the Temple of Inscriptions, the Temple of the Sun appears to have turned its back. Pakal's son Kan Bahlam dedicated the complex on 16 March 692, or 9.13.0.0.0, an important date in the Maya calendar, when he was a relatively old man, and perhaps he wished his own program to have little to do visually with that of his father, since he also seems to have made little contribution to the Palace. The Cross Group temples feature a design principle also present in House AD of the Palace, where a single high vault intersects parallel ones at a right angle, creating huge interior spaces. Here the mass of Maya architecture has been reduced to fabric that envelops void. A small shrine at the rear of each structure [56] forms a symbolic sweatbath, a *pib naah*, in the accompanying texts (literally meaning "undergound pit oven"!), and the iconography of each temple runs from the shrine's sculptured panel to the facade and onto the roofcomb, constructed in each case as a lightweight stone assemblage, finished with stucco ornament.

Palenque sits on the first substantial rise to break the long plain from the Gulf of Mexico. Moving due south, the elevation climbs, going both uphill and downdale, until one arrives at Tonina, set at about 900 m (2,950 ft) above sea level, higher than any other major Classic "lowland" site. Seven distinct south-facing terraces rise from the plaza level [57], and the public imagery deployed on these terraces provides ample evidence of how Tonina handled and intimidated its enemies.

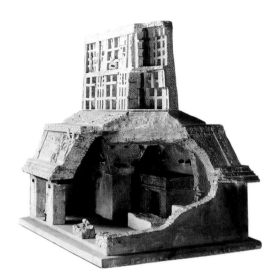

56. A cutaway model of the Temple of the Cross reveals Palenque's architectural innovation. In bisecting the parallel vaults with a single corbel, architects opened up interior space in a way not adopted at any other Maya city.

A huge stucco facing rising from the fourth to fifth level features a terrifying death god who bears the decapitated head of a regional lord in his hand [58]. Multiple carved stone and modeled stucco sculptures of bound captives were discovered *in situ* or hurled off the terrace [137], and many sculptural fragments found on the plaza probably once composed a fifth-level frieze, together creating displays of Tonina's most famous victims and the supernatural stories that the seizing of captives may have emulated.

Tonina follows a more rigorous geometry than most Maya cities, with right-angle relationships between most buildings. This is especially evident on the plaza level, perhaps following the geometry of the two ballcourts. The larger of these, H6, emphasizes the theatricality of the Maya ballgame and its role in public sacrifice as a post-war ritual. Protruding from the sloping walls along its narrow alley are unusual markers, each composed of a trussed human body attached to a shield. At Tonina, the architecture served the mission of its warrior kings.

Today the boundary between Mexico and Guatemala for much of its length, the Usumacinta River was a great artery in Classic times. The river's traffic probably made some Maya cities wealthy, but it also promoted discord and provided relatively easy access for uninvited warriors. Given their relative proximity and similar environments along the river, Yaxchilan and Piedras Negras might be expected to have developed along similar lines, but the opposite is true. Their main relationship seems to have been primarily antagonistic,

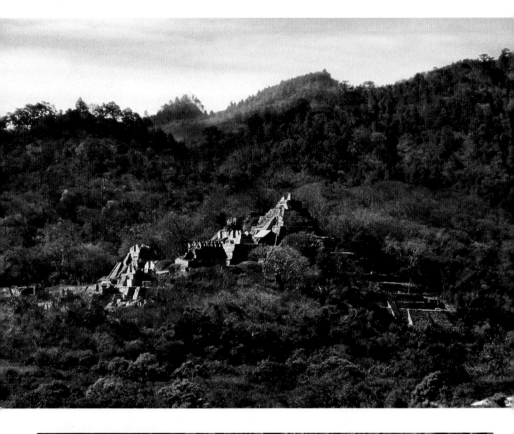

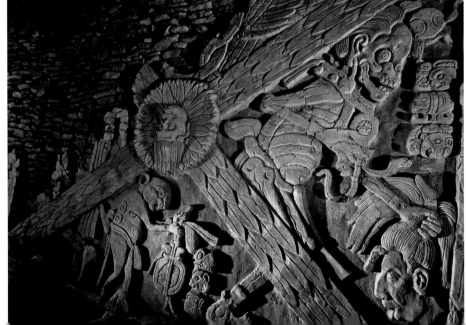

57. Set in the Chiapas highlands, Tonina developed architectural setbacks against a natural hill, giving its lords a dominating position from which to attack lowland cities such as Palenque. Elaborate stone and stucco facades, some of them decorative and others narrative, map onto the giant risers.

and they inhabited different political orbits, with differences, as Charles Golden and Andrew Scherer have shown, manifest also in burial patterns and ceramic use, both at the two great cities and at smaller affiliated sites.

Yaxchilan planners capitalized on a steep hill perched on land surrounded by an omega-shaped bend in the river that slowed the water in front of their main plaza. Remnants of stone pilings remain in the river, vestiges of what was once a pier, bridge, or tollgate. Small, independent structures were built on terraces rising up the hillside, such that all buildings above plaza level command river views to the northeast. The elite are buried in these structures instead of massive funerary pyramids, and unlike most other Maya cities, few galleried buildings form palace quadrangles at Yaxchilan, although the complex comprising Structures 42–52 may once have formed a palace, or the entire plaza-level construction might have functioned as a grand palace. Structures on the plaza's southwest side feature portraits of female dynasts, and a carved lintel in Structure 23 notes that Lady K'abal Xook, queen of Itzamnaaj Bahlam III, commissioned the building [145]. These may have been women's palaces, the special preserve of royal wives and female attendants; indeed, one tomb found in Structure 23 held a sewing and fiber arts kit with picks and needles, essential equipment for any Maya weaver [36].

While women commissioned plaza-level buildings, Yaxchilan rulers played king of the mountain, dominating the highest points of the hillside with structures announcing their supremacy. Early in the eighth century, Itzamnaaj Bahlam III claimed the highest point with Structure 41; fifty years later, his son Bird Jaguar IV commanded control of the plaza from Structure 33 [59]. He apparently also leveled Early Classic buildings, whose carved lintels he then incorporated into new projects [120]. Powerful and assuming, these structures attempted no Palenque-style engineering innovations. They are narrow, single-chamber structures; heavy roofcombs over their vault capstones would exacerbate the tendency of corbeled constructions to collapse. Apparently aware of this problem, Yaxchilan builders reinforced buildings with interior buttresses, leaving even less interior space. Yet capturing interior space may not have been the priority that capturing the mountain was: in front of Structure 33, Bird Jaguar also erected a carved speleothem within a pit, as if to create a symbolic cave and its

58. On one of the setbacks at Tonina, a "turtle-footed" death god gleefully holds out a severed human head, whose closed eyes signify death, much like a painted figure from a ceramic vessel. A cheerful rodent follows behind. Feathered banding overlays the scene, as if to reveal the perishable architecture of a victory celebration.

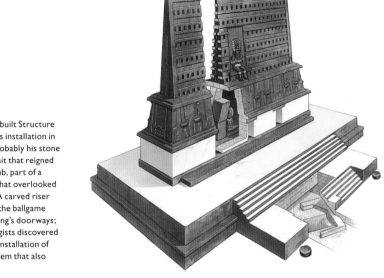

59. Bird Jaguar IV built Structure 33 to celebrate his installation in 752, and it was probably his stone and stucco portrait that reigned from the roofcomb, part of a towering crown that overlooked the plaza below. A carved riser commemorating the ballgame abutted the building's doorways; below, archaeologists discovered a tomb, near the installation of a carved speleothem that also honors the king.

attendant springs beneath his pyramid. Like Palenque, this design at Yaxchilan may have expressed the pan-Mesoamerican concept of *altepetl*, or "water-mountain."

Structure 33 also features carved steps, an architectural element used widely at Yaxchilan, Dos Pilas, Copan, and other cities. On its stairway, carved panels show Bird Jaguar and his ancestors holding double-headed serpent bars or playing ball. Carved stairways celebrating victory often are installed at the victorious site, although some were erected at the defeated site, such that the defeated always would be reminded of their humbling. Yaxchilan's Structure 44, the former type, offers the single most dynamic record of carved steps, with defeated captives on stair treads that must be repeatedly stepped upon. The risers, on the other hand, relate Yaxchilan family genealogy, placed where no one can ever step.

Along with Yaxchilan, the other principal city on the Usumacinta is Piedras Negras, and the two were in keen competition. Strategically located between dangerous rapids and the San José Canyon – the damming of which has been threatened by Mexico and Guatemala repeatedly – Piedras Negras retains more Early Classic structures than most western cities and may have been the unchallenged authority on the river until late in the seventh century, when Yaxchilan's fortunes rose.

Having started with complexes of palaces integrated with funerary pyramids toward the southern reach of the site – and marked by sequences of monuments – construction of later palaces and temples moved northward. An archaeological project directed by Héctor Escobedo and Stephen Houston discovered that the site was dramatically transformed at the end of the seventh century, when earlier buildings were leveled, and tons of material were brought in to raise the level of the West Group Plaza and Acropolis, possibly to mark the significant 9.13.0.0.0 k'atun in 692. Over the course of the eighth century, dynasts erected stelae and altars to commemorate the passing of time and celebrate victories in warfare, and they built towering *muknal*, or burial places, to honor dead kings and family members. Although many buildings were rebuilt time and again, in a fashion more like Tikal than Palenque, one major focus of successive rebuilding was Structure O-13, built into a hill in the East Group Plaza, creating the largest single structure at Piedras Negras and a site of veneration. At this pyramid's base, archaeologists discovered a tomb they identify as that of Ruler 4; he died in 757, and his successors paid homage to him by installing their monuments on the same building.

The eighth century also saw active and abundant building in the West Acropolis [60]. The greatest of all Piedras Negras compounds, the West Acropolis is a vast palace framed by two large pyramids whose levels number nine when counted from the plaza floor. In the construction of galleries, Piedras Negras

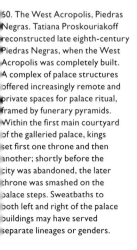

60. The West Acropolis, Piedras Negras. Tatiana Proskouriakoff reconstructed late eighth-century Piedras Negras, when the West Acropolis was completely built. A complex of palace structures offered increasingly remote and private spaces for palace ritual, framed by funerary pyramids. Within the first main courtyard of the galleried palace, kings set first one throne and then another; shortly before the city was abandoned, the later throne was smashed on the palace steps. Sweatbaths to both left and right of the palace buildings may have served separate lineages or genders.

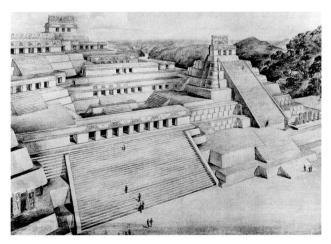

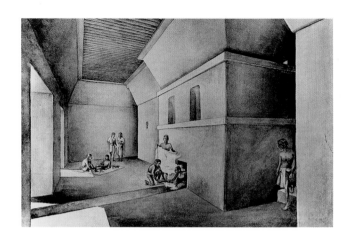

61. Sweatbath P-7, Piedras Negras. Proskouriakoff's reconstruction of one of at least seven sweatbaths at the site demonstrates how they functioned. A spacious dressing room under a timbered roof surrounds a small steam chamber, reached only by a narrow passageway.

architects adopted the engineering techniques pioneered by Palenque designers in the use of parallel corbels, although the cross-corbel concept does not appear to have been used. A vast flight of stairs separates the palace from the plaza floor, and as at Palenque, what seems to be an inviting galleried building instead blocks easy entry to the courts behind and above it. In Tatiana Proskouriakoff's reconstruction drawing [60], the principal throne in a formal receiving room can just be glimpsed through the colonnade on the north side of the first court. Far more private rituals would have transpired in the court behind, almost entirely inaccessible from the first, and these more private rooms and courtyards may have been used by court women, as at Yaxchilan, but even more isolated from public view. From the structures at the top, a commanding river panorama came into view, but the buildings all face away from the water.

Each side of the West Acropolis features a sweatbath. Although found from time to time at other Maya centers, the sweatbaths at Piedras Negras were the grandest ever constructed, and no fewer than eight have been explored to date. To accommodate the special needs of a structure that had a vaulted steam room, complete with firebox, the builders sprung half a corbel vault from the steam chamber and then met the corbel with a huge span of timbers, creating a capacious interior space [61]. The large antechamber served those for whom the baths met medicinal and hygienic purposes, ritual purification, and social requirements, along with the needs of women, midwives, and newborns.

In the southeast: Caracol, Copan, and Quirigua

To the far east and south, Maya settlements developed farther apart than in the heavily populated Peten and Usumacinta regions. Topography probably played a role, with the Maya Mountains of southwestern Belize providing both isolation and resources for Caracol. Known in large part as the site that successfully joined the Kaan dynasty (based at Calakmul and Dzibanche) to make war on Tikal in the sixth century, Caracol was also adjacent to valuable wildlife and birds, minerals and materials, all readily exploited in the nearby Maya Mountains. Caracol used its resulting wealth to build vast structures and connect them with a web of causeways.

At the web's center lies a group of buildings known as Caana [62], and its massive principal structures, palace and funerary structures were integrated in a program specific to Caracol. Palace buildings begin about halfway up the platform, as if to monitor movement along the central axis. Then, at the top, cut off from public view, an entire complex opens up, so that members of the court could have remained separated from the rest of the population.

Almost 200 km (125 miles) due south of Caracol lies Quirigua, Guatemala; a journey further south of some 50 km (30 miles) brings one to Copan, Honduras, the southeastern-most of all Maya cities. These two southern centers shared history, sculptural styles, and architectural practice, and the Copan lineage may have founded both of them. The answers to some questions about Copan may lie under the modern town, which rests on a key section of the ancient settlement. Other answers were surely washed away when the Copan River

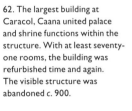

62. The largest building at Caracol, Caana united palace and shrine functions within the structure. With at least seventy-one rooms, the building was refurbished time and again. The visible structure was abandoned c. 900.

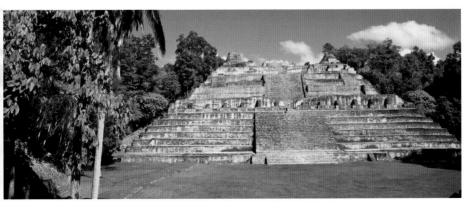

63. The so-called Principal Group at Copan. The long narrow plan of the site replicates the long narrow valley in which Copan lies. The current town sits atop another important group.

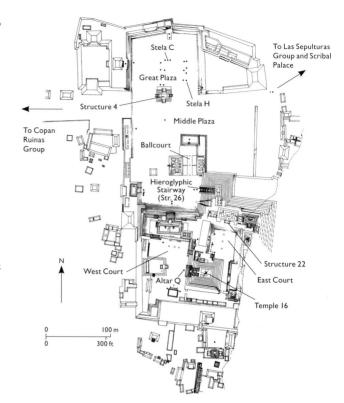

64. The Ballcourt, Copan. Rebuilt three times by Copan kings, the Ballcourt is situated at both the center of the ritual precinct and at the center of Copan ritual life. Three carved markers installed down the court's central alley created metaphorical openings to the Underworld; giant macaw heads served as markers along the court's sloping sides.

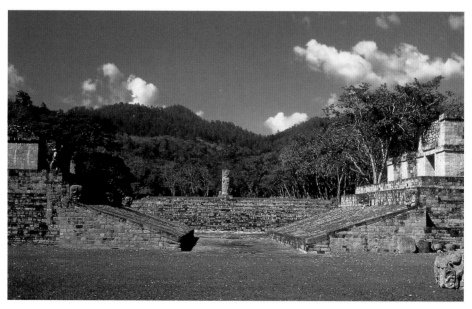

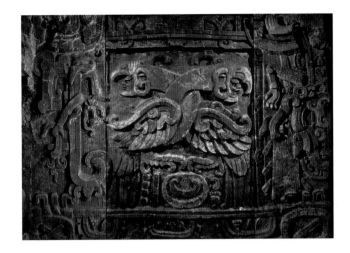

65. Deep within Copan's Temple 16, archaeologists found astounding constructions, including temples and tombs, all encasing that of the founder (see also ill. 125). Emblazoned on the exterior of the so-called Margarita structure are an entwined quetzal (*k'uk'*) and macaw (*mo'*), both with solar deities in their beaks, making for a giant representation of the founder's name, K'inich Yax K'uk' Mo'.

edged close to the Acropolis and destroyed elegant palace structures that were still *in situ* in the nineteenth century.

The rolling terrain of the Copan Pocket of the Copan River Valley provided superb opportunities for dramatic siting of architecture, and planners considered both vistas and alignments with the peaks and the saddle in the hills to the north [63]. As a result, the Principal Group effectively is a microcosm, with the surrounding landscape channeled and condensed into the man-made world. Within that man-made complex, the Ballcourt intensifies the reading of the landscape, as if the entire site could be reduced to its parallel structures and sculptures [64]. One of the most beautiful of all Maya courts, the Copan Ballcourt lies at the heart of the Principal Group, placing the ballgame at the heart of royal ritual.

At the end of the last century, archaeologists tunneled deeper into the Copan Acropolis than had ever been attempted at a Maya site. From far below Temple 16, a nine-level pyramid, came evidence of the tomb of K'inich Yax K'uk' Mo', the dynasty's founder, who reigned in the early fifth century, founding a new lineage that would direct Copan to great heights. Within Temple 16, they found structures they nicknamed Yehnal, Rosalila, and Margarita that had been constructed over the founder's tomb, which was interred deep within the Hunal platform. Overlying each other like onion skins, multiple layers of construction were carefully buried so as to retain much of the elaborate stuccoed polychrome ornament that honored Yax K'uk' Mo' and the Sun God [65, 125].

Subsequently, fueled by wealth and powerful leadership, Copan grew rapidly, and the Acropolis became a huge bureaucratic palace in the Late Classic period. Amid many different Acropolis buildings, Temple 16 remained an ancestral shrine, its latest iteration honoring Yax K'uk' Mo' with stone mosaic ornamentation and associated sculpture [166].

Near Temple 16 was Structure 22, which may have been a principal royal receiving room in the eighth century. Its exterior was conceived to be a symbolic mountain, with the doorway its cave portal; maize gods flourished at its cornices, only to be scattered when the building collapsed years later [101]. Huge Witz heads – indicating the symbolic mountain – display long noses at the structure's corners, much like the god heads of Puuc architecture in northern Yucatan. Next door, set back from Structure 22 and off the court's central axis [66], may be a *popol naah*, or "mat" or "council house," indicated by the prominent mat motif on its frieze. To the east, a now-lost graceful tower may have surveyed movements along the river.

Between the Ballcourt and the Acropolis stands the great Hieroglyphic Stairway, a large pyramid whose steps are inscribed with over 2,000 glyphs relating the history of the Copan dynasty [67]. The text starts at the top and runs to the bottom, so that a supplicant beginning at the pyramid base would have the experience of walking back through time. Five three-dimensional Copan rulers garbed in Teotihuacan costume, some atop two-dimensional captives, sit on projections from the staircase [163]. These ancestors, full-figure versions of the history recounted in the inscriptions, accompany supplicants as they travel through time, at last entering a sacred antiquity at the summit that bore a text, as David Stuart has shown, in two "fonts" – Mayan, and what Maya scribes envisioned Teotihuacanos would have used to express the same words.

William Fash and colleagues have shown that the Hieroglyphic Stairway text was begun in the early eighth century by Waxaklajuun Ubaah K'awiil to honor the great Ruler 12, who was buried within. But in 738, Waxaklajuun Ubaah K'awiil was taken captive and beheaded by a Quirigua king. A common artistic response to military defeat is silence: at Tikal, foreign wars brought production to a standstill. So, too, at Copan. But within a few decades of that defeat, the dynasty's fifteenth successor, K'ahk' Yipyaj Chan K'awiil, resumed production of what his fallen predecessor had begun.

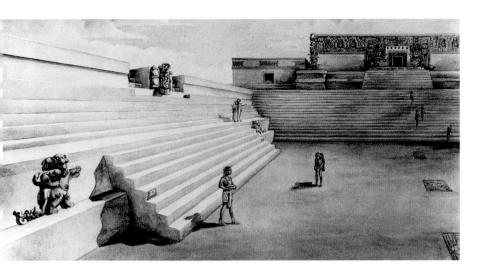

66. One of Copan's greatest builders, Waxaklajuun Ubaah K'awiil constructed Structure 22 as a principal palace at the beginning of the eighth century. The *Witz* doorway configures the structure as a mountain; Maize deities flourish at the cornices (ill. 101). In the foreground is the Jaguar Staircase, with the solar Jaguar God of the Underworld at center; the three panels set into the plaza floor make the space a symbolic ballcourt.

67. Whereas many hieroglyphic steps enunciate a particular victory, the Copan Hieroglyphic Stairway proclaims the triumph of Copan throughout time. An ascending supplicant goes back through time and must address the five great Copan rulers whose oversize representations sit in full relief on the stairs (ill. 163), including Waxaklajuun Ubah K'awiil, who died ignominiously at Quirigua.

In contrast to the recounting of victory on Quirigua stelae, Copan's expanded stairway text incorporates the thirteenth ruler's demise as if it were just another death in the dynasty's long history. In this way, the Hieroglyphic Stairway demonstrates that Copan has always been a victor, this particular situation no more than a blip on its radar.

While the Acropolis grew higher over time, the expansive plaza – comprising the Great Plaza and Middle Plaza – retained its integrity as a huge open space, matched to the Acropolis very closely in terms of area and an effective visual counterweight to its mass [63]. Although rebuilt periodically, the level was raised only slightly in the early eighth century, when older monuments were removed to the margins. A key building at the meeting of the Great and Middle plazas is Structure 4, a radial pyramid with stairways on all four sides, which was rebuilt several times and held broken early monuments. But it is Waxaklajuun Ubaah K'awiil who made the biggest mark on the northern end of this plaza, in the early eighth century deploying a program of monumental stelae, each manifesting a different deified aspect of his persona [159].

By the late eighth century, local lineages in the Copan Valley were vying for status. Nowhere is this clearer than in the Sepulturas compound, where the House of the Bacabs was the central building of a palace grouping that included adjacent homes and possibly storage rooms of widely varying quality. Presumably the lineage in this complex had gained wealth and prestige through their skill as extraordinary artists – to which they attest through some of the most artistically elaborated hieroglyphic texts known today.

Neighboring Quirigua lies in the flat Motagua River Valley, today little more than an island of forest amid banana plantations. Quirigua lords may have gained exclusive control of the trade in uncut jade, most of which was found in the middle Motagua Valley. After Quirigua's victory over Copan in 738, ruler K'ahk Tiliw Chan Yopaat rebuilt the main group in Copan's image. Accordingly its acropolis, palace, and ballcourt lie at the south end of the Great Plaza – with little previous architecture in their way, builders conceived of a plaza far grander than Copan's. But without the counterweight of an equally large acropolis, and without Copan's defining plaza boundaries, the effect pales. The visitor is left to ponder the stelae set up on the Great Plaza, the tallest ones ever erected [165].

Río Bec and Chenes architecture

Short shrift is often given to the architecture of the Río Bec and Chenes sites, the best known among them Becan, Xpuhil, and Chicanna in the former region and Hochob in the latter, although any distinction between the two styles has depended on the presence of towers (Río Bec) and their absence (Chenes). Outside the traditional geographical region for this architecture, Ek' Balam [71] has buildings modeled on Chenes prototypes. These cities are often overlooked because their few monuments have yielded almost no legible texts, and while art historians can hang the architectural – and of course sculptural – developments at Copan and Quirigua on the armature of their known internecine warfare, no such narrative can be constructed for Río Bec and Chenes programs. But there is good reason to look at these sites closely. For one thing, their buildings are among the most sculptural constructions of Maya architecture, particularly during the Late Classic. For another, from the tombs and caches of these cities have come exceptionally fine small-scale works.

Like Structure 22 at Copan, most Río Bec and Chenes buildings feature great zoomorphic mouths as their central doorways [69]. In their relatively flat surroundings, these structures all become symbolic mountains, or Witz, making architecture into topography. Chicanna's zoomorphic maws deliver the visitor into single chambers, often with a second, dark chamber directly behind, configured perhaps for royal reception in front and tribute storage at the back. At nearby

68. This graffito from Chicanna presents a pyramid far grander than anything found at the site, perhaps a memory of a towering temple at Tikal. Parasols, comparable to those that frame the text of Bonampak's Room I (ill. 215), have been set at the doorway at top.

69. Both low and pyramidal structures at Chicanna feature open-mouth Witz doorways, making of the site a range of personified mountains. Here a visitor would step across lower teeth to approach the doorway.

70. Great towers dominate the Xpuhil skyline, none with a functioning stairway but rather with stucco sculpture that both imitates stairs and presents a "false" chamber at the summit. Despite this remarkable deception, the pyramids probably hold tombs at their bases.

Xpuhil and Becan, palace galleries are anchored by great solid towering masses, often in pairs [70]. But these are false pyramids, for despite the appearance of steps and shrine, both are created of stucco atop a stone structure: the exterior steps cannot be ascended, and the superstructures, which resemble ones in the Peten, have no interior rooms, although some towers have inner stairways. These towers may be funerary monuments, with tombs at their base.

At Ek' Balam, in the state of Yucatan, artists crafted a Chenes-style facade around a doorway on the fourth level of the Acropolis, but this facade is made out of modeled stucco [71]. The enormous mouth of a zoomorphic creature surrounds the doorway, and life-size human figures, also modeled from

71. Among the most elaborate of all portal entries can be found at Ek' Balam, to the north of Chichen Itza. Great lower fangs frame a landing for those entering the sacred chamber; winged figures look outward from the upper register, as if protecting supplicants.

stucco, stand and sit on this creature's face. Inside this building was the tomb of a powerful eighth-century ruler, and the whole structure was buried in ancient times, hence the facade's remarkable preservation.

Puuc architecture

A band of hills known simply as the Puuc ("hills") runs in a large circumflex-shaped form in western Yucatan and northern Campeche. Although receiving little rainfall (less than 50 cm or 20 in. annually) and with neither surface streams and lakes nor underground sinkholes, the Puuc was home to dozens of Maya sites, almost all of which flourished in the ninth century, supporting a far larger population than lives in the region today.

John Lloyd Stephens and Frederick Catherwood spent months documenting the region's architecture (and fighting malaria; the disease would eventually kill Stephens); Uxmal, the largest and grandest of the cities, was the featured subject of the now lost panorama they installed in New York City to great acclaim in 1843. But once the famous travelers had brought Puuc architecture to modern attention, these buildings' presence was insistent, and casts of the facades were installed at the 1893 World's Columbian Exhibition in Chicago [6]. The young Frank Lloyd Wright walked to work past these reconstructed buildings every day, absorbing their formal qualities: later he would build Hollyhock House in Los Angeles and other remarkable signature structures that made explicit reference to Puuc architecture.

Like Piedras Negras or Palenque, Uxmal juxtaposes palace quadrangles with freestanding pyramids [72], some of which may have been funerary in nature. The account told to Stephens about the Pyramid of the Magician would suggest that some pyramids went up quickly. According to the legend, an old hag nurtured an egg, from which then hatched a dwarf. Both of them held magical powers. She thought so much of the dwarf's abilities that she had him challenge the city's king to a series of contests. In one round, the king challenged the dwarf to see who could build the largest structure overnight; when the dwarf awoke at the top of the Pyramid of the Magician, he had won that contest. Yet with two distinctive profiles, the Magician must have been built in at least two phases. On its west side, facing the quadrangles, a dangerously steep staircase

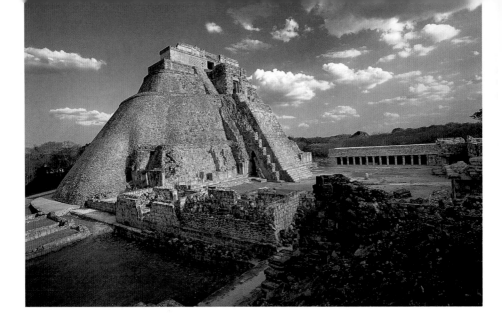

73. Miniature houses top
Nunnery doorways. Some feature
tiny thrones and may once have
included human figures; others
reveal the fancy finish of
perishable thatch roofs.

leads to a monster-mouth Chenes-style shrine; a far gentler
slope on the east leads to a typical Puuc chamber at the very
top, with its characteristic mosaic ornament conforming to
a compressed facade above the doorway [72].

The Magician looks out over the Nunnery Quadrangle,
a palace that was conceived as a quadrangle from the first,
as opposed to being transformed into a quadrangle over time,
as at Palenque. The Nunnery, like many Puuc buildings,
demonstrates some of the characteristics that make Puuc
architecture both visually satisfying and an engineering marvel
[74]. First, Puuc designers invented the "boot" stone, and they
used it to stabilize the corbel vault. Literally shaped like a
high-topped shoe, the boot stone functioned as an internal
tenon, anchoring the final course of stonework to the previous
one. The greater stability meant that they could begin to use
the corbel vault as a doorway, a practice that had been used
only rarely, notably in the Twin Pyramid Complexes at Tikal.
Additionally, they developed an efficient construction method,
in which thinly cut veneer stones overlaid a rubble core.
This required much less volume of finished stone, and the fine
workmanship of the veneer stones allowed them to be fitted
together with almost seamless precision.

The Nunnery's North Building was the first part of the
compound to be completed, and its roofcomb runs over its
front load-bearing wall, like a false storefront of

nineteenth-century America. Although one might expect such constructions to be unstable, keeping the weight off the vault stones in fact anchored the structure, and the walls bearing these "flying facades" are sometimes the only ones left standing. Later Nunnery buildings gave up this feature. Puuc architects also recognized the monotony of regularly spaced doorways of equal size; each Nunnery building finds a different solution to spacing and size, culminating in the great South Building, whose central corbel doorway becomes the quadrangle's gateway.

The builders of the House of the Governor took all the lessons of the Nunnery and used them in a single structure, composing what may be the single most beautiful building of ancient America [75]. The building's plan suggests three individual structures, linked together by huge recessed corbel vaults. Vaults rarely exceed the height of the wall up to the springline, but these sloping vaults spring from the base of the overhanging facade and are thus unusually high, visually driving the building upward as if they were arrowpoints.

Only the central doorway of the Governor is a square, and each pair of flanking rectangular entries stands yet another measure farther from its predecessor. This feature makes the building seem to flatten out, as if such spacing were to go on infinitely. Simultaneously, however, the upper facade's slight outward lean – or what is called "negative batter" – makes the building seem tall and light. (Some modern clothing, after all, has yielded the same effect, with shoulder pads that visually whittle waists and make the wearer look taller!) Furthermore,

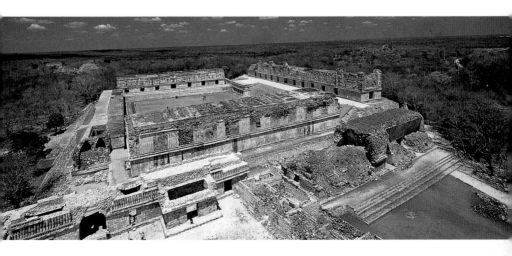

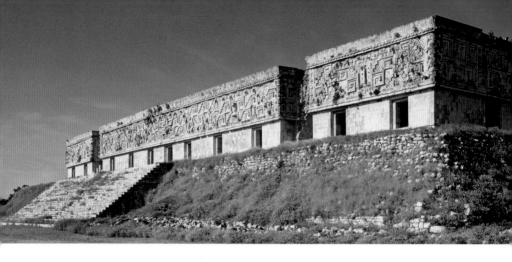

75. The last king of Uxmal commissioned the House of the Governor. The subtle visual refinements initiated in previous constructions at the site find their consummation in what may be the single most remarkable Maya building.

both effects are countered by the heavy, slightly overhanging upper facade, which presses down on the doorways and casts sharp shadows. As if to compress the full complement of ornament from a "flying facade," the upper level's elaboration is dense and rich, yet focused on the seated ruler over the central doorway who surveys his realm.

Given the huge platform of the Governor, there could have been a plan for a quadrangle, a project perhaps dropped at the beginning of the tenth century, when Uxmal was apparently abandoned. On the other hand, any additional construction would have eliminated the powerful view that the ruler would have had, particularly when seated on the double-headed jaguar throne still *in situ* in front of the building. Perhaps when the building was completed, Uxmal's king may simply have found the results so satisfying that not another stone was moved.

Elevated and stuccoed causeways (called *sacbeob* in Yucatec Mayan) connected the small Puuc cities to one another, and just 18 km (11 miles) from Uxmal, passage into the center of Kabah

76. The Arch at Labna denotes entry and exit from the most elaborate palace compound at the site. Like other freestanding archways in the Puuc region, its two faces are dramatically different; here textile patterns carpet the walls of the entry view.

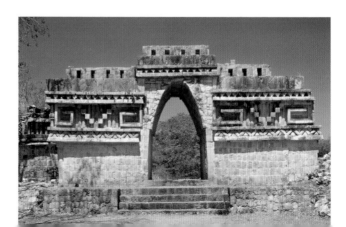

was marked by the single greatest freestanding arch that the Maya ever built. A short road both connected and separated palace complexes at Labna, just a short distance from Kabah. Far to the east, the longest road known – 100 km (62 miles) – linked Coba to Yaxuna; Yaxuna, located only 20 km (12 miles) from Chichen Itza, was a power in both the Late Preclassic as well as the ninth century.

The mosaics on Puuc buildings suggest the motifs of textiles, given the patterning that covers facades like tapestries [75]. Many buildings have dark, private rear chambers that cannot easily be seen from the front of the structure. The Puuc Maya might have used these private chambers for the storage of textile wealth, promulgated from building facades. At Labna, the two sides of the Palace arch present completely different mosaic adornments, with the far richer facade reserved for the interior [76]. Small houses flanking the arched opening probably held god images.

Most Puuc buildings also feature stacks of deity heads, sometimes at the corners of buildings, other times at cornices, and most dramatically at the House of Masks at Kabah, carpeted with deity heads. Their great protruding snouts have long baffled Mesoamericanists: while early twentieth-century travelers wanted to read them as elephant trunks, later they were all primarily identified as Chahk (Rain God) masks, but Linda Schele and Peter Mathews identified many of them as different aspects of Itzamnaaj, the principal creator god, who was often known in his powerful avian version. Buildings guarded by Itzamnaaj were places of divination and priestly power: the House of Masks once proclaimed its potency with its dazzling facade.

Chichen Itza: northern lowland architecture in the era of southern city collapse

Chichen Itza, ruled by the Itza for at least part of its florescence from the ninth to the eleventh centuries, was the single most powerful Maya city of all time, but its power was concentrated into a much shallower timespan than most southern lowland cities. Additionally, its rise accompanied the decline of the south, and it may have been much more ethnically mixed than any previous Maya city, resulting in greater architectural diversity [77]. Accordingly, although many buildings recapitulate types known elsewhere, there are new

ones that took root in Chichen's fertile mix, including the round building plan, clusters of piers and columns, and serpent columns, along with new sculptural forms such as chacmools [181] and thrones supported by the raised arms of sculptured human forms ("atlanteans"), treated in Chapter 7.

The city's southern sector, often called "Old Chichen," retained the most traditional forms of Maya architecture. The Red House, for example, features parallel corbel vaults and a roofcomb running over the central load-bearing wall, a lesson learned from either Piedras Negras or Palenque. The Temple of the Three Lintels is a Puuc-style building in its proportions, design, and ornament, but made without Puuc refinements, boot stones, or veneer masonry.

Within this southern quadrant builders erected a structure with a remarkable plan: the Caracol, so-called for its conch-like plan of concentric circles which rest in turn on a small trapezoidal plinth atop a larger trapezoidal platform [78]. The central doorway of the Caracol does not align with the platform steps, so that the building visually seems to be ever circling in motion. Entering the interior, constructed of finely cut and finished stones, an ancient user of the building would have ascended to the second story by ladder, then taken tiny steps to the top. Much of the upper story has collapsed, but three small openings, which may have focused on the

77. This schematic view of Chichen, made by the group INSIGHT from a 3D model based on laser-scan data, takes us from the Sacred Cenote, at lower left, south to the Castillo, with the Caracol in the distance. Other cenotes dot the landscape.

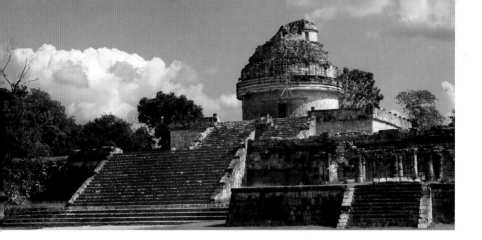

observation of the synodic periods of Venus, survive. This round structure, then, may have been dedicated to the cult of Ehecatl/Quetzalcoatl, paired aspects of a Central Mexican deity associated with round buildings and whirlwinds, as well as Venus; among the Maya he was known as Kukulcan, or "Feathered Serpent." Often depicted in an S-shape, wrapped around a ruler, the Feathered Serpent may in fact be spinning in the vortex of his principal temple, at the heart of Chichen.

The great Castillo lies at the center of the city's northern quadrant as it is known today [79]. Even in the sixteenth century this pyramid was still in some use, for when the first Bishop of Yucatan, Diego de Landa, visited the site, he was able to count the 91 steps on all sides, whereas Stephens found the structure an overgrown ruin in 1840. Although Chichen Itza had been abandoned for centuries, Maya people still visited its Sacred Cenote [77] (the Yucatec Mayan dz'onot has become cenote in modern parlance), the great sinkhole connected by a sacbe to the plaza, to make offerings; the entire sector of the Castillo, plaza shrines, and the Sacred Cenote may have been maintained for centuries after abandonment, much as certain buildings at Tikal may have been maintained for pilgrims. Those 91 steps on each side of the radial Castillo total 364, and 365 if one counts the additional serpent heads on the north side as a step. Furthermore, at the time of the semi-annual equinoxes, a seven-segment serpent of light and shadow brilliantly appears against the pyramid's northern face, when viewed from the west. In other words, along with Uaxactun's E-VII-sub or the Tikal Twin Pyramid Complexes, the Castillo is a giant chronographic marker, both summing up the solar year in its numerology and marking its passage.

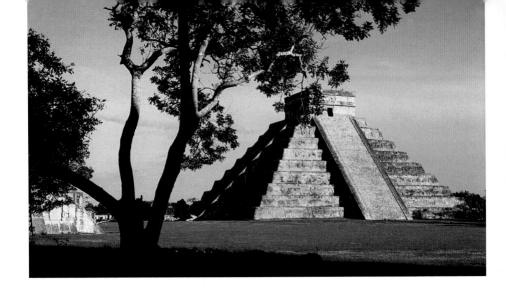

79, 80. On the two annual equinoxes, the nine distinct setbacks of the Castillo (as it has been nicknamed, along with Kukulcan) cast a seven-segmented serpent of light against the north staircase, directing movement to the Sacred Cenote. The visible Castillo contains a "fossil" pyramid within, whose royal furnishings – a throne and a chacmool (ill. 181) – have remained in situ for a thousand years.

Additionally, the Castillo is a nine-level pyramid, taking the same form as funerary pyramids in the south. Mexican archaeologists pierced the north staircase in 1936 and found a complete smaller version of the same building buried within [80], with the exception that it had only a northern stairway. This earlier, unexcavated pyramid, like the Osario temple to the south, may well hold a tomb. Linda Schele and Peter Mathews have proposed that the Castillo was conceived as "Snake Mountain," the Coatepec of Central Mexican legend, a place central to Mesoamerican creation beliefs. This may explain the stone vessels with turquoise offerings interred in the north stairwell, and the assemblage of three jades laid atop a turquoise mosaic mirror back in the earlier Castillo building [17], for both offerings are associated with foundations and creation beliefs. Uaxactun's E-VII-sub [44], one of the oldest of the radial buildings, shares the iconography of Snake Mountain, a concept that may be more ancient than Maya culture.

To the west of the Castillo lies the Great Ballcourt, the largest of ancient Mesoamerica [81]. The reliefs and paintings that line the court and associated buildings narrate the sacred founding of the city and its supernatural charter. Furthermore, the Great Ballcourt was seen as the crevice from which the Maize Gods could be renewed and resurrected time after time. As large as a football field, it may not have been designed for mortal play: making contact with its rings, 8 m (26 ft) straight up from the playing field, would have defied typical play. In fact, the use of the structure may have been symbolic.

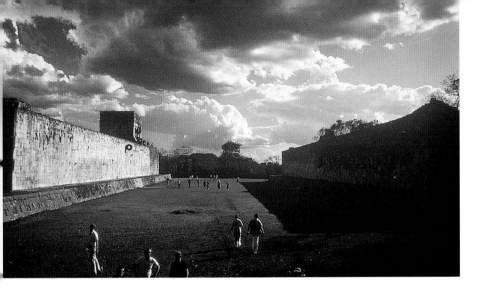

81. As large as a football field, the Great Ballcourt at Chichen Itza dwarfs human participants, for whom driving a ball at or through its high and small rings would have been nearly impossible. Three huge panels feature scenes of victory and sacrifice along each of the sloping walls at eye level (ill. 179).

82. Just outside the Great Ballcourt lies the strange T-shaped building known as the Tzompantli, or skull rack, decorated with hundreds of skulls, shown as if strung up for humiliation.

The adjacent Skullrack (*Tzompantli*) takes the shape of a letter T, its facade of repeating human crania four rows deep confined to the crossing of the T [82]; eagles, warriors, and Feathered Serpents stand in support of sacrifice along the spine. Another unique structure, it might have been for the display of decapitated sacrificial victims from the Ballcourt [179]. Nearby, the Platform of the Eagles features alternating jaguars and eagles consuming human hearts. Such imagery is similar to that of the Toltec capital at distant Tula in Hidalgo, and may refer to practices of human sacrifice and cannibalism common to both cities.

To the east stands the Temple of the Warriors, the largest of a series of colonnaded buildings that feature serpent columns, monolithic benches, and chacmools (altars in the form of reclining captives) [83]. In fact, as archaeologists discovered to their amazement, the Temple of the Warriors subsumes a nearly identical version of itself; the later building was simply enlarged and built over the earlier one, so that the front chamber of the Warriors rests directly over the corbel vaults of its fossilized predecessor. At the top, serpent columns frame the doorway, with a chacmool in between. The large throne in the rear chamber may have been for gatherings of powerful lords from distinct lineages, suggested by the individualized attire of the mini-atlanteans who support the throne and the paintings of warriors on thrones in the fossil temple.

The dozens of columns in front of the Temple of the Warriors feature both warriors and tribute bearers; some

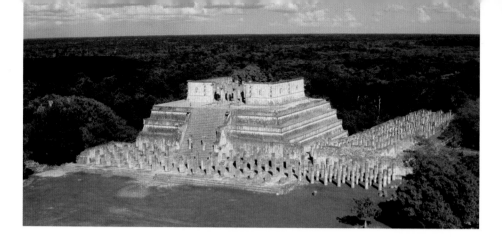

83. The Temple of the Warriors, Chichen Itza. Dozens of columns populate the west (front) and south facades, probably once supporting a perishable roof over a gallery for careful screening of visitors to the temple's summit.

of the latter are female. These columns supported a roof in antiquity; to enter the temple, one had to walk among this grove of guardians, and surely in the gloom one keenly felt their looming presence. By the time the visitor's eyes had adjusted to the darkness, he or she was suddenly plunged into the brilliant light of the staircase. The building, then, manipulated and controlled the observer, leaving little room for deviation from the practice spelled out by the iconography.

Nearby, the Temples of the Big Tables and the Little Tables were similar to the Temple of the Warriors in format. We can only wonder at the circumstances that led the Chichen Itza lords to make several buildings of this kind. Some must have gone up simultaneously; others, as evidenced by the Warriors' own sequential construction, expanded an earlier version. Were these buildings council houses for the powerful lineages that came together at Chichen Itza? Each lineage may have been responsible for garnering tribute and payments, all delivered and stored in these remarkable buildings, although the Temple of the Warriors, the largest of these structures, was an architectural rival to the Castillo.

The Temple of the Warriors is very similar to Temple B at Tula, in both the way columns frame the building's front and formed contiguous plaza-level buildings. In fact, the entire plan of Tula relates closely to the main plaza at Chichen, not just reversed but rotated as well. Before AD 900, when the Toltecs were fully in power and reaping the benefits of the trade routes that brought American Southwest turquoise to Chichen Itza, Tula and Chichen had established a special relationship, although the nature of that relationship – whether amicable or warlike – is still unclear.

The large, somewhat enclosed space south of the Temple of the Warriors and behind the Group of the 1000 Columns could have functioned as a public market, as some have supposed. On the south side of this plaza lies the so-called Mercado, or market building [84]. With a unique floor plan among Maya buildings, what sort of function did this structure have? Like many Late Classic Maya palaces of the southern lowlands and the Puuc, the Mercado offered an appealing *stoa*-like facade – in this case, of columns with sloping benches carved with parading warriors behind – but like those palaces, in fact, entry beyond the facade is keenly limited, in this case, through a single door. What lies behind the facade is a single, grand atrium. Columns line this space, while the outer wall is solid, ensuring privacy for royal receptions or banquets. George Kubler long ago suggested that it might have been a tribunal, given the unusual floor plan. What tribunals would have looked like, if indeed they existed, is not known, but the Mercado may well have been a building for a specialized function, one not represented at other sites. Vivid representations of autosacrifice suggest that it was a building for ritual penitence [180]. Whatever its function, the Mercado was built using recycled columns, and it seems to have

84. Spanish for market, the Mercado – seen here in plan and elevation – was not a market at all but one of Chichen Itza's most private palaces. Created rather hastily with recycled columns, the building features uneven numbers of columns along a side.

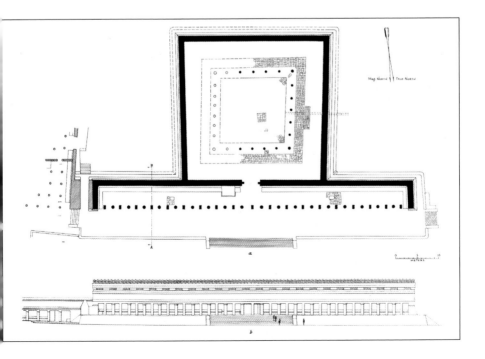

been thrown together hastily, with uneven numbers of piers along the patio's east and west sides. Unlike most Maya public buildings at Chichen Itza, the Mercado had a thatched roof, and at some point, attackers burned the building down, leaving the abandoned mess for modern archaeology to decipher.

Abandoned though it was, Chichen was not forgotten, not by pilgrims, nor by those who kept the records of the past that survived into the sixteenth century and beyond. And nowhere was the memory of Chichen Itza kept more alive than at Mayapan, which thrived after the fall of Chichen. Unlike Chichen, Mayapan was a walled city, perhaps both to keep its population in, and to keep others out. At its center was a radial pyramid, a pale but important shadow of Chichen's Castillo. Mayapan lords ordered pieces of Puuc facades dragged to their city, perhaps delivered punitively, perhaps brought as trophies, or to bring authority from an inherited or appropriated past, reusing and replicating them for new construction. Dozens of small colonnaded buildings, mostly facing the pyramid, were sloppily made, using columns and stucco.

Finally, some of the last Prehispanic Maya architecture was constructed along the Caribbean coast, where Spanish invaders spotted the thriving Tulum as they made their approach to Mexico, and where, once abandoned by the Maya, the pirates of the Caribbean found shrines and palaces to use as occasional bases of operation. The greatest of these coastal sites, Tulum was little more than a large town. Protected by the coral reef offshore, it was an ideal way station for the ocean-going canoes of Maya traders. Freshwater springs at the edge of the sea provided water. Once beached at Tulum, traders with valuable cargo might have felt some security as well, for Tulum was walled on its three land-facing sides, with watchtowers built into the corners, the landing protected and safe.

Although beautifully sited, with Structure 45 gazing out at the sea as if it might have been an ancient lighthouse, most of Tulum's diminutive buildings are oriented inland, their backs to the water [85]. The Castillo, the largest structure at the site, was nevertheless exceptionally small by the standards of earlier Maya buildings, and its rooms were quite tiny. In general, Tulum's builders worked hastily and casually, depending on thick coats of stucco to even out shabby workmanship. The negative batter that lightened Uxmal's buildings is so exaggerated at Tulum that buildings appear ready to keel over.

Far to the south, in the highlands of Guatemala, rival K'iche' and Kaqchikel Maya kingdoms built independent cities in the last century before the Spanish conquest. Badly sacked by the Spanish invaders, K'iche' Utatlan remains rubble today, but Kaqchikel Iximche, which became the first Spanish capital of Guatemala in 1524, is in better condition, and the sixteenth-century chronicler Bernal Díaz wrote of its ample chambers. Founded between 1470 and 1485 on a plateau surrounded by defensive ravines, Iximche provided separate compounds for its ruling lineages, each with elegant living chambers, temples, dance platforms, and a ballcourt. Such programs were common among highland Maya towns.

Many Spaniards commented – unfortunately rarely more than in passing – on the extraordinary architecture and life of the people they fought doggedly for a generation in Yucatan. When Francisco de Montejo subjugated Yucatan to Spanish rule in the 1540s, Maya lords were still carried in palanquins and Mayan hieroglyphic writing was commonplace. The one late and fine Maya city of which we know almost nothing is Tiho, which became the site of modern-day Mérida, founded in 1542. Some of its blocks can be found today in the cathedral walls, or in Montejo's house [230], both along the main square of Mérida. Great recyclers of ancient buildings themselves, the Maya must have lamented the destruction yet nevertheless found it part of a familiar pattern.

85. The white towers of the Castillo at Tulum make the building visible from the Caribbean Sea, but the structure itself turns its back to the water, addressing instead the other palaces and temples of the small walled city.

Chapter 4 The Human Form

In Maya art, the human form is omnipresent, whether in representations of gods or of humans. What makes that human form so appealing to the modern eye is the seeming naturalism of Maya representation. Figures sit, kneel, hold objects, or touch one another in ways that are astonishingly lifelike. And the emphasis on people, as well as the things people do, has made Maya art seem approachable.

The main subject of monumental Maya art is the king, whose Mayan title is *k'uhul ajaw* ("holy lord"), and the most featured representation is his royal person – so much so that many Maya stelae depict only the king and narrate only his deeds [158]. Even when the featured representation on a monument is not the king himself, either the nature of the depiction or the text relates that individual to the king. When one goes beyond the limited possibilities of stone sculpture and the sort of weight that was given to it, however, many other elite individuals – surely many from the royal family but also merchants, priests, and war captains – were able to commission their own depiction in art. One might think this is logical, if only because they were the ones with the economic wherewithal to do so. By comparison, the Aztecs made some representations of rulers, but few representations of named

86. Often rendered with grotesque faces, the Monkey Scribes are usually shown hard at work, writing, painting, or carving. On this cylinder vessel, captured in a rollout photograph, an artist with a quick and free line renders twin simian scribes wearing waterlily headdresses and pointing to books covered with jaguar pelts.

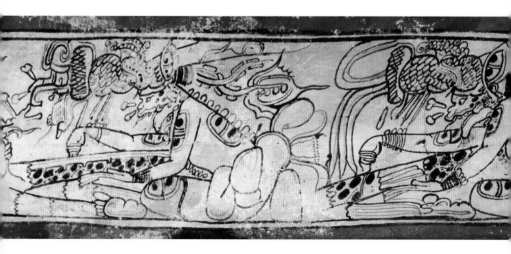

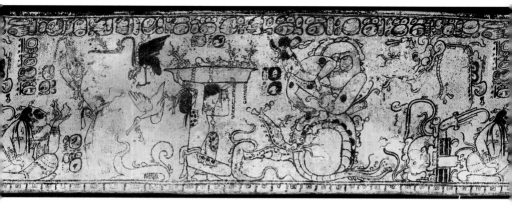

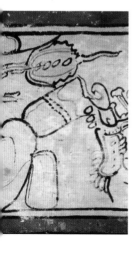

nobles other than warriors survive, so the same situation did not emerge among that later civilization.

Additionally, some of the most powerful Maya supernaturals had human form. Human perfection was summed up in the body of the Maya Maize God, whose representation as full-grown male youth included a strong, taut body, smooth skin, and luxuriant tresses [201]. The Hero Twins, demigods who could exert their powers both with mortals and among the gods, also took idealized young male form [87]. Their half-brothers, the Monkey Scribes, took grotesque but recognizable human form in most cases [86]. Many members of the Maya pantheon – Itzamnaaj, Chahk, and K'inich Ajaw among them – were anthropomorphic, but with specialized non-human facial features (and attributes): Itzamnaaj, the supreme deity, and K'inich Ajaw, the Sun God, always feature square eyes, and the latter's are cross-eyed [125]; even K'awiil, who has a face based on a serpent and a leg ending in a serpent head, features a human torso and arms. Supernatural insects grasp torches, and jaguars and bats dance as if human.

Over a period of a few hundred years, the Maya mastered skills to render these divine and human forms. The Maya came to represent both gods and humans in natural poses – overlapping one another, reaching out to one another's bodies, and in a variety of positions, from sitting and standing to playing the drums or the ballgame. Mastering such representation was no small matter: no other civilization in Mesoamerica came close to the achievement of the Maya in this respect, and only a few civilizations of the premodern world were their equals.

Representing the body

Many of the Maya skills in representation seem to have been perfected in the seventh and eighth centuries AD, but the story of their development began centuries earlier, during the Preclassic and Early Classic. In the Early Classic, the Maya artist typically made a highly conventionalized rendering, in which the body was carved as it is known by the mind to be, resulting in a human form completely shown. For example, fifth-century Stela 1 from Tikal features the standing king Sihyaj Chan K'awiil [88]: in order to include the entire body, the artist renders both legs, parallel but separated with the slightest of overlap at the feet; the torso faces front, and the arms adopt an almost impossible position, in order to show upper and lower arms, as well as hands drawn as if they were in mittens. The head then faces to the side, in profile. Of course, no one other than a contortionist can actually stand like this, but the point is that the features of the human body are complete, at least in profile.

But if one looks closely at the monument, the seeds of representational change have already been sown. The small

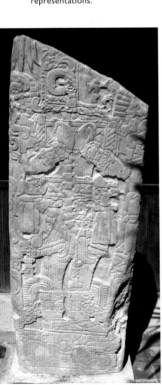

88. A fifth-century sculptor wrapped the two-dimensional image of Sihyaj Chan K'awiil II around three sides of Tikal Stela 1, creating a sense of the costumed body within three-dimensional space. Although the king's posture remains conservative and static, small deity figures on the stela sides are animated, prefiguring later representations.

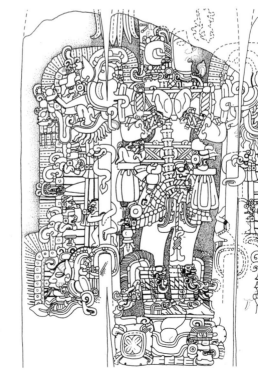

figures who scale the ritual staves at the seams of the front and sides are rendered far more fluidly [88]. A jaguar to the lower left of Sihyaj Chan K'awiil flexes a lower limb and reveals the inside of a paw, providing an early signal of foreshortening. The paired figure at right rests languidly on a shiny disk; above, coming out of serpent mouths, small god figures on both left and right sides feature legs and arms almost completely overlapping and torsos in three-quarters representation. Thus by the time this monument was made in the fifth century, new modes of representation had been adopted for minor figures, while the most conservative style was retained for the ruler.

The presence of novel representations among the minor figures on Stela 1 may have been stimulated by developments in other media that had fewer technical limitations than stone sculpture. At Río Azul, during the Early Classic, the art of making clay figurines flourished [89]. Their bodies modeled entirely by hand, the figures sometimes featured mold-made heads. Delicate hands applied clothing layer by layer and hair in strands, yielding lifelike figures that adopted natural poses. Even with their standardized faces, the figurines are engaging little humans, lively in their aspect.

Maya painters adopted new modes of representation for pots and walls before artists considered using them on monumental sculpture, at least for the principal figure. The mural from Structure B-XIII at Uaxactun [212] provides a window on the sort of representation that was possible around the same time as Tikal Stela 1 was carved. Most interesting for the purposes of the representation of the human form are the many figures on two registers: they are shown shifting their weight, one foot off the ground, in energetic exchange with one another, and bodies overlapping. The Maya artist demonstrates the ability to show the human figure in motion in the Uaxactun mural, especially when one member of the procession turns to look over his shoulder, a pose that would be featured in the Bonampak paintings nearly three centuries later.

Ultimately, by the height of the Late Classic the Maya artist created representations that featured the human figure the way it is seen by the eye, foreshortened and with overlapping parts, rather than as the body is known. For example, on Bonampak Sculptured Stone 1, probably dedicated in 692, the enthroned king's legs are rendered with dramatic and confident foreshortening [90].

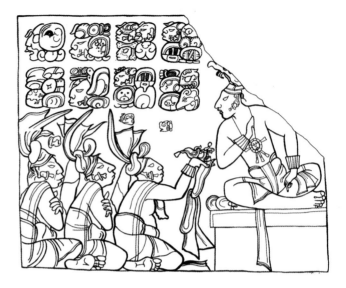

90. In the deeply incised scene carved onto Bonampak Sculptured Stone 1, three lords (yet with only two visible feet!) present their new king with a royal headband bearing the Jester God ornament, as seen in this drawing. The king's arm across his chest helps retain his center of gravity even as he leans toward his nobles.

The seated lords at left are rendered effectively in profile, the limited views of their crossed arms suggesting a posture of ease. Additionally, the first of these lords reaches up to offer a headdress, revealing his bulging paunch. The frame cuts off part of the final figure, but the eye sees each body, head to toe, to be complete: only upon careful scrutiny does one realize that there are just two feet rendered for three men. The effect is so convincing that the eye does not question the rendering. It is as if the sculpture were some visual puzzle that the viewer's brain and eye conspire to complete: this sort of representation was a dramatic step forward in the ability to capture a three-dimensional image and formulate it on a flat surface.

A late eighth-century panel at the Kimbell Art Museum further refines the possibilities of foreshortening [91]: within an architectural space, a victorious warrior presents three captives to the Yaxchilan king who sits cross-legged upon a throne bearing his name. The king easily moves his weight off-center, leaning toward his underling. His right hand presses into his thigh and the left is deftly turned. The lord sits under swag curtains, inside a palace space; the warrior approaches from just outside the palace, one foot still on an approaching step, as if in some careful grading of social status, where the captives sit and kneel yet farther outside the palace chamber. Draped lavishly in cut and shredded cloth, a visual metaphor for cut and shredded flesh, the captives express heightened

emotions with their dramatic gestures. The captive at far left may kiss or lick dirt from his hand in submission, the middle one raises his hand to his forehead in what seems to be a gesture of woe and resignation. The left-hand captive is severely truncated by the panel's frame, yet there is no mistaking the artist's confidence that the viewer will still see the complete human figure.

That such representational skill also enhanced emotional resonance can be seen on a panel recovered from Palenque in 1999 [134]. There, the hand of the king, K'inich Akhal Mo' Nahb, presses into that of an attendant to his left, a synapse that sends a sensual charge between the men as one palm makes visceral contact with another.

Such skills in rendering the human figure became conventionalized, and the range of solutions to both the organization of the composition and the rendering of an

91. On a panel from the Usumacinta Region housed at the Kimbell Art Museum, swag curtains reveal a sajal, at right, presenting captives to a ruler on a throne bearing inscriptions rendered in reverse. The sajal reaches upward, creating a diagonal that is matched by the line of captives that slants from left to right.

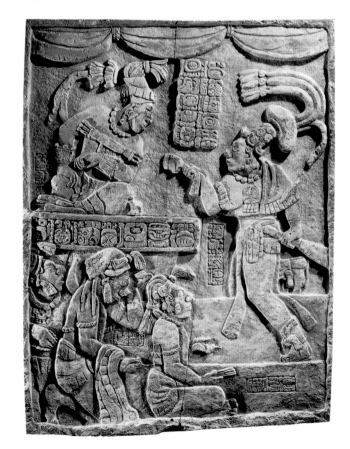

92. Painted on Room 2's North Wall (see ill. 217), Bonampak Structure 1, one captive languishes on a diagonal, whereas another, hands raised and back to the viewer, pleads for his life. Both faces are rendered in profile, but the painting of an eyelash on the upper captive's face is an attempt to indicate three-dimensionality, also visible in the twisting, composite views of each figure.

93. (below) Although Maya artists occasionally attempted to render frontal faces in two-dimensional, linear formats, these experiments were usually reserved for the faces of captives or secondary figures, such as this rabbit playing a drum on a painted cylinder vase.

individual figure remained limited. Some attempts never reached successful solutions: rear views of bodies rarely convince the eye, although the Maya tried to show the back of the uppermost captive of the north wall of Room 2 of the Bonampak murals [92]; frontal faces in strictly two-dimensional media (as opposed to the high relief of a Copan stela) were attempted on the occasional secondary figure on Maya pots [93] and on some carvings of captives at Naranjo and elsewhere.

In a few cases an exceptional artist developed a fluid three-quarters view of the body, as, for example, on the Black Background Vase [94]. More typically, the painters of cylinder vessels managed to suggest the body in a three-quarters view using a handful of specific techniques [94, 192, 200, 201]. In a number of examples, the painter leads the viewer's eye from the frontal, foreshortened crossed-legs to the torso. To arrive at a convincing portrayal of a face in profile, one shoulder drops

down, and the other rides up, revealing an expanse of neck [128]: it is here that the turned body is achieved. Although the face seems to be in profile, its three-dimensionality is suggested simply by a single stroke projecting the eyelashes or brow from the hidden side of the face [92]. Turning one hand to reveal the palm or the wrist to reveal the ties of its bracelet also enhances the effect that the figure itself is turning. Despite what is often deft handling of the human figure on Maya vases, Maya artists could also exhibit seemingly reckless disregard for right and left hands, sometimes reversing them and sometimes painting two of the same on a single figure [94].

Throughout the Classic period, Maya artists portrayed the human body along a narrow proportional range, with the scale of the head to that of the body from 1:5 to 1:8, the lankier proportions occurring even during the Early Classic when the figures seem shorter because of their heavy adornment with ritual costume, especially the towering headdresses. Proportions of 1:7 and 1:8 are used nearly universally on painted ceramics of the Late Classic; squatter proportions on carved lintels may derive from the compact and compressed format of that sculptural form. Reflecting their shorter stature, women rarely stand more than seven headlengths to the body.

Maya ceramic sculptors also came to use a slightly shorter proportional system, with most figures standing about six or seven headlengths [95–97]. Faces often receive the greatest

94. On a vessel known as the Black Background Vase, the artist captured the young lord's body in three-quarters view, the subtle torsion evident at the belly, and used color shading to convey three-dimensionality. Despite these skills, he painted a left foot on the right leg and a left hand on the right arm, although these features may have an unknown meaning.

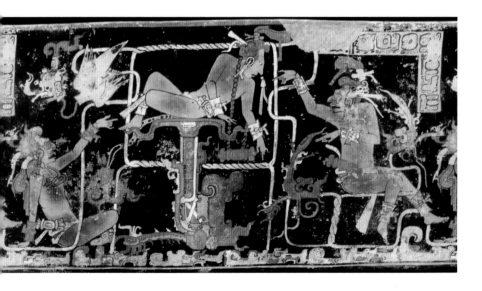

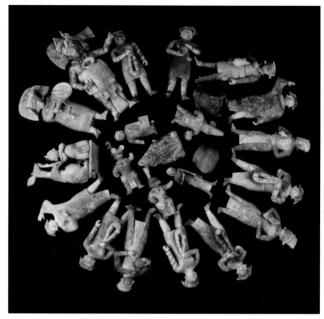

95. (right) The twenty-three figurines that Michelle Rich discovered in El Perú-Waka' Burial 39 were arranged in two concentric circles and laid at the deceased king's feet. The figurines, both human (ill. 35) and supernatural, comprise a royal court scene.

96. (below) Excavated in the residential Group C at Palenque in association with burials, this figure was part of a larger censer used for ancestor veneration.

97. (opposite) The Maya considered Chak Chel to be a woman warrior, the aged midwife who both delivered infants and brought on destructive floods. Like many other figurines, she retains brilliant blue post-fire pigment.

emphasis, along with headdresses, and many bodies are simply rendered, putting emphasis on the detailed and lifelike faces. Proportionally very large feet provided a standing figure with the means of staying upright. Some figures were modeled entirely by hand, with a separate mold-made face often added and then detailed by hand; others were made entirely in molds.

Maya figurines made during the Late Classic reveal a far more extensive range of activities and emotions than monumental sculpture. Hundreds of figurines come from the island of Jaina, off the coast of Campeche, but fine-quality figurines have been excavated across the Maya world, especially at Río Azul, El Perú-Waka', Aguateca, and Palenque [35, 95]. Some portray the nobles of the court, often dressed as warriors or ballplayers; others explicitly depict Maya gods. More female figures are rendered as figurines than in any other medium, suggesting that a broader clientele may have commissioned or purchased the figures. At Lagartero, figurines were predominantly mold-made, and many were found in a huge deposit, mainly headless.

Working in pliable clay and modeling entirely by hand, an artist successfully mastered the stooped posture of age in a figurine of Chak Chel, the old midwife goddess of the Maya [97].

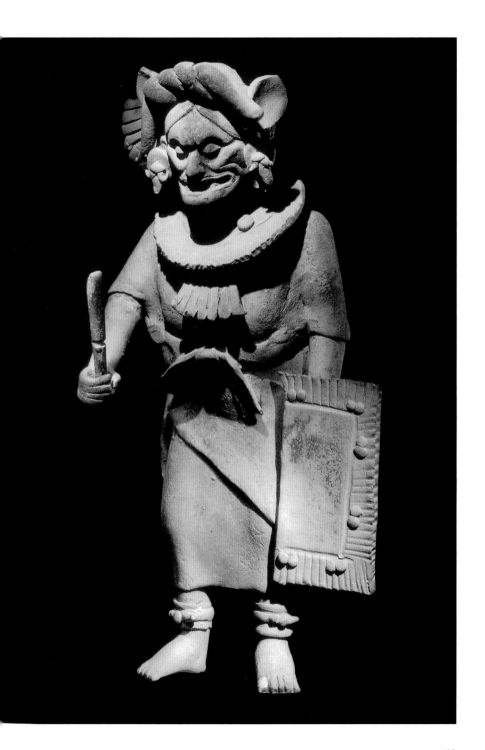

98. These figurines, one at Dumbarton Oaks (left) and the other at the Detroit Institute of Arts (right), were made from the same mold. The mold comprised the bodies of the young woman and old man, but they were made distinct by varying added elements and positioning. The Dumbarton Oaks figurine was likely made after the Detroit one, for some of the details are less sharp.

A woman warrior, she also prepares to attack, her shield at her side. A pair of ballplayers at the National Museum of Anthropology in Mexico City is frozen for all time in dramatic postures, an imaginary ball between them; only their heads were shaped in molds. The artists who mastered paired figurines often deployed three molds, one for each head and one for the conjoined bodies and then finished with added detail and brilliant pigments.

These paired figurines reveal expressions – and actions – rarely seen in Maya art. Probably about a dozen examples feature a young woman and old man embracing – or a woman and a rabbit, or other beast. While the woman of each couple stares impassively into the distance, the old man leers, surely a subject of amusement for the Maya. The Detroit Institute of Arts and Dumbarton Oaks each own such a pair [98] where the

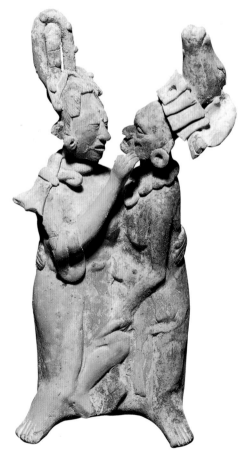
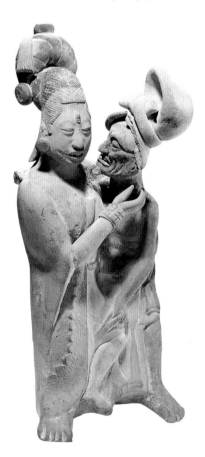

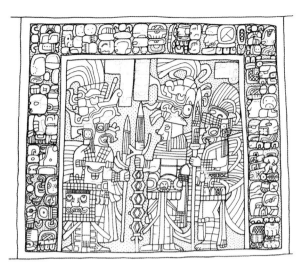

99. This ninth-century lintel from Halakal, in the Yucatan, includes the names of lords from Ek' Balam and Chichen Itza, suggesting interaction among polities analogous to those of the southern lowlands. The carved image, seen here in a drawing, portrays three elaborately costumed figures, two wearing deity masks.

same mold was used to fashion the bodies, but these were finished with different heads; those of the Dumbarton Oaks example were oriented toward one another, so that the viewer reads a loving sexual intensity into the encounter, in contrast to the sheer ribald clowning of the Detroit pair.

Throughout the Late Classic the human figure could be rendered in ways that seem to the modern eye to be truly naturalistic. But the portrayal of the human form takes a sharp turn in another direction at the end of the period. In the ninth century, at Halakal and other satellites of Chichen Itza, the human form started to be rendered neither as it is known nor as it is seen, the two modes of representation that had previously informed Maya art. Artists rendered the three figures on a panel from Halakal [99] with legs that do not align with their upper bodies, as if one team of artists started carving from the bottom, another team from the top, and then failed to meet in the middle.

Ninth- and tenth-century Chichen Itza sculpture adopted highly conventionalized forms of representation – particularly for monumental sculpture, and probably based on Central Mexican models. These conventions required that the legs be in profile, parallel, and overlapping above the knees. All faces are in profile, and torsos may be represented in profile or frontally. Artists rarely used foreshortening and show no modeling of arms and legs. Figures often seem weightless and in fact may float off their groundlines, as they do in Chichen

Itza paintings. Postures vary little from figure to figure on most monuments, creating the sense of corporate identity rather than individual human forms.

Physiognomy and portraiture

Like other Mesoamerican peoples, the Maya idealized youthful male beauty and particularly the handsome, unblemished face of the Maize God. For the Maya, Maize God theology was complex: the Maize God was the father of the Hero Twins and Monkey Scribes; he also personified the yearly agricultural cycle, the renewal and death of plants. In the *Popol Vuh*, creator gods took maize dough to fashion human beings, making the possibility of ideal beauty attainable for all noble humans. Most representations of the human face in Maya art focus on this ideal beauty.

The face of the Maize God was understood to be the growing ear of maize, still on the stalk [101]. The Maize God has flawless facial features, but he also has abundant straight hair that the Maya understood to be like luxuriant corn silk. On the maize plant, every kernel sends out a single strand, so luxuriant corn silk – or luxuriant hair – signaled bounty and plenty. At the top of Copan's Structure 22, Maize Gods were tenoned into the cornice, vivid symbols of the abundance guaranteed by the king who would stand in the doorway below.

An ear of maize grows long and narrow, tapering to a point. In their profiles, the Maya sought this same line, continuous from the nose to the forehead and then tapering nearly to a point [105]. Most noble Maya underwent head modification as newborn infants: strapped to their cradleboards, their still soft crania were molded into shape. Sculptures at Palenque indicate that some Maya lords affixed something to the bridge of the nose so that the line from tip of the nose to top of the forehead would be unbroken and nearly straight. The heads of both King Itzamnaaj Bahlam III and his wife, Lady K'abal Xook, on Yaxchilan Lintel 24 [145], aspire to this ideal, as does their hair – the bead through which it is threaded at the center of the forehead emulates the Maize God's usual hairstyle. Like the Maize God himself, such portrayals of Maya nobility never indicate aging, but only vibrant youth.

At the same time that the Maya idealized the Maize God, they also sought to emulate some aspects of the Sun God,

100. (above left) When excavating a Copan palace compound, archaeologists found both halves of this remarkable sculpture of a Monkey Scribe. Alert, with painting supplies in both hands, he may represent a deified ancestor, venerated in a compound that may have gained prestige through the scribal arts.

101. (above right) In contrast to the Monkey Scribe, the Maya Maize God embodied human perfection, with his tapering forehead, prominent nose, and luxuriant tresses. His hands gently wave, like the maize plant's foliage. Once tenoned into the Copan Structure 22 cornice, the Maize God would have seemed to grow organically from the building.

K'inich Ajaw. Unlike the Maize God, K'inich Ajaw never features a fully human face: he always has large, squared eyes with the pupils crossed [125]. Additionally, he has an upper front tooth in the shape of a capital letter T. The Maya incorporated these two aspects of his physiognomy into the noble persona. First of all, at the same time that babies' foreheads were reshaped, mothers often dangled a bead over babies' faces so that their eyes would become permanently crossed. And secondly, many adult males filed their upper front teeth into the T-shape. Stephen Houston and others have noted that from such a shaped mouth would have come elegant and trained speech. Additionally, some lords added jade inlay: an ideal smile may have flashed both cut teeth and dark green spots.

In contrast to these ideals, the Maya may well have viewed a protruding forehead as one of humanity's most disfiguring features, along with the wrinkled lower face that comes from both aging and tooth loss. A captive carved onto a step riser at Tonina features both [102], and the profile of his face forms

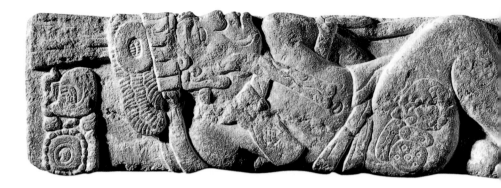

102. A staircase riser from Tonina Monument 27 positions the aged profile of the captive to be trod on time and again. Few humans in Maya art ever feature the telltale signs of aging; that this captive does may be part of his visual humiliation.

the edge of the step itself; a youthful warrior may have taken particular pleasure in stepping on his less-than-perfect visage. A servant in the dressing scene of the Bonampak murals has a sharply protruding forehead, perhaps marking him as a foreigner or of low birth.

Interestingly enough, many gods have faces that are particularly wizened, craggy, and wrinkled. While noble lords rarely age (although they do gain weight), some gods have old age as an attribute. The old cigar-smoking God L, for example, is specifically toothless, his nose bulbous, and his chin pointy [199]. The Jaina figurines of old toothless men who make love to young women may well be portraying the exploits of gods, perhaps even God L himself, since he, too, surrounds himself with young female courtiers.

Of all the Maya supernaturals, only the Monkey Scribes achieve the human grotesque [86]. Their half-brothers, the Hero Twins, take after their shared sire, the Maize God, in their beautiful faces and physiques – as do the Monkey Scribes in many instances. The scribal entourage includes other members of the court who do not conform to the Maya ideal, among them hunchbacks and dwarfs, known to have been the confidants of kings throughout Mesoamerica. But some Monkey Scribes are hideous, their faces barely human or turned to monkeys altogether, their fate in the *Popol Vuh*. A sculpture excavated from the Scribal Palace at Copan [100] evinces pathos from the viewer, for although homely, the Monkey Scribe seems altogether human, but with the sort of face never seen on a Maya king. Although rendered as a divinity – and unnamed – this Monkey Scribe from Copan more surely portrays the face of a specific individual than any commemorative stela from that city.

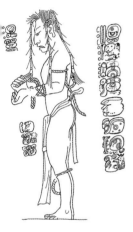

Artists frequently include images of themselves and their circle on Maya vases [200], but few suggest portraiture. In fact, when portraiture is as idealized as it typically is on Maya vases or monumental sculpture, it barely seems portraiture. Few two-dimensional renderings without shading – a description of most Maya formal portraiture – can capture a particular physiognomy. Most of the world's traditions of portrait-making were, in fact, effective exploiters of three dimensions, whether in Rome or Ife. A few figurines would seem to be specific portraits – but these are mainly captives. One can distinguish sequential rulers at Yaxchilan, but this is largely because of both identifying texts and the workmanship, not because the faces of these kings are readily identifiable. Furthermore, the principal figures on many Maya monuments have suffered intentional damage to the face such that a particular physiognomy would be hard to recognize.

Despite such obstacles to recognizing portraiture in Maya art – its linear two-dimensional quality, the pattern of damage, and what may have been a preference for ideal, Maize-God-like renderings – there is one striking exception: Palenque. There a tradition of stucco sculpture evolved and with it, a tradition of lifelike, evocative portraiture. A stucco head without specific provenience at the site bespeaks a particular individual beyond the limits of youth with his deeply brooding expression and focused intensity [106]. Slightly larger than life, the head seems to have been made by an artist directly studying his subject, or perhaps from a life or death mask.

The physiognomies of some Palenque kings are so well known that they can be recognized across the site: Kan Bahlam's distinctive underbite, along with six fingers and toes, characterized low-relief stone carving, particularly in the Cross Group panels [131]. A stucco head from adjacent Temple 14 also features this king, as do ceramic incensarios that have been recovered from palace compounds. When incense was offered in a brazier atop the ceramic assemblage, the king would have been venerated, perhaps as an ancestor who held power after death.

Finally, the portrait of the most famous of Palenque kings, K'inich Janaab Pakal, probably once reigned over Palenque from various stucco facades at the site. When the great patriarch died, his heirs wrenched one of these portrait heads [105] from a wall and jammed it under the sarcophagus, along with a

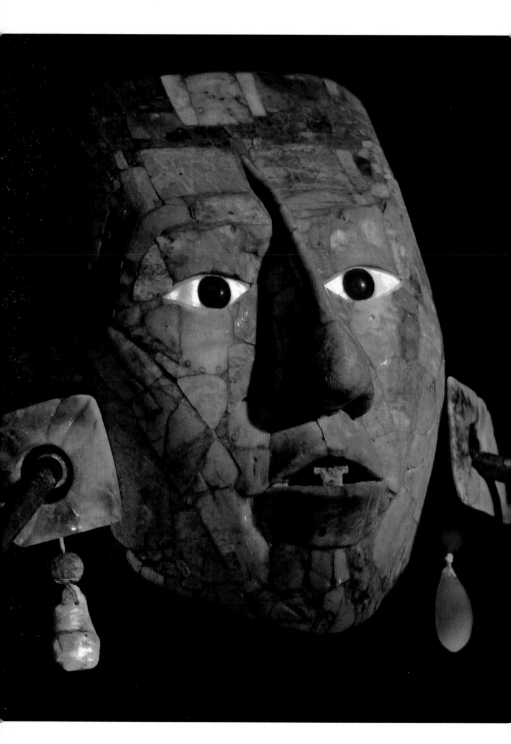

104. (opposite) Crafted from jadeite, shell, and obsidian, some of the pieces reused, the funerary mask of Palenque's K'inich Janaab Pakal portrays the king as eternally alive and youthful, the color of fresh vegetation, like a young Maize God. Flowers carved onto his ear flares evoke the fragrance of paradise, and inside his mouth is the Sun God's T-shaped tooth.

105. (right) Wrenched from a now-unknown architectural setting at Palenque, the stucco portrait head of K'inich Janaab Pakal was interred in his tomb, probably completing the ritual "killing" of his essence.

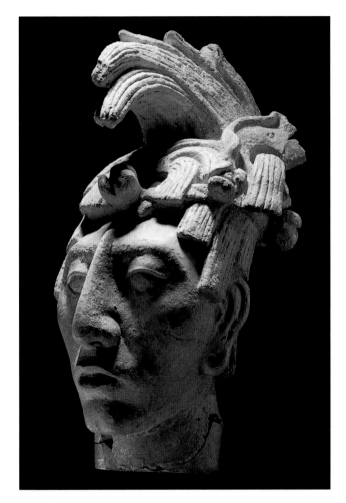

106. (below) Pensive and calm, this portrait of a Palenque male noble exemplifies the skills local artists mastered in shaping pliable stucco into lifelike, individualized forms.

female portrait head. Pakal wears identical hair ornaments on the Oval Palace Tablet [128], his accession monument: this stucco head, with its youthful aspect and seeming optimism, may date from the earlier years of his long reign. Another portrait was layered over his face once he had died; tesserae of jade and other precious materials were glued to what likely was a light armature and assembled on top of his face [104]. Although each jade rectangle was like a kernel of maize, and the entire mask converted Pakal into the Maize God, the jade mask was a powerful portrait of the old man, with piercing eyes and a narrow jaw. Even in the most recalcitrant of media, jade, the Palenque artist could still express the individual.

Chapter 5 Makers and Modelers: Developing Sculptural Style

107. Among the carved bones in the tomb of Jasaw Chan K'awiil, from Tikal, was this tiny spatula: rendered in the finest of lines is an artist's hand, painting, emerging from a supernatural realm. Perhaps it is the very hand of the carver who made this exquisite drawing.

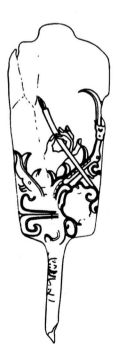

The sixteenth-century *Popol Vuh* describes the creation of the world and humans by deities whose names include *tzacol*, "maker," and *bitol*, "modeler." These primordial artisans measure and stake out the earth's four sides and corners and shape bodies out of wood, clay, and finally corn dough, which yields humans who give offerings to their creators. The artistic record suggests that ancient Maya artists saw their acts of material transformation and enlivening as analogous to creator deities' acts. Incised on a bone from Tikal Burial 116 is a painter's hand emerging from a serpent maw [107], a portal to another realm, and images on vessels frequently show deities such as Itzamnaaj, the Maize God, or the Monkey Scribes painting in books [86, 200]. For sculptors too, carving, modeling, and shaping were sacred acts that emulated primordial ones. Dedication texts for stone monuments, named in inscriptions as *k'uhul tuun*, "sacred stone," or *lakamtuun*, "banner stone," are analogous to texts at Quirigua that recount deities setting stones on the date 4 Ajaw 8 Kumk'u, another world creation story. Each time humans planted (*tz'ap*) or bound (*k'al*) a stone, the primordial creative act was renewed. And in some dedication texts, works are dedicated *-itaj* or *-ichnal* – "in the company" or "field-of-view" of – ancestors and deities. Rulers and others performed rites that activated sculptures and buildings through song, speech, and movement. Indeed, the process of creating a building, artwork, or space was a collaborative one where performance was integral. Some sculptors signed their work, using the word *uxul*, which may translate as "carving" or "scraping," comparable to the painter's *tz'ihb*. These phrases, although analogous to a modern artist's signature, may have connoted offering.

Monument types

The Maya sculptural tradition is intertwined with architecture, for carved stone monuments were placed inside, in front of, or on buildings or in plazas, but here we treat it separately to closely track the development of techniques and regional

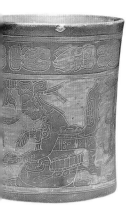

108. On this incised cylinder vessel from Copan, a seated scribe carves or paints an anthropomorphic head.

traditions. Yet we also include other sculptural forms such as stuccoed architectural facades and hand-held objects or costume ornaments. From massive to minor, these shaped forms were installed and experienced together in the ancient Maya world.

Tatiana Proskouriakoff was formative in defining Maya stone monuments as a distinct artistic tradition, tracing the development of the carved human form over the course of the first millennium AD. On stelae, vertical, freestanding stone monuments whose proportions mimic the human body. Some stelae were plain, but the most commonly carved subject was the k'uhul ajaw, or "holy lord" [126], sometimes accompanied by family members, regional governors, court members, and captives, as well as deities and ancestors who oversee events. Images often portray calendar celebrations, especially completions of a twenty-year k'atun, when the monument was planted or bound: the sculpture thus refers to itself, the reason for its dedication, and the primordial deities' actions it emulates. Altars, low monuments in squared, rounded, or zoomorphic shapes such as turtles, frequently were set in front of stelae to receive offerings [27, 159].

The Maya also elaborated functional architectural forms including the lintel, a stone or wood slab set above a doorway and bearing carvings on visible faces, seen before entry into and once inside the portal, requiring the observer to squat, crane the head, or even lie down to see the composition [146]. Panels were square, rectangular, or oval forms set into buildings' interior and exterior walls [132]. Columns and jambs, especially in the north, portrayed humans or deities who appear to hold up the lintel or building [170]. Dedication texts recounted on lintels or panels often narrate the dedication of the buildings into which they were set, indicating that they were perceived as integral parts of the structures.

Maya sculpture was made not only to honor kings and gods, but also to negotiate relationships between men and the powerful supernatural forces that deities embodied. In adopting permanent materials and standardized representations – particularly the stela – in the third century AD, the Maya developed successful solutions that would, in turn, be used by an ever-widening gyre. At first limited to Peten-area centers, sculpture began to appear in the fifth and sixth centuries at Copan and Quirigua to the south, Oxkintok to the north, Caracol to the east, and Yaxchilan to the west.

Late Preclassic to Early Classic

110. (opposite, left) On the granite Stela 11, found buried at Kaminaljuyu, a ruler wears an avian costume, including a mask and headdress carved in a slightly higher level of relief than the human face they obscure. This is an early example of costumed transformation, also prevalent at Izapa and in later Maya art.

111 (opposite, right) Izapa Stela 1, made of andesite, is an early portrayal of the Maya rain deity Chahk, who uses a basket for fishing. The stela was paired with Altar 1, in the form of a toad or frog, creatures associated with rain.

Massive architectural facades of the Late Preclassic era in the Maya lowlands featured modeled stucco representations of the heads or bodies of Maya supernaturals. Stucco adheres and endures best when applied in rounded curvilinear courses supported by an architectural framework, especially tenons. The results were programs that eschewed the right angle. Deities are shown as oversize heads, 6 m (20 ft) high, frontal and modeled in stucco in three dimensions. They also appear in stuccoed architectural friezes as whole, anthropomorphic bodies with zoomorphic faces or masks, shown in active poses and in profile, legs apart, and with costume elements such as twisted ropes, ties, and headdresses covering much of the body [109], comparable to the rendering of the anthropomorphic body in the contemporaneous San Bartolo murals [209]. The images in the stuccoed architectural friezes, comprising scrolled details, overlapping curves, and substituted elements, although difficult to tease apart at first glance, pulsate with energy.

In the Late Preclassic in the Pacific Coast and highlands, emerging dynasties adopted the curvilinear style seen in stucco architectural friezes to formulate standing representations of rulers on stelae. Furthermore, many formal properties that had been developed to represent deities were used in the portrayal of humans, including an idealized naturalism, profile representation, and scrolled details forming costume elements.

In the Late Preclassic Maya lowlands, the role of the king can be perceived, but his actual representation rarely survives – and of those that do survive, none reaches the dimensions of the deity heads on architecture. Instead, some are small in scale, to be held, worn on the body, or cached in a tomb; others are half-size to full scale. In the paintings of San Bartolo in the Peten, dating to around 100 BC, a ruler is crowned;

109. On El Mirador's Tecolote structure, swimming or diving anthropomorphic gods wearing early rain god (Chahk) headdresses give evidence of widespread power of this deity.

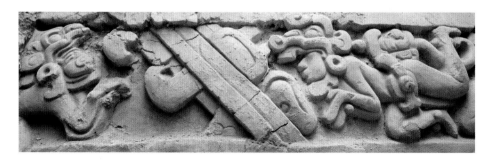

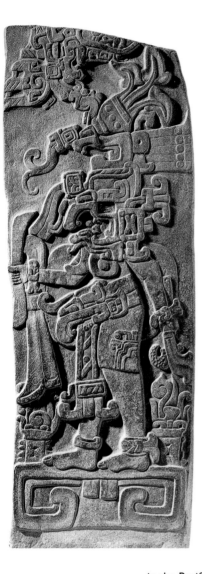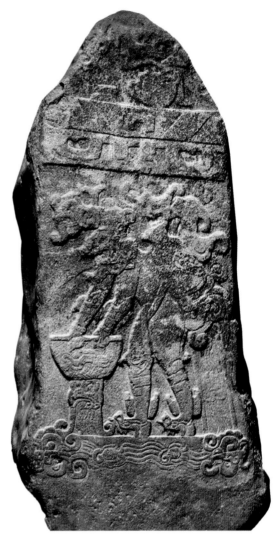

in the Pacific Coast and highlands of Chiapas and Guatemala,
full-figure humans perform rites on first-century BC and
first- and second-century AD stone stelae at Takalik Abaj,
El Baúl, and Kaminaljuyu [110]. Other early stelae depict deities
in action, such as Izapa Stela 1's portrayal of Chahk fishing [111],
and some portray humans transforming into deities. The
rendering of parallel but separated legs in profile, frontal torso,
and head in profile, also seen in the San Bartolo paintings and
on Preclassic sculptures from Nakbe in the Peten and

Actuncan in Belize, becomes the standard in sculpture from the third century and later in the Peten.

The third-century cultural flowering known as the Early Classic took off when the impetus to render the human agent and his deeds, in association with monumental architecture, became part of the permanent pattern of the Maya lowlands. With the adoption of full-figure representations in the Peten, generally on stone monuments featuring a single figure, Maya kings proclaimed their right to rule. And although giant deity heads continue to flank building stairways into the Early Classic [43], with the transition to lowland stone sculpture, gods also appear in diminutive form, held in the hand – and perhaps under the control – of larger, active kings.

Early Classic sculpture at Tikal

By virtue of the range and number of surviving stone monuments, Tikal, in central Peten, offers the clearest picture of the artistic development that took place from AD 250 to 600. Some early sculptures remained on display until the site's ninth-century collapse and afterward, to be rediscovered in the nineteenth century, and in the 1960s, the University of Pennsylvania recovered tombs and buried stone monuments, including the earliest dated stela found *in situ*, providing substantial evidence of art-making in the third and fourth centuries. Guatemalan archaeologists in the 1980s found startlingly different three-dimensional fourth-century stone sculptures that stand outside the ordered world of stela-making [115], and the discovery of another well-preserved fifth-century stela makes the picture of Tikal sculpture more informed than for any other Maya city.

What we think about Maya art is always determined by the sample: one must be prepared for discoveries that undermine what scholars have come to accept as truths and to recognize that even what seems to be exhaustive archaeology is never complete. In Maya art the problem is most acute for earlier centuries, for early sculptures frequently were broken in warfare, and even when not, the Maya often reinterpreted the past in ways that called for the movement, hiding, or destruction of earlier works, or they planned new building programs that encased old ones. By contrast, when the Maya abandoned cities in the ninth century, public monuments were

left *in situ*, subject to little more than the creeping liana or the towering mahogany for over a thousand years, and among the first to be recorded by explorers.

Additionally, because production was limited to a few cities, there never were great numbers of Early Classic sculptures, nor did many distinct regional styles emerge until the late fifth century, when the loci of Maya political power began to be more dispersed. At the beginning of the era, Tikal was an important political center, and the polity gained more strength at the end of the fourth century, when Teotihuacan lords from Central Mexico fought and married their way to the Tikal throne. In the mid-sixth century, Caracol lords from the foothills of the Maya Mountains teamed up with the Kaan dynasty to crush Tikal, causing a 130-year hiatus in monument dedication there. This is the lacuna that marks the end of the so-called Early Classic, although the hiatus does not mean complete cessation of art-making, for at Tikal and elsewhere, the Maya continued to bury rulers in offering-filled tombs such as Burial 195, known for its remarkable preservation of the shells of stucco wooden sculptures [23]. Moreover, other polities continued to produce monumental sculpture, for this collapse, although extensive, was neither ubiquitous nor uniform.

Although one might anticipate that the earliest dated Tikal monument, Stela 29 [112], would be a hesitant effort,

112. Facing to the right, the king on Tikal Stela 29 holds out the head of the Jaguar God of the Underworld, a Tikal patron deity; an ancestor faces downward from above. The Long Count on the back, 8.12.14.8.15 (9 July, AD 292), is the earliest securely dated inscription at Tikal.

any developmental quality is evinced in workmanship, not in content. With a date in the Maya calendar correlated to AD 292, Stela 29 is the first dated Maya monument found in context. Probably in an act of violence during the fourth century or later, the shaft of Stela 29 was smashed, and its large upper fragment was dragged to a garbage dump, where archaeologists found it in 1959. As a stone prepared for carving, Stela 29 has qualities associated with the Early Classic in general: from local rock, stoneworkers quarried a fairly smooth shaft that nevertheless bore imperfections, resulting in an uneven surface. The glyphic cartouches adjust to the surfaces of the rock, listing slightly to the right, and include substantial gaps between the glyphs where the stone features a natural recess. There is no border other than the edges of the quarried rock. All carved surfaces bear the same low relief, the background carved away to leave the finished surface, particularly along the bar-and-dot numbers that are prefixed to glyphs. Carved lines adhere to the same thickness, and all carved surfaces are equally finished; no chisel marks remain in evidence, but the grain of the stone is still visible.

We think of the figural portion of a sculpture as the front, and so did the Maya: sculptures *in situ* always feature the figure looking at the plaza or public space, although later stelae have figures on more than one side that look in other directions. On Stela 29, the text and the image were assigned equal space and thus may carry equal weight. The text appears on the monument's rear, causing the reader to move away from the human representation to access the text, like most early stelae. Contemporaneous works on jade celts, whose proportions are similar to those of stelae, use a similar composition. The Leiden Plaque [113], which would have dangled from a ruler's waist, features incised images of a ruler on one side and an inscription narrating the accession of an *ajaw* on the back. This separation of text and image would change as later sculptors integrated figures and texts on all sides of stone monuments [119], even as monuments' lateral sides and rears remained a consistent locale for Classic-period inscriptions.

After AD 400, figures in profile on the fronts of Maya sculpture almost universally look to the viewer's left. The Stela 29 figure seems particularly anomalous, looking to the viewer's right, but it might have formed part of a pair of facing

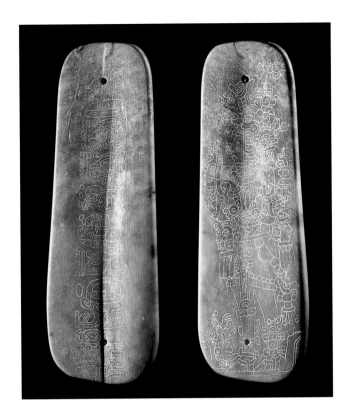

113. The incisions on the greenstone celt known as the Leiden Plaque portray a ruler standing over a captive on one side and a text on the other. A costume element that would have dangled from a ruler's belt, its figural carving is self-referential, for it features a ruler wearing celts just like this one.

monuments, or it may not have been anomalous at all, for during the late third and fourth centuries other early monuments from the central Peten, at Uaxactun and Xultun, feature lords that face left and right, and sculptors may have been freer in their designs. Typical of Early Classic rendering is the human hand, shown as a simple mitten, clutching an angled serpent bar that Maya kings carried as a symbol of power for most of the first millennium AD [88].

To the uninitiated modern viewer, the multiple heads arrayed across Stela 29's surface present a confusing muddle clarified only by the open space surrounding the king's masked face. The profile head of the Jaguar God of the Underworld, Tikal's patron god, appears in three forms – from the mouth of the serpent bar, at the king's waist, and held out on draped cloth, perhaps to show it as an opened bundle or headdress. The Jaguar God of the Underworld, the sun at night, wears the Tikal toponym as his headdress, as if to show that the sun rises and sets at Tikal.

The king on Stela 29 wears abundant insignia, including a shark-like Jester God on his forehead and what may be the mask of Chahk – god of lightning, rain, and decapitation, the same god as on the Preclassic friezes – rendered onto his face. There are no feathers shown, and the king does not wear a headdress, but the Jaguar God of the Underworld in the king's left hand with cloth ties may be a headdress not yet worn. Rather, the crown of the king's head, from his forehead back to his fontanel, features a spiky hairstyle often called a "mohawk," studded with bones, a hairstyle that terrifying Aztec deities wore. At the top of the monument, floating above the king, is a disembodied head facing downward. An eroded glyph in its headdress may have named the figure, perhaps the lord's deceased father.

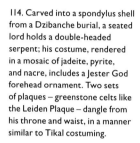

114. Carved into a spondylus shell from a Dzibanche burial, a seated lord holds a double-headed serpent; his costume, rendered in a mosaic of jadeite, pyrite, and nacre, includes a Jester God forehead ornament. Two sets of plaques – greenstone celts like the Leiden Plaque – dangle from his throne and waist, in a manner similar to Tikal costuming.

In the century following the making of Stela 29, Tikal kings continued to portray rulers in this manner, rendered in profile on one side of a stela, with a text on the rear, as on Chak Tok Ich'aak's broken Stela 39. But other forms were introduced, including three-dimensional seated stone sculptures, one known as the "Hombre de Tikal" [115]. Other early seated figures appear in stone at Copan, in ceramic at Tikal and Copan, in fuchsite at Uaxactun, and in wood in an unprovenienced sculpture now in New York [24]. The seated sculpture may have embodied the concept of "enthroned" – indeed, one verb root for accession is *chum*, its logographic form an image of a man's seated rump. Seated rulers also appear in profile during this period. On Tikal's third-century Stela 36 is a seated ruler holding two heads like those on contemporaneous Stela 29. A reused Olmec pectoral now at Dumbarton Oaks features an incised image added to the back with a seated Maya ruler whose

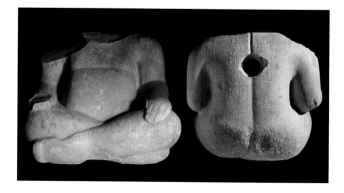

115. (right) Known as the Hombre de Tikal, a corpulent ruler rendered in three dimensions sits cross-legged, with both hands on his knees, one palm up, and one down. This limestone sculpture, likely of the fourth-century king Chak Tok' Ich'aak, was later decapitated, and texts were added in the fifth century. It was discovered in a fifth-century Tikal burial.

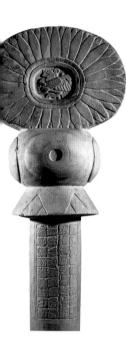

116. The limestone sculpture known as the Tikal Ballcourt Marker (AD 416) is a rendering of a feathered standard, a form the shaft recounts the arrival of Teotihuacanos at Tikal and the accession of Spearthrower Owl, whose name appears in the feathered ring, at top.

accompanying inscription includes the seating logograph. And on a shell pectoral from Dzibanche [114], a lord sits on a throne edged with mat designs. Dzibanche may have been the seat of the Kaan dynasty at this time, but images such as this one share a visual language of power with distant Tikal.

In 378, in a series of events generally understood as conquests, Teotihuacan warriors or their local proxies attacked independent Maya kingdoms, including Tikal, Uaxactun, and La Sufricaya, resulting in radical upheaval. As recounted on the later Stela 31 [119], on the same day that Sihyaj K'ahk', a Teotihuacan military leader, arrived in Tikal, the Tikal king Chak Tok' Ich'aak died; plus, multiple sculptures from his and earlier reigns have been discovered broken, in trash or buried. The usurper who took the throne, Yax Nuun Ahiin (known elsewhere as Curl Snout), introduced new technology and a new ideology that resulted in fresh works of art, although some apparently were looked upon with disdain a few generations later.

Several monuments connected to the fourth-century conquest stand out: Stela 4 of AD 396 [117] and the Ballcourt Marker of 416 from Tikal [116], and Uaxactun's Stela 5 of 396. The Ballcourt Marker, a stone representation of a wood and feather standard, takes its form from Teotihuacan, where paintings show such feather standards used in a game like field hockey, and where a similar stone representation was recovered. Featured in the center of the Tikal Ballcourt Marker's feather standard is a hieroglyph making its initial appearance, a small-eared screech owl holding a Teotihuacan-style dart thrower, or atlatl. The text on the monument's post also speaks of this person, "Spearthrower Owl," and the arrival of Sihyaj K'ahk' at Tikal in AD 378. David Stuart has shown that the name of Spearthrower Owl, possibly a Teotihuacan ruler, also appears on Stela 31, where it is written that he was Yax Nuun Ahiin's father.

Stela 4 celebrates the installation of Yax Nuun Ahiin, the probable usurper [117]. Seated on a throne, the king holds out the familiar Jaguar God of the Underworld Tikal patron on the left, and the Central Mexican god Tlaloc on the right; he wears pecten shells around his neck and a frontal helmet with attached feathers that is a simplified image of a Teotihuacan war god. More than any other Tikal stela, Stela 4 seems an unshaped boulder, hastily prepared for carving, with a text that follows the curving surface. However, its most unusual feature

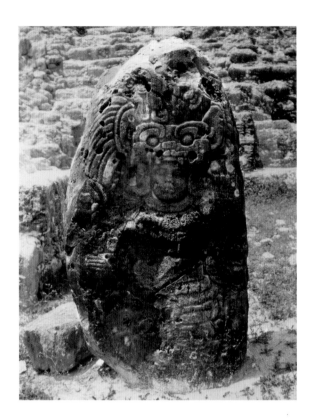

117. Yax Nuun Ahiin II came to power at Tikal in the wake of the Teotihuacan incursion late in the fourth century. On his monument, Stela 4, both Maya and Teotihuacan formal qualities are evident, as are deities from the two religious traditions.

is the frontal face of Yax Nuun Ahiin, seemingly an adaptation of the Teotihuacan preference for frontal protagonists.

In 1963, archaeologists opened the richest Early Classic tomb ever found at Tikal. In Burial 10, they found Yax Nuun Ahiin surrounded by nine individuals, a dog, and a host of lavish offerings. Pecten shells, like those rendered on Stela 4, edged the collar around the principal lord's neck. Elegant painted and stuccoed pots, many exhibiting a fluent blending of Maya and foreign styles, held the tomb's provisions [190]. Gods from distant Teotihuacan were featured on the painted surfaces of ring-stand vessels and tripod cylinders, both new formats in the Maya ceramic inventory, but their vessel lids featured three-dimensional Maya figures as decorative handles. Nearly identical to a rich tomb from Kaminaljuyu, in highland Guatemala, Burial 10 memorialized a king who inspired a rich blending of Maya and Teotihuacan art styles and techniques.

On 9.0.10.0.0, or 19 October, AD 445, his son, King Sihyaj Chan K'awiil, memorialized himself and his lineage at Tikal with

a new monument, Stela 31 [118, 119]. A model of both innovation and conservatism, it was carved on all four sides, unlike any surviving predecessor at Tikal. Calakmul sculptors had used all four sides of a shaft for the images and texts on Stela 114, from AD 431, but with Tikal Stela 31, sculptors deployed images on multiple sides to create a relationship between son and father. For the front of Stela 31, Sihyaj Chan K'awiil returned to the format used on Stela 29 [112], which was by then 150 years old. In doing so, Sihyaj Chan K'awiil anchored himself to Stela 29's early king, other ancestors, and divine patrons, and reasserted the lineage that linked them.

By the mid-fifth century, when Stela 31 was carved, Tikal was quarrying limestone of a finer grade, less vulnerable to pitting. Prior to sculpting, masons would work the slab into a nearly perfect prismatic shaft. The sculptors carved away the background, throwing the relief onto another plane, in what we can call "cameo" style; the sculptors then worked with exacting tools so that the level of detail achieved on Stela 29 seems little more than a rough draft. Like the Stela 29 figure, Sihyaj Chan K'awiil is masked, indicated by face paint and the cut-away nose piece; both wear a thick twisted rope along the side of the face, indicating power as a priest, and a Jester God forehead adornment, demonstrating royalty.

Despite the agglomeration of head ornament, both kings are shown without headdress, and with a "mohawk" hairstyle with inserted bones. Sihyaj Chan K'awiil additionally wears his name above that hairline, and the scrolls of his name glyph reach up to the down-facing figure of the upper margin, explicitly named as Yax Nuun Ahiin, his father, the representation of ancestry, and shown as the Sun God, K'inich Ajaw. In addition, the names of other ancestors adorn his body: dynasty founder Yax Ehb Xook's name appears behind his ear, the headdress held aloft has Spearthrower Owl's name, and the heads attached to his belt bear the names of his mother and a fourth-century king. He is a walking genealogical treatise.

Unlike previous representations of Tikal kings, he takes an active stance, holding up his headdress; with its powerful ear flares and chin strap, the headdress is the very image of those worn by deities on monumental stucco facades: Sihyaj Chan K'awiil thereby displays his unparalleled status, like the young Napoleon who took the imperial crown from the pope and placed it on his head himself. At first pass, the monument's

18. In the eighth century, the broken Tikal Stela 31 was set into the superstructure of 5D-33-1st, fire was lit at its base, and the sculpture and shrine were buried inside a new, larger building. This photo by Edith Hadamard shows the stela in situ, the soot from burning still evident.

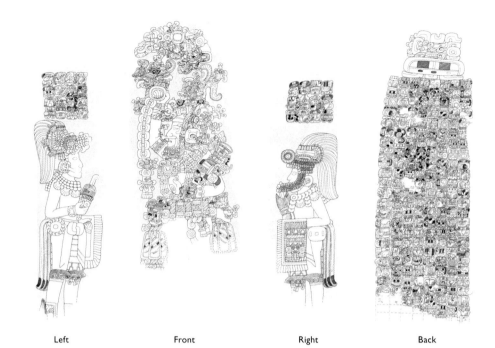

| Left | Front | Right | Back |

119. On the front of Tikal Stela 31, the body of Sihyaj Chan K'awiil bears a profusion of ancestor and deity heads, each wearing an identifying headdress, generating a biography of ancestral and religious affiliations. The text on the monument's back is the longest and most complex to survive the Early Classic. At right, a 3D view shows the relationship of the Maya ruler carved on the monument's front and the Teotihuacan warrior named as his father on the left side.

imagery seems to be a technical and iconographic refinement of the earlier iteration. A consideration of Stela 31's entire program, however, thickens the plot. The text on the back of the stela begins with an initial date of 445 and follows not only with the longest known Early Classic text but also with the single most informative statement about the Tikal royal family from its founding until that date. In other words, just as the nature of the representation on the monument's front returns to Stela 29, and likely other lost monuments as well, so the text also makes a reconnaissance of the past, recounting Sihyaj Chan K'awiil's ancestors' setting of stones on earlier calendar endings, and connecting his action of setting the stela with their acts in earlier k'atuns. But this text also includes the arrival of Sihyaj K'ahk' and even states Spearthrower Owl's death; what undoubtedly had been a dramatic shift in power is here woven into a narrative defined by the steady march of the k'atuns and the rulers who mark their completion by setting stones.

The sides of Stela 31 depict warriors in Teotihuacan costume. Rendered with open space surrounding the human representation in Teotihuacan fashion, but with elongated bodies and lankier proportions characteristic of Tikal, even

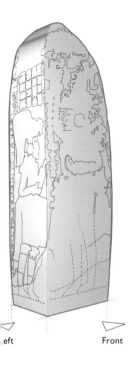

the Teotihuacan warriors feature a blended style of foreign and local. When the two profile warriors are seen simultaneously, a single warrior appears, seemingly holding a shield in the left hand, an atlatl (spear-thrower) in the right, and with mirrored helmet, coyote-tail waist ornament and pecten-trimmed collar. Close inspection reveals that the two images are not exact reflections, but the result is that a single Teotihuacan warrior materializes behind Sihyaj Chan K'awiil, guarding him and enforcing his position. The text identifies this man to be his father, Yax Nuun Ahiin, and Spearthrower Owl his grandfather, underscoring the message of the monument's front.

Although effectively a survey of the past, Stela 31 points to the future too, both in its rock and refined surfaces, and in its flanking representations of simpler figures less burdened by ritual paraphernalia. In addition, many later sculptors would use the sides and backs of stelae, carving on multiple surfaces to portray figures in imagined three-dimensional space and to encourage viewers to walk around monuments. Furthermore, around this time more women took their place on monuments, indicating that the mother's lineage was also becoming important to a ruler's legitimacy.

This monument can be recognized as the single greatest achievement of the era, a work that both sums up what had gone before and cleared the path for what would come later. Absorbed into the canon, the seamless imagery of warfare and rulership would be henceforth present, but never again with the shock value such imagery had when new. Perhaps because of the monument's power to make visceral the troubled politics of its times, the sculpture's butt was smashed and the large, upper fragment hauled to the top of Temple 33 during later times, when it was buried, with burnt offerings, in the same building that held the body of the portrayed king [118].

Sculptors made further innovations at fifth-century Tikal: with Stelae 1 [88], 2, and 28, artists carved images that seamlessly wrap around the monument's front and sides, creating the illusion that one is seeing the ruler's elaborate costume from the side. But by AD 500, human figures on stelae at Tikal and elsewhere carried much less ritual paraphernalia, resulting in forms that are easier to read from a distance. Tikal stelae of the late fifth and early sixth centuries feature relatively lanky lords in simple costume, without background scrollwork and cut in fairly high relief, as if based formally on the side figures

of Stela 31. These figures' poses are constant over four rulers' reigns, with each stela portraying a standing ruler in profile, holding a staff possibly used for fire-drilling to commemorate calendar endings. By the middle of the sixth century at Tikal and elsewhere, stela fronts gained a carved frame, enhancing the sense that these representations were constructed pictures rather than organic shapes emerging from rock.

Early Classic sculpture beyond Tikal

At other sites, local features, usually focused on local gods or ritual practice, took hold – for example, the hand-held foliated jaguar first appeared on Xultun stelae in the fourth century and then sustained into the ninth. Far from the central Peten, as new cities began to make stone monuments, sculptors often used different solutions, although the key elements of standing king and related text remained a constant.

Although one might turn to Calakmul as an artistic foil to Tikal because of their long-term rivalry, few Early Classic monuments survive there. Mexican archaeologists have unearthed tombs that attest to Calakmul's early wealth, and they found fifth-century stelae buried in Structure II. But epigraphic studies by Simon Martin and Nikolai Grube reveal that the Early Classic origins of Calakmul's Kaan ("Snake") dynasty lie not only in Calakmul but also in Dzibanche, a site in Quintana Roo that used the Kaan emblem glyph in the fifth and sixth centuries, suggesting that the Kaan dynasty moved between these sites.

The earliest monuments at Yaxchilan, to the west, are lintels that were later reset in an eighth-century building. Lintel 48 [120], which bears an exquisitely carved full-figure Long Count date from AD 526, is the first in a series ordered by the tenth ruler of the Yaxchilan dynasty. He also commissioned lintels bearing a list of his predecessors and naming their captives from other Maya polities, especially Piedras Negras, a down-river rival for the next three centuries.

We get a taste of this rivalry from Piedras Negras as well. Panel 12 [121], a wall panel from circa AD 518, portrays a Piedras Negras ruler lording over captives, including one from Yaxchilan. Panel 12 is a multifigural composition with a hieroglyphic text that divides the scene in half, so that the two sides face each other like pages of a book. The model for such representation

20. Yaxchilan Lintel 48, featuring the Long Count date 9.4.11.8.16 (2 February, AD 526), uses full-figure glyphs to render the date, including a toad (top, right) for the *winal* (month) glyph. It is the beginning of a longer text, also spanning Lintels 47 and 34, that narrates Ruler 10's accession.

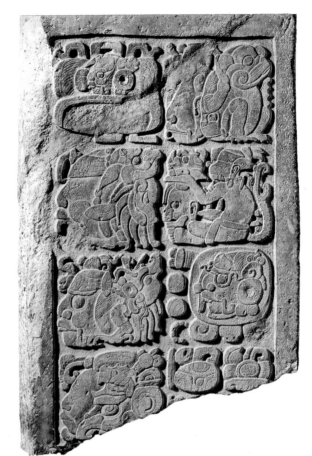

21. Panel 12 (AD 518), the earliest extant dated sculpture from Piedras Negras, depicts a ruler lording over captives whose hands are bound; third from left is Knot-eye Jaguar I, a Yaxchilan ruler. It was found buried in the last phase of Structure O-13, where Panels 2 and 3 were installed (ills. 141 and 142).

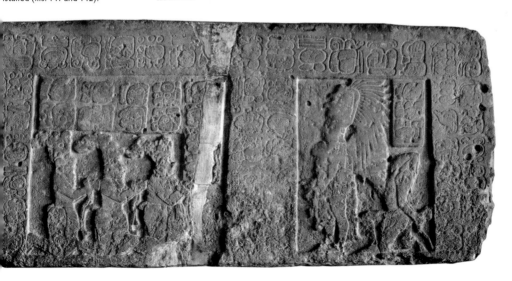

122. (right) Quirigua Monument 26 (AD 493), made of gray schist, shows that the characteristic frontality of later Quirigua and Copan stelae is present in one of the region's first monuments. Standing on a personified mountain, with corn in his headdress, this early ruler embodies the Maize God.

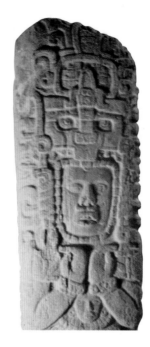

124. (opposite) Motmot: Within a quatrefoil, indicating a transformative portal, two seated Copan dynasts, the founder K'inich Yax K'uk' Mo' and his son, face two framed columns of inscriptions, comparable to the image on the carved peccary skull found in Copan Tomb 1 (ill. 22).

123. (below) Made in the Peten, ceramic offering vessels with frontal, three-dimensional faces of gods and humans may have spread religious cults and provided the models for frontal representations when they were exported to distant locations. Here Chahk appears on the main, lower vessel.

may indeed have been a book, or perhaps a tripod cylinder vessel – surviving ceramics of the fifth and sixth centuries initiated multifigural compositions [191], and such small-scale works may have been the inspiration for monumental ones.

To the south, a diversity of sculptural forms developed. Quirigua Monument 26, dated AD 493, reveals a novel solution [122]: a frontal face that may have been derived from those of architectural facades, incensarios, or small jade sculptures. Widely exported, incensarios featured beads at the edge of the face [123], like the face on Monument 26. Fifth-century sculptors of the Peten also experimented with frontal representations, like that of Uaxactun Stela 20 (AD 495), but the region's limestone limited their ability to carve deep, three-dimensional forms. In contrast, fifth-century Quirigua sculptors effectively used schist to make the polished, nearly three-dimensional, frontal face on Monument 26, even as the body is improvised and roughly incised. The sorts of rock available at Copan and Quirigua (schist, sandstone, and tuff) made good use of the frontal format and helped assert a regional style that would flourish in the eighth century.

When Stephens and Catherwood visited Copan in the nineteenth century, they recorded stelae that Sylvanus Morley

later dated to the Late Classic. But it was not until the late twentieth century that the art and architecture of Copan's early centuries came to light. Tunneling in the Acropolis revealed stone sculptures and layers of buildings adorned with polychrome sculpture made of modeled stucco, all intentionally buried, and sometimes with great care. The fifth-century Motmot Marker, Copan's earliest dated extant sculpture, shows a calendar commemoration to mark the important 9.0.0.0.0 bak'tun ending on 11 December, AD 435 [124]. Carved in low relief, this round limestone sculpture served as a capstone to a woman's burial, although this location was a secondary resetting.

It is in K'inich Yax K'uk' Mo's honor that many other Copan sculptures were made, particularly within Temple 16, the great funerary monument for this king and others, where one extraordinary building succeeded another, all in his memory. On the west facade of an early phase, called Yehnal (dating to before 445), artisans modeled stucco into the form of an enormous head of the Sun God K'inich Tajal Wayib, with his characteristic squared pupils, large nose, and T-shaped tooth, and painted the sculpture a deep red, capturing the heat of the blazing sun [125].

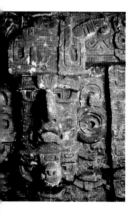

25. (below) Yehnal: The giant representation of the solar deity K'inich Tajal Wayib is comparable to Late Preclassic heads of gods on buildings in the Peten, but here functions as reference to the divine ancestor Yax K'uk' Mo', who was venerated as the sun.

Warfare and sculptural destruction

Regional styles to the west and south all seemed to be set in place when a round of warfare sent shock waves across the Maya realm, ending the Early Classic. According to Caracol Altar 21, the lords of Caracol, in league with the Kaan dynasty, went to war with Tikal twice, in 556 and 562, probably resulting in local devastation, destruction of monuments, and backbreaking tribute. The effects of these attacks are certainly seen in the condition of Tikal's early monuments, for the city's Early Classic narrative, so elegantly laid out on the North Acropolis in the sequence of stelae, was dismantled, its monuments broken or buried. Stela 4 [117], with its vivid portrayal of a usurper, was reset upside down, the powerful frontal face buried and removed from view, with just the stumpy legs and feet left on public display; just as strikingly, it was only righted in the twentieth century. But these were neither the first nor the last instances of Maya sculptural decontextualization and destruction.

In the 1930s, the discovery of a carved throne smashed in the Piedras Negras Palace chilled scholars' bones: they imagined that an angry mob had risen up against their priests, bringing a peaceful civilization to a sudden close. But we now know this was the result of warfare; whenever enemy Maya lords claimed victory and entered a city, they smashed monuments and took god images captive or destroyed them.

Such attacks often had profound impact on the artistic record. All Tikal monuments from before the late fourth-century Teotihuacan conquest had been smashed. The trauma of their destruction must have been immense, yet ultimately it yielded to an unprecedented artistic innovation. The fourth-century conquest led to new types of sculpture and new imagery, as seen on Tikal Stela 31 [119] and late fourth- and fifth-century ceramics [190], characterized by emulation of local and foreign imagery. Stela 31, crafted within a campaign of self-promoting grandeur, most certainly was made possible by fifth-century prosperity, yet such innovation was short-lived, for there was less novelty in subsequent generations. Even so, after Tikal recovered from the Caracol wars and the resulting sculptural hiatus, late eighth-century sculptors would again create exciting and innovative works in the site's wooden lintels [156] that both celebrate their victories and create dynamic compositions of a sort not before seen at Tikal or any other Maya site.

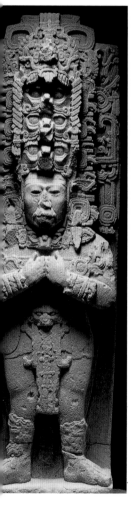

126. Monument 168, found buried in the Tonina Acropolis, portrays the ruler Jaguar Bird Tapir with Early Classic features such as clasped hands at chest, but his body is rendered frontally, with feet opening to the sides, an innovative solution later prevalent at Tonina and Copan for three-dimensional ruler portraits (ill. 159).

In a world context, the complexities of warfare almost always leave their mark on the artistic record, whether in the formation of a new art in France following the French Revolution or the destruction of old art forms in that same conflict. Warfare frequently forces the movement of art: as booty, art is hauled off by victors; as refugees, artists infuse a new region with their works; as victims of the colonial enterprise, artists may nevertheless resist the new master.

Victory may enhance social organization or political repression, both of which may yield a change in the artistic record. All across the Maya area, the wars that wracked it sent stress fractures through the artistic endeavor, making of art not a slave of time's inexorable, steady progression but an expression keenly tied to local phenomena, developing in fits and starts. Behind every work of Maya art lie both makers and patrons; that artwork's ultimate survival depends on both accident and historical circumstance.

Sixth-century continuity and transformation

Although some Maya cities fell to their knees in the sixth century, they would be reinvigorated in subsequent centuries. Other polities survived the sixth century without great interruption; still others were founded anew. The artworks created during the second half of this century, including Lacanha Stela 1, a late sixth-century stela that portrays a ruler holding a shield bearing a fourth-century archaized figure, seem to set the stage for the sculptural developments of the seventh and eighth centuries.

At Tonina, a site with little known Early Classic presence, the sandstone Monument 168, from AD 577, portrays a standing ruler in the manner of many earlier stelae [126]. But this rendering is nearly three-dimensional, the ruler's carefully carved head emerging from beneath a towering headdress of stacked deity heads, his arms and legs almost fully articulated, yet still attached at back to the rectangular block, which bears inscriptions on its sides. Experimentation with three-dimensionality would become one of the sculptor's goals at Tonina, Copan [159], and Quirigua, whose sandstone and tuff allowed more carving freedom, and even at Piedras Negras, where sculptors shaped limestone into higher and higher relief in a quest to release the human form from intractable stone.

Chapter 6 Maya Sculpture of the Palace and Court

The Late Classic era

127. In 736, Dos Pilas Ruler 3 commissioned Dos Pilas Stela 2 and its analogue, Aguateca Stela 2, to commemorate his victory over a Ceibal king in 735. On each stela, Ruler 3 wears a costume evoking Teotihuacan, including balloon headdress, rectangular shield, and cut-away mask and apron with the face of Tlaloc.

The idea of the Late Classic period that runs from AD 600 to 900 is a modern one, but in some sites, the beginning of this era was a time of perceived change. Tikal, Piedras Negras, and Copan, among others, faced destruction in the sixth century, but artists subsequently would create extraordinary art and architecture and renew their cities. By the end of the seventh century, Maya cities were thriving throughout the lowlands, and most Late Classic art was made between 680 and 800. In this era, the Maya experienced fabulous wealth for a tropical rainforest society, and they used their economic well-being to support the making of art and architecture, and at dozens of sites, local styles took hold. Because many were abandoned in the ninth century, southern lowland Maya cities preserve the Late Classic slice of life and art better than that of any earlier period.

Accordingly, the texts that tell Late Classic history also survive in abundance. This chapter looks closely at monumental sculpture rather than the political intrigue that its texts may suggest, but the paths to war and peace narrated in inscriptions often had repercussions in the visual record. Military victories led to more making of monuments than did defeats, but Late Classic Maya art is not just shorthand for the history of the victorious. For one thing, some powerful cities such as Calakmul and Coba carved monuments proclaiming success on porous limestone, leaving only pitted and fragmentary efforts for modern consideration. Furthermore, when victors forced artists of a defeated polity to make works of art, the results were sometimes new and imaginative, the pathos of loss visceral in victory. Remarkable works turn up in surprising places: no equivalence exists between political and military power and the power of works of art.

During the Early Classic, one historical event emerges above all others: the arrival of Teotihuacanos at Tikal. By the Late Classic florescence, no active Teotihuacan community or military force was in residence at any Maya site, and central Teotihuacan was burned to the ground no later than AD 650.

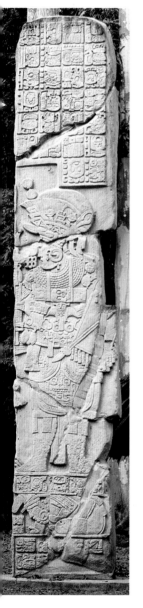

But even as Teotihuacan's real power waned, its value as political currency took on greater significance. Although Maya lords preferred traditional Maya dress for portraits made upon installation in office, war portraiture often featured Teotihuacan battle attire [127], expressing, as Andrea Stone has proposed, social connection or disconnection, respectively. Even when Maya people were at war with other Maya, they evoked the specter of "foreignness," manipulating the power of Teotihuacan war gods to enhance local prowess.

The Late Classic period, especially the eighth century, represents the highest achievement of many aspects of Maya civilization. The Maya wrote many long texts featuring unprecedented complexities, relating the deeds of gods and men, and demonstrating skill in astronomical observation. Some numbers that record mythological events in the past and predict ones in the future go from hundreds to thousands to billions of years, orders of magnitude that astonish us today. In this respect, the Maya sense of time ever expanded, with a yet larger cycle always lying beyond the largest stated one – and in this expressing a sense of infinity. Indeed, when the illusion of a Maya-predicted apocalypse in 2012 worried the Western world, Mayanists worked to convey the real story that, as opposed to predicting an end, Mayan hieroglyphs foretold events improbably distant in the future.

In the seventh and eighth centuries, southern lowland populations reached their peak, and elite society grew more complex, as many more non-royal Maya nobles commissioned works of art. Palaces of perishable materials of the previous era were replaced with stone-roofed buildings, and the Maya built most of their towering temples in this period. But at the same time that they were making some of their finest works of art, the quality of life in the eighth century diminished radically. We might imagine the cultural backdrop against which the visual narrative is set: during the eighth and ninth centuries, the southern lowland Maya experienced what is commonly called the "collapse." But the demise was probably gradual, a slow erosion of all aspects of life, punctuated by violent decline and subtle recovery. Simply put, population and its attendant demands outstripped the environment, which could no longer provide enough food, fuel, or material for shelter. Without adequate supplies of maize and beans, without wood to cook – or to reduce limestone to the quicklime necessary to effect

maize nixtamalization (without which maize has little nutritional value) – society began to unravel.

Warfare ravaged many sites; kings fell captive or hostage. Piedras Negras Stela 12 [143] records the defeat of Pomona in 795, Yaxchilan's last lintel records the capture of the last known Piedras Negras king circa 808, and both Piedras Negras and Yaxchilan would soon after be in ruins. Dos Pilas featured their victorious king [127] in a rich variant of the Teotihuacan War Serpent reigning over the devastated king of Ceibal in AD 735, but within decades, Dos Pilas was under siege [50], and subsequently Aguateca, its twin capital, was burned to the ground. But a city burned was a city that might never be rebuilt, for where would the thatch or timbers come from? An environment destroyed must have led to utter degradation, first of the physical world and ultimately even the spiritual.

The story of Late Classic sculpture is not a substitute for the written history of the ancient Maya – nor for the civilization's archaeology. Late Classic sculpture tells its own tales. In monumental stoneworks at city after city, the Maya used the format of the stela, lintel, or wall panel to present a picture of those who ruled and their achievements. But whereas the sculptural trajectory in one city might promote artistic imagination and achievement, conservatism is preferred in another. To know the work of one Maya city is not necessarily to know the work of others. To know Maya sculpture the modern viewer must look carefully and city by city, to see the paths followed by individual royal families.

At a number of Late Classic sites, sculptors strove to narrate complex historical and political affairs involving humans and deities, for which they created multifigural compositions that portrayed peak moments of a story [146]; at the intersection of text and image, they stretched the communicative potential of both. In other cases, sculptors made portraits to be enlivened embodiments of divine rulers. To this end, some worked to increase the three-dimensionality of their renderings [138]; others portrayed breath by depicting a jade bead beneath the nostril [129]; yet others suggested movement by showing feathers swaying or muscles just tensed [134]. Framed scenes that truncated human bodies conveyed a sense of time and depth [91].

Sculptors also worked to increase viewer engagement with monuments. They carved figures and texts on monument sides to encourage movement around them and in some sites

arranged monuments to inspire movement across plazas and structures, such an experience being an essential aspect of Maya spaces. Indeed, much of Late Classic sculpture – and other artistic media – engages with the performative. Portraying rulers conducting calendar-ending ceremonies, many were made for and dedicated during such rites. Occupying plazas and buildings, they served as backdrops for – and partners in – dances and other performances.

Palenque

In every respect, Palenque sculptors examined the qualities of traditional and conservative Maya art and sought alternative solutions. At Palenque in the seventh and early eighth centuries, Maya sculpture achieved some of its greatest complexity and technical finesse. Even the conventional format of the stela was discarded in favor of new types of wall panels. Imaginative sculptors worked the site's first extant wall panel, the Oval Palace Tablet [128], to form the back of an elaborate throne, its characteristic oval shape that of the rounded cushion portrayed

128. On the Palenque Oval Palace Tablet, Lady Sak K'uk', who survived the early seventh-century wars with Calakmul, hands a mosaic headdress to her son, K'inich Janaab Pakal, the new Palenque ruler. The tablet was set into the wall behind Pakal's throne in House E and surrounded by stucco ornament.

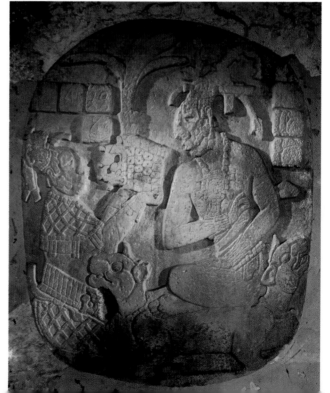

in Maya throne rooms [200]. Set in a wall in House E, above a stone seat, this tablet engaged with its perishable analogue, comparable to the thatch carved in stone on the building. When sculptors of subsequent generations carved an oval behind the king, they were invoking both real cushions of this shape and the revered Oval Palace Tablet, which remained on view. Palenque sculpture, as with much of Maya sculpture, is self-referential, in dialogue with itself and the sculpture of predecessors.

Probably carved in the mid-seventh century, the Oval Palace Tablet celebrates the young K'inich Janaab Pakal's accession to the throne in 615, when he was twelve. Pakal, his torso turned to the front and the rest of his body in profile, sits on a double-headed jaguar throne. Remarkably, this representation is the first royal carving of a ruler so simply attired, as if to show power embedded in the man, not the trappings of office, but the setting was appropriate, for in his throne room he was not on public display. Lady Sak K'uk', in profile at left, hands her son the Jester God-studded headdress of rulership. Although a few Early Classic monuments feature women, Lady Sak K'uk' takes a more prominent place in the composition, for she carried the lineage of rulership, the patriline apparently wiped out with the Kaan dynasty's attacks on Palenque in 599 and 611.

Made shortly before Pakal's death in 683, the carved sarcophagus lid from his tomb in the Temple of the Inscriptions reveals both elaborate compositional skill and hasty execution, with rough chisel marks still in evidence [129]. Was this hastiness a sign of the speed with which the tomb was prepared, or a recognition that the funerary sculpture would not be studied by casual viewers? Perhaps, but other Palenque panels show similar workmanship, including the Temple 21 panel and one at Dumbarton Oaks, where the quality of finish diminishes from top to bottom, leaving roughed-out toes. Dense and fine-grained, Palenque limestone frequently was polished so that not a single chisel mark remained. Yet Palenque sculptors often put their greatest energy into finishing representations of human faces, sometimes at the cost of other areas.

In his eighties when he died, Pakal may have seemed immortal, and his complex burial program conspired to promote the notion. On the surface of the sarcophagus, in the only rendering known of a glorified king on his back (for otherwise this is the posture of the defeated or newborn),

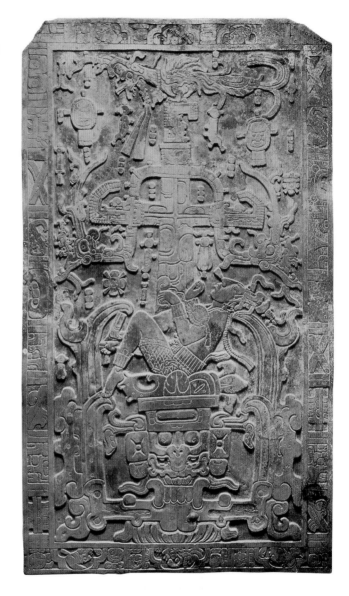

29. In a reclining posture indicating rebirth, and with characteristics of the Maize God and K'awiil, K'inich Janaab Pakal rises from the Underworld's skeletal maw. Carved on his sarcophagus lid, the image depicts Pakal's rebirth along the path of what George and David Stuart interpret as the "Shiny Jeweled Tree."

Pakal, dressed as the Maize God and at the moment of death or rebirth, simultaneously falls into and rises from the open maws of death, which Karl Taube identifies as a skeletal centipede. From his body rises the World Tree, the earth's central axis, while on the sarcophagus sides, ancestors sprout from cracks in the earth, each emerging as a specific fruit tree, including the nance, cacao, avocado, and guayaba, vivid evidence

130. As seen in this rendering by Proskouriakoff, each Palenque Cross Group temple features an interior shrine designed to evoke a perishable dwelling. Symbolic sweatbaths for gods, each shrine includes a large limestone panel – here, the Tablet of the Cross – framed above the cornice by stucco ornament (see also ill. 56).

that Pakal's death has brought forth renewal for both maize and other fruits of the earth.

Pakal's tomb effectively was a sculptural assemblage, including many different components. Key to the assemblage is its narration – and essentially activation – of Pakal's rebirth. Inside the uterus-shaped cavity of the limestone sarcophagus, the dead body was dressed as the Maize God, abundant jade jewelry adorning the remains [104], but – in an unusual twist for a royal burial – without painted or carved ceramics. Pakal's food for the journey seems only to have been the jade bead in his mouth. Yet his death and rebirth as a maize plant renews the entire range of human agricultural endeavor. The nine stucco figures along the wall serve as ever-constant guides. Pakal's own stucco portrait was wrenched from a sculpture elsewhere (probably House A-D in the Palace) and wedged under the sarcophagus, ceremonially "killing" Pakal as part of his transformation to immortality [105].

In 692, to celebrate the thirteenth k'atun of the ninth bak'tun, when he also erected Palenque's only carved stela, Pakal's son K'inich Kan Bahlam dedicated his magnum opus, the Group of the Cross [55, 56], comprising three temples with interior stone panels carved with intricate relief. At this time, Palenque must have been at the height of its economic power, and the panels' intricacy and content point to the plowing of economic wherewithal into capital construction. Each massive Cross panel is composed of three huge slabs built into a small shrine at the rear of the temple, forming what Stephen Houston has identified as a *pib naah*, or symbolic sweatbath, a place where gods are born, with a sculptural program that extends onto the buildings' front panels and their roofcombs.

Designed as a group, the Cross tablets feature a unified iconography and text. Dates deep in supernatural history at left pair with events in Kan Bahlam's life at right; each panel features both the pouty-faced Kan Bahlam and the diminutive, bundled figure of what may be the ruler as a child, the twisted rope part of an heir-designation rite seen also on the Temple 19 platform. On each panel, Kan Bahlam displays images of the gods: held out on cloth, and roughly the size of god images discovered at Tikal [23], their depiction offers a clue to the handling and wrapping of such deities. The imagery of the Tablet of the Cross takes its iconographic subject – the World Tree – from Pakal's sarcophagus lid; the Foliated Cross features

the renewal of maize and the sacred mountain from which maize comes; but it is the enigmatic Tablet of the Sun that provides insight into how the program may have come about.

Unlike works of art from other places that celebrate conquests, making it possible to imagine resultant wealth, Palenque sculpture emphasizes stasis and calm. But at the heart of the Tablet of the Sun [131] is the shield with the Jaguar God of the Underworld, a Maya god of war and fire who embodies the sun at night during its Underworld journey. In emphasizing the solar aspect of this powerful god, the building's modern nickname undermines his other traits: his visage appears often on warrior shields, covering the faces of Maya rulers as they charged into battle. Furthermore, two crouching, aged gods support the great shield at the center of the tablet's composition. At left is God L, an aged Underworld deity, patron of merchants and traders, who also appears on a side panel in the Temple of the Cross; the god to the right may be another view of him. This may have served as a visual metaphor, one that underpinned Aztec trade and warfare as well: trade supports war, and war

131. On Palenque's Tablet of the Sun, Kan Bahlam, at right, is paired with himself as an adolescent, at left; both present deity effigies to a shield bearing the Jaguar God of the Underworld. Twisted cloth falls down the adolescent's back, possibly referring to a "rope-taking" that David Stuart interprets as a pre-accession rite.

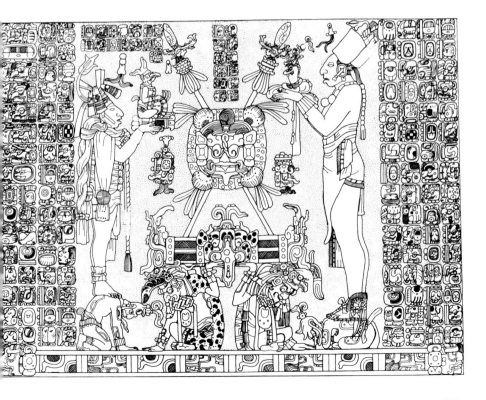

crowns and leads commerce. If we marvel at the wondrous architecture and sculpture that flourished in seventh-century Palenque, we need only look to this panel to see how they paid for it, with both war and trade, presented emblematically.

In no other work does the image of a god so dominate the picture plane as does the Jaguar God of the Underworld on the Tablet of the Sun. For Maya works of art, the compositions of the Cross panels are outrageously novel, without successors, an avant-garde that failed to attract a response other than rejection. The later works of Kan Bahlam's reign, including a victory panel in Temple 17, suggest his own capitulation to convention.

Commemorating his accession, K'inich K'an Joy Chitam II, Kan Bahlam's successor and another of Pakal's sons, revisits the Oval Palace Tablet's headdress presentation scene. Having formed the back of a new, monumental throne, his Palace Tablet [132] is carved in the shape of a capital letter H, with the figural portion set in the upper, central portion, and a lengthy hieroglyphic text below. In the image, K'an Joy Chitam, seated in front of an oval cushion, receives the headdress from his

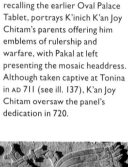
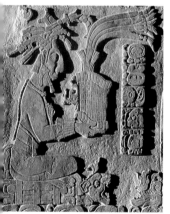

132. Palenque's Palace Tablet, recalling the earlier Oval Palace Tablet, portrays K'inich K'an Joy Chitam's parents offering him emblems of rulership and warfare, with Pakal at left presenting the mosaic headdress. Although taken captive at Tonina in AD 711 (see ill. 137), K'an Joy Chitam oversaw the panel's dedication in 720.

father (the ancestor Pakal) and the *took' pakal* – the "flint" and "shield," implements of warfare – from his mother. The workmanship is of high and even quality: elaborate full-figure hieroglyphs initiate the text, and the image's balanced composition includes finely wrought details such as eyelashes and toenails only a few millimeters long.

Yet what we know about the monument gives us pause, for K'an Joy Chitam II was taken captive in 711 by Tonina, a polity to the south, which displayed the Palenque ruler bound in rope on their Acropolis [137]. This event was not acknowledged at Palenque, but the Palace Tablet subtly hints at the disruption. Although most of the text narrates the life of K'an Joy Chitam, a text in the final columns states that someone named Ux Yop Huun dedicated the Palace gallery in 720. What happened? Artists must have started the panel before K'an Joy Chitam was captured, but with that capture their work was suspended, the monument perhaps draped in cloth. Resuming the work circa 720, the sculptors added new text, creating a seamless inscription that smoothed over the hiatus caused by their king's capture. Yet as David Stuart has observed, the text indicates that K'an Joy Chitam oversaw this panel dedication.

Discoveries at Palenque in the last fifteen years have opened new windows into the site's eighth-century dynastic and artistic history. Projects led by Arnoldo Gonzalez Cruz and Alfonso Morales Cleveland explored buildings to the south of the Cross Group, in Temples 19 and 21, where they found stucco and carved stone panels depicting rulers and their entourage.

Inside the Temple 19 chamber, sculptors installed panels with paired images of K'inich Ahkal Mo' Nahb, who acceded in AD 721, and the man who would be his successor, Upakal K'inich, the former in carved stone and the latter in modeled stucco, on two sides of a tall architectural pier [133, 134]. Portraying each man with an enormous head of a water bird engulfing the body and filling much of each panel's upper half, they reveal what must have been a more widespread practice of magnificent costumed performance at Palenque. On the stuccoed panel, performer and costume are in profile; placed on the pier's eastern side, the striding figure faces out of the building, looking toward anyone walking into the room. Yet this is also a side view of the figure on the stone panel, for on the pier's front, northern face, the ruler's body and the bird's gaping maw are shown frontally. Although they portray two distinct individuals, the panels'

133. (right) The red and blue pigments remain vivid on this stuccoed pier from Palenque Temple 19, discovered by the Proyecto de las Cruces. Upakal K'inich wears a giant water bird costume, possibly a cormorant, comparable to the costume his predecessor wears in the stone panel on the pier's front face.

134. (far right) On this stone panel from the Palenque Temple 19 central pier, kneeling nobles support K'inich Ahkal Mo' Nahb, who is dressed in water bird costume, certainly related to the patron god known as GI. The Proyecto de las Cruces found this panel wrenched from the pier and broken into fragments.

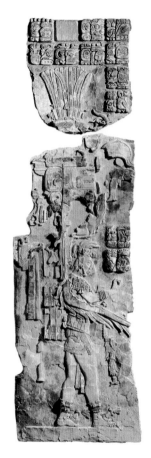
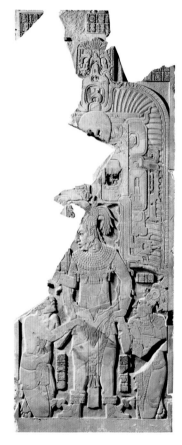

architectural context suggests the viewing of two sides of one performance, thereby also making an analogy between the two dynasts. On the stone panel, two kneeling nobles assist the ruler, one adjusting the costume, the other supporting his hand, their touch a remarkable visual passage.

Also in Temple 19's large room was a platform with carved panels portraying Ahkal Mo' Nahb with royal attendants presenting him the headband of rulership; behind him, the mosaic headdress, seen on the Oval Palace Tablet and the Palace Tablet, rests on a stand [135]. These panels' rites are comparable to earlier accession scenes, but here the presentation takes place amid multiple royal attendants. Moreover, as David Stuart has shown, the actions of humans are contextualized within mythological events involving the accession and rebirth of a Palenque patron god, beginning in

135. On the south side of the Palenque Temple 19 platform, an attendant presents K'inich Ahkal Mo' Nahb the headband of rulership. Ahkal Mo' Nahb wears a headdress with a water bird capturing a fish, which connects him to the patron god known as GI; the attendant wears an avian headdress linking him to Itzamnaaj.

3309 BC, and the caption identifying Ahkal Mo' Nahb states he appears in the deity's guise. In earlier inscriptions, from the Temple of the Inscriptions and the Cross Group tablets, rulers' actions are compared to mythological events, but here, and in the Temple 19 pier panels, the ruler performs in order to become one with the gods. Even so, by rendering attendants supporting both costume and costumed [134], the sculptors of the pier's stone panel highlight the artifice of performance, noting that the performer's art, just like the sculptor's, is a creative act through which gods may be manifest.

In nearby Temple 21, archaeologists found another exquisitely carved panel edging a platform. Also from Ahkal Mo' Nahb's reign, this panel portrays a rite naming a younger family member as the next heir to the throne. Overseeing this rite, at the panel's center, is Pakal, over fifty years after his death, surrounded by a feathered frame and holding a stingray-spine bloodletter. The portrait is consistent with earlier representations, and perhaps even more lifelike: it is Pakal in the guise of a deity, the eternally venerated ancestor.

The final chapter of Palenque sculpture is, quite literally, written, for the last works emphasize text and derive from the scribal arts. One monument, the Tablet of the 96 Glyphs from the mid-eighth-century reign of K'uk' Bahlam II, is small in scale and was probably executed by a single master sculptor [136]: the large-scale projects of earlier regimes had vanished, yet the energy concentrated into small works yielded new results. It demonstrates Mayan calligraphy at its most remarkable, for the sorts of lines achievable with a brush have been transposed to stone, where they flow like a silken thread, denying the inherent stoniness of the matrix.

136. The Tablet of 96 glyphs, from the reign of K'uk' Bahlam II, was found in the Palenque Palace, near the base of the Tower. On this tablet, sculptors fluidly inscribed text, adopting characteristics of the painted word to carved limestone, as seen in this glyph reading Janaab Pakal.

Tonina

Tonina is home to the latest Long Count date in the south, AD 909 on Monument 101. After its abandonment in the early tenth century, many of Tonina's finest sculptures fell down its steep embankment, either pushed by man or moved by forces of nature, losing their original context. Archaeologists have rediscovered a wealth of monuments, including low and round stones bearing a huge calendrical glyph marking the end of a twenty-year k'atun, most set alongside the ballcourt, to finely carved three-dimensional renderings, to pained representations of captives, male and female, who kneel, sit, or lie down, some rendered in two dimensions, and others in three dimensions.

Most stelae, made of sandstone, stood in three dimensions, text frequently on the figure's spine or lateral sides, similar to the sixth-century Monument 168 [126]. In the Late Classic, the rulers' bodies were further freed from the stone backing; installed on terraces, these rulers were made present through their representations. These sculpted rulers dominated images of captives on the Fifth Terrace, where a depiction of the Palenque king K'an Joy Chitam II in bondage was once set [137]. Strikingly, although the panel is of local sandstone, the fluid style belongs to Palenque, suggesting that Tonina lords captured Palenque artists along with their king.

137. Palenque king K'an Joy Chitam II, wearing signs of his royalty such as jade jewelry and a Jester God headdress, appears on Tonina Monument 122 as a bound captive in 711, although he may have survived until AD 720.

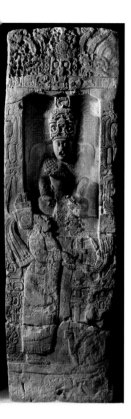

Piedras Negras

In the early seventh century, K'inich Yo'nal Ahk I began to rebuild at Piedras Negras after the city's sixth-century destruction, erecting monuments in the South Group. His stelae set a pattern that would be followed by generations of rulers to come. As Herbert Spinden pointed out early in the twentieth century, monumental freestanding stelae at Piedras Negras follow particular formulae, featuring first an enthroned king, followed by one or more warrior monuments. Set in clusters around the city, the stelae mark rulership reign by reign. A "niche" monument initiates every series, featuring the king seated within a deep rectangular space, at the top of a ladder, celebrating the first calendar ending – of a five-year *hotun* – of his reign. In the earliest stelae, the ruler appears alone, but in later ones, his mother or regional governors witness the ceremony.

Mesoamerican peoples generally believed that the soul dwelt in the head: Piedras Negras sculptors worked to accentuate the head and shoulders of each successive ruler by increasingly freeing them from the stone, such that the late eighth-century Stela 15 renders the body in nearly three-dimensions, an extraordinary feat given the obdurate limestone. But this impetus to three dimensions appears principally in rendering the ruler. On Stela 14 from circa AD 761, sculptors portrayed the mother standing in front of the niche where the ruler is seated [138]. It is a brilliant solution to a longstanding artistic problem: how not to occlude the ruler's image? The mother's role is both accentuated and visually downplayed by her compression into two dimensions, on what is in fact another plane of sculpture, closer to the viewer, and contrasting with the strength of her son's frontal representation, his face and hands in high relief.

The warrior stelae, in contrast, offer images of heavily armed and outfitted aggressors [139]. The Teotihuacan War Serpent dominates victory monuments at Piedras Negras, particularly in the seventh century, with the war god headdress represented at a scale larger than humans.

Piedras Negras sculptors deployed inscriptions in configurations that required readers to circumambulate monuments and thereby perform a sacred rite understood to renew the world. They also engaged the four sides of the stela's prismatic shaft to suggest arrangements in three dimensions,

38. Piedras Negras Stela 14, nce colored with blue-green d red pigments, was installed Structure O-13. The young uler 5 sits in a niche to celebrate s first k'atun ending in office; his feet stands his mother, rikingly rendered in low relief ainst her son's high relief.

139. (right) On Piedras Negras Stela 35, Ruler 2 wears a Teotihuacan war costume, including a balloon headdress, rectangular shield, and necklace with pecten shells. The monument's looted upper half, shown here, is now in the Rautenstrauch-Joest-Museum in Köln, Germany; the bottom half portrayed a captive cowering before the ruler.

140. (below) Pictured on the back of Piedras Negras Stela 3 are Lady K'atun Ajaw and her daughter; on the front was her husband, Ruler 3. Installed at the edge of the Acropolis, the stela presented the male to the public plaza and the females to the more private milieu of the royal palace.

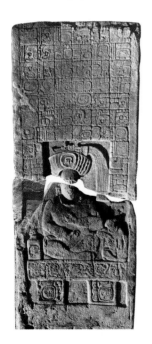

whether to indicate subsidiary figures positioned behind the ruler, as Tikal Stela 31 [119] had done, or to portray the ruler and his wife as parallel actors on the front and back of stelae. Lady K'atun Ajaw, a princess from the Namaan polity (the site of La Florida on the San Pedro Mártir River), is featured on the backs of Stelae 1 and 3 [140], her full frontal representation analogous to that of men and comparable only to the prominence of Lady K'abal Xook at Yaxchilan in the same era. Such featured female protagonists offer some clues to the role in political life that women achieved, especially concerning courtly and inter-polity affairs. Strikingly, most representations of powerful women cluster between 680 and 720, a time of great political consolidation, when marriage may have played as great a role as warfare in Maya politics. By using the front and back of these stelae, sculptors also exploited their placement on the edge of the Acropolis [60], the royal palace, to portray the king and queen, each standing before a throne, looking toward the plaza and its public realm or the palace and its courtly realm, their engagement with the physical setting expanding the monument's communicative potential.

But Piedras Negras sculptors also sought more complex narrations on panels, starting in the sixth century. Wall panels

141. (below) Piedras Negras Panel 2 (AD 667) depicts Ruler 2, right, and an heir. Kneeling are six armed warriors from Bonampak, Lacanha and Yaxchilan. The text narrates two ceremonies of the taking of the *ko'haw*, the Teotihuacan-style war helmet.

142. (bottom) The court gathering portrayed on Piedras Negras Panel 3, carved circa AD 782 in Ruler 7's reign, is a retrospective image depicting his father, Ruler 4, enthroned at center, celebrating his first k'atun in office.

remained the locus of compositional complexity in the seventh and eighth centuries, particularly, as Stephen Houston has demonstrated, in the posthumous portrayal of ancestors. Circa AD 800, near the end of the city's florescence, sculptors installed three such panels on Structure O-13, the largest pyramid ever constructed at Piedras Negras, where archaeologists found Burial 13, the tomb of Ruler 4 (Itzam K'an Ahk II). Panel 2 [141], like the sixth-century Panel 12, portrays the king as victorious warrior with Yaxchilan vassals. The two other panels, including Panel 3, offer scenes of courtly life.

Commissioned at the end of the eighth century by Ruler 7, the small Panel 3 [142] is retrospective, portraying the royal court as it was in an earlier generation, but with a liveliness

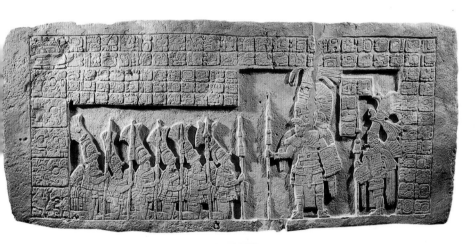

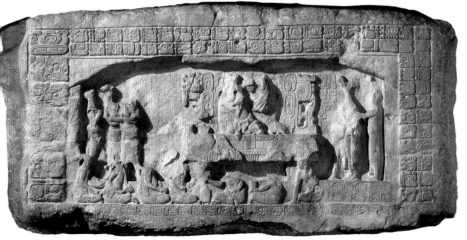

143. Piedras Negras Stela 12 (AD 795) depicts thirteen individuals: Ruler 7, at top; two warriors, one a La Mar ruler, flanking two captives at center; and eight captives at bottom. Installed on Structure O-13, the stela commemorates the defeat of Pomona and may depict a captive presentation that occurred on that temple.

in the rendering of ongoing interactions among its many individuals rarely seen in monumental art. Despite the later violence wrought upon the stone, one can still see that the enthroned king – Ruler 4 – reaches out vigorously to address those at his feet and side, as they chat among themselves, and even fidget in position. Such rendering of action would appear to cap the development of carving at Piedras Negras, which shortly thereafter ceased altogether.

In the era of Panel 3, from 780 until the end of the century, a time when sculptural traditions across the southern lowlands were languishing, Piedras Negras sculpture reached its greatest heights, with new formats and sophisticated views of past events, including the innovative Throne 1, an extraordinary royal furnishing that was ripped from its housing and smashed during a battle circa 810. In this last king's reign, the seated niche figure gave way to a standing representation of the ruler on Stela 15; in place of the conventional warrior stela, previously featuring

a standing figure, Stela 12 [143] depicted a seated warrior and standing lieutenants presiding over the heap of captives below, the impulse to embodiment giving way to that of narration.

Stela 12 may have been the last major monument made at Piedras Negras: the victory it celebrates over Pomona, however, must have been hollow, for Piedras Negras soon met its demise. With its position at the top of Structure O-13, only the monument's upper portion could have been seen from the ground – and thus most viewers would have missed Stela 12's lower half. But the monument as a whole was an extremely complicated affair, compressing into its narrow format the message of the entire north wall of Room 2 at Bonampak [217]. In doing so, the sculptors devised new solutions to visual problems, including the incorporation of architectural space. The victor at top sits in a three-quarters position, his body dramatically foreshortened; his two war captains stand to either side, down several registers, on a staircase for captive sacrifice, covered with draped cloth. Between them sits an elegantly attired captive – texts often note that captives are "dressed for sacrifice" – who, like the captive atop the steps at Bonampak [92], has been rendered with face in profile but his back to the viewer. Beneath him sit eight other captives, naked and bound. These eight captives are among the most striking figures of Maya sculpture, for they reveal emotions. The figure

144. Pomona Panel 1, featuring the site's distinctive sculptural style, portrays seated royal figures wearing interior court clothing (loincloths, kilts, and jewelry), their bodies turning in opposite directions to create composite poses using profile and frontal views.

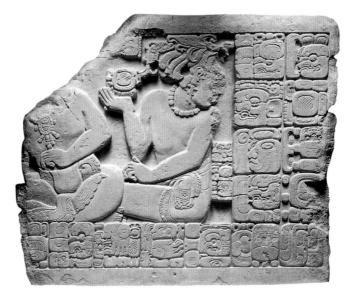

at far right collapses in resignation; the figure beside him scowls at the feet of the warrior atop him. Despite their bonds, their faces present the highest degree of Maya beauty. From top to bottom of Stela 12, the depth of carving diminishes, until the captives seem little more than drawings on stone. Over a dozen small inscriptions run across or near their bodies; some are sculptors' signatures – and in fact may identify these captives as the sculptors themselves.

When the lords of Piedras Negras conquered Pomona, they must have demanded artists in tribute, artists who knew that death awaited on the sacrificial staircase. When those artists arrived at Piedras Negras, they may well have worked on Stela 12, whose hybrid forms include both the higher relief of the ruler on top and the extremely low relief of the elegant figures at bottom that is more characteristic of the Pomona sculptural style [144]. Yet in its own way, despite the demise predicted for these captives, the monument allows for their survival: the viewer today glances only casually at the seated victor, choosing instead to focus on the tangled bodies who draw attention at the bottom of the stone.

Yaxchilan

Most scholars agree that the end of the eighth and beginning of the ninth centuries were troubled times, as the collapse caught up with every Classic city of the southern lowlands. But the artistic response to the situation was by no means uniform. After all, Piedras Negras sculpture ceased at its moment of peak achievement, and that final moment was an exuberant one, with abundant and large-scale works. The more predictable path might be the one we can identify for Yaxchilan, where the sheer number of stone sculptures made between 723 and 770 outstrips any other city, and where a curve that notes rise, flourish, and decline can easily be charted.

From the city's establishment in the Early Classic, the lintel was the dominant format of Yaxchilan sculpture, and its architectural positioning spanning a door frame saved it from long-term exposure to damaging elements. With its slightly private location, the lintel may have been seen as a locus for more varied subject matter. Originally purely textual [120], lintels may have adapted texts and images from now-lost books. Such an origin may also explain the sudden appearance of new and

imaginative compositions, as was the case first in the reign of Itzamnaaj Bahlam III (also known as Shield Jaguar), early in the eighth century, when his wife Lady K'abal Xook commissioned a building and its lintels [145–147], and later, at mid-century, during the reign of Itzamnaaj Bahlam II's son "Yaxun" Bahlam IV (the famous Bird Jaguar, the Yaxun reading a debated one), who introduced a wide retinue to royal representation [148].

Dumbfounded by the extraordinary quality of Lintels 24, 25, and 26, Sylvanus Morley could not believe they had arrived on the scene without precedent, and so misdated Lintels 15 [148], 16, and 17 to make them the visual forebears. We now know how wrong Morley was in imagining the smooth development of sculptural complexity, for in fact, invention and artistic genius

45. On Yaxchilan Lintel 24, Lady K'abal Xook, kneeling in front of her husband, the ruler Itzamnaaj Bahlam III, uses a thorn-studded rope to draw blood from her tongue. The text is laid out in an architectural frame that suggests a rite indoors or in a doorway.

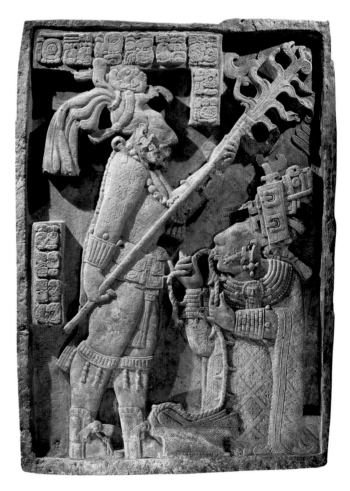

146 (right) Yaxchilan Lintel 25 depicts Lady K'abal Xook, right, witnessing the war god, Aj K'ahk O' Chahk, in the serpentine vision she has conjured following bloodletting. Her *huipil* drapes over her belt and at her feet, drawing attention to her elegant attire. The text, rendered in reverse, includes her husband's accession date. (below) The inscription on the lintel's front face names the building, Structure 23, as a house of Lady K'abal Xook's gods.

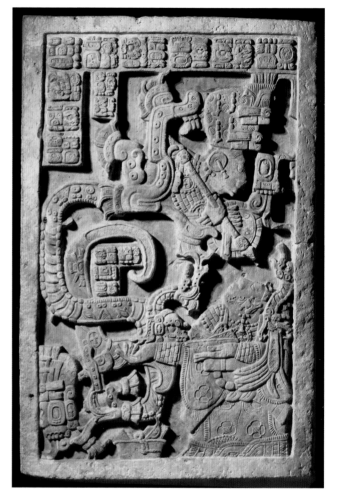

can propel innovation in erratic beats. Not only were Lintels 24–26 [145–147] of astounding quality, but they also captured subject matter never before executed on stone, the queen's bloodletting producing a vision of a war deity that effectively sanctions the accession and warfare of her husband. Simultaneously, Itzamnaaj Bahlam III memorialized his success

in a war waged against Bonampak and other cities, with an equally innovative program that encompassed both lintels and carved steps on Structure 44. The carving of buildings' multiple lintels or stair blocks in sequenced narrations allowed Yaxchilan sculptors to experiment with telling stories in progress, using a series of images to convey episodes in a punctuated narrative, in which single images point forward and backward in time, suggesting what just happened or what will soon come about. Moreover, sculptors portrayed figures in the midst of action, as when Itzamnaaj Bahlam III grasps his captives by the hair, his back leg showing the effort of throwing his entire body into the action [150]. Such narrative complexity would reach its Maya apogee with the Bonampak murals.

In the subsequent generation, Bird Jaguar IV took these same subjects, as well as others, and commissioned more

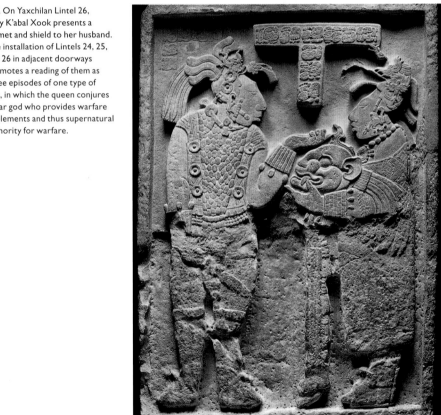

147. On Yaxchilan Lintel 26, Lady K'abal Xook presents a helmet and shield to her husband. The installation of Lintels 24, 25, and 26 in adjacent doorways promotes a reading of them as three episodes of one type of rite, in which the queen conjures a war god who provides warfare implements and thus supernatural authority for warfare.

148. On Yaxchilan Lintel 15 from Structure 21, Lady Wak Tuun, a wife of Bird Jaguar IV, repeats the serpent ritual depicted on Lintel 25, one generation later, although the complexity of the composition has been simplified, making the woman's role clearer.

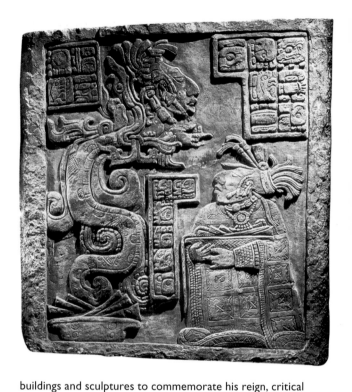

149. (opposite, left) On one side of Yaxchilan Stela 35, Lady Ik' Skull, another wife of Itzamnaaj Bahlam III and the mother of Bird Jaguar IV, draws blood from her tongue, and the other side (shown here) depicts her conjuring a serpentine vision. It was found inside Structure 21, an unusual place for a stela.

150. (opposite, right) Yaxchilan Lintel 8, carved in exceptionally low relief, presented an innovative composition, with two victorious lords – the ruler Bird Jaguar IV and a sajal – at the margins, grasping captives by the hair and wrist. The captives' names are inscribed on their legs.

buildings and sculptures to commemorate his reign, critical to establishing his right to rule since he came to power after a ten-year interregnum. Where one or two monuments might have been carved under his father, Bird Jaguar commissioned up to a dozen to celebrate a single event; some works narrate events from the past, such as Stela 35 [149], showing his mother in a bloodletting rite similar to the earlier queen on Lintel 25. In fact, Bird Jaguar was intent on demonstrating connections with his ancestors, both by resetting lintels [120] from the polity's older rulers and by creating new images that depicted himself and his ancestors in analogous rites, seen, for example, on Structure 33's hieroglyphic stairway [59]. In the process, new representations of the human form were introduced, but the quality of carving dropped so significantly that many of the era's key monuments – especially Lintel 8 [150] – are known almost exclusively in line drawing, the stone surface so poorly graven that photography barely captures its sense. One may consider this a form of artistic "inflation," in which the increased coinage has reduced the value of any single image. By the year 810, such practice yielded a final result, Lintel 10, a purely textual

monument. The clumsy framing of the text suggests that the carver had to cope with new information as it was presented, so that he jammed in more words at the end, without regard to the neat, measured configuration of a century before. Yet because this text narrates the capture of the Piedras Negras king, as David Stuart discovered, it was important information indeed; the impetus to create beauty had given way to the impulse to record power over one's enemies.

In short, if one wanted to see a visual record that "reflects" in some way what archaeologists think Maya life of the eighth century might have been like, one would probably propose Yaxchilan. Here, concentrated wealth and power at the century's beginning did not hold for long. Bird Jaguar turned to new, more collaborative forms of government, resulting in a visual explosion in which he shared the public record with regional governors and lieutenants. Ironically, like a latter-day political strategist, even as he amended the political structure, his efforts undermined his own polity, for the regional lords took increasing power and began to make works of art that outstripped his own. Ultimately, Yaxchilan faced its political and artistic demise: all monuments from the reign of Itzamnaaj Bahlam IV, Bird Jaguar's son and one of the last known Yaxchilan rulers, were smashed, likely by enemies from one of the polities Itzamnaaj Bahlam IV – in the lengthy inscription displayed on the steps of his Structure 20 – claimed to have defeated.

Tikal

151. The 11 Ajaw date on Caracol Altar 3, one of the polity's distinctive "Giant Ajaw" altars, correlates with the Long Count 9.5.0.0.0, in AD 534. After emerging from oppression by Caracol and other polities in the sixth and seventh centuries, Tikal briefly adopted this monument form.

Although pre-eminent in the Early Classic, Tikal lagged in the late sixth century and for much of the seventh century struggled to recover from multiple external attacks, including a dynastic schism of the mid-seventh century that resulted in a rival capital at Dos Pilas, whose lords would ally with the Kaan dynasty and defeat Tikal again in 679. But in AD 692, ten years after acceding to the throne, Jasaw Chan K'awiil commemorated the first k'atun ending of his reign by dedicating Stela 30 and Altar 14 in the first of the site's specialized architectural precincts called Twin Pyramid Complexes. The dedication would have been a momentous occasion, for with these monuments, Tikal resumed commemorating the k'atuns as their ancestors had done. This celebration also marked an important k'atun, the thirteenth of the ninth bak'tun. Stela 30, portraying the ruler fully in profile, harks back to the polity's stelae from the late fifth and early sixth centuries, its conservatism effectively an archaism proclaiming an unbroken connection with that past, whereas Altar 14, an Ajaw altar, appropriates a sculptural form from Caracol, their once oppressor [151].

Ultimately, the Tikal kings developed a strong local style in the eighth century, characterized by the sequence of Jasaw Chan

154. The top of Tikal Altar 8
depicts a prone, bound ballplayer,
his lower legs and feet in the air,
squeezed into the altar's rounded
form. The rope runs from the
captive's tied arms to the stone's
perimeter, urging the observer
to envision the monument as a
great, tied ball.

152. (opposite, left) Tikal Altar 5
features an unusual rendering of
two men, including the ruler
Jasaw Chan K'awiil, performing
a ceremony over the bones of a
female ancestor, named in the
lower caption. Her remains are
portrayed as a skull stacked atop
long bones.

153. (opposite, right) Tikal
Stela 16, paired with Altar 5,
commemorates the completion
of fourteen k'atuns (stated in the
text over his head) in AD 711. In
the image carved on the stela
front, shown here in a drawing,
Jasaw Chan K'awiil wears a royal
costume common on eighth-
century Tikal stelae.

K'awiil's Stelae 30 (692) and 16 (711); Yik'in Chan K'awiil's Stelae
21 (736?), 5 (744), and 20 (751); and Yax Nuun Ahiin II's Stelae
22 (771) and 19 (790). Most were dedicated on k'atun endings
and set within Twin Pyramid Complexes, and they carefully
follow the model established by Stela 30: a laconic text, limited
to the front of the monument, and the ruler in profile, some
shown scattering, others holding an incense bag, and each
holding a staff in front of his body or at a diagonal. Jasaw Chan
K'awiil's Stela 16 [153] differs from this pattern, rendering the
ruler frontally, his feet turned outward, and his feathered
backrack stretching to the side and framing his wide body and
wide stance. But his successors would return to the profile royal
representation, as if the conservatism were required for the
polity's calendar commemorations, the artistic stasis affirming
political stability. As depicted from 711 to 790, the king's royal
uniform – including cutaway mask, feather backrack, belt
trimmed with oliva shells, and hipcloth with death-eye trim
– may have been meticulously preserved to be worn by one
generation after another and the images made from a template.

Two additional sculptural formats – altars and lintels
– thrived in eighth-century Tikal, infused by fresh military
success. On altars, round stones placed in front of stelae, Tikal
lords rendered their hapless captives in humiliating postures,
taking liberties with the captives' representations that were
not taken with those of the rulers. On Altar 8 [154], paired with
Stela 20 in a Twin Pyramid Complex, the unfortunate is trussed

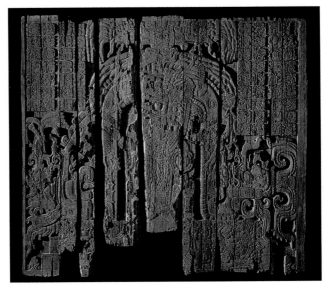

157. (below) Tikal's stela tradition survived into the ninth century. Stela 11, from 869, depicts a ruler in a position long standard at Tikal; the floating figures and articulated frames were innovations.

up like a Maya ball, probably to indicate his death in a ballgame; on Altar 10, paired with Stela 22, the captive is bound to a heavy scaffold and rendered over a quatrefoil cartouche, indicating an opening to the Underworld [27].

Although many Maya sites used wooden lintels hewn from tropical hardwood trees, the most elaborate ones to survive come from Tikal, where beams of sapodilla spanned the inner doorways of temples sacred to ancestors [156]. Several lintels celebrating victories over Calakmul and Naranjo featured giant god effigies and their litters, of the sort also scratched in Tikal graffiti [155], and the novelty of these lintels, set in high places where even a peek at their imagery would have been a rare privilege, offers a counterpoint to the repetitive stelae. The effigies themselves were precious invocations of divinity but entirely made of perishable materials. Inscriptions intimate that these images were warfare's treasured booty, and that Tikal gained them from defeated rivals.

Tikal and nearby sites managed to keep the stela tradition alive into the ninth century, and Stela 11, from AD 869, typifies the last monuments of the region [157]. Ninth-century monuments flare at the top, and decorative motifs frame the edge of the pictorial field, abruptly truncating feathers and scrolls. Spindly legs support human figures in the ninth century, leaving them weightless and ungrounded. On Stela 11, the ruler scatters blood

or incense in a renewal ceremony for the k'atun ending, and hovering above are the gods known as "Paddlers," who typically canoe the Maize God to the Underworld for his annual renewal. But neither the ruler nor the Paddlers could renew Tikal, for this was the last stela raised at the polity, and by 900, Tikal was no longer a place for new sculpture or art of any kind.

Calakmul and the expansion of the Kaan dynasty

The Kaan dynasty, centered at Calakmul in the seventh and eighth centuries, was the most powerful Maya polity in the seventh century, with tentacles in many sites established through military triumphs, marriage alliances, and colony formation. But no amount of historical reconstruction of Calakmul's political impact can compensate for the near-absence of legible, figural sculpture from this great city-state. Nevertheless, a few of the 117 stelae at the site offer insights into its sculptural program.

Calakmul erected large, wide monuments, many male–female pairs that celebrated united lineages, a practice at their ally El Perú-Waka' as well, and one that was compressed into a one-stela format at Piedras Negras. Calakmul reached its apogee under Yuknoom Ch'een II, and although he commissioned more than a dozen stelae, all were eroded beyond recognition when found. Most monuments mentioning Yuknoom Ch'een II survive from other places, from sites such as El Perú-Waka', La Corona, and Cancuen, claiming connections to the Kaan dynasty by commemorating royal visits, joint ballgames, and marriage alliances or by acknowledging defeat or accession under the auspices of this king.

Extraordinarily fine monuments have come to light in recent excavations at La Corona, led by Marcello Canuto and Tomás Barrientos, who, together with David Stuart, have demonstrated this is the origin of the "Site Q" panels that appeared on the art market in the 1960s. La Corona has no stelae, perhaps because its Calakmul overlords prohibited this practice. Instead, staircases were lined with diminutive low relief panels featuring extensive inscriptions and images of royalty and nobles, some in courtly attire, others dressed as ballplayers [1]. Figures are often paired, either on the same panel or adjacent panels, such that the art of this place is not about the singular ruler but about social interactions, often with the holy lord from Calakmul. La Corona Panel 1 (comprising Panels 1a and 1b),

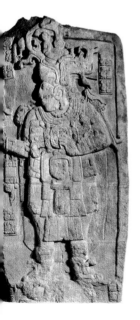

from AD 677, commemorates the visit of La Corona's ruler to Calakmul, where he visited Yuknoom Ch'een II.

Studies of these and other newly discovered panels, along with monuments long known, have revealed a complex political network of sites in southern Campeche and the Peten, where Calakmul expanded to create a trade route for jade acquisition and to hobble their rival Tikal. Royal burials at Calakmul contain abundant jade, including funerary masks made of jade and shells, no doubt the fruit of this network. Notably, this is the region from which the finely painted "Codex-style" ceramics appear to originate, and it may well have been one or more of these client states that produced ceramics for their own use and for their Calakmul overlords [199–201].

Despite its astounding seventh-century successes, Calakmul fell to Tikal in AD 695. Yet the stelae of Calakmul's Yuknoom Took' K'awiil, who inherited a polity crippled by defeat, are the best preserved of the site, having been made from a rock – certainly imported – that survived beautifully, although looters cut them to pieces in the 1960s. Stela 51 [158], from AD 731, shows the ruler with frontal body, feet splayed outward, and shoulders and arms arced in a manner recalling the ruler's costume and wide stance on Tikal Stela 16 [153]. But this monument is carved with varying levels of relief, the ruler's right arm in lower relief than his torso, his left arm almost tactile, in yet higher relief; the sculptors thus conveyed three-dimensions not only through overlap and occlusion but also by modulating the relief, such that the ruler begins to emerge from the stone, creating a more enlivened presence than the static figures rendered in stone at Tikal.

Copan and Quirigua

At both Copan and Quirigua, Maya sculptors worked with local, idiosyncratic rock that allowed them to experiment with three-dimensional rendering and ultimately discard the two-dimensional format established in the Peten. Although perhaps discovered originally by experimentation with the presentation on ceramic incensarios or the carving of small jade figures, a format of low-relief representation enhanced by an isolated three-dimensional face became dominant at Quirigua. More yielding than the limestone of the Peten, Quirigua's brownish-red sandstone provided a medium to enhance the human face.

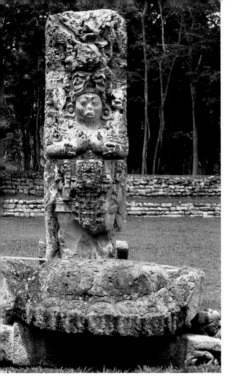

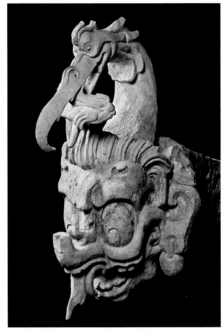

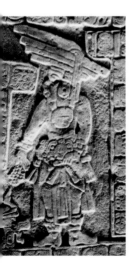

At nearby Copan, workers discovered that volcanic tuff quarried from the hills yielded easily to the chisel when first taken from the ground but then hardened in the air over time [159]. They carved the tuff into elaborate programs of architectural ornament, transforming the tradition of stuccoed architectural sculpture into one of more durable stone, and producing magnificent shapes with projecting forms to portray dynamic versions of gods such as Chahk [160]. In the stela tradition, sculptors were carving massive, disproportionately leggy sculptures, with three-dimensional relief of head and arms, yet still held fast by the prismatic stone shaft at the beginning of the seventh century. By the eighth century, the shaft melted away as sculptors freed profoundly lifelike sculptures. Many appear as if oversized kings had been frozen in time on the plaza, with fully-formed feet obliquely planted to support the full regalia. The distinctive Copan turban [166] would turn up at distant Nim Li Punit, Belize, depicted there in profile [161].

Copan achieved sculptural glory with the production of multiple stelae in the early eighth century that celebrated Waxaklajuun Ubaah K'awiil. Stela J [162], dated AD 702, had an elaborate inscription deployed in the form of a woven mat

and was installed at the site's eastern entrance; other stelae, including Stela C [159], dedicated in 711 along with an altar in the form of a turtle, were installed in the principal plaza. But in 738, the Quirigua king took Waxaklajuun Ubaah K'awiil captive and beheaded him. Fueled by their prowess, Quirigua erected a potent stela program, installing the tallest sculptures ever made by the Classic Maya [165]. Several Quirigua stelae mimic Copan subjects, including the mat of Stela J. Appropriating the art of the defeated is common in the history of art, but one also wonders whether Copan sculptors weren't captured along with the king and forced to create the program, although innovations in monumentality, content, and placement of monuments and carvings to encourage dance, as Matthew Looper has discussed, demonstrate that these stelae were not mere copies of the Copan ones. Later in the eighth century, Quirigua sculptors introduced an original format in the carving of several-ton river boulders into what scholars have dubbed "zoomorphs," such as Zoomorph P [164], where one of the last kings sits within the open mouth of a great turtle-like creature.

Quirigua's capture of Waxaklajuun Ubaah K'awiil was undoubtedly a trauma for Copan, but the city would rebound; as recounted in Chapter 3, in 755, the dynasty's fifteenth successor dedicated a new, expanded Hieroglyphic Stairway [67] that subsumed his death within a lengthy dynastic history emphasizing success and continuity, an effective visual erasure

162. (above) The inscriptions on Copan Stela J, from Waxaklajuun Ubaah K'awiil's reign, are cleverly arranged as strips woven into a mat pattern, requiring the reader to follow the glyphic phrases as they cross over and under one another.

163. This sculpture of an ancestor, now in Harvard's Peabody Museum, was originally installed on the Hieroglyphic Stairway at Copan, amidst glyphs narrating the polity's long history (see ill. 67).

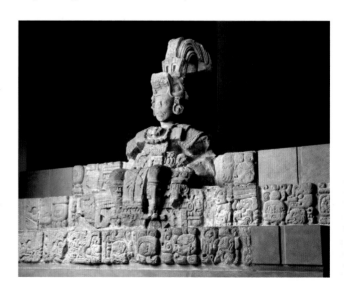

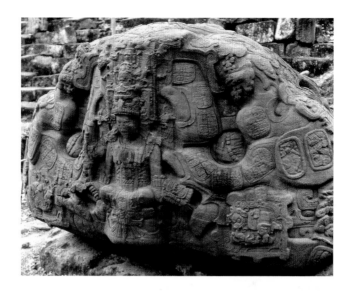

164. Quirigua sculptors carved massive boulders from the Motagua River into innovative forms portraying rulers in supernatural contexts. Zoomorph P depicts a late eighth-century ruler emerging from the mouth of a great turtle, perhaps reenacting the rebirth of the Maize God.

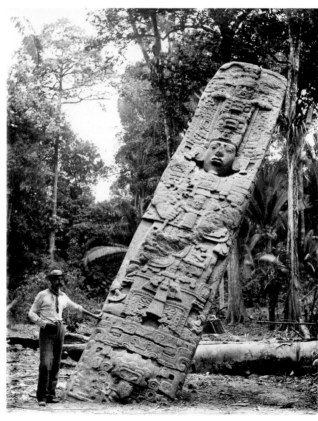

165. After the Quirigua king K'ahk Tiliw Chan Yopaat captured Waxaklajuun Ubaah K'awiil of Copan in 738, he sought to replicate his enemy's great plaza. The result at Quirigua was a spacious plaza, occupied by towering stelae, including Stela E, from AD 771, measuring 10.6 m (35 ft) including the stela base.

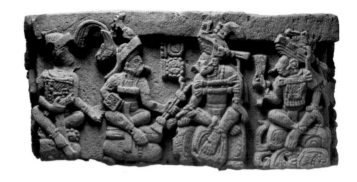

166. At the center of the west face of Copan Altar Q, K'inich Yax K'uk' Mo', who had died over 300 years earlier, hands a fiery torch or dart to the contemporary ruler, Yax Pasaj Chan Yopaat. Beneath this altar, archaeologists found a cache of large felines, including jaguars, as well as birds, such as macaws.

of the Quirigua attack. A similar statement appears on Altar Q [166], a large square altar commissioned by the ruler Yax Pasaj Chan Yopaat in 776 and set in front of the final version of Temple 16, the funerary structure of K'inich Yax K'uk' Mo'. A text carved on the altar top narrates events in the life of Yax K'uk' Mo', including his arrival at Copan, and connects him seamlessly across centuries. The images on the altar's four sides do the same: on the west face, the ancestor K'inich Yax K'uk' Mo' hands a fiery scepter to the living ruler Yax Pasaj, and framing them are the fourteen rulers who reigned in between, another visual statement of dynastic continuity.

Dos Pilas and the Petexbatun region

The Petexbatun region also experienced dramatic political change in the seventh and eighth centuries. Stelae were erected at Tamarandito and Arroyo de Piedra in the sixth century, but at some point they were broken, likely because of warfare within the region or involving outside forces. There was an infusion of activity in the area in AD 648 when Bajlaj Chan K'awiil, son of one of the Tikal rulers during the "hiatus," established a new dynasty at Dos Pilas. During his and his successors' reigns, sculptors created a variety of stone stelae, panels, and stairways that narrated k'atun celebrations, alliance with Calakmul and other polities, and their own defeats and successes in warfare, including several engagements with Tikal, as deciphered by Stephen Houston and other epigraphers.

168. (opposite) Ceibal Stela 3, dated AD 889, has registers similar to stelae from Oxkintok and other northern sites (see. ill. 174). In the middle register is a single figure, likely the ruler, in front of a flowering cave or mountain, and in the top register are two seated figures wearing Tlaloc masks.

In AD 736, Dos Pilas Ruler 3 erected two stelae – Dos Pilas Stela 2 [127] and Aguateca Stela 2 – that commemorated the 735 capture of Yich'aak Bahlam, ruler of Ceibal, a city on the Pasión River, an important route for riverine trade. On these

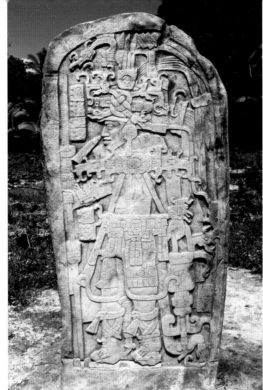

67. (right) On Ceibal Stela 1, found in the South Plaza, a ninth-century mustachioed ruler wearing a plaited serpent headdress is rendered in a style characterized by eclecticism, with elements from southern lowland Maya polities as well as sites in the Yucatan, including Chichen Itza.

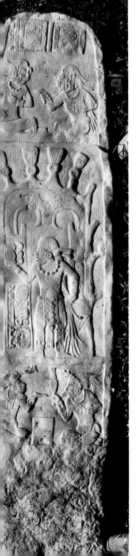

twin stelae, Ruler 3 is dressed in Teotihuacan costume. Comparable to the Piedras Negras warrior stelae, they draw on the visual language of the once mighty Teotihuacan to proclaim victory. Beneath his feet on both stelae, squeezed into a lower register, is the humiliated Ceibal king. Ceibal then became a vassal, but this would end with the abandonment of Dos Pilas and Aguateca c. 800.

Yet this was not the end for Ceibal, which would see a renaissance after the arrival in 830 of a new ruler who acceded under the auspices of Ucanal, a site in the Peten. The imagery on the monuments made at Ceibal over the next few decades, such as Stelae 1 and 3 [167, 168], is a hybrid of Maya forms with those from the Gulf Coast and Central Mexico. Although some twentieth-century scholars hypothesized that these foreign styles resulted from intrusive migrations or conquests, more recent interpretations suggest that the explanation lies with Maya rulers who, in the face of declining Classic-period Maya identities accompanying the collapse, drew on foreign forms to expand the visual language of their power, comparable to what would take place at Chichen Itza in the ninth and tenth centuries.

Chapter 7 Sculpture of the North: The Art of Yucatan and Chichen Itza

Maya art of Yucatan – and that of Chichen Itza in particular – developed along a somewhat different trajectory from the art of the southern lowlands, but with very early beginnings. The great cave of Loltun may have provided shelter for some of the region's earliest human settlement in the age of mastodons; and as a place of emergence the cave played a key role in the Late Preclassic, when a richly arrayed ruler was portrayed over the entrance, suggestive of the painting of the Maize God at San Bartolo [209]. In recent years archaeologists have been digging deeper, revealing early architecture, particularly at Edzna. At Oxkintok, monuments from the fifth century subscribe to representations characteristic of the southern lowlands. Late Classic monuments generally survive in poor condition and follow conventions known elsewhere, although a stela depicting a ballplayer at Edzna may point to local innovation.

While Maya art ceased to be made in the south after AD 900 altogether, the end of the millennium nevertheless was a rich and fruitful time in the north, and the making of Maya art continued unabated until the Spanish invasion in the sixteenth century. It was, after all, in Yucatan that Bishop Landa met with local elders in the sixteenth century to record their writing system. The sculptural media of the south – and the freestanding stela especially – adapted to local conditions in the north, where the raw materials were of a somewhat different order and where the very environment of scrub tropical rainforest differs from the high-canopy deep rainforest of the south. Time and political identity also played a role, so that continuities with the south are seen in the widespread carving of stone stelae at Ek' Balam and in the Puuc (literally "hills"), the hilly region to the west, in the eighth, ninth and tenth centuries, with innovation and discontinuity in far greater evidence at Chichen Itza at the end of this period and sustained for some time afterward.

The study of the art of Yucatan has also differed from that of the southern lowlands. Whereas recent investigations of the sculpture of Palenque, for example, have been driven by hieroglyphic decipherment, the northern monuments bear

laconic texts, if any, and have fewer securely anchored dates. This makes the personal and local historical interpretation that has fueled the study of southern lowland art difficult, if not impossible. Less deep archaeology also has resulted in limited knowledge of earlier or small-scale sculpture. New work at Acanceh, for example, has revealed a rich Preclassic phase; a long occupation there was sustained into the Late Classic. Around the end of the Early Classic, its Palace of the Stuccoes featured richly colored stucco paneling [169], depicting both animated spirit companions and the the glyph PUH ("cattail reed"), which may refer to the legendary "Place of Cattail Reeds," known as Tollan in Central Mexico: northern artists there were fully in control of the iconographic inventory known at Copan, for example, but no texts articulate the program.

Furthermore, Yucatan sculptors – from the earliest efforts in the fifth century to the years just before the Spanish invasion – had a different quality of limestone available to them, dense but less fine-grained, durable but less successful for bas-reliefs. Best preserved are those sculptures that were three-dimensional in their format, conceived as architectural ornament, or planned for an interior location – a description

169. Spirit companions in animal form adorn the Palace of the Stuccoes at Acanceh, inside colorful frames that are spaced by the PUH glyph, meaning cattail reed, a likely reference to Teotihuacan. The zoomorphs dance and sing, like the *wahy* of some painted ceramics (see ill. 202).

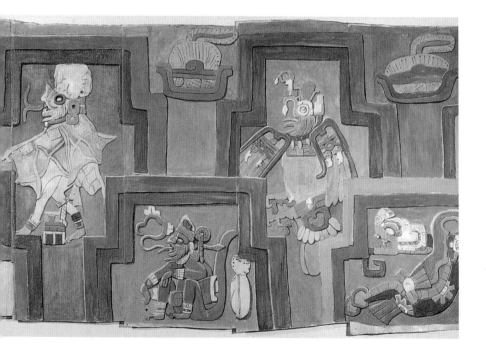

that in fact fits many of the works at Chichen Itza. Where the high-canopy rainforest long shielded the southern lowland architecture from scrutiny – and thus focused attention on the freestanding sculptures – the architecture of the north has always stood out against the scrub forest, leaving it more vulnerable to both human and natural depredation.

As a result, architectural studies of the north have flourished while studies of its sculpture have often foundered. Northern sculpture operates on different terms from sculpture of the south, even when they are contemporaneous. Some of its characteristics include flamboyant and exaggerated poses that enhance legibility, particularly when viewed from a distance. Processional friezes, common at Chichen Itza [179], invite the viewer to become a participant and to move along prescribed paths. Its impulse to exterior three-dimensionality infused new energy into architectural sculptural programs alongside jambs, lintels, and built-in wall panels, both making the buildings permanently populated and emphasizing particular ideologies.

The dating of northern sculpture has long been problematic, but scholars now agree that the last inscribed dates at Ek' Balam fall early in the ninth century, at Uxmal in the early tenth century, and with a cluster at Chichen Itza at the end of the tenth century. Much of the latest phase of Chichen includes no datable inscriptions and will be assumed to end circa 1100, with a brief overlap leading to the rise of Mayapan, which in turn fell in the mid-fifteenth century. As we saw in Chapter 3, all dating of northern architecture in the centuries immediately prior to the Spanish invasion is problematic, although there is hope that renewed archaeology across the region will eventually provide clarity. Although many northern sites have extensive early occupations, most sculpture outside of Chichen Itza and Mayapan dates from the eighth and ninth centuries, a period sometimes called the Terminal Classic, a term too redolent of both the train station and a certain decadence for use here. Simple century assignments are preferred.

Wars of conquest during the eighth and ninth centuries fueled the economic success of the north at the expense of the south. Populations also flowed toward the north, attracted by economic opportunities, for surely the construction of such remarkable centers required vast amounts of skilled labor. Uxmal's ceremonial precinct draws on a city like Palenque for its plan, but its galleries and palaces with elaborate mosaic

stone ornament would appear to owe something to the
precedents of distant Copan. The two cities may have
developed their low-slung architectural styles simultaneously,
but even the widespread use of curly-nosed Chahk (the Maya
Rain God), Itzamnaaj (the paramount deity, and especially
in the avian aspect), and Witz (personified mountain) masks
would appear to have prototypes in early eighth-century
Copan architecture. Because of new patterns of migration,
the greatest influences on the north seem to have come from
the Maya peripheries, whether to the far south, from Copan,
or the west – particularly from the Usumacinta cities. The
impulse to three-dimensionality seen at Copan [100, 101] and
other sites to a lesser degree achieves a rich florescence at
Chichen Itza: the leggy proportions that take hold at Chichen
and elsewhere last appeared in the south on monumental
sculpture in seventh-century Copan, and the frontality with
which the north so fluidly experiments also characterizes much
Copanec sculpture. With its emphasis on the ballgame, solar
deities, and leggy proportions, the sculpture of Cotzumalhuapa
– a center of non-Maya art-making along the Pacific slope of
Guatemala in the eighth and ninth centuries – may have found
resonance at Chichen Itza.

Sculpture of the Puuc region

Some of the most exciting Puuc sculptures played a role in
architectural complexes that no longer survive. Although little
more than rubble remains today at Cumpich, in southern
Campeche, a powerful three-dimensional sculpture from
the site grips the modern eye at the National Museum of
Anthropology, as it must have done in the past before the loss
of arms, legs, and penis, when the turn of the head away from
the central axis of the body was even more pronounced. Like
a Maya Laocoön, the battered captive struggles with a snake-
like rope that binds his neck.

Three-dimensional assemblages of jambs and lintels were
commonly constructed in many cities at the southern edge
of the Puuc. At Xcalumkin, a door jamb-and-lintel assembly
[170] featured an interior lintel of Itzamnaaj as an avian deity,
appropriately on high; in this form Itzamnaaj also had reigned
over scenes at Palenque [129] and Piedras Negras. Paired
dancers with axes, characteristic of the deity Chahk, frame

170. Xcalumkin thrived in the
eighth century, erecting many
highly adorned buildings, including
this jamb-and-lintel configuration.
The lintel features the Principal
Bird Deity, or Itzamnaaj in his
avian aspect; he also perches atop
the cross on the Palenque
sarcophagus lid (ill. 129).

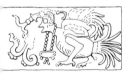

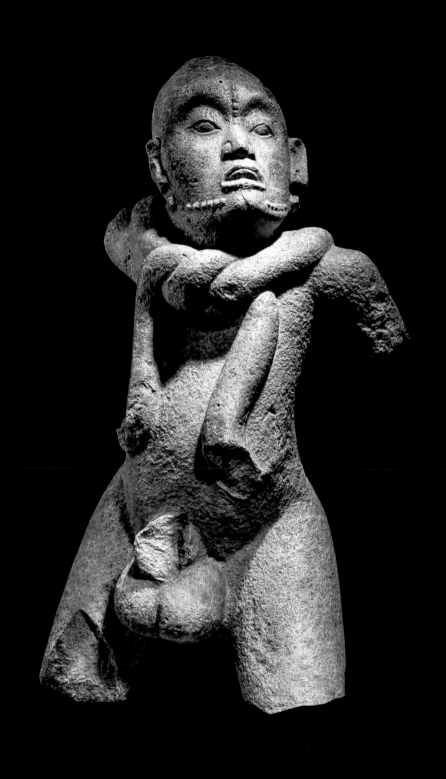

1. (opposite) This powerful captive, defiant in defeat, comes from Cumpich, in southern Campeche, perhaps part of a larger tableau of victory, the rest of which is now lost.

2. (below left) Collected over a century ago from rubble near the House of the Governor, this slightly larger than life-size head retains the brilliant polychromy that once articulated the entire building. The white circles around the eyes form part of a deity mask.

3. (below right) Stela 14, Uxmal. Bound, exposed captives anguish at the base; above, Lord Chahk, the Uxmal king, stands atop a double-headed jaguar throne, hurling darts from an elaborate atlatl.

the doorway, and suggest that ritual dancers may have entered and exited here, bringing rain and fertility to a parched region.

At Uxmal, a well-developed sculptural tradition dovetails with that of the late eighth century in the Usumacinta lowlands. On stelae, standing figures hold copal bags, engage in scattering or sprinkling rituals, or stand atop hapless captives – some of whom are naked and humiliated, like the Cumpich figure [171]. A border clearly demarcates the scenes of most monuments, in many cases forming a roof over the protagonists, and suggesting a setting within a palace structure. Around 900, the lord depicted on both Stelae 11 and 14 [173] adopts huge feather adornments, more hat-like than most headdresses, and on Stela 14, the hat includes a cutaway mask of Chahk, the Maya Rain God, which hangs in front of the king's face. Although little remains today, such behatted figures sculpted in three dimensions were once featured on the front facades of some principal palace buildings, the Nunnery's West Building and the House of the Governor among them [74, 75]. But whereas the

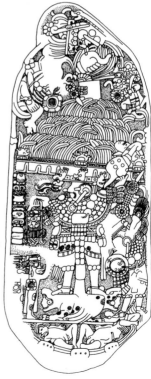

Nunnery figures once sat, the stela figures are generally active. The ruler on Stela 14 lifts his weapon high with his left hand, bringing it in front of his headdress, in a daring pose.

In some respects Stela 14 [173] is a conventional effort: it aggrandizes the ruler, setting him atop a two-headed jaguar throne. But with a detailed complexity of composition, it also speaks the ideology that this lord sought to promote – a structure of power articulated differently in the Cumpich figure. Above the Uxmal lord, an ancestor's deified head gazes down, framed by two diminutive, floating figures. These floaters are the Paddlers, the gods who ferry the Maya Maize God from one stage of life to another [11], and who occur on Maya ceramics and in the upper margins of very late stelae at Tikal and elsewhere. Here the Paddlers may well carry the ancestor as harvested maize.

But what actually renews the Maize God is human sacrifice: at the base of the monument, the humiliated captives provide that sacrifice to the Underworld, rendered here as if a stylized cenote that frames their naked bodies. So embedded in what seems to be a florid version of a conventional stela is actually a suppressed narrative – which may of course be the case in other instances as well. A knowledgeable Maya audience needed only a few cues to see the entire narrative, much as a crucifix can initiate the story of Jesus in a Christian viewer's mind. For the Maya, the story of the Maize God was the heart of their religion, and his growth, flourishing, and decapitation followed the agricultural cycle.

Northern sculpture often bears a vivid sense of narrative. Not only do figures in general take active postures (e.g. Oxkintok Stela 21 [174] and Edzna Stela 6), but many stelae are laid out with three specific registers. Compositions featuring registers also occur in the southern lowlands, but generally only at the end of the eighth century and into the ninth, just when they also take hold in the north. The register, of course, is also an essential feature of a complex program like that of the Bonampak murals [215] and appears in late sculptures at Ceibal [168]. With three separate frames, often separated by text, such compositions on northern stelae look like the pages of surviving Maya books such as the Dresden Codex [228]. Oxkintok Stela 21 may present a king or ancestor scattering below from his perch at top, with the current ruler or war captain at center. The composition, probably from the late

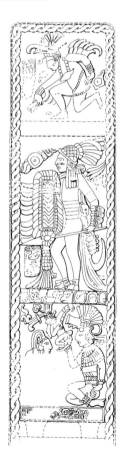

174. Oxkintok Stela 21 and many other northern examples break down into registers, similar to the pages of a Maya book. The warrior at center wears a simple cap and carries a flexible shield like that of many supporting figures in the Bonampak battle scene.

 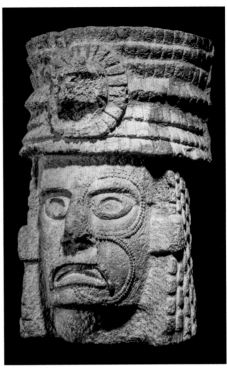

75, 176. (above left) Warriors
lance on carved jambs from rear
doorways of House of the Masks
at Kabah; (above right) the
monumental head, now fallen
from the facade, bears the same
distinctive face tattooing as does
the warrior at left.

eighth century, relates to both Piedras Negras Stelae 12 [143]
and 40, from the same period.

One of the most elaborate buildings of the north, the House
of Masks at Kabah, also features elaborate door jambs that
frame an interior room. Each jamb presents two scenes against
elaborate scrollwork: above, apparently a dance between
victorious warriors [175], and below, their domination of an
abject captive. One protagonist wears an elaborate woven
sleeveless jerkin, like that of the Oxkintok war captain, and
distinctive face markings [176], indicating a gold mask or perhaps
the sort of tattooing found on at least two great heads from
Kabah, probably portraits of this same man. Two remarkable
stucco heads from Uxmal [172] also bear distinctive eye paint,
perhaps identifying a single individual or ancestor: they may once
have been set within the mouths of stucco or stone serpents.

The widespread use of the column in the north lent
itself to processions and continuous compositions, and some
surely derive from the formats common to ceramic vessels.
With its bejeweled dwarf, elegant musicians, and attendant

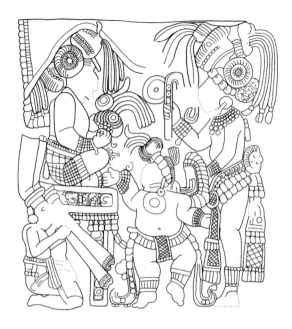

177. Now in the Campeche Museum, the Tunkuyi Column features a courtly scene under swag curtains, similar to scenes on painted ceramic vessels. Like the Kimbell Panel (ill. 91), the glyphs on the throne read from right to left.

lord, the column of Tunkuyi suggests the luxury of courtly life [177]. Like many painted vessels, the column's composition is closed, with figures who all face toward the dancing dwarf, and not continuous.

Chichen Itza

While their neighbors to the west and south built cities and erected monuments that emulated the sacred practices of the southern lowlands, the Maya at Chichen Itza would come to build a new kind of sacred city. As we saw in Chapter 3, Chichen Itza in its day was perceived to be a capital without rival, a Tollan, or a "Place of Cattail Reeds." Although the Chichen lords may have found ways to control the jade and gold trade, providing themselves with an unprecedented economic base, the story of public art and architecture at Chichen speaks of rulership and glory. The lords of Chichen incorporated seamlessly the ideology of Central Mexico into a Maya context, making their city and its monuments the envy of Mesoamerica.

A few stelae have been recovered at Chichen Itza, and the city has carved stone lintels that record rulership and authority. But Chichen was also a place of sculptural invention, developing new ways to promulgate an official message, from

massive interior low-relief sculptures at small scale to a virtual sea of carved pillars, from a Red Jaguar Throne studded with jade disks to the chacmool, a sculptural form that has been recovered within multiple buildings. Repetition and replication provided a consistent message, one that emphasized the role of the Feathered Serpent as a unifying authority.

One unique form known from the city is the gold disk [178]: twelve have been recovered from the Sacred Cenote, and they were probably once sewn to mantles. Their complex designs were almost certainly executed using a challenging repoussé technique at Chichen Itza itself, given the fascinating mix of Central Mexican costume, Feathered Serpent, and Maya representational practice. On one of these disks, a warrior wearing a Toltec butterfly pectoral emerges from the heaven-borne rattlesnake, and other figures wear Toltec helmets and hats, but the composition depends on eighth-century Maya examples: the four young men who hold the sacrificial victim occupy a realistic space; the large deity head underpinning the scene is a Maya skeletal centipede; and feathers follow a whiplash line, like those on a Tikal stela of the eighth century.

In detailed registers in the Lower and Upper Temple of the Jaguars [223], as well as the North Temple of the Great Ballcourt, sculptural narratives engaging vast numbers of individuals would seem to tell the tale of the city's divine charter, with the complex and dense paintings of the Upper Temple spelling out the wars that put its lords in power. The story told would seem to be a cosmic one, the vast numbers

178. Once sewed onto cloth, gold foil disks would have made for radiant raiment. Nearly illegible today (left), the disks bear highly detailed narrative scenes visible only in reconstruction (right). Figures wear Toltec insignia but the deployment of figures, including one with a frontal face, is consistent with eighth-century Maya models.

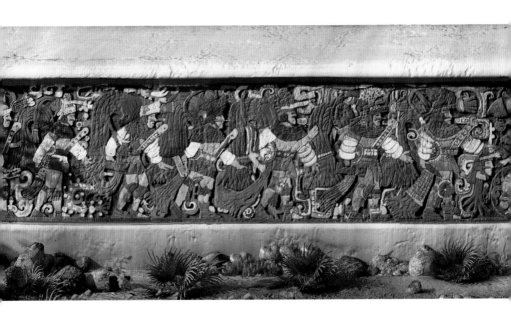

179. As seen in this rendering based on remaining color patches, brilliant colors once brought the nearly life-size figures of the Great Ballcourt sloping entablatures to life. To the right of the oversized ball, marked by a skull, a fruiting vine and six serpents spurt from the neck of the decapitated figure like bloody gouts.

of the defeated recalling both the mass interment of sacrifices at the Temple of Quetzalcoatl at Teotihuacan and the mass slaughter that would take place late in the fifteenth-century dedication of the Great Temple of Tenochtitlan.

Very low-relief carvings line the interior walls of the Lower Temple of the Jaguars and the North Temple. Individual slabs were assembled and then carved *in situ*, before receiving a light coat of paint. In the Lower Temple of the Jaguars, the sculptors relate the creation story once again: the Maize God is reborn within, recorded in registers and at diminutive scale; the supporting pillars depict the aged ancestral deities who make the world's renewal possible. A sacred charter of war and sacrifice may be spelled out here: the tools of warfare dominate the upper registers. At the North Temple, elaborate rituals accompany the seating of rulers, including auto-sacrifice, the ballgame, and hunting. Here vast Feathered Serpents rise up along a central axis, suggesting religious domination underpinned by agricultural renewal from a supine maize deity at the basal register. World Trees and human sacrifice also affirm the early sacred narrative of San Bartolo [208].

The six massive sculptural panels lining the Great Ballcourt recount the aftermath of victories of Chichen lords [81, 179]: it is this success in warfare that leads to the reenactment of the narrative, and that renews the Maize God from the cracked

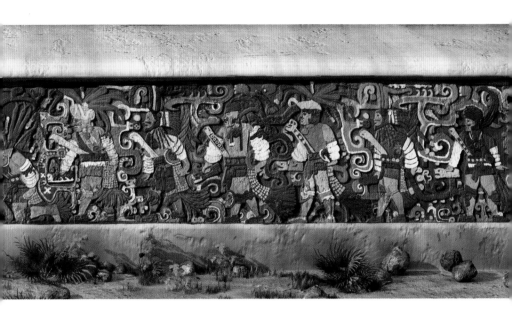

earth time and again, right at the site of the ballcourt.
Like the warrior door jambs from Kabah [175], scrolls fill the
background, suggestive of blood and smoke, or moisture-laden
clouds, like those of Yaxchilan Lintel 25 [146]. Half-round
Feathered Serpents that run above the low-relief panels seem
to come to life through the ballgame sacrifice. Contrary to the
modern myth that was established in the twentieth century and
promulgated by generations of on-site guides and guidebooks,
in which the "winners" were sacrificed by the "losers," the
evidence in these grisly panels is that it is the losers who suffer
decapitation. But there is no progression here, only a static
inventory of six great sacrifices. Each sacrifice takes place over
a great ball, a gaping skull described on the surface. These skull
balls may indicate that the Maya used human skulls in the center
of their rubber balls, thus forming hollows that would give
them some bounce. Some skulls were physically deposited in
the Tzompantli, or Skullrack, just outside the ballcourt, one of
the earliest such racks in Mesoamerica, where such skulls were
surely displayed, commemorated as they are by the rows of
hundreds of stone skulls, all slightly different [82].

Although scholars have tried to develop credible sequences
for construction phases at Chichen Itza based on artistic style,
the material culture itself is vexing, and much of it exciting and
novel in the history of Maya sculpture. A huge carved sacrificial

stone, imaginatively formed as a ball lodged in a ballcourt ring, bears an indisputable date of 864, written in a conventional format. But the imagery – warriors and ballplayers of lanky proportion inside S-shaped feathered rattlesnakes – has often been thought to be from several centuries later, based on characteristics of style and subject matter. Some scholars have even wanted to read Chichen Itza as an immediate prelude to the Aztecs, when clearly it is not. Rather, what we may be seeing are artists of different traditions – from Central Mexico, from other parts of the Maya region, and from Veracruz – developing a style that would have unifying power and imagery for hundreds of years.

Although true of most Maya traditions, the concentrated energy of the artistic program at Chichen Itza is quite astonishing, for everywhere the city was carved or painted, or both. Most sculptures were carved *in situ*, and the very process of production must have filled the city every day with skilled laborers. Across the main plaza from the Great Ballcourt, dozens of columns and piers were carved, forming the colonnade in front of the Temple of the Warriors and the so-called Mercado [83, 84]. Carved benches in the Mercado establish a format that would be replicated time and again,

180. An undulating feathered rattlesnake edges the dais of the Mercado arcade. Below, a priest removes the heart of a sacrificial victim; other captives, tied one to another, await their turn on the stone.

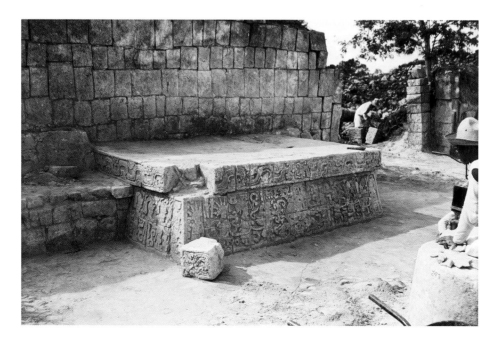

from Tula right up to the Aztec capital at the time of Spanish invasion, with processional figures limned on projecting sides. Like the players of the Great Ballcourt panels [179], warriors differentiated only slightly from one another line up and then meet at the central panel; we now see that most are captives, and they converge at the dramatic site of heart sacrifice.

Three-dimensional sculptures at Chichen Itza

An impulse to three dimensions thrived in the north, as we have seen at Cumpich [171]. In the Puuc region, figures in flayed skins wield star-shaped maces (at Oxkintok) or may have supported thrones (at Xkulok); enormous erect phalluses projected from walls or were set up in courtyards. But the greatest success in this regard was at Chichen Itza, where entirely new categories of sculpture were invented. Many appear simultaneously at Tula in Central Mexico.

Chief among the new sculptural forms at Chichen are the chacmools, serpent columns, mini-atlanteans, and standard bearers, all of which become omnipresent in the buildings of rulership. The chacmool – "great" or "red jaguar" – was so dubbed in the nineteenth century by the workmen of adventurer Augustus Le Plongeon, and the term has come to mean all sculptures of reclining figures with the head at 90 degrees and facing forward, who hold a vessel for offering on the belly. The local workers who coined the term may have retained some ancient lore of a buried red jaguar, although surely one could not have mistaken the reclining chacmool figure for a jaguar! Nevertheless, at least one Red Jaguar Throne was buried at Chichen Itza, and it came to light in 1936, when José Erosa Peniche's men stepped into the chamber at the top of the "fossil" temple buried so pristinely within the Castillo, where the visible temple of today encases a hidden one. In fact, the Red Jaguar Throne with its accompanying chacmool had been sealed in place [181], and the two sculptural forms there and elsewhere – the Temple of the Chacmool, for example – usually function together, the throne the seat of rulership and the chacmool the place of offerings to rulership.

Eventually, chacmools would be found in many places, not surprisingly at Tula and even farther to the north, in modern-day Jalisco, and at Quirigua; later, the Aztecs would create recherché versions for the Tenochtitlan sacred precinct,

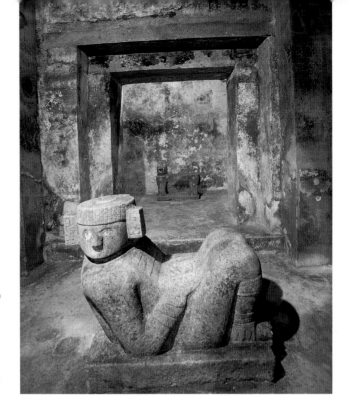

181. Within a "fossil" temple perfectly preserved inside the Castillo, the relationship between the ruler's Red Jaguar Throne and the chacmool is made clear. The chacmool holds a disk for offerings; the ruler would have sat on the turquoise-studded *tezcacuitlapilli*, a Toltec mirror back known from Central Mexico (see also ill. 17).

layering Tlaloc (Central Mexican rain god) imagery onto the chacmool forms. Consistently, through time and across cultures, the chacmool seems to function as a locus for offering, the receptacle on the belly for human offerings, in all likelihood [181]. At the same time, these chacmools bear the iconography of the fallen Mesoamerican warrior, and the disk each holds on his belly is akin to the disk held by the Maize God, where it is the point of renewal and self-replication. Jade plaques hurled into the Sacred Cenote depict the Maize God holding just such a disk. The relationship between warriors and the Maize God is spelled out in narratives across the site: the chacmool may concentrate the ideology of rebirth into the body of a single figure, furthermore making of it the sort of liturgical furniture that indicates ritual function to all comers.

After the decline of Chichen Itza

Chichen Itza's world of so many high-status individuals suffered such decline around 1100 that almost nothing was built, few sculptures made, and only scarce ceramics fired thereafter.

182. A stone turtle from Mayapan features 13 ajaw signs on his back, indicating 13 periods of 20 years, a k'atun wheel of 260 years.

183. Despite the eroded condition, traces of the glyph 10 Ajaw suggest that Mayapan Stela 1 celebrates 10.18.0.0.0, or 1185; the text forms a thatch roof sheltering deities within a shrine. Copan's Stela J also features a stone thatch "roof."

Chichen Itza became a ghost town, although it survived as a pilgrimage destination.

To the west, and probably also around 1100, the city-state of Mayapan came to fore, in the wake of and perhaps the cause of Chichen's decline, although little evidence survives. Regardless of their role in this cultural disruption, the lords of the city sought to cite the past: workers hauled pieces of sculptural facades from the Puuc region to Mayapan, and radial pyramids at Mayapan replicated Chichen's Castillo. In forging their own tradition, Mayapan sculptors turned to both three-dimensional forms, in clay and stone, as well as a renewed stela tradition. Large and small ceramic sculptures present single deities, many associated with agricultural fertility, and the widespread "diving" gods from the period offer tamales or balls of corn dough. Stone turtles at Mayapan [182] register the count of k'atuns, the twenty-year periods celebrated on the round altars of the southern lowlands [151], particularly at Tonina and Caracol: wooden posts for sacrificial rituals may have been fitted into their backs. The stelae at the site configure the carved surface as if it were a house or shrine, the text forming the roof, and gods within [183]. Remains of a stucco chacmool have turned up in archaeological excavation. Given the severity of sequential declines, this renewal in the twelfth and thirteenth century is remarkable, a revival of ancient traditions that survived some very grim times indeed.

In the decades before the Spanish invasion, coastal trading towns along the Caribbean, including Tulum [85] and Santa Rita Corozal, sprang to life, supporting the lively culture that Bishop Landa witnessed and described in the mid-sixteenth century. An exploratory mission under the leadership of Juan de Grijalva spotted coastal Tulum in 1518 and identified it as a trading hub. Prevented by the massive coral reef from venturing close to shore, he nevertheless waxed eloquently over what he saw, comparing it to far-off Seville. Tulum is best known today for its diminutive architecture and elaborate paintings, both described in other chapters; two seventh-century stelae probably were carried there as tribute or perhaps as booty from a Classic site, or relocated from nearby Xelha, where a substantial first-millennium town grew up around a pristine cenote, as precious as the freshwater springs that bubble up along Tulum's beach.

**From the Hand of the Scribe:
Painted Vessels in Maya Art**

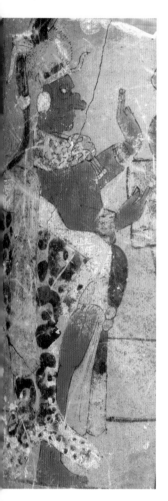

Painted Maya vessels are the most extraordinary ceramic
art of the New World. Although Maya ceramics serve
archaeologists in the usual fashion – as evidence of dating,
like most archaeological sherds – their changing rim shapes
are almost trivial when compared with their surfaces. In the
lively paintings and carvings that encircle their exteriors, Maya
pots provide a window on ancient religion, ancient story-telling,
and even the way art came to be made. They are, perhaps, for
the art historian, one of the most rewarding and least studied
media of the Maya [184]. The only analogous tradition in the
world comes from ancient Greece, where the surviving
ceramics painted by remarkable artists also provide a wide-
ranging picture of religious and civic practices.

The Maya, of course, used ceramics alongside gourds every
day, as small cups for drinking vessels, tall cylinders for storing
and pouring ritual beverages, and plates for delicious foodstuffs,
from tamales to corncakes served up with sauces. Among the
elite, many of these vessels were finely potted and elaborately
painted, and some held foodstuffs even in the tomb, so that a
traveler in the afterlife would have sufficient nourishment.
But the Maya also made pots to commemorate important life
passages: a young prince's transition to manhood, an accession
to kingship, a victory in battle or the ballgame, or the
negotiation of a dowry or marriage. Most of all, when a noble
man or woman died, friends and relatives commissioned new
ceramics that would accompany the deceased into the tomb.
The paintings on the vessels may have been sacred themselves.
These elite and commemorative vessels formed a powerful
visual tradition for a thousand years.

Techniques

Always working without the wheel, the Maya depended on
two basic techniques to form pots, and they sometimes used
them in tandem. Most commonly, artisans built ceramics using
the coil method, although no trace of that technique survives
in finished elite vessels. Sculptural additions, often mold-made,

needed to be carefully attached, in order that no breakage should occur during firing; potters made firing holes into the open mouths of creatures or hid them where they are not visible. The other basic method for making a pot was slab construction, most obviously to form ceramic boxes. Small slabs were carved or stamped before being added to cylinders to serve as tripod feet. Few vessels show any evidence of fire clouds – the dark blotches characteristic of vessels fired in pits – so the Maya must have been firing them inside saggers, protective ceramic vessels designed to protect polychrome slips from carbon deposits.

Various media were used to finish fine vessels. Despite the deceptively high gloss that many of these wares still bear today, the Maya did not invent glaze or glass: like ancient Greek wares, Maya vessels were painted in clay slips made from tested recipes of clays and minerals. Broad slip palettes came into use in the fourth century AD and lasted until the ninth, with results that ranged from mustard to purple, with shades of red and orange in between. Low firing temperatures yielded blues and greens, but these have faded, leaving only lingering grays. Some schools of Maya ceramic painting eschewed the broader palette, notably the Codex-style painters, who used only carbon black, red, and sometimes cream.

At the end of the fourth century AD, post-fire stucco techniques from Teotihuacan were adopted for Maya use. Using a thin, prepared quicklime into which mineral pigments were dissolved, painters developed a broad palette, complete with blues and greens. Common in fifth-century burials, completely stuccoed pots became rare during the Late Classic. Applied post-fire, stucco paint was sometimes used in conjunction with other techniques, particularly carving but also painting. Sometimes the slightest dots of post-fire paint were used to accentuate details; post-fire blue was also occasionally applied to rims, as on the Vase of the Seven Gods [198]. Both deeply carved and lightly incised ceramics were created by Maya artists, more commonly during the Early Classic than later on, and in many cases to render even more fine detail than Maya brushes could create during that era. Maya artists carved leather-hard wares, dipped them in slip either before or after the carving, and then burnished them before firing, yielding solid glossy dark browns and black tones.

Early Maya ceramics

The beginnings of Maya vessels lie in shapes cut from gourds, a reliable and unbreakable source of containers both in the past and today. Eventually the Maya began to make these shapes in clay, and they finished their vessels with rocker stamps or with simple slips.

At the end of the Late Preclassic, Usulutan ware, perhaps from lower Central America, became widespread, its distinctive cream-on-red wavy stripes produced through a resist process entailing the application of slip over designs made in a waxy substance that burned out in firing, leaving the areas that had been covered by wax the color of the clay support. A single-spouted cacao vessel arrived simultaneously, initiating a tradition of specialized vessels for the precious, bitter chocolate drink favored by Maya elites. The Maya soon invented new shapes for these early pots, and many had tetrapod mammiform ("breast-shaped") supports [185].

Early in the first millennium AD, the Maya begin to finish their ceramics with polychrome slips. As this practice became the standard wherever they were also building monumental religious structures, the Maya began to evince a greater sense of cultural homogeneity, in what can be considered one of the markers that the Early Classic had taken root. These earliest polychromes provide evidence of the same clearly defined Maya gods who appear on Preclassic monumental stucco facades and the earliest stone sculpture of the Late Preclassic and Early Classic. Some early mammiform vessels are works of fine potting, as well as painting, and some even employ the practice of imitating other materials (skeuomorphism) that would

185. Tetrapods with mammiform feet are among the finest elite vessels of the second and third centuries at Tikal. This elegant example features textile designs still woven by Maya women today.

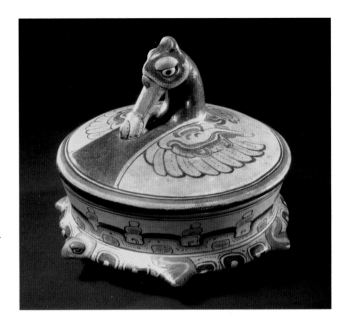

186. Heavy basal-flange bowls characterized fourth-century Peten ceramics, many of them anthropomorphic or zoomorphic. Unusually small and delicate in scale, this example features a water bird – in both two and three dimensions – on its lid and a turtle swimming in water as the bowl itself.

become common in the Late Classic, particularly gourds and other perishable vessels [37, 192, 193].

For most of the fourth century AD, the lidded basal flange bowl – a form that may have entered the Maya inventory when rich tombs became the rule by AD 300 or so – dominated as the most important ritual vessel shape. Some demonstrate a successful hybridization with other forms and adopted the four bulbous – but no longer mammiform – supports. Large, heavy, and rarely showing much wear, these may have been presentation vessels for dedications or for funerals. Typically, the knob took the sculpted form of an animal or human head, its body then completed by a two-dimensional painting flowing across the surface of the lid [190]. The integrated painting and sculptural form suggests that the painters of these vessels were also their potters. Maya artists articulated the various surfaces: the narrow vertical panel of the bowl itself, the large arcing lid, and even the handle and the flange are usually painted.

The most elaborate examples of the basal flange vessels and related hybrids reveal shared religious concepts in works that engage the viewer directly, often by articulation of ceramic elements that must be handled by the user. For example, on a small bowl with matching lid from Tomb I of the Lost World Complex at Tikal [186], the head and neck of a water bird form

the three-dimensional handle, its wings painted in outline on top of the lid. In its beak is a mollusk or snail, visibly being pulled from two dimensions into three. The basal flange has been worked into the body of a three-dimensional turtle who swims through linear undulating dotted scrolls, a Maya shorthand for water. This constant interplay between two and three dimensions forces the viewer to confront the artificiality of artistic renderings; the experimentation between sculpture and painting seems surprisingly modern in its focus on the liminal interface between those two modes of representation. But liminality is also the subject: this watery world occupied by fish, turtles, and predatory water birds is one of the porous membranes of the cosmos, where the actions of those on earth and those in the afterlife come in contact with one another.

Many Early Classic ceramics express such concepts of the cosmos. But a few lidded bowls try to do more, as Maya artists began to articulate sacred narrative across their surfaces. A bowl from Becan [187] features a cosmic crocodile who has just feasted on three humans, their bloody bodies sliding down the lid. Each leg of an unprovenienced tetrapod now in Dallas [188] is the snout-down head of a peccary, the wild boar of the tropics, marked by a long curl that indicates earth. Atop the lid sits a fully sculptural figure in a canoe, his oar poised mid-stroke. His

187. One of the largest Maya vessels ever found, this vessel from Becan features a strange lizard man slipping from two to three dimensions. Severed bodies slide down the lid.

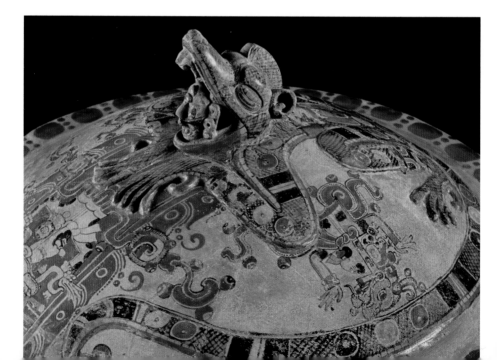

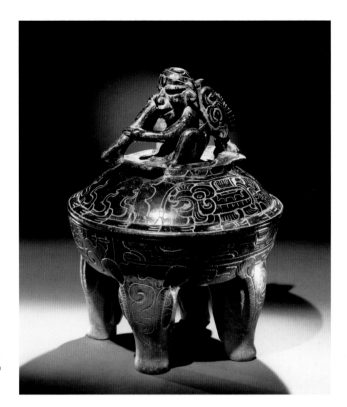

88. Four snout-down peccaries support this lidded vessel, and ing holes double as their ouths. The fully formed monkey ddler on top is a personification the day, making its diurnal rney.

monkey-like features are complemented by the hieroglyph for sun on his head, indicating that he is the supernatural incarnation of the concept of the day, making his diurnal journey across the surface of a world supported by peccaries at its four corners.

More than almost any other introduction from outside the Maya area that can be identified today, the tripod cylinder vessel – almost certainly a Teotihuacan invention – was an instant hit among the Maya [190, 191]. Even before the Teotihuacanos had imposed their will on the Tikal throne in the late fourth century, their characteristic style of pot-making had already worked its way into the Maya repertory of vessels. In the fifth century, the tripod cylinder was the most important elite vessel; by the seventh century, however, the Maya of the Peten and Chiapas made none, although the archaic vessel type still appeared among the inventory of pots depicted on vessels of other shapes, and the form still found favor from time to time in Belize.

A single offering at Becan from the fifth century emphasized the cultural interaction between local Maya and

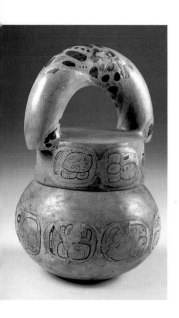

189. One of a small number of "screw-top" vessels known, this example from Río Azul was the first to be tested and to yield proof that it held cacao. The glyph for the valuable substance is at top left. A painted jaguar pelt strip wraps the handle.

distant Teotihuacan, with complex meanings we can no longer retrieve. Within a locally made tripod cylinder vessel sat a large two-part Teotihuacan figure who in turn held within ten tiny solid figurines and a host of jade, shell, and ceramic adornments. Did the Maya themselves perceive the tripod cylinder as the vehicle that had opened the door to Teotihuacan?

Other vessel types entered the Maya inventory during the apogee of Teotihuacan influence, including ring-stand bowls and two-part jars (sometimes called "cookie jars"); the Maya may have been the inventors of the lock-top pot – often described as "screw-top" jars – and other forms that sometimes fell from favor almost as suddenly as they appeared [189]. Testing of the lock-top pot discovered at Río Azul demonstrated that it entered the tomb full of Maya chocolate. Shaped like a very small handbag, the vessel has a handle painted as if wrapped with a jaguar pelt, a sign of its royal ownership. Two-part "cookie jars" made especially effective god effigies, and their interiors may have held precious offerings. One example, from Yax Nuun Ahiin's tomb at Tikal, is an old Underworld god who sits on a stool of crossed human femurs and holds a severed head in his hands.

From Tikal to Copan, the tripod cylinder almost entirely replaced earlier forms in the fifth century. Many were finished with post-fire painted stucco that even in its pastel palette remained close to the Teotihuacan formulas. Like the Teotihuacan vessels, many Maya ones have matching lids, but unlike Teotihuacan ones, most Maya vessels have zoomorphic or anthropomorphic handles, some of human heads that turn the vessel into an upright body. Some vessels, particularly early fifth-century ones, are squat, with proportions akin to Teotihuacan-made vessels; others are taller, with a mid-vessel tapering "waist" that heightens their anthropomorphism.

An example from Yax Nuun Ahiin's tomb sits squarely on its tripod feet, the body of the pot standing in for the body of the man whose mold-made head is the knob [190]. This sort of allusion was also achieved in basal flange vessels, but it became more convincing in the taller tripod cylinders. With knobs and tripod supports that were sometimes mold-made or stamped, these pots were probably easier to produce than basal flange vessels, and their relatively smaller size and lighter weight made them easier to handle without damage.

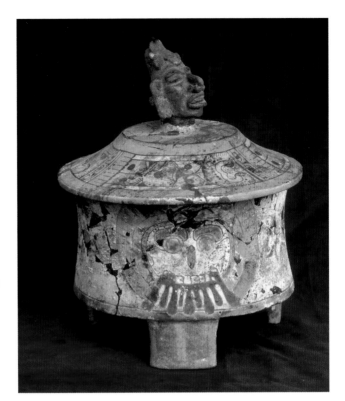

0. Burial 10, the early fifth-
ntury resting place of Yax Nuun
niin and nine sacrificial victims,
used new, hybrid forms of
ramics. The tripod cylinder
d post-fire stucco adornment,
spired by Teotihuacan, took on
new form at Tikal, animated by
man and animal heads. Some
ads were mass produced to
nerate sets of fine wares.

Previously, no surface of the basal flange bowl was
sufficient for any sort of narrative. But with the advent of
the taller and straighter wall of the cylinder, the impulse to
narrative took off. On some tripod cylinders, extremely
complex stories are visually narrated, requiring repeated
turnings in order to grasp the unfolding tale. A vessel in
Brussels shows a lord's transformation after death, with a
trip through the afterlife, past the dormant sun and turtle shell,
the surface of the earth, through which new life is channeled
in the form of the Maize God [191].

The impulse to narration

How can one explain this impulse to tell stories that indicated
protagonists, their deeds, and the places these deeds took
place? No other society in the New World managed to
encode this impulse in visual narratives that encompassed the
supernatural world, the human world, and their settings, with

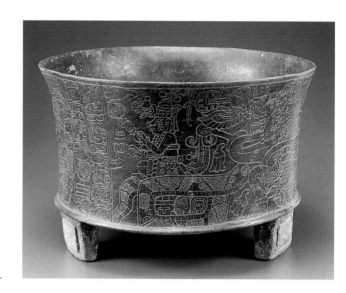

191. A journey through the Underworld wraps around this large and low tripod vessel, beginning with the playing of music just to the right of the text.

regional practices that nevertheless subscribe to a recognizable Maya "style," or way of making. What made the Maya so different? One way to think of how this all happened is to think of the medium and its message as if they were computer hardware and software. A stela is hardware. A pot is hardware. A building is hardware. Software programs these media. Software is the system of iconography. Mayan hieroglyphic writing is software. Software can wreak havoc on hardware, and the desire to use new software drives the invention or acquisition of new, improved hardware. Certainly throughout the Early Classic period, the principal software for conveying the message of Maya religion and history – the writing system – improved. As the writing system became more phonetic and less logographic, it more easily handled temporal statements moving both backward and forward through time; it included expansive lateral statements regarding the gods and their activity. Even though there is some evidence of sophisticated early phonetic spellings, the preference (perhaps of readers, rather than writers) for logographs proved limiting.

When what had been short notations in the third century were replaced in the fifth century with longer, discursive texts, writing reproduced not only facts, but also nuance and detail. In other words, the software for representing language and speech improved, thus putting pressure on the software for visual representation – and consequently the hardware – to

improve as well. Apparently it did improve, as tripod vessels with continuous narratives attest. One particular type of hardware – the basal flange bowl – could not run this new software system and quickly became outmoded. The new form, the tripod cylinder, successfully did handle it, securing the vessel shape's survival for more than a century.

But the tripod cylinder had elements that did not support visual narrative. The vessel knob lent itself to sculptural forms, most of which were iconic and not narrative; the vessel lid offered a space for visual continuity but not narrative continuity. The three slab feet themselves simply kept the body of the vessel off the ground. What had been universally appealing about the tripod cylinder – including its strong associations with Teotihuacan power – no longer held true by AD 600, and the form was replaced by the simple cylinder, with neither lid nor feet.

Late Classic ceramic traditions

In the ceramic art of the Late Classic period, the Maya artist began to portray himself and his role at court [86]: right-hand man to the king, keeper of accounts, and of course, maker of art and writer of records. Reed or quill pens tucked into his hair or headdress, the artist depicted himself as ready for any job that might come his way [200, 204]. And just as the artist began to include himself in the visual record, so he did in the written record, and from time to time a Maya scribe even signed a painted vessel [195]. Even so, the names and genealogy of most Maya artists have vanished. The handful that survive may well be anomalous – but anomalous or not, they offer us key insights into at least some instances of art-making.

Depictions of scribes often feature them in groups, and Maya artists may have worked collaboratively, as did, for example, the artists who carved the portrait of the last Aztec ruler, Motecuhzoma, an event recalled long after the fact in a mid-sixteenth-century watercolor. Maya sculptures that bear signatures often bear several of them, so the notion of working in groups, probably of kinsmen, was probably pan-Mesoamerican. The best-known Maya ceramic traditions can also provide evidence of many artists working together. In almost all cases, a single artist painted an entire pot, from background to details to text, but sitting right beside

him may have been one or more helpers, who mixed nearly identical slips from shared pigments [193]. Another person – perhaps a woman, since almost all Maya ceramic facture today is by women – may have made the thin-walled cylinders. All known signatures are those of men.

Some Early Classic Maya pots bear dedication texts that encircle their rims, but during the Late Classic period, the rim texts became highly standardized. For much of the twentieth century, scholars thought that the painters of Maya ceramics were illiterate. After all, they reasoned, if the inscriptions painted around the rims of Maya vessels repeated the same text through time and across geography, regardless of the scene painted below, wasn't that proof enough of their mindless quality? What, of course, such reasoning failed to consider was that the text might not be directly related to the scene, and when that liberating thought dawned on Mayanists, a new period of understanding of Maya artists and art-making was ushered in. Michael Coe's first hypothesis, that this textual sequence might represent a funerary chant, did not hold, but his challenge opened the door to waves of new insight. Individual decipherments of glyph after glyph in the "Primary Standard Sequence" have made it clear that this text is about the business of making art itself. As most scholars now interpret the rim texts of Maya cylinders, an inscription reads something like this: "It came into being, it was blessed, the writing on his drinking vessel for cacao [or atole]." The text

192. Using a strong – if nevertheless somewhat unremarkable – line, the artist has carved the pot at the leather-hard stage, burnished and fired it, and then finished the vessel with post-fire blue paint. The streaky brown slip yields an appearance of carved tropical wood.

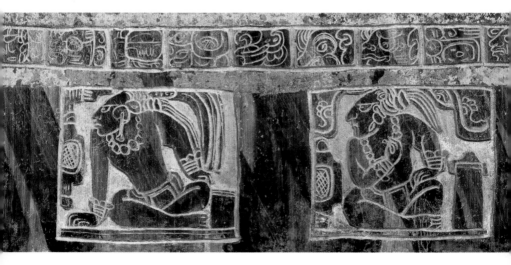

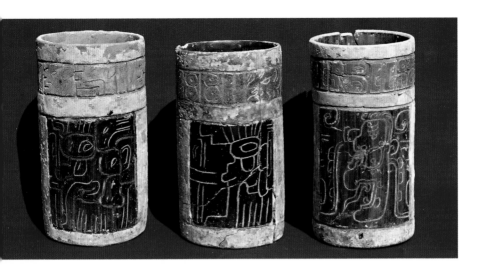

93. These three vessels are part of an amateurish set of twelve pots interred in a chambered tomb at Tikal in 682, all seemingly potted and decorated on the occasion of a royal funeral. The painter of the vessel at right is the most skilled of the entire group, mastering slip that imitates wood before working a sure line across the vessel's surface.

may go on to say to whom the drinking vessel – or plate, another common vessel shape – belongs. Additionally, in a handful of cases, the name of the artist appears. In other words, the long-mysterious text talks about function, patronage, and authorship, alongside captions that identify individuals portrayed and establish relationships among them.

Most finely painted ceramics that survive come from burial chambers, but countless extant potsherds make it clear that many also found their way to the trash. Many more vessels without provenience – hundreds, if not thousands, in museum and private collections – are known than those with archaeological context [94]. Only a small percentage are of the quality of those illustrated in this chapter. An excavated set from Tikal Burial 196, for example, shows no surface wear but an interesting pattern of making: the vessels were potted as a set, the pigments mixed at the same time, and the subject consistent [193]. But the artist of the vessel at right in ill. 193 skillfully applies brown and black pigments to make a streaky wood-like surface that artfully deceives, turning clay into wood – a "skeuomorph" that the worker of the vessel at left only attempts, and where the center vessel fails altogether.

This pattern of mastery – skilled, competent, and essential failure – repeats along all dimensions of the vessels: the rim inscription, for example, runs from legible, at right, to schematic in the others. Most striking is the incision of the deity head, a K'awiil marked as "stone," like the Emiliano

Zapata Panel [12]. Also notable is the calligraphic flair of the example at right, where the line varies from thick to thin, quickly and confidently cutting into the leather-hard clay. By contrast, the image at left depends on broken straight lines, and that of the center vessel depends on a few hard, short lines of equal weight. A family, or a trio of young lords, like those of Bonampak, might have made this set and prepared their contents specifically for the funeral of the Tikal lord. But only one of the vessels succeeds as a demonstrable work of art, even as each fulfilled a role as a receptacle for sustenance for a posthumous journey.

Regional styles

So much unbridled variation is found among the thousands of known Maya ceramics that one would be hard pressed to define the ultimate limits of Maya ceramic painting style [93, 94]. But the best-known styles now encompass dozens of very fine wares, and Dorie Reents-Budet and her colleagues have juxtaposed clay analysis against stylistic considerations, and then aligned those investigations with studies of the hieroglyphic texts, to identify ceramic workshops and their locations.

The names of the sites where these workshops flourished, among them Motul de San José and Nakbe, were not the most prominent of Maya sites in their era. And strangely enough, many of the most powerful Maya states, as known from their public art and writing, provide little evidence of high-quality ceramic workshops. Despite years of excavations, neither Palenque nor Yaxchilan has yielded a significant ceramic vessel, although fine vessels of tecali (cave onyx) are found in the region; and many of the seventh- and eighth-century wares from Tikal are workmanlike, particularly when compared with the extraordinary vessels of earlier times. Furthermore, some of the most exciting centers for ceramic painting may have had little – or in some cases no – monumental sculpture. Nevertheless, some clear regional associations of ceramic painting styles can be made, and the principal workshops are known either by comparison with excavated examples, through chemical analysis of clay, or by identification of place names written into the texts on the pots. A highland Guatemala style is known for its straight-sided low cylinders, painted primarily in reds and oranges, with a chevron border and red rim, and is anchored to

its origin by examples excavated at Chama [203]. A related style probably came from the Motagua River drainage, to the east. A northern Peten/southern Campeche style – probably made throughout the greater Calakmul political sphere – is called "Codex-style" for its characteristic black-on-cream painting of red-rimmed cylinders and plates [199–201]. Motul de San José (which used the *ik'*, or "wind," emblem glyph) was a center of remarkable invention, including the "Pink Glyphs" style [184] and the style known from the Altar de Sacrificios pot [202]– both of which display a flamboyant use of color and manipulation of subject. Both red-on-cream and black-background styles of painting center on the Naranjo–Holmul region.

In many of these workshops the continuous surfaces of the cylinder vessels provided artists with new spaces for their work. Uncluttered and uninterrupted, the vessel walls helped artists achieve new levels of narrative and storytelling. And, just as artists had exploited the interaction between two and three dimensions in the Early Classic, during the Late Classic they explored the potential of continuous storytelling, with amusing twists that force the viewer to turn the pot time and again. While some workshops specialized in historical narratives [34] – and the highland artists may have filled a need created by the absence of stone sculpture – many artists turned to the religious world for their subject matter. Whereas much fourth- and fifth-century religious ceramic art focused on encapsulating cosmic settings, the seventh- or eighth-century vessel frequently provides a window on ancient myth-making; some of the myths are only familiar from the ceramic tradition, but many survived to be included in the sixteenth-century *Popol Vuh*.

Naranjo and Aj Maxam

For works that seem to be highly conventionalized, with a red-on-cream palette and constrained subject matter, the widely known Maize God pots of the Naranjo–Holmul style nevertheless took some strange turns [194, 197]. At Holmul itself, an example of the style features the Maize God dancing within a square drawn within the circle of a plate, as if a manuscript page had landed on the dish. One very large plate (33 cm or 13 in. across), which features set-in low cups and might be thought of as an ancient "chip and dip" server, integrates the other common subject matter of this style,

simple cormorants, all into a single vessel, the pattern and monotonous color making it difficult to read its imagery.

But some Naranjo artists took the craft of painting to new heights. Archaeologists unearthed one very fine example [194] at Buenavista, Belize, part of Naranjo's political sphere, that can be dated to the first decade of the eighth century by the ruler it names. The circumstances of its location and dedicatory text provide evidence that this vessel – also called the Jauncy Vase – was a present to local lords from the Naranjo king. Painted on a tall tapering cylinder, two dancing Maize Gods stand out clearly and even calmly against their creamy background: they move in an anomalous counterclockwise direction, and unlike most examples, these Maize Gods stand quietly, their extended arms the only sign that they dance at all. No frenetic dwarves accompany them, and the feathers of one figure do not overlap the other, nor the text. Traces of blue paint limn the rims. More meticulously drawn than any other example of this subject, the Buenavista Vase also seems less imbued with life.

And yet what seems to be the same artist worked in a very different manner when he painted the vessel known as the "Bunny Pot" [196]. Here the staid workmanship of the

194. (right) Excavated by Joe Ball and Jennifer Taschek in Belize, the Buenavista Vase was probably painted in Naranjo c. AD 700 and bestowed upon a provincial lord as a valuable gift. Like the later works of Aj Maxam, traces of blue-green stucco still remain on the rim. Two Maize Gods dance against a creamy background.

195. (far right) The names and titles of the artist rim the base of this cylinder, and the nominal "Aj Maxam" appears just to the right of center, under the point of one of the floating panels. All texts read left to right, for clockwise turning of the vessel.

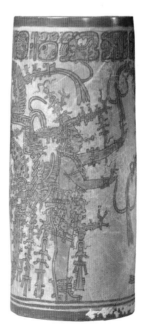

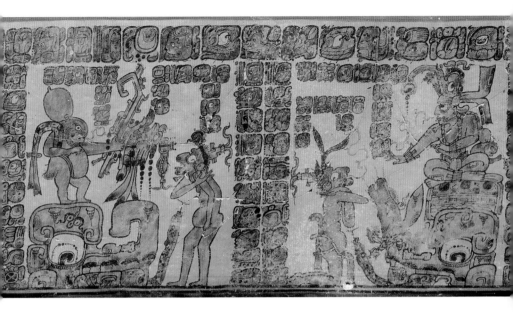

196. Like Aj Maxam, his successor at the Naranjo court, the painter of the "Bunny Pot" worked in more than one painting style, since he would seem to be the master of the Buenavista Vase (ill. 194) as well. Here he indulges his gift for comedy, ridiculing God L, who is stripped and humiliated while the Bunny claims his headdress.

Buenavista Vase gives way to comedy on a vessel painted in a range of earth tones. "That rabbit took my belongings!" claims a nearly naked God L – in an unusual representation of first-person speech – to the enthroned K'inich Ajaw, or Sun God, the words connected to his mouth by delicate scrolls. But what God L can't see is that K'inich Ajaw may have put the animal up to the theft, for the naughty rabbit peeks from behind the throne; on the opposite side of the pot, the haughty rabbit stands on the throne, flaunting God L's trappings.

Toward the end of the eighth century, a Naranjo artist who may have been heir to the Buenavista workshop painted three striking Maya pots of very different styles that all reside at Chicago's Art Institute [195, 197, 198] – and probably worked side-by-side with the author of a few others, including a chocolate pot at the Yale University Art Gallery, and perhaps a tall rectangular vessel known as the Vase of the Eleven Gods. His name is obscure, but he called himself "he of Maxam," a toponym that may have referred to the heart of the Naranjo polity, and so he will be called Aj Maxam here. The three pots may well have come from the same tomb and were probably painted within a very short period of time. Although undated, they can be attributed to the last twenty years of the eighth century by the rulers they name, like those of the earlier generation. These were years of artistic and political ferment: in eastern Chiapas,

a troupe of Maya painters made the Bonampak paintings in the same period [215–218]; at Palenque, by 800, the city and its artists may have been essentially abandoned. But at Naranjo, a star painter made extraordinary paintings and displayed a range of what is an almost unmatched talent. The phrase, *u-tz'ihb Aj Maxam*, "the writing" or "the painting of He of Maxam," appears on the simpler vessel of the three, a black floral design with glyphic panels painted on bare clay, trimmed with red [195].

Most stunningly, Aj Maxam worked in three distinct styles related to Naranjo, a black background style, red-on-cream, as well as his signature work. His success as a multivalent painter recalls the achievements of a handful of Archaic Greek painters, who painted both black-figure and red-figure vases for about a decade. Like the Greek examples, the Naranjo black background and red-on-cream are essentially a positive and negative: the red-on-cream created by drawing the figures and painting them in, and the black background requiring that the artist outline the figures with contour lines and then fill in the background, letting fired clay function as the color of the anthropomorphic figures and their setting. The three cylinders all exhibit exquisite but meticulous calligraphy that, in addition to the identifying tagged name on the pot with simple floral designs, marks them as the work of an individual painter. In his version [197] of the red-on-cream Naranjo–Holmul region standardized imagery of the dancing Maize God (there must be dozens of known examples of this "Holmul dancer" from the area), Aj Maxam gives the old

197. The Maize God dances with his dwarf or hunchback – probably a metaphor for the stunted or fungal cob – three times around the surface of this large cylinder vessel. Aj Maxam's handwriting is readily identifiable: the glyphs over the third Maize God are nearly identical to those over God L's head in ill. 198.

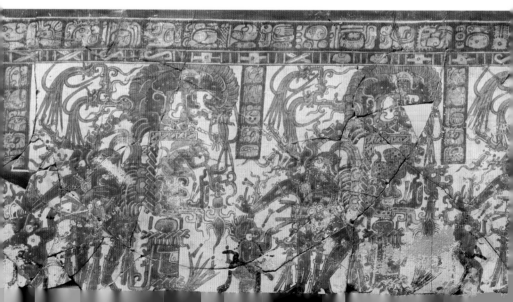

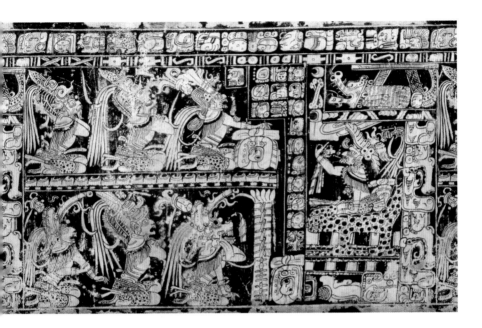

198. (above) On this tall, elegant
vessel known as the Vase of the
Seven Gods, God L reigns over
six lesser deities from his
luxurious palace. Typically, he
wears the muwaan bird headdress
and puffs away on a small cigar.

standard a fresh solution, featuring three Maize Gods, rather than two, and then twisting their bodies so that they truly seem in motion. He has added highlights in a charcoal slip that, painted over the red slip, reads as if it were dark navy blue, like few other examples. Yet on the black-background Vase of the Seven Gods [198], the very same God L who is humiliated on the "Bunny Pot" reigns in splendor from an Underworld palace – perhaps a cave, given the "stone" mountain frame of his throne – over six attendant gods, who present bundles of cloth on the occasion of world-ordering at the completion of thirteen bak'tuns on 4 Ajaw 8 Kumk'u in 3114 BC.

The two most important aspects of the Maya economy were maize agriculture and tribute, whose payments may have been demanded as a result of warfare. The Maya juxtaposed agriculture and trade or tribute subtly. The steady message on elite ceramics of Naranjo praises the Maize God; the more subtle story is that of God L, whose role as the patron of trade and tribute is ridiculed in one generation and seemingly elevated in the next.

Both the Buenavista Vase [194] and the Aj Maxam pots may have been made in the same family workshop, albeit in different generations, working closely for the king, and in various styles. After the Buenavista Vase was fired, stucco was added to its

lower rim, a custom followed by other Naranjo-area pots, including the Vase of the Seven Gods [198]. Interestingly enough, the tall, tapering proportions of these two vessels are also nearly identical, despite having been made as much as seventy-five years apart. Painting styles apparently changed more quickly than the styles and shapes of vessels, which may have been a more conservative backdrop.

Taken as a whole, the range of this Naranjo workshop is extraordinary. Across generations, sharply differing styles emerged from a single hand; the range of patrons also makes it likely that there are other masterpieces by his hand: although some Naranjo tombs have been sacked and looted, there may yet be archaeological treasures to come to light.

199. From within his lavishly appointed chamber, an aged and humanized God L distracts himself with five beautiful young women while an execution transpires on the other side of the Princeton Vase. One of the great masters of Codex-style painting, the artist of this vessel used a light wash to create subtle visual effects. The rabbit scribe in the foreground busily writes in a jaguar-covered book.

Codex-style vessels

Particularly in the regions of Calakmul and Nakbe, Maya artists painted vessels with fine black line on creamy backgrounds, sometimes using a thinned black wash for detail, and rimming them with red paint in what has come to be called "Codex" style [86, 87, 199–201]. Centuries later, near the time of the Spanish invasion, the Maya limned their books with black and red writing on off-white stuccoed pages [227, 228], closely resembling some

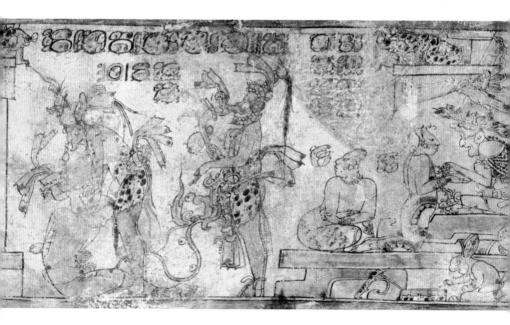

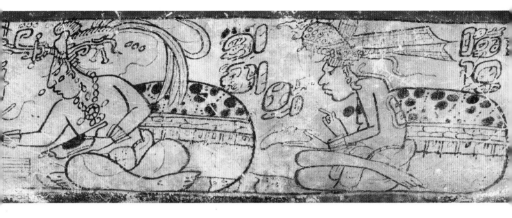

200. (above) Both the Maize God and the Monkey Scribes frequently appear on Codex-style vessels, often with laconic texts. Here the Maize God is also scribe, perhaps giving instruction in the family business to one of his sons, a Monkey Scribe.

of the all-glyphic pots that make reference to Calakmul. The Aztecs, who painted their books with a wide range of colors, nevertheless used what may have been an ancient metaphor – "the black, the red" – to refer to the concept of writing, as if this Mayan writing were the origin of the expression.

The makers of these vessels may well have had a clear sense of their own role in the making of art and writing, for the supernatural patrons of art and writing are a common subject in Codex-style vessels. Ill. 86 shows us hideous Monkey Scribes, writing frantically in open, jaguar-pelt covered books, their hands bound, perhaps to hold their writing implements securely. Skilled in scribal arts, highly educated, and keepers of many written secrets, scribes may have felt truly vulnerable at court, the Maya equivalent of Shakespeare's "the first thing we do, let's kill all the lawyers"; they may well have kept their heads down and promoted their kinship to clever but mindless monkeys. Yet the Maize God – the father of the Monkey Scribes in the *Popol Vuh* – only occasionally appears as a scribe, but it makes sense that he would be one, since Maya children would pursue the work of their parents. The idea that writing is the family business runs widely through the Codex-style pots. The Moon Goddess, too, is a relative of the Maize God, for she wears the Maize God's attire, particularly the beaded skirt and belt ornament – dress worn by many women in monumental art as well. Her most notable progeny is the rabbit, which may accompany her, perhaps as a spy, to the court of God L, the nemesis of the Maize God, as rendered on the Princeton Vase.

On the Princeton Vase, a distracted old God L dallies with five beautiful young women in his palace, adorning them with

jade jewels, perhaps stripped from the Maize God, since he also seems to have hidden the Maize God's belt ornament in his lap. At the same time, a rabbit scribe busily records notations for the palace. Meanwhile, on the other side of the pot, two oddly disguised characters decapitate the Maize God. They might be the Hero Twins, in disguise, in a mythic episode where they carry out sacrifices in order to convince the Underworld gods to volunteer for their own demise. Despite some modern restoration, the Princeton Vase is an ancient masterpiece, for the fineness of its line, the effective use of wash, and its compositional complexity. Although the style relates to the making of Maya books, the composition here is designed to

201. Hunahpu and Xbalanque bring their father, the Maize God, back to life from a cracked-open turtleshell on the surface of this presentation plate. Subtle wash suggests atmospheric effects; the clean red rim provides visual definition.

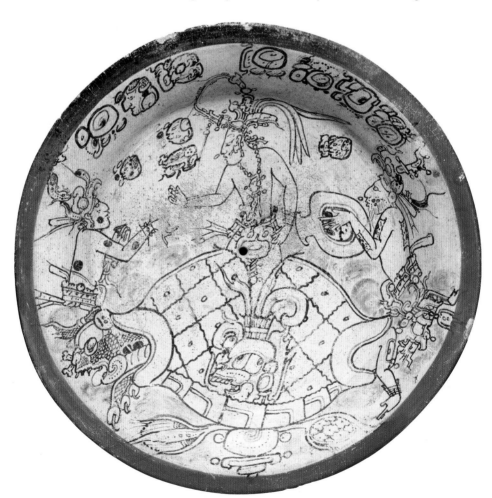

202

work most effectively on a continuous surface: the woman farthest to the left tickles the feet of the woman who kneels in front of God L, as she tries to draw her attention to the scene of sacrifice on the other side. The result is that the observer of the pot turns it in his or her hands, reading the story around continuously, and clockwise; the text above reads from left to right, or counterclockwise, resulting in the turning of the pot in both directions. The artist has drawn the five elegant women as if they were moving through slow motion or even stopped action, caught one frame at a time, the brush or pen lingering over the sensuous curves of their bodies.

The narrative range of Codex-style vessels is vast, and many of the stories related on their surfaces occur nowhere else. Common subjects include the Death of the Baby Jaguar, known from a frequently reproduced example at the Metropolitan Museum of Art, and scenes from the life of the Maize God, whose rebirth is vividly painted on a plate at the Museum of Fine Arts in Boston [201]. On this plate, one of the supernatural Hero Twins, Xbalanque, waters his father from a large vessel, while the other, Hunahpu, extends his hand in invitation, as if to call him up out of the turtleshell symbolizing the parched, cracked earth. Perhaps nowhere is the pious filial relationship more dramatically rendered, and one can easily imagine the political utility of such imagery on a gift to an aged sire.

The two faces of the Ik' pots: Pink Glyphs and the "Altar" style

Only two or three late eighth-century monuments at or near the site of Motul de San José on the shores of Lake Peten-Itza feature an emblem glyph with a main sign of *ik'*, meaning "breath" or "wind." Despite such a limited presence in stone, this emblem glyph commonly appears on ceramics from the site, and several ateliers of painters may have worked there, with particular success in the Late Classic [184, 202]. At Motul de San José, the ceramic record may have had as much validity as stone, for particular rulers and their rites of passage are portrayed on painted vessels.

The Pink Glyphs vessels are known for the unusual rosy tones used to paint the hieroglyphic texts, but the mix of these bright and subtle tones has not always worn well, and many texts have eroded. A number of different artists worked

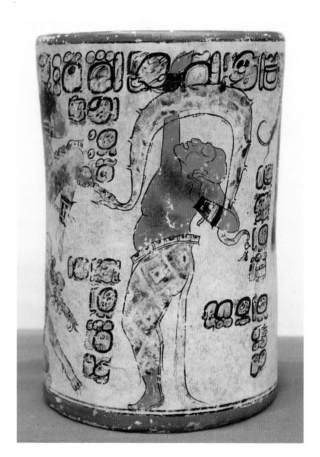

202. A painter at Motul de San José made this work, a gift to a lord at Altar de Sacrificios; hence the name "Altar Vase." One of the greatest of Maya ceramic painters, he worked with delicate brush and visual panache, pushing the hand of the snake dancer right through the painted ceramic rim text in a self-conscious flourish. Note how the dancer balances on the balls of his feet.

together on these pots, sharing pigments and slips, but with different results. Many artists rendered scenes of sacrifice unusual in ceramic art – almost as if they wanted to demonstrate to posterity that the Maya really did perform penis perforation or wear giant jaguar suits. Some feature a character nicknamed the Fat Cacique, who usually watches others make sacrifices. Some of the painters rendered all the principal figures with cutaway masks, as if the viewer had x-ray vision to see through the disguises of the ceremony. All offer fresh views into life and rituals at the Maya court.

In 1963 Richard Adams unearthed an extraordinary Maya vessel at Altar de Sacrificios that bears the *Ik'* emblem, probably a gift or payment from a distant Motul de San José lord [202]. Painting in mid-eighth century, the Altar Painter aggressively created dramatic settings in part by violating glyphic boundaries,

the fluid hand of a snake-suited dancer penetrating the painted text. As scholars subsequently determined, each figure on the Altar vase bears a text that identifies it as a *wahy*, a supernatural spirit or dreaming companion of a Maya lord or polity, suggesting that these strange alter egos may have gathered together in an alternative consciousness, much as the lords may have gathered in the real world. Dangerous and mischief-making, these spirits may have unleashed the creative imaginations of Maya painters. Here, as he applied the slip, the painter let color pool on bodies, creating a sense of volume and depth while rendering dramatic foreshortening. An equally masterful artist painted the Black Background Vase, giving three-dimensional form to his backlit human figures, rounding their bodies with deft shading via a technique Michael Coe terms "reverse chiaroscuro."

The Altar painter would have learned from predecessors at Motul: early eighth-century painters in the tradition mastered the rendering of schematic architecture on vessels at Dallas and Dumbarton Oaks. The Altar painter himself worked closely – perhaps sitting side by side in a family workshop – with another extraordinary painter to whom a closely related group of three pots in the Princeton University Art Museum can be attributed. The swirled orange and white interiors suggest the Usulutan wares of hundreds of years earlier, present as well in a later set, possibly from the beginning of the ninth century, excavated at Ceibal and probably among the last of the *Ik'* wares. A great tradition came to an end.

Chama and Motagua region vessels

Some regions of the Maya highlands, particularly along the drainage of the Chixoy River, part of the Usumacinta River system, saw the rise of fine vase-painting traditions, although no great Maya cities – and no monuments – are found there. Still, powerful lords lived there, and when they died, they took finely painted ceramics with them to the tomb. Many simple subjects were painted time and again on straight-sided cylinders, often low ones, and on gadrooned cups, a shape of vessel based on the gourd and rarely occurring in the lowlands. Brought from Guatemala to Philadelphia many years ago, the Chama Vase is among the most familiar of Maya pots [203]. White chevrons on black ground trim both the upper rim and lower margin of the cylinder, probably a replication in paint of

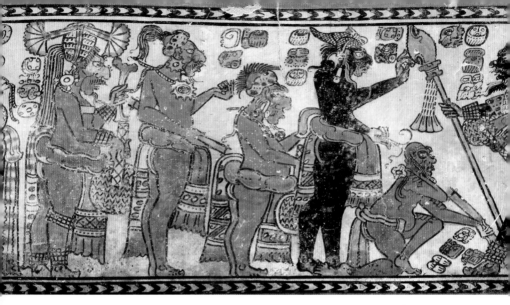

203. Chama-style vessels usually have perfectly straight sides, unlike the tapered cylinders of the Maya lowlands. The chevron border, possibly a reference to feather trim, is characteristic of the region.

the feather borders that often edged Maya attire. The subject once again is trade and tribute, as two Maya merchants, dressed in the black body paint of their Underworld patrons, engage one another. Typical of Chama painting are the exaggerated facial features and pronounced buttocks and ankles. Other Chama pots depict supernatural bats, single deity heads, animals playing musical instruments in processions, and scenes of Pawahtun, an old Maya god who lived in a shell.

The highland site of Nebaj yielded the exceptional Fenton Vase [204] about a hundred years ago, but the discovery of

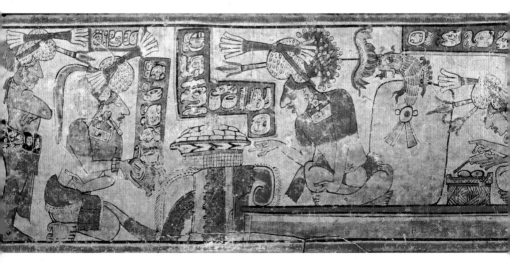

other vessels in similar style has now led to the determination that the workshop lay near San Agustín Acasaguastlan, in the upper drainage of the Motagua River. The vases in this style all tell of the warfare and tribute payments of the region, and the owner of the Fenton Vase may well have been a tribute-paying lord to distant San Agustín Acasaguastlan. On the Fenton Vase, record keepers tally the sums, while the lord examines the bolts of cloth and basket of tamales in front of him.

Other styles of Maya ceramics of the Late Classic period occur in too many sizes and styles to categorize them all. Large, heavy plates with stylized birds of prey were painted throughout Campeche. Several styles flourished in Belize, at least one of them with a looser use of line than elsewhere. Copador wares, made to the south of Copan, use only "pseudo" glyphs, as if in imitation of more typical ceramics of the period.

Northern ceramic traditions

204. One of the best known of all Maya vases, the Fenton Vase of the British Museum features the presentation and recording of textiles, foodstuffs, and spondylus shells. Although made at some distance from the great Maya cities, the vessel celebrates the lavish courts and extravagance widely known in the eighth century.

Maya artists of northern Yucatan painted ceramics, and polychrome plates featuring birds of prey are particularly common, but in the eighth century a distinctive style of carved wares was favored by the rulers at Xcalumkin and Dzibilchaltun, who commissioned fine pots that may have come from the city of Chunchucmil, according to the latest work from Reents-Budet and her colleagues. Long called Chochola vessels after the name of a nearby town, ceramics in this style are cups, straight cylinders with slightly flaring rims, or cylinders with rounded bottoms, and were made at more than one site [7, 205]. Although their carved surfaces may seem to be the dominant characteristic, a number of other features also pertain. Many show carved imagery only on one side and are paired with text on the other – often in a diagonal column; others are paired with resist patterns, or a combination of the two. Yucatan was known for its honey and wax production, and some of the wax was used to produce the resist designs. An extraordinary example in a less familiar style takes the shape of a deeply grooved squash and names the king of Xcalumkin in a carved text.

The technique of carving may have put constraints on the ability of the artist to render action, and although there are lively images of two or three figures, more typically a single figure is rendered. The K'awiil of ill. 205 has been reduced to key iconographic elements; he is seemingly disembodied, but

205. In Yucatan, a carved style of pottery – usually called Chochola – was made near Xcalumkin, in modern-day Campeche. On this particular example, K'awiil floats up from a waterlily; on the back, batik-like resist patterns run under a primary standard sequence.

reversed right and left hands emerge from the water scrolls below. Carved into the background is elaborate cross-hatching, perhaps shorthand for agricultural fields. The reverse is marked by both text and seemingly evanescent resist patterns, like traces of lost gauzy cloth.

206. Despite their shiny surfaces, Plumbate vessels used no glaze but only the technology of oxygen reduction during firing. Found from Tula to Chichen Itza and a host of other locations, the pottery is characteristic of the Toltec era. Here the form clearly depicts the Maya god Pawahtun, aged and wrinkled, inside his shell.

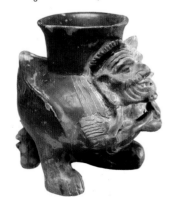

Plumbate and the ceramics of the Postclassic

New ceramics appeared late in the ninth century across the entire Maya region. In Guatemala and Chiapas, mass-produced Fine Orange pottery from Tabasco began to appear, with uniform stamped-in designs turning up at disparate locations, from Veracruz to the Peten. New vessel shapes also took hold: small cups and low bowls became common, as did ring-stand vessels of various shapes, some bases supporting straight-sided cylinders, others with tapering or bulbous containers [207]. This effort at mass production may have accompanied new rituals: at Chichen Itza, for example, feasting may have taken on new value, and thousands of ring-stand vessels may have been needed for public use. An example at the Yale University Art Gallery may have come from Chichen Itza or its environs. K'awiil is featured on both sides of the pot, carefully incised prior to firing. Multiple vessels of this shape were deposited in caches at Chichen Itza; the consistency of size and shape made for ease of shipping.

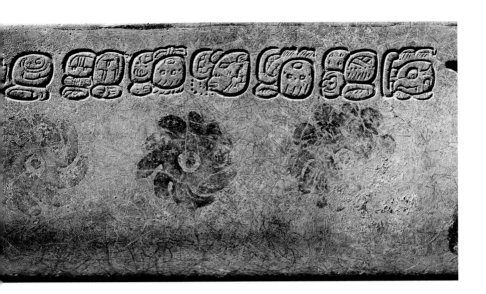

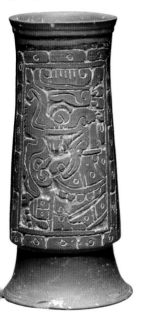

207. (below) About AD 900, fine-orange ring-stand vessels became common in Yucatan, but manufacture may have taken place in Veracruz or Tabasco. The imagery depicts K'awiil, a common Maya subject (see ill. 193).

With the rise of Toltec civilization and widespread metallurgy in Central Mexico, a new ceramic style, manufactured along the Guatemala–Chiapas border, came into widespread production. Called Plumbate, the ware's shiny surfaces emulate metal and develop when oxygen is cut off – or reduced – during the firing process. Many Plumbate vessels are zoomorphic or anthropomorphic effigies made with molds [206]. Single figures, they cannot provide narration for religious ceremony in the way that painted cylinder vessels can. Nevertheless, some Plumbate vessels display Maya gods; one, for example, features Pawahtun, with his unmistakable traits: a craggy, aged and hunched old god who stands within a shell, and a unifying religious subject among the Maya from the earliest times until the Spanish invasion.

Maya ceramic artists mastered a kind of alchemy, transforming humble clays and dull pigments into works of permanence and beauty. The ability to render the foreshortened human figure in action along the continuous loop of the cylinder was another sort of magical transformation, one that compressed narrative with a few strokes of the brush, imbuing the basic materials with time and duration. The absence of central political authority served the Maya well during the Late Classic, allowing for the development of regional styles; in turn, some of those styles attest to among the greatest achievements of ancient Maya art.

Chapter 9 The Splendor of Colors:
The Art of Murals and Books

Perhaps nothing has been so confounding to received wisdom about Maya art as the 2001 discovery of a nearly complete program of painting dating to around 100 BC at San Bartolo, Guatemala. What is now absolutely clear is that painting developed alongside monumental sculpture in the Maya lowlands, a tradition that remained unabated until the Spanish invasion, and a steady stream of discoveries in the twenty-first century confirms the extraordinary quality of Maya painting. Even as the full picture of San Bartolo was revealed, archaeologists in Mexico in 2004 came upon equally stimulating Late Classic paintings in the North Acropolis at Calakmul. The only certainty is that the picture of Maya painting will continue to change.

Often called frescoes, Maya paintings are applied on dry or moist stucco, and are usually dependent on vegetal gums, rather than true fresco, in which wet stucco is impregnated with pigments. Maya painters also worked in other media (ceramics having been covered in the previous chapter), and books and textiles were painted in all periods, but few traces of them are extant today.

Within a given art tradition, we sometimes have the sense of "fast" and "slow" time, a subject of keen interest to George Kubler many years ago. Bound by technique, material, the notion of vertical shaped shaft, and the formal subject of the ruler, sculpture makes slow stylistic changes. But painting is more "intuitive," as Daniel Kahneman has characterized "fast" time, the hand conveying the deeper will of the brain fluently, more so than the mind might consciously express. Sculpture lags behind, repeating known patterns in "slow" time, engaging in dialogue with itself. Furthermore, representation of the king requires a conservative approach, in order to emphasize and underscore ancestors and continuity. But as walls for painting became available, they were of different size and dimension, inside and outside the building, providing a changing environment, ever-challenging to the artist, and opening up new vistas for multifigural composition: the fast time of painting could race ahead of the slow time of sculpture.

San Bartolo in the Late Preclassic

As William Saturno's team discovered, artists at San Bartolo began painting as early as 400 BC, when they created monochromatic red paintings, 300 years before the now-famous paintings of the Pinturas building [208, 209]. Around 100 BC, artists and their patrons embarked on an ambitious new program for the Pinturas building, crafting a series of paintings that wrapped the interior walls, and that record key religious narratives: the life of the Maize God and the establishment of World Trees. The two intersect directly across from the entry to the room, where the Maize God establishes his own tree, the pillar at the center of the universe. To the right, the young Maize God grows in the Underworld, where he plays music and

208. On the west wall at San Bartolo, Hunahpu – marked by the spot on his cheek – pierces his penis before sacrificial offerings and a World Tree. Featuring an *ajaw* glyph, one of the earliest Mayan inscriptions found in the lowlands is carefully painted above. A woven mirror back on his hip sports a jaunty bird.

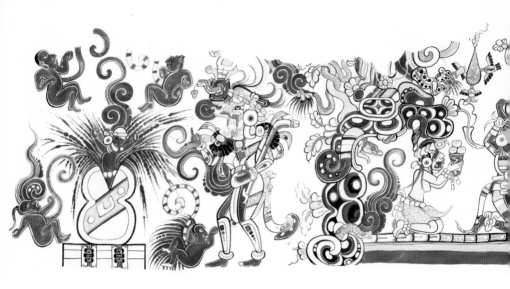

209. With didactic clarity, the painters of San Bartolo enunciated Maya mythic origins. Here, four maize maidens kneel and attend the Maize God within a cave formed of serpent maw and speleothem; male attendants bring a gourd and thrones. At left, five bloody babies burst from a split gourd.

dances; to the left, four more World Trees grow, as young gods pierce their penises in front of them. On the North Wall, five babies – possibly referring to the first human lineages – burst from a split gourd, and the Maize God, along with male and female attendants, retrieves corn and a flowering gourd from a cave, certainly the Mountain of Sustenance, while additional males bring him thrones for his annual reign.

The religious narratives here are mature ones, and they remained fundamental to Mesoamerican belief at the time of the Spanish invasion. The artistic practice is equally established: like later muralists, artists mapped the entire program with a light red sketch line on the smooth, fresh plaster. The consistency of scale and spacing suggests the precision of the grid that must underpin the project, even if no trace of it survives. Artists applied colors and then finished the painting with a dramatic carbon line, leaving an unpainted crisp margin between the red color field and outline of human and animal bodies, enhancing legibility for the viewer. Heather Hurst has studied the paintings as well as reconstructing them, identifying the careful practice of the Maya artists and identifying three distinct hands, perhaps a master with two students, who worked collaboratively; to the south, at Cival, in a contemporary setting, Hurst has seen similar practice, with renderings of Maize Gods at a similar scale. A Maya tradition of painting circa 100 BC had fully launched.

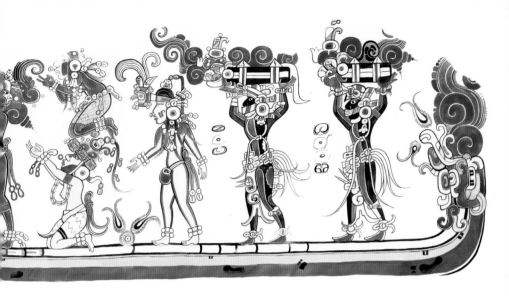

The Early Classic

Early Classic murals survive primarily in tombs, and paintings for the tomb in this period may principally have been monochromatic: such is the case at Palenque, Río Azul, and Tikal. The simplest of paintings is found on the walls of Burial 48 at Tikal from AD 457, where the artist quickly sketched out his program in charcoal on dry white stucco and then painted over the lines with black carbon paint, leaving drips and blobs in his haste [210]. Framing a Maya date that probably records the date of death, the stylized symbols create an ambiance of sacred essence for the Maya – here, apparently, the watery

210. University of Pennsylvania archaeologist Linton Satterthwaite inspects the painted inscription of Burial 48, a record of 457 in bar-and-dot numeration, 9.1.1.10.10, presumably the date of death of the tomb's occupant, Sihyaj Chan K'awiil. Symbols of precious liquid also were hastily painted on the walls.

world through which the deceased must travel, and whose precious droplets nourish the Maize God or king's rebirth [11]. Far more exactingly executed are the nearly contemporaneous tomb paintings at Río Azul, painted in red with black highlights. Some feature paintings that wrap around protruding stalactite-like formations; others limn stucco surfaces carefully cut into the limestone bedrock. The paintings of Tomb 12 [211] consist of eight simple and very large glyphs, two to a wall – but what astounded Maya scholars about their discovery was that they recorded the cardinal points of the Maya world, indicating north, east, south, and west, like points of a compass. The interred was then at the center of the cosmos, a symbolic pillar of the universe, and destined for resurrection in Maya cosmology, much like the central tree of K'inich Janaab Pakal's later tomb. At Palenque, an early tomb in Temple 20 depicts nine painted guardians, also like Pakal's tomb, but rendered exclusively in powerful shades of red.

Rich polychrome painting in a palace context is now known at La Sufricaya and Xelha as well as from Uaxactun, suggesting a broad but largely unknown polychrome tradition

211. In Río Azul's Tomb 12, pairs of painted red glyphs mark the cardinal directions. Karl Taube and colleagues interpret the first glyph of each pair as a directional avian deity; the second names the direction, here east (*lak'in*) at left, and south (*nohol*) at right. A black text at the top of the east wall notes the burial – *muhkaj* – of the tomb's occupant.

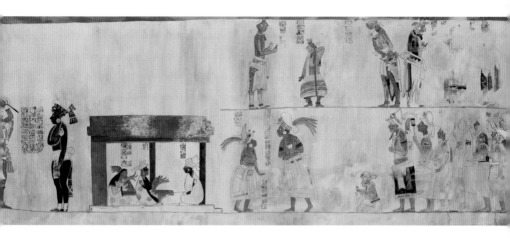

212. On an Early Classic Uaxactun bench painting in Structure B-XIII, women grieve at a vacant throne within a small structure; in front of the house a lord in black body paint receives a warrior with a dart thrower. At far right, musicians process, with gestures like those of the later Bonampak murals.

in the fifth and sixth centuries. In 1937, a single extended painting encompassing various scenes was found at Uaxactun [212]; flanking one side of an interior doorway, it was presumably part of a larger program that had fallen from the matching wall. Stepping through the doorway, a noble would have stood in the throne room of one of the most important Early Classic palaces of Uaxactun, a building similar to Chak Tok Ich'aak's Early Classic Palace of Tikal. Underneath the paintings was a running 260-day count, the ritual calendar of divination characteristic of many Mesoamerican books known from the time of the Conquest, a thousand years later. Events are punctuated along the linear day count, and perhaps correlate with the elaborate figural scene above. Framed by a broad red outline, as are Maya books, the Uaxactun painting gives a sense of what a Maya book of the period would have looked like.

The figural program above features vignettes of the court at about one-quarter life size, and they reenact the rituals that would have taken place within the palace. A visiting warrior in Teotihuacan dress receives a cordial welcome while lords prepare for bloodletting. Like the Bonampak murals, those of Uaxactun include numerous musicians. These musicians demonstrate the great skill of the painters, for the figures overlap one another, and a single musician turns to the man behind him, in part of a formula for the representation of musical retinues that would be repeated 300 years later, at Bonampak. And like Bonampak, there might be a problem with succession: women gather around an empty throne.

Late Classic paintings: Calakmul, Bonampak, and beyond

Early travelers to the Maya region spotted fragments of murals in high vaults, and they hoped that extensive painted buildings would be found. Discoveries at Calakmul in the twenty-first century, alongside the paintings known at Bonampak and from the Puuc region, as well as the cave paintings at Naj Tunich, are beginning to frame a picture of a remarkable tradition, and although survival is enigmatic and surprising, the expectation of explorers a century ago has begun to be fulfilled.

At Calakmul in the seventh century, artists painted a radial pyramid in the center of a vast plaza with larger-than-life figures who animate the risers in pairs or in threes, all naming the individuals with glyphs that read, for example, "atole person" and "tobacco person," titles appropriate for market purveyors [213, 214]. Comparable to the techniques Maya painters used for centuries, artists sketched in red, painted in colors, and then finished with a black outline. The imagery, with its thick red border and narrative content, bears a clear relationship to Maya painted ceramics from the seventh and eighth centuries. The representation of the human form, including the energetic and powerful standing female figure in a gauzy blue dress, cannot easily be distinguished from painted ceramics of the period: the man who lifts an inscribed blue *uk'ib* ("drinking vessel") to his lips or the woman who takes the large water jar feature the animated and flat hands common to ceramic painting. Almost

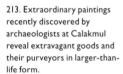

213. Extraordinary paintings recently discovered by archaeologists at Calakmul reveal extravagant goods and their purveyors in larger-than-life form.

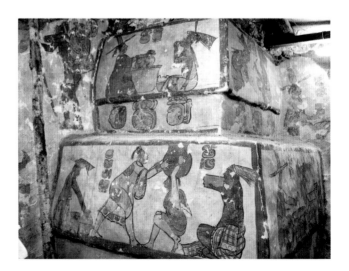

216

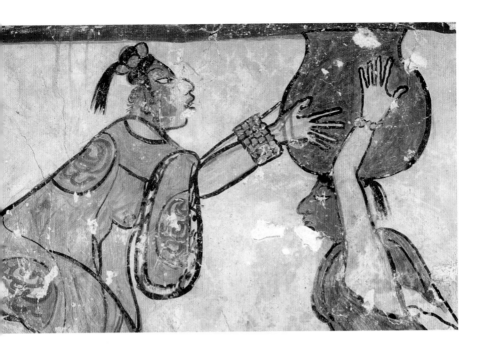

214. A detail from Calakmul reveals the artist's attention to the human form, beginning with a sketch of the voluptuous woman's body with red paint and finishing with her fancy blue dress.

impossible to imagine within the framework of Maya sculpture of the period, such a work fits within a tradition encompassing the Uaxactun painting and what we know about ceramics.

Here we see the Maya artist in easy mastery of the human form, from panel to panel, all in an invitation to sample what is on offer, and simplified for easy viewing at distance, providing a window onto activities rarely preserved elsewhere: one man serves bean gruel while another drinks; the weight of the heavy vessel shifts from the woman in blue to the servant in dun dress. The gauzy blue cloth with its intentional transparency that reveals the voluptuous female body shares commonalities with the group of enthroned women in Bonampak Room 3, but here, the artist has paid particular attention to the breast, right down to the nipple, along with the soft curves of the torso. The artist has adorned almost every figure with a blue-green element or other color highlight, so that at least a tiny daub of the brilliant color is carried from figure to figure to bespeak luxury to the viewer from below. Although repainted various times – one wonders at the shelf life of these paintings, fully exposed to the elements – the building was encased in a much larger one by within a generation or two, the remarkable walls preserved within.

Bonampak

A number of buildings at Yaxchilan had long been known to
preserve traces of polychrome in the vaults, a clue to what
would come to light in 1946, at Bonampak, just 26 km
(16 miles) away. Painted in a small three-room palace for
its dedication in 791, the Bonampak paintings of Structure I
[92, 215–218] acknowledge a relationship between these centers
and the victory they shared, although the text of Room I
explicitly states that the building itself belonged to the king
of Bonampak, Yajaw Chan Muwaan – who may no longer have
been alive when the building was completed.

Structure I was painted inside and out, although little
remains of the exterior ornament. Just below the cornice runs
a long text, probably once consisting of nearly a hundred glyphs,
framing the outside of the building in the same way that a Maya
vase rim text frames the vessel. The unusual architectural design
of the building also provided for the viewing of the paintings;
observers can sit on wrap-around built-in benches within each
of the three separate chambers, and these benches also protect
the colorful walls from casual damage.

The Bonampak murals stand out from all other Maya
works of art for a number of reasons. First, the paintings depict
literally hundreds of members of the Maya elite, in the most
realistic representations that survive of many rituals known
otherwise only from texts and laconic representations. As a
result, the paintings are frequently the illustration called upon
for so many aspects of ancient Maya life – from social
stratification to warfare to palace life – without regard for the
nature of the paintings themselves. Second, the paintings are
scaled at one-half to two-thirds life size, so they create a lifelike
environment for the viewer sitting on the benches. Few other
ancient Mesoamerican works are so experiential for the
modern viewer as well. Third, the paintings reveal emotion,
particularly in the rendering of the captives in Room 2. Emotion
and humor feature in the painting of ceramic vessels, but no
other monumental work so captures the spirit of agony and
victory from ancient America. And finally, although several
artists worked on the paintings, some, particularly the masters
of the north walls of rooms I and 2, were extraordinary in
their ability to render the contours and movements of the
human body. The three rooms can be read in sequence, from
rooms I to 3, although Room 2's battle took place first, and

this room was also the largest and its bench the highest: it would surely have served as the throne room from which the most important lord would preside. In sandwiching the room celebrating battle between rooms celebrating additional dynastic events, the paintings also provide a united, harmonious narration of a world that seems simultaneously fractured by war and sacrifice on the eve of the Maya collapse. Bonampak painters, like those at Calakmul [214], sketched the program in red line, developing a unified scheme across the three rooms.

Room 1 features the introductory notation ("initial series") for a Mayan text, indicating this room's likely primacy in the reading order. Above the text, lords in white mantles – some of whom are explicitly titled *yebeet*, or "his messenger" – approach a royal family assembled on a large throne, including a small child whom a servant holds up to the lords. A bundle to the right of the throne bears glyphs that identify the contents as five 8,000-bean counts of cacao, a substantial tribute or tax payment in a world where the cacao bean was one of the few standard means of exchange. The lords, then, are paying tribute or taxes and cementing their loyalty to the royal family at the same time.

215. Bonampak, Room 1, east and west walls, AD 791. A royal family gathers in a throne room at upper right, with piles of tribute at their feet; across the room, at left, messengers travel to rituals at the site. Parasols mark the beginning and end of the text – which also runs across the south wall, not shown here – framing it like colophons. Musicians at lower left and regional governors attend members of the court. Reconstructions by H. Hurst and L. Ashby.

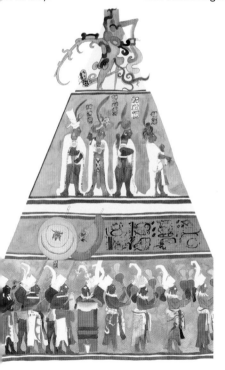

The damaged text below notes that the Yaxchilan ruler supervised a key event, an installation in office, and also states the dedication of the building in 791. It seems likely that a tomb discovered under the Room 2 bench by Mexican archaeologists in 2011 is that of Yajaw Chan Muwaan; the captions over the throne in Room 1, like one-third of the captions overall, are reserved but not painted, and perhaps the king who commissioned the paintings died during the project's execution.

Only a viewer seated on the built-in bench could have studied the north wall over the doorway. This wall shows three young lords preparing for celebration and dance, which they subsequently perform on the south wall, once their matching costumes of jaguar pelt, quetzal feathers, and boa constrictors are completely in place. A servant to the right of the lord at center daubs his master with red paint; another servant strains to secure a feather backrack in the frame of the lord at left.

Infrared photography has unmasked the skill of the painter, who applied a lively final black outline over the blocked-out colors. Body contours and the rendering of torsion reveal a deep understanding of human form and the foreshortened, rounded way in which the eye sees rather than what the brain knows. Not only is the rendering of hands particularly meticulous, but the detail of the line on this wall also indicates close kinship to the sculptural tradition of Yaxchilan rather than to the small-scale paintings of Maya vases. The young lords of the dressing scene of the north wall then assume their principal role, dancing, on the south wall – the one seen upon stepping into the room. In making such sequences specific, the Maya painters emphasize the narrative that threads its way through the rooms. Protagonists reappear from scene to scene as the story moves both backward and forward in time. In this regard, the paintings are more visually narrative than any other Precolumbian work of art. If we were to describe this in linguistic terms, we might say that the paintings are like a series of verbal events – and in this, they differ from the more typically nominative representations of Maya stelae. The paintings of Bonampak may be the only works of Maya art that visually surpass the narrative complexity of Mayan writing.

On the lowest register of Room 1, Maya musicians and regional governors flank the dancers at center. Here the Maya artist attempts to represent aspects of movement and sound otherwise unknown in Maya art. The maracas players move as

if in stop motion, their arms changing frame by frame; the drummer's hands were painted with palms turned to the viewer, his fingers clearly in motion. In this, the painted wall attempts to represent sound itself in the drummer's fluttering hands. What is remarkable is that the Maya artist knows here what the eye will see and brain will believe, a step yet beyond the problem of what one knows and what one sees. Such sophisticated phenomena are completely unexpected – but the Maya artists represent aspects of motion that would not be captured by western artists until Eadweard Muybridge made frame-by-frame photographic records of body movement in the late nineteenth century.

The very sensibility of Room 2 differs from Room 1: a single battle scene encompasses all three walls surrounding the viewer upon his or her entrance into the space, seemingly drawing any viewer into the fray, and set a few years in the past [31, 92, 216]. Dozens of combatants charge into battle from the east wall, converging under a large elbow of text on the south wall, where jaguar-attired warriors, including Yajaw Chan Muwaan, strike an enemy with such energy that his body seems to fly toward the viewer, right out of the picture plane. Unusual dark pigments used in the background indicate that the battle takes place in dusk or dark. Duration and time are also encoded into the battle painting. On the upper east wall, the battle has just started, yet the sense of movement runs across

216. A photographic detail reveals the confusion and chaos mastered in the painted battle on the south wall of Bonampak, Room 2. Bodies fall, and warriors work in teams to drive their captives to the ground in defeat.

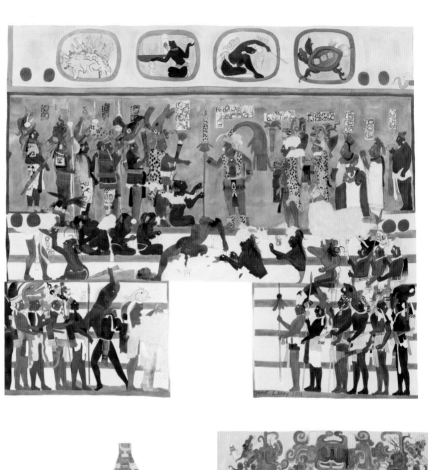

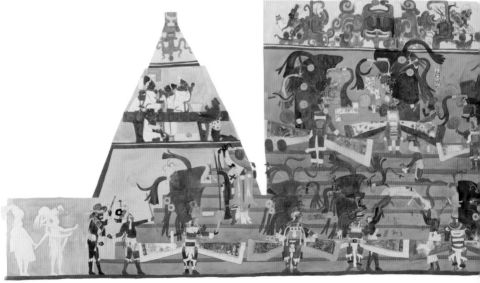

the south to west walls, then looping around to the lower registers, where captives are seized by victorious teams of two or three. In other words, time is shown in sequence, with preliminaries followed by the climax of conflict, and ending with convergence on the defeated.

On the north wall, Yajaw Chan Muwaan, accompanied by warriors and female dynasts, including his Yaxchilan wife, receives presented captives [217]. Constellations hover over the sacrifice, including the Turtle at right (Orion), probably indicating that the sacrifice begins at dawn. Elegantly drawn, with sweeping, continuous lines defining body outline, eyes, hands, and hair, the captives are among the most beautiful figures of Maya art. Captives at right reach out, as if to protest their treatment at the hands of the warrior at far left, his figure partly truncated by the crosstie holes. Bending over, this warrior grabs a captive by the wrist, and either pulls out the fingernails or trims off the final finger joint. Blood arcs and spurts from the hands of captives sitting in a row, most of whom also seem to have lost their teeth, and one howls in agony. A single captive, his body torqued in a dorsal depiction, appeals to Yajaw Chan Muwaan, who stares over his head. At his feet, a dead captive sprawls, cuts visible across his body; his foot leads to a decapitated head, gray brains dribbling from the open cranium.

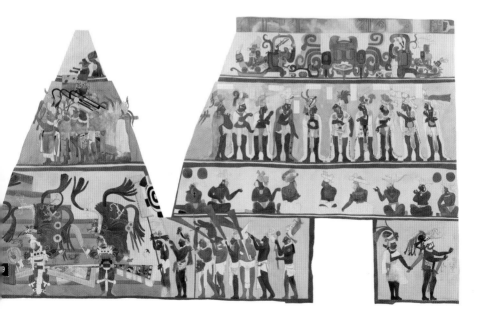

No figure in Maya art is painted with greater understanding of the human anatomy nor with more attention to the inherent sensuality of naked flesh than this dead captive of Room 2 [92]. The powerful line of the diagonal body both leads to the comparatively wooden rendering of the king but also subverts his image: for any individual seated on the bench, the captive's body is in the center of what one can see. In making this visual statement, the artists of Bonampak pushed their skills to the limit, making sensuality of sacrifice and death: the eroticized body of Room 2's dead captive, sprawled on the diagonal, dominates the scene altogether and undermines the representation of victory.

In Room 3, the three young lords of Bonampak stand atop a large pyramid that wraps around the east, south, and west walls, leading a troupe who all wear "dancers' wings" for a final performance [218]. Whirling lords dance while captives led in from the side fall under the blade at the center of the south wall. In the upper vault scenes Maya artists have rendered other intimate views of palace life. A band of masked musicians carries a dwarf drummer high on a litter on the west vault. The ladies of the court gather in the throne room, depicted in the upper east vault, to pierce their tongues and instruct a little child, presumably the same one featured in Room 1, who holds out a hand for piercing.

"Micro images" about 2 cm (0.8 in.) high – that is, the size of many a pot inscription – are painted in several locations in Room 3, but a particularly fine one at the center of the south wall, where it would easily be spotted, names Itzamnaaj Bahlam III, the coeval king of Yaxchilan at the end of the eighth century. This same powerful dynast is named as the "overseer" of the installation in Room 1; he is carved as a victorious warrior on a lintel that spans the doorway to Room 2; and it may well be that this entire program is designed to honor him and to present him with captives, like carved panels of the region.

The scale of warfare at Bonampak may show an elite world out of control: if this battle is just one of many undertaken, whether by or for Yaxchilan, then the Bonampak murals reveal a world convulsed by war and chaos, beyond the reach of the order and control the painted walls sought to confirm. Perhaps the single greatest achievement of Maya art, the Bonampak murals are the finest paintings of the indigenous New World.

Naj Tunich and Xultun

Drawings, incised petroglyphs, and handprints are all found in Naj Tunich cave in Guatemala, but the most important works, even if judged only by their scale and completeness, are the paintings made by artists using a brush and a black paint that was like a thick ink. Based on the texts in the paintings, Andrea Stone has determined that the nearly one hundred paintings were made in eighty years or less, and none later than 771. The paintings read as vignettes that compose no particular whole; many are purely textual. Some include surprising iconography, including one of the few erotic images of Maya art. One of the most striking is Drawing 21, part of an important group of paintings [219]. Here, Hunahpu, one of the Hero Twins, prepares to strike a rubber ball that bounces down a flight of stairs. The artist demonstrates particular skill in rendering the line of the shoulder: both its strong contour and the quick squib drawn as the interior ankle bone provide evidence of the Maya mastery of human form.

19. A skilled hand rendered the monochrome paintings at Naj Tunich. In Drawing 21, Hunahpu, a Hero Twin, prepares to strike a ball bearing the coefficient of nine.

New discoveries from circa 800 at Xultun, in the Peten, are thrilling, their fragmentary state notwithstanding [220]. William Saturno and his colleagues have shown that these paintings provide clear evidence of lunar tables and what scholars call "ring" numbers, analogous to those of the later Dresden Codex [228], with long numerical passages, along with 260-day counts. A painted seated ruler, set on a throne within a niche, is attended by servants; the three figures in black body paint on an adjoining wall recall the three dancers of Bonampak; the red ground line below the painted figures, like that used by vase painters on ceramic cylinders, unifies the scene.

20. Heather Hurst is seen here hard at work in 2012, shortly after the discovery of paintings at Xultun, revealing the large scale of the figures despite the tiny structure where they are located.

At roughly the same time that artists were at work at Bonampak, an artistic practice developed at Cacaxtla, a hilltop acropolis hundreds of miles north of the Maya region, where remarkable paintings came to light starting in 1976. Although the painters at the site deployed a visual vocabulary and technical expertise that draws on Maya representation, it is now clear that despite its Maya relationships, the Cacaxtla tradition belongs to Central Mexico, its Maya forms spelled out for a non-Maya audience.

Paintings in the Puuc

In the eighth century and probably throughout the ninth, artists also began to paint the walls and vaults of buildings throughout the Puuc region of Yucatan and Campeche. As yet unspecified relationships may link Puuc sites to Bonampak and its painters: Bonampak Structure 1 has an unusual vertical facade for a building in its region, but such facades are common in the Puuc. Few paintings in the Puuc survive intact but traces survive widely.

At Chacmultun and Mulchic, artists painted in registers and used a broad palette to render dozens of figures engaged in some aspect of warfare. On Chacmultun's lower register, great litters are hoisted aloft, perhaps carrying images of gods; fragments of red and orange parasols – like those of Bonampak – survive, but those who carried them do not. The running step frets at the lower margin are also like those lining a bench at Bonampak. More survives at Mulchic, where a knife-wielding lord sits above the fray, his posture and headdress similar to the king's on Stela 12 from Piedras Negras [143]. Victims pile up at his feet, some crushed by stones and others garrotted. The victorious warriors all don the costume of Chahk, the Rain God.

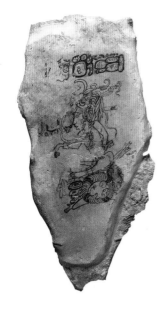

221. Monochromatic capstones in either red or black on cream dot the occasional palace across the Puuc sites; most feature the Maize God or K'awiil. This stunning example from Ek' Balam – where at least 20 examples have come to light – shows the departed king, transformed into Maize God.

Painted capstones

Vault capstones featuring black or red paint on a cream ground have been found across the Puuc region, many celebrating K'awiil or the Maize God. Stunningly, nearly two dozen have come to light at Ek' Balam, about 60 km (35 miles) northeast of Chichen Itza. The chamber outside the tomb of Ukit Kan Le'k Tok' featured a painting of the apotheosized king, transformed into the Maize God at the end of the eighth century [71, 221].

Chichen Itza

A new style of painting appeared at Chichen Itza, probably at the beginning of the ninth century, when a new architectural style simultaneously took hold, all part of a new political system that dominated Yucatan in the period. Aware of new styles of art in Central Mexico and along the Gulf Coast, artists gave their attention to the individual human form and the situation of that form in scaled architectural settings. Conventionalized renderings depict human beings who dwarf their diminutive architectural settings [222–224], and backgrounds no longer provide convincing definitions of deep space. Furthermore, although the paintings of the southern lowlands and the Puuc had presented historical scenes that could be interpreted in terms of larger religious themes, the paintings at Chichen Itza, especially those of the Upper Temple of the Jaguars, specifically lay out a religious matrix through which history can be interpreted. Artists overlap figures to a limited degree, but essentially they have given up the foreshortening that suggested depth and have elected, instead, to layer figures in registers, even though there are often no specific ground lines.

222. Individual painted panels of the Upper Temple of the Jaguars depict battle scenes in different settings, completely lining the walls; here, red hills and steep crevasses form the backdrop for a fierce engagement along the back wall of the temple.

The result is that the Upper Temple of the Jaguars paintings have little visual focus, and the even disposition of figures in six of seven panels has made it difficult to isolate central action of the sort that focuses the related battle painting of Bonampak,

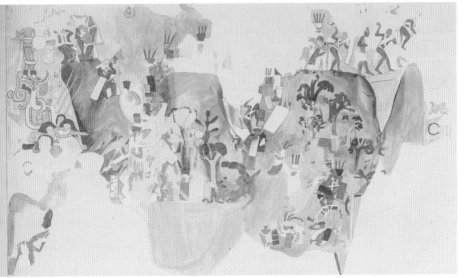

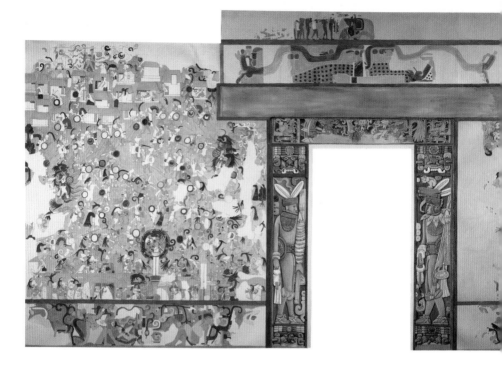

223. The doorway of the Upper Temple of the Jaguars includes a wooden lintel, with a figure inside a solar disk at right; above the lintel is a painted prostrate Maize Deity. Painted sculptures of Toltec warriors line the doorways; battles rage to left and right.

224. (opposite) As Toltec warriors glide by in canoes, life goes on in a Maya village. A green feathered serpent rises up from a newly thatched structure while a smaller building burns behind it.

for example. Nor are there are any inscriptions, which elsewhere enhance the reading of a Maya work of art. Nevertheless, these paintings were disposed across all four walls of the inner chamber of the Upper Temple, itself one of the most ornate and inaccessible of Chichen Itza temples, its massive and beautiful serpent columns poised atop the Great Ballcourt. They may well have been the most important paintings at Chichen, a city where the mural tradition thrived in many locations. So what did they mean?

Reading order is guided by the central panel of the East Wall, the wall a viewer sees first upon entering the chamber. The central panel is the only one to feature just two figures, who sit in dialogue with one another; they are larger than any others within the narrative. At right, resplendent yellow rays flare from the figure's body: he is a solar deity, shown within a great feathered serpent; at left, in brilliant jade and feathers, is the Maize God, just the edge of his jaguar cushion visible behind him, yet he, too, has taken on aspects of the radiant sun. On a panel beneath them is the prostrate dead Maize God, the source of endless renewal, his jade-bead costume symbolizing kernels of maize. This wall would have been illuminated during the mid-August zenith passage of the sun,

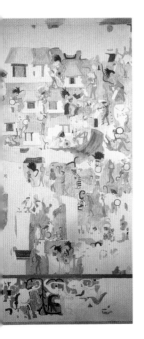

the anniversary of the day when the Maya believed Creation had taken place in the fourth millennium BC. August is the season of green corn celebrations, the time of determination of the viability of the year's crop of maize. All other action flows around the cycle of these gods of maize and sun, with the repeated motif of the dead Maize God, starting with the panel to the right of their portrayals and reading in a counterclockwise fashion.

The paintings offer a temporal progression, beginning with scenes of preparation for battle and moving to outright havoc. On one level, the paintings seem to show the changes through the day, from dawn to dusk; they may also show the shifting seasons. Throughout the program, the Maize/Sun God rules from a solar disk; the Feathered Serpent reigns from within the undulating green snake. Battles take place in locations defined by specific landscapes, including strikingly red hills where feathered serpents deliver warriors to attack. In the last painting, the victorious warriors mount scaffolds and climb steps to slaughter the population, in a very different kind of warfare from the one engaged in at Bonampak, where the painting emphasizes capture over death on the battlefield.

Far more fragmentary paintings in the Temple of the Warriors [224] have been reconstructed to show warriors

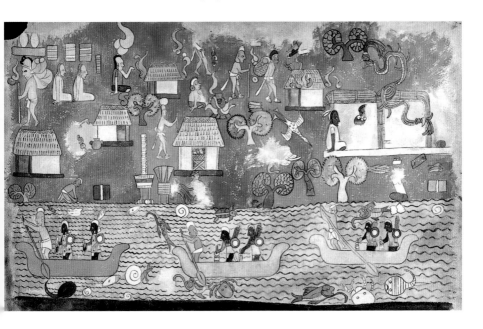

in Central Mexican costume who travel in canoes to take Maya prisoners, to "stripe" them as captives by running an obsidian blade lightly down their bodies, and to set fire to Maya villages. Any deep archaeology at Chichen Itza will likely bring more paintings to light.

Tulum, Tancah, Rancho Ina, Santa Rita Corozal, and Mayapan

During the final florescence of Precolumbian Maya culture, Maya painters adorned the walls of temples at towns along the Caribbean coast of Mexico, as well as some farther south, such as Santa Rita Corozal in Belize. The palette emphasized dark and intense colors, rather than the lighter values of the color schemes of Chichen Itza and Bonampak, with conventionalized figures that were nevertheless rendered in a naturalistic proportional scheme. Whereas the Bonampak artist knew where the eye made visual adjustments, the Tancah artist made no such accommodation, and thus showed complete renderings of both arms and both legs, for example, of the Chahk (Rain God) impersonators [225]. These Chahk impersonators converge on the Maize God – probably his impersonator as well – in preparation for his sacrifice. At nearby Rancho Ina, rich blues and ochres limned the exterior of a small painting, in panels of textile designs legible at distance.

At Tulum, a dark-background negative painting scheme was devised for structures 5 and 16. Such a program made the figural representation jump out and the ground recede,

225. Armed with sacrificial axes, Chahk impersonators close in on a seated Maize God. His decapitation was understood to be analogous to the harvesting of ears of maize.

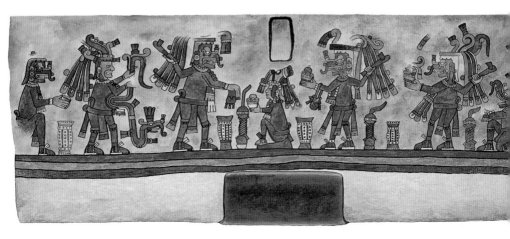

226. Against a Maya blue background, warriors stab solar disks painted at the back of a bench in the Mayapan "Room of Solar Symbols" that was connected to the Castillo as part of the city's final phase, in the fifteenth century. Eight identical panels were found, possibly a reference to the eight-year Venus calendar.

heightening legibility and visibility. Across multiple registers, highly conventionalized gods and/or god impersonators approach seated lords. In some examples the cosmos is configured, from the aquatic world at the base of the painting to the stars at the top. The Maya adopted the symbols for the starry heavens from their contemporaries in Central Mexico, and they shared with them many aspects of conventionalized representation.

At Santa Rita and Mayapan, iconographic details reveal close kinship with manuscript traditions of Central Mexico. At Santa Rita, the old Maya Sun God has been decapitated just as a new sun rises. At Mayapan, solar disks rise from the back of a bench, as if generated through the force of those gathered in front of the painted scene [226].

Maya books

Although Diego de Landa burned books across Yucatan, four examples survived his actions and other atrocities of the Spanish invasion; later housed in European libraries, three take their names from the cities where they reside (Dresden, Madrid, and Paris). A fourth, known as the Grolier Codex, came to light c. 1970 and is now housed in the Museo Nacional in Mexico City. All postdate the Classic era, but those of the first millennium presumably looked quite a bit like the survivors: taller than they were wide and consisting of folded fig-bark paper laboriously prepared, beaten, and overlaid to

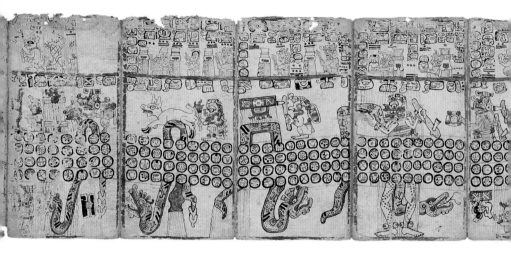

227. Various gods carry out sacrifices to propitiate rain in the Madrid Codex "serpent pages" – a section characterized by undulating snakes that continue from one page to another. At left, a death god holds a torch to a deer readied for offering. Days in the 260-day calendar form a central band. With its screen-fold pages, a Maya book can be opened to many pages and even different sections simultaneously.

create continuous sheets. As seen on pots, Maya books of the Classic period usually appear to have been bound between two wooden boards covered in jaguar pelt.

The organization of the painted imagery in Maya books affected the very nature of much of Maya art. The stela form retained book-like proportions and probably adopted book imagery from time to time; the continuous folded paper allowed for narrative to flow across the pages, with subjects ideal for transfer to fine-line painted vessels. Yet the book was private.

Andrés Ciudad Ruíz and his colleagues have recently provided compelling evidence that nine scribes worked to paint the Madrid Codex [227], each of whom painted complete and individual passages, sometimes with spontaneous, possibly improvised, content. Much of the manuscript addresses agricultural deities and auguries.

Scholars have long agreed that eight scribes labored over the Dresden Codex [228], perhaps painted in the fifteenth century. Its most stunning pages deal with a sequence of malevolent Venus gods. Painted with a broad and subtle palette that ranges from red to orange to blue, the Venus gods take shape across distinctive and reserved color backgrounds, blue, red, and cream, as if they were windows into another world across a unified page, a sort of surprising punctuation at irregular intervals. Other painters adhered to registers and gave no definition to colored backgrounds. The artists of the Dresden Codex may have worked with quill pens, bringing lively detail to each figure.

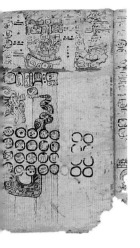

Although highly fragmentary, the single-sided and simply executed Grolier and the double-sided elegant Paris manuscripts complement the astronomical complexity of the Dresden Codex, the former through ring numbers that chart the synodic movements of Venus. The Paris is best known for its perceived zodiac animals, all suspended from a skyband, but the manuscript also shows multiple Maize Gods, at least one with umbilicus attached, adjacent to scenes in which deities float among twisted cords, like the Black Background Vase.

There are some ancient art forms for which we have not a single fine ancient example – textiles, for example – yet we know of their existence from other art forms. The surviving books offer us a glimpse of ancient Maya book art, but little more, although they were once ever-present among the elite. Maya kings took a book into the afterlife with them; archaeologists find only clumps of stucco sizing today. The written word was clearly of the greatest value to the Maya: its power clearly alarmed Bishop Landa, for had he thought their books to be trivial, he would have had little reason to round them up and set them on fire as he did in 1562.

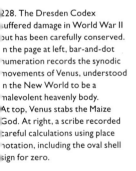

228. The Dresden Codex suffered damage in World War II but has been carefully conserved. On the page at left, bar-and-dot numeration records the synodic movements of Venus, understood in the New World to be a malevolent heavenly body. At top, Venus stabs the Maize God. At right, a scribe recorded careful calculations using place notation, including the oval shell sign for zero.

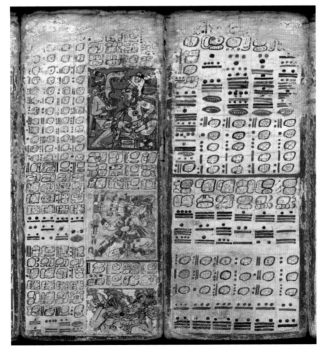

Chapter 10 A Modern World of Maya Art

The subject of this book is Maya art, with a focus on the first millennium AD. But Maya culture did not end with the arrival of Europeans to the Americas. Over the course of the past five centuries, Maya people have suffered epidemics, conquest, slavery, forced resettlements, and genocide, but Maya people and Maya culture in a diversity of forms continue to thrive in their ancestral homelands of southern Mexico, Guatemala, Honduras, and Belize, as well as in other countries of the world to which Maya people have emigrated, including Canada, the United States, and Germany. There are more than 6 million people who speak Mayan languages today; Guatemala and Mexico recognize twenty-nine Mayan spoken languages, but many linguists recognize additional languages as well as many dialects within these language groups, and there are even more people of Maya descent whose primary language is Spanish, English, or another European language. Their linguistic, cultural, and economic diversity is great, as are their continuing artistic, architectural, and literary traditions. We make no claim to offer a complete summary here – instead, we offer only a small sample.

The year of Christopher Columbus's arrival, 1492, is marked as a date that changed the Americas, but there was little contact between Maya people and Europeans for a number of years. During his fourth voyage to the Americas in 1502, Christopher Columbus encountered a large trading canoe near the Honduran Bay Islands. Loaded with textiles, cacao beans, and copper bells, with both men and women aboard, and propelled by twenty-five paddlers, this canoe is now believed to have belonged to Maya traders. Several groups of Spaniards attempted to make landfall on the east coast of the Yucatan Peninsula in the 1510s, but Maya warriors repelled them. Maya society and culture remained relatively intact during these years, but their lives indeed were changed by the waves of European diseases such as smallpox that began to pass through their communities, referred to in the chronicles as *Mayacimil*, the "easy death" that caused widespread death and depredation in 1515–1516, long before Spanish settlement.

Tenochtitlan – capital of the Mexica (Aztec) Empire – fell in 1521, and Spaniards razed many Aztec buildings and constructed the capital of colonial New Spain on its ruins. In the following decade, efforts were made to conquer other parts of Mesoamerica. In 1523, Hernán Cortés ordered Pedro de Alvarado to head south to capture the K'iche' Maya kingdom. Drawing on their successful strategy of allying with indigenous groups who were enemies of the most powerful in the region, Alvarado partnered with the Kaqchikel Maya kingdom and, along with indigenous warriors brought from Central Mexico, defeated the K'iche' kingdom in 1524. Continuing in the tradition begun in Mexico, the city of Santiago, the first capital of colonial Guatemala, was built on top of Iximche, the Postclassic Kaqchikel capital, but was later moved after Kaqchikel uprisings, as recounted by the great chronicler of the Spanish invasion, Bernal Díaz del Castillo, who lived in Iximche for more than a year.

Florine Asselbergs has discovered that the *Lienzo de Quauhquecholan* [229], made by indigenous Quauhquecholtec scribes from Puebla, Mexico, narrates the roles their families played in alliance with the Spanish in the conquests of Mexico and Guatemala. Similar to other efforts elsewhere in the sixteenth century, scribes produced this document in order to gain privileges in the Spanish colonial system. Painted on cotton and designed as a large map onto which numerous events are set, the *Lienzo de Quauhquecholan* includes many details of

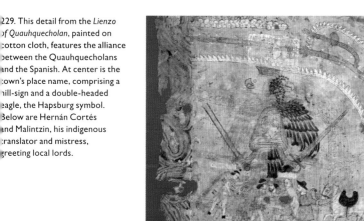

229. This detail from the *Lienzo of Quauhquecholan*, painted on cotton cloth, features the alliance between the Quauhquecholans and the Spanish. At center is the town's place name, comprising a hill-sign and a double-headed eagle, the Hapsburg symbol. Below are Hernán Cortés and Malintzin, his indigenous translator and mistress, greeting local lords.

230. The Casa de Montejo, built by hundreds of Maya laborers, was a residence for Francisco de Montejo's family. On the facade are carved limestone sculptures of indigenous warriors holding weapons and Spanish warriors atop the heads of vanquished native people, amidst other figural sculptures, coats of arms, and European columns and ornamentation.

Guatemalan geography, especially around Chimaltenango: Asselbergs thus believes it was indeed painted in Guatemala.

Francisco de Montejo attempted to conquer Yucatan in the 1520s and 1530s, but the efforts were repeatedly stymied, although he and his son (and namesake) succeeded in the early 1540s and built their capital on top of the Maya town of Tiho, naming it Mérida. They used stones from Precolumbian buildings to construct Christian churches and residences for Spaniards, including the Casa de Montejo [230], whose sixteenth-century facade is extant today. Along with many other indigenous groups, Maya people in Yucatan were forced to pay tribute to their new Spanish overlords, both with products such as cacao, honey, or salt, and with their labor. Yet Maya people in some regions continued to resist subjugation. In the Peten, the Itza capital at Tayasal in Lake Peten Itza remained independent until 1697. There were also many large and small rebellions over the next few centuries, including the widespread uprising in Yucatan known as the Caste War, from 1847 to the 1930s. Furthermore, countless people fled to the highlands of Guatemala or the deep forests of Chiapas to escape subjugation.

In addition to the destruction of capital cities, selected Precolumbian Maya towns and sacred sites were appropriated and transformed, as colonial churches and government

buildings were built directly on top of Precolumbian pyramids, as at Izamal, where the Franciscan convent was built on a truncated pyramid. This tactic was both practical, because Precolumbian structures offered convenient building material, and ideological, for the dismantling of pagan structures was a strong statement of the authority of the new religion and colonial regime. Yet it was also opportunistic, for friars transformed places already considered sacred, which people were accustomed to visit, into Christian locales (although this allowed many Maya people to sustain traditional rites and beliefs under the guise of Christianity, a practice that would alarm the friars by the middle of the sixteenth century).

The colonial infrastructure in the Yucatan Peninsula and elsewhere was built with the labor of Maya people, who learned new architectural techniques such as the keystone arch and vault construction, which they used in tandem with traditional building techniques. A sixteenth-century architectural innovation was the open chapel, also built throughout Central Mexico, comprising an open apse with an altar at center, set in front of a large open courtyard or plaza; these were used for Catholic rites, and the open shell in front of a plaza allowed masses to congregate. Samuel Edgerton notes that the first open chapel in Yucatan was constructed in 1549 at Mani, another Precolumbian town where the Franciscans built a convent and later a school, but these chapels were constructed in many other locations, frequently as a single church building for visiting priests to periodically evangelize and perform sacraments. The open chapel at Dzibilchaltun [231] was constructed in 1593 in the main plaza

31. This sixteenth-century open chapel, commissioned by Franciscan friars, was built on the plaza of the Maya site of Dzibilchaltun. The open shell of the chapel, which holds the Christian altar, faces toward the cenote Xlacah, a natural well that Maya people considered sacred.

of the Precolumbian site and adjacent to the cenote; Edgerton suggests that local Maya people would have continued to perceive this cenote as they had for centuries, as a cave-like portal allowing access to deities of earth and rain.

Meanwhile, indigenous elites throughout Mesoamerica were adapting to the new colonial system, learning to write in alphabetic script and learning Latin and Spanish at schools established by Franciscans in Mexico City, Mérida, Mani, and elsewhere. They also learned to use the Spanish legal system to claim privileges within the colonial regime. Some extraordinary documents – which we may today deem works of art – were created in the sixteenth century by indigenous elites who produced genealogies and maps as evidence for land and ruling claims. One of these, known as the Xiu Family Tree [232], comes from the *Xiu Family Chronicle* of 1558–1560, created as a "proof of nobility" to demonstrate rights to traditional lands.

232. Painted for the Spanish crown by Antonio Gaspar Chi, the Xiu Family Tree features Tutul Xiu, Xiu family progenitor, from whose body emerges a tree bearing his descendants' names as its fruit. Modeled after European Tree of Jesse images, it was modified for the Yucatec context, with a hill, cave, and offering at the base.

It was made by Gaspar Antonio Chi, who descended from the prominent Xiu and Chi lineages and was trained in a Franciscan school in Mani, which had been the Xiu capital. As Constance Cortez has discerned, Chi's Xiu Family Tree is a syncretic image incorporating Christian as well as Maya and Nahua concepts, with Tutul Xiu, the family progenitor, at the base of a Tree of Jesse, his descendants on branches emerging from his body, with a cave and deer offering at its base.

At schools such as the one in Mani, friars also collected information about indigenous customs, and Diego de Landa's *Relación de las Cosas de Yucatán*, for which Gaspar Antonio Chi provided information, remains an important source for understanding the Maya of Yucatan before and after the conquest. In this document is Landa's famous "alphabet," for which he urged Chi to show him how Mayan hieroglyphic writing worked; although this is a blatant case of cross-cultural misunderstanding, for Landa mistook Chi's syllables for alphabetic letters, it was the necessary key for Yuri Knorosov to begin to crack the code of the Mayan hieroglyphs in the mid-twentieth century.

Chi still knew the glyphic script, as did other indigenous scribes in sixteenth-century Yucatan, and John Chuchiak writes that scribes used both alphabetic and hieroglyphic script, the graphic pluralism allowing them to continue as keepers of sacred knowledge and to function as scribes or notaries for communities needing documents in alphabetic script in Spanish or Mayan. But also in the middle of the sixteenth century, Diego de Landa and other friars worked to root out and quell old practices. In Landa's infamous *auto da fé* of 1562, hundreds of objects and manuscripts were burned, and Chuchiak has found numerous other, later cases of Church leaders destroying documents using the older glyphic script: indeed, he believes that glyphic texts were confiscated and destroyed into the late eighteenth century. We can only imagine what was lost at the hands of zealots.

Over the course of the sixteenth to eighteenth centuries, indigenous lineages throughout the Maya region and Mesoamerica continued to keep their family histories alive, both through documents now lost as well as oral histories. Yet these narratives were inevitably changed as the families adapted and redefined identities in the new colonial context, in relation to both the colonial regime and other Maya ethnic

groups and lineages. In the north, in Yucatan, scribes in multiple towns kept the books of the *Chilam Balam,* which recorded the history of the past and foretold prophecies, organized by the count of the k'atuns.

In the south, in the Guatemalan highlands, the K'iche' and Kaqchikel people also continued to maintain family records and narratives. For example, the *Popol Vuh,* transcribed in the sixteenth century and translated into Spanish (by a Spanish Dominican friar) in the eighteenth century, is a K'iche' story recounting the mythical and historic origins of the K'iche' people, starting with the creation of the world, the actions of heroic deities against the underworld gods, and the creation of humans, among other events, and then recounting the birth of lineages and stories of migrations of the K'iche' ancestors. As described elsewhere in this book, these stories have analogues in Preclassic and Classic period Maya art, and although recorded in the colonial period and blended with Christian traditions, they are an essential source for enhancing our understanding of ancient Maya art. Other examples of texts transcribed in the eighteenth century are the *Titles of Totonicapan,* another K'iche' document, the *Annals of the Kaqchikels,* and the *Songs of Dzitbalche,* a transcription of earlier, undated Yucatec Mayan poems.

Similar stories of lineages and communities have also been kept alive through dramas, dances, and other festival performances in communities throughout the Maya region, in present-day Yucatan and Chiapas in Mexico, and several of Guatemala's departments. For example, the *Rabinal Achi,* performed annually on 25 January in the town of Rabinal in Alta Verapaz, Guatemala, addresses conflicts between the Rabinal and the K'iche'. According to Dennis Tedlock, this drama has roots in the fifteenth century. Other dances and dramas not only include ancient stories but also enact the Spanish Conquest and subsequent historical events.

Maya art also thrives in the textile traditions of numerous communities in southern Mexico and Guatemala [233]. Textiles, made primarily by women today, are an important way to express local and ethnic identity, with particular designs reserved for each community, especially in the highlands of Chiapas and Guatemala [234]. Weavers and sewers use both native materials and ones introduced over the past five centuries. Wool and silk – both introduced in the Colonial

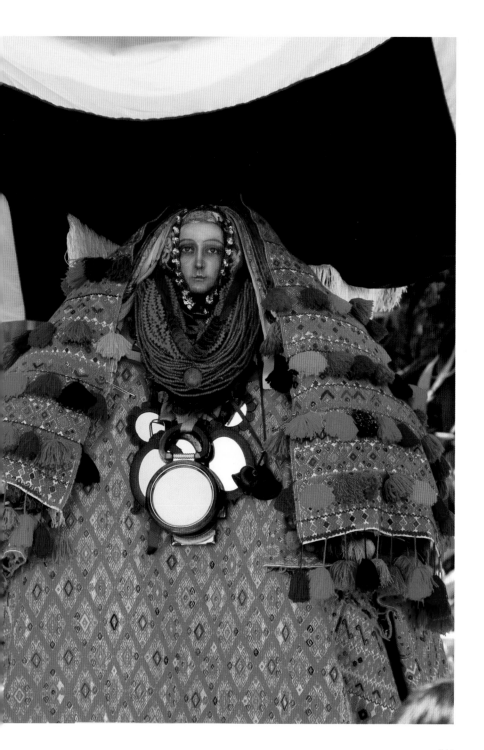

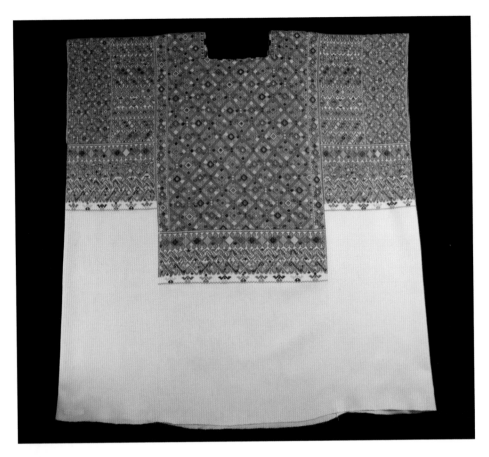

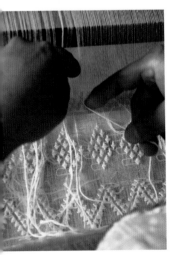

period – have played a key role in twentieth- and twenty-first-century textiles, as have more recent introductions of rayon, acrylic, and polyester, all interwoven with native cottons. Techniques include weaving on back-strap looms, embroidery, and brocade [235], among others. Many designs have been preserved for generations, but weavers also innovate and create new designs based on outside fashions, as Chip Morris has documented. Sna Jolobil, the House of the Weaver, based in San Cristobal de las Casas, Chiapas, is a weaving cooperative of women from thirty different communities designed to support weavers, sell their products, and keep weaving traditions alive.

As in the Classic period, engagement with the landscape continues to be another fundamental form of art-making and ritual practice of Maya people. Throughout the Maya region, people continue to make offerings in caves and in some places

adorn cave entrances with brightly colored Mexican *papel picado* ("perforated paper"), marking them as sacred sites as their ancestors have done for millennia; in remote settings they also venerate live rock, along with ancient structures and sculptures. In the Mexican state of Chiapas, Evon Vogt has recorded the practice of Tzotzil and Tzeltal Maya people erecting and venerating shrines at the bases and tops of mountains in honor of mountain gods; these shrines, comprising Christian crosses, often adorned with pine branches and red geraniums, are another syncretic tradition in which practitioners merge both Maya and Christian beliefs.

In addition to these continuing traditions, Maya art also encompasses new products made in new contexts, with artists and artisans continuing to reshape their identities in the face of changing politics and demographics. For instance, Maya art is made today for tourists – whether the wooden sculptures that numerous vendors sell to tourists at the archaeological site of Chichen Itza, the painted genre scenes made and sold in Santiago Atitlan and other towns around Lake Atitlan, or textiles produced and sold in tourist centers throughout Mexico and Guatemala. Maya art today can also be an art of resistance, such as the many murals, t-shirts, and figurines made in support of the Zapatista movement in Chiapas, starting in the 1990s, in which art was used both to raise awareness and to raise funds for autonomous governments or individuals.

Finally, Maya scribes and linguists, along with epigraphers and other scholars, have been working to revive and disseminate the ancient Mayan glyphic tradition to communities across Mesoamerica, giving people the tools to create new manuscripts and other artworks based on the ancient script but written in diverse Mayan languages, Spanish, and English.

"Where *did* the Maya people go?" is a question that is surprisingly often asked of us, likely in response to the dissemination of information in popular culture about the Classic-period Maya collapse, or to the fact that much of the attention about Maya people is focused on their Classic-period florescence. But the answer to this question is a simple one: Maya people are in many places, both in their ancestral homelands and elsewhere, continuing to keep alive the traditions of ancestors and forging new paths in today's global society.

Chronological Table

EARLY AND MIDDLE PRECLASSIC (1200–250 BC)	1000 BC	Founding of Ceibal
	500 BC	Village life at Tikal; growth and development at El Mirador, Nakbe
	400 BC	First Mayan writing in Peten, at San Bartolo
LATE PRECLASSIC (250 BC–AD 250)	100 BC–	Stelae dedicated at Kaminaljuyu and Izapa
	100 BC	Murals of San Bartolo
	50 BC	Tikal Burial 85 in North Acropolis
	By AD 150	Main pyramids rise at Teotihuacan in Central Mexico
	Around 150	El Mirador, Nakbe collapse
	By 250	E-VII in use at Uaxactun
EARLY CLASSIC (AD 250–600)	292	Earliest Long Count date on a Maya stela found in archaeological context
	378	Arrival of Teotihuacanos at Tikal, Uaxactun, and elsewhere
	426	K'inich Yax Kuk' Mo' founds a dynasty at Copan
	445	Sihyaj Chan K'awiil dedicates Stela 31 at Tikal
	562	Caracol and allies defeat Tikal in war; start of hiatus at Tikal
	5th–6th centuries	Kaan dynasty centered at Dzibanche
	577	Tonina Monument 168 dedicated
LATE CLASSIC (AD 600–900)	599, 611	Kaan dynasty defeats Palenque
	615	K'inich Janaab Pakal becomes king at Palenque
	By 650	Teotihuacan enters decline; Kaan dynasty expands
	679	Dos Pilas and Kaan dynasty (centered at Calakmul) defeat Tikal
	680–720	Greatest number of female representations on Maya monuments
	683	Death of Janaab Pakal at Palenque
	692	Completion of thirteen katuns (9.13.0.0.0) celebrated at multiple sites
	695	Tikal defeats Kaan dynasty, centered at Calakmul
	723	Yaxchilan Structure 23 is dedicated as the house of Lady K'abal Xook's gods
	711	Tonina captures Palenque ruler K'an Joy Chitam
	731	Broken gold object interred under Copan Stela H
	735	Dos Pilas Ruler 3 captures Ceibal king
	738	Quirigua takes Waxaklajuun Ubaah K'awiil of Copan captive
	742	Yaxchilan ruler Itzamnaaj Bahlam died
	752	Bird Jaguar, Yaxchilan ruler Itzamnaaj Bahlam's son, acceded to throne
	755	Dedication of second version of Copan Hieroglyphic Stairway
	770–	Aj Maxam paints in multiple styles at Naranjo
	–771	Paintings made in Naj Tunich cave
	776	Copan Altar Q dedicated
	791	Paintings at Bonampak
	795	Piedras Negras defeats Pomona
	–800	Dos Pilas and Aguateca under siege and subsequently abandoned
	8th–9th centuries	Chenes, Río Bec and Puuc architecture flourished
	808	Yaxchilan captures Piedras Negras Ruler 7
	830	New ruler accedes at Ceibal
	832	First hieroglyphic date at Chichen Itza
	869	Tikal Stela 11 erected
	900	Toltec trading routes extend from Yucatan to U.S. Southwest; gold at Chichen Itza
	907	Last Long Count date at Uxmal
	909	Last Long Count date in Southern Maya lowlands, on Tonina Monument 101
EARLY POSTCLASSIC (AD 900–1200)	1100	Chichen Itza falls into decline; founding of Mayapan
LATE POSTCLASSIC (AD 1200–1530)	1300–1500	Surviving Maya books painted
	1400–	K'iche' and Kaqchikel Maya kingdoms thrive in highland Guatemala
	15th century	Tulum flourishes

Glossary

4 Ajaw 8 Kumk'u: a Calendar Round date corresponding to 13.0.0.0.0, which marked the completion of thirteen bak'tuns in 3114 BC and was the date from which all Classic-period Long Count dates were counted. On this day, deities were put in order, and three stones were set, activities later repeated in world-renewal ceremonies. Although often noted as a date of "creation," this date is preceded by others in the Maya calendar.

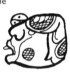

Ajaw: a royal title that was frequently qualified by *k'uhul* to create the title *k'uhul ajaw* ("holy lord"), and used for rulers of Maya polities. Also the last (twentieth) day of the Tzolk'in calendar, a 260-day calendar comprised of the integration of 13 numbers and 20 day-names.

Atlatl: spearthrower with origins in Central Mexico; it appears in Maya imagery with Teotihuacan contact in the fourth and fifth centuries AD.

Bak'tun: a period of 400 years of 360 days, it usually is the first number listed in a Classic-period Long Count date.

Basal flange vessel: an Early Classic vessel type, comprised of a wide, deep bowl with a heavy projecting rim or flange encircling the lower part of the vessel, just above the base. This flange often was decorated to form part of a larger sculpted image.

Bloodletter: a pointed tool used for drawing blood from one's body as an offering, it was often portrayed with knotted bands that came to be symbols for bloodletting sacrifice.

Calendar Round: a type of date used from the Preclassic to the Post-Classic periods, comprised of a day in the 260-day sacred calendar and one in the 365-day solar calendar, which together form a cycle that repeats every fifty-two years.

Celt: shaped like an axe head, with a rounded top and pointed or flattened bottom. Like its utilitarian counterpart, this type of object was frequently made of precious greenstones such as jadeite to create a ceremonial object. The form initially was created by Olmec carvers and adopted by Maya artisans.

Chahk: rain/storm god, often depicted with an anthropomorphic body, serpentine face, and spiral pupils, and wearing a bivalve shell ear flare. He frequently holds a trefoil-shaped stone and an axe with shining celt to create thunder and lightning or for sacrifice (*below*).

Ch'ok: "sprout" or young plant, used as a title to name princes, heirs to the throne, and other young royalty.

Cinnabar: mercuric sulfide, the brilliant red ore of mercury, used to cover skeletons and objects in tombs and as a pigment.

Codex: book; Maya and other Mesoamerican books were made of animal hide or bark paper (from the ficus tree) that was covered with a thin layer of stucco and painted with images and hieroglyphic texts. The most common form was the screenfold codex, long strips of hide or paper seamed together and folded like an accordion.

Copal: aromatic tree resin, from pines and other trees, that is burned as incense in ceremonial contexts. The word in Classic Mayan was *pom*.

Corbel vault: in architecture, a type of vault created by stacking stones gradually closer together from a springline until the two side walls can be spanned by a capstone. In contrast to the rounded or Roman arch, corbel vault walls slant inward. In some Maya sites, vaulted rooms were set parallel to each other to enhance stability.

Ear flare: ear ornament worn by Maya nobles, usually made of jadeite or shell. Frequently, they are comprised of several parts: an ear flare frontal (often decorated with designs of flowers or faces), a tube for insertion into the earlobe, and beads and strings for counter-balance in front and back.

Eccentric flint or obsidian: objects of flint or obsidian that were knapped into shapes of animals, humans, deities, or geometric forms, as opposed to functional tools.

Emblem Glyph: a ruler's title comprised of three parts, the word *k'uhul*, "holy," *ajaw*, "lord," and a changing element that identifies the kingdom, such as that of Tikal, whose name was Mutul or Mutal.

God L: An aged toothless deity with fancy textiles and Muwaan headdress (*below*). Usually powerful at court and in the conduct of long-distance trade, God L is also ridiculed by an anthropomorphic rabbit.

Huipil: a loose-fitting woman's garment, usually woven on a backstrap loom, that is comprised

of two or three strips seamed together, with a hole in the center for the head, and adorned with woven, brocaded, and embroidered geometric and floral designs. The garment drapes over the shoulders and may form a full-length dress; today many women wear the *huipil* as a blouse tucked into an untailored skirt, all held together with a broad belt.

Iconography: a type of art historical analysis involving the study and identification of images and their meaning.

Itzamnaaj: a powerful sky and creator deity, portrayed as an aged male with squared pupils and crossed eyes (*below*).

Jaguar God of the Underworld: the solar deity at night, identifiable by the twisted cruller between his eyes (*below*). This aged deity, associated with war and fire, often appears on ruler face masks, warrior shields, and incense burners.

Jester God: an emblem of Maya rulership that appears on royal headdresses and headbands. The characteristic attribute is a three-pointed headdress, at times with vegetal forms. This entity can have an anthropomorphic or zoomorphic face with an upturned

serpentine nose and spiral pupils (*below*). Its origins are in Olmec maize symbolism.

K'atun: 20 years of 360 days, and usually the second number in a Long Count date. In the Classic and Post-Classic periods, the k'atun was an important calendar ending, and Maya rulers and other people performed rites to mark their endings.

K'awiil: lightning deity depicted with an anthropomorphic body and serpentine face, spiral pupils, and a mirror on his forehead from which emerges a burning torch. Usually portrayed with one foot or leg as a serpent, he was an important deity of Maya royalty, and kings frequently held scepters with his image.

K'in: the Mayan word for sun and day. The logograph, which looks like a 4-part flower, frequently marks the face or body of K'inich Ajaw, the sun god.

K'inich Ajaw: one form of the Classic-period Maya solar deity. Common attributes include crossed

eyes with squared pupils and a T-shaped front tooth; also distinctive are curled barbels at the sides of his mouth. He is often colored red and with one or more k'in (sun) signs on his face, eyes, or body.

K'uhul: "holy" or "divine," used as a qualifier, e.g. k'uhul ajaw ("holy lord"). It derives from the word k'uh ("god").

Lakamtuun: "banner stone" or "large stone," the name in Classic Mayan for the vertical free-standing stone monument today called a "stela."

Lintel: a horizontal load-bearing architectural element, made of stone or wood in the Classic period, that spans a doorway between pillars, columns, or jambs. At some Classic-period sites, lintels were carved with images and texts and then painted.

Logogram: in the Mayan writing system, a sign that stands for a word, as opposed to a syllabogram, used for a syllable. The Classic-period logo-syllabic writing system uses a combination of logograms and syllabograms to record language phonetically.

Long Count: calendrical system used in the Classic period to record the number of days that had passed since the start of the 5,125-year cycle beginning in 3114 BC. In the Classic period, the Long Count usually is comprised of five numbers recording periods of time in descending quantities, specifically bak'tun (400 years), k'atun (20 years), tuun (year of 360 days), winal (month of 20 days), and k'in (day), but some texts also recorded larger periods before the bak'tun number.

Maize God: deity of maize, portrayed as a young anthropomorphic male with sloping forehead, evoking an ear of corn. His hair is frequently tied in a hank at the top of his head, evocative of corn silk. Maya kings often dressed as the Maize God, enacting the cycle of death and rebirth.

Metate: grinding stone used for grinding corn and other foodstuffs. Originally a Nahuatl word, it is a loan word in Mexican Spanish and other languages.

Milpa: agricultural field in Mesoamerica, used frequently for growing maize, beans, and squash. Originally a Nahuatl word, it is a loan word in Mexican Spanish and other languages.

Muknal: burial place, coming from the verb root *muk-*, "to bury," used in hieroglyphic texts concerning ancestors' tombs.

Principal Bird Deity: a supernatural bird that appears to be the avian form of the powerful sky deity Itzamnaaj (*below*). In images, this bird frequently appears at the top of the World Tree.

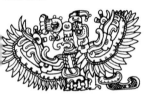

Provenience: source or origin, referring to known archaeological context for ancient Maya objects. An object that is looted or otherwise taken from the ground without use of archaeological techniques to record its context, is unprovenienced. Provenance is the history of ownership.

Roofcomb: in Maya architecture, an element set at the top of the corbel vault to serve as a building's upper facade and designed to display large-scale iconography visible from a distance. Although sometimes solid masses, as on Tikal pyramids, lighter stone lattices stabilized corbel vaults by channeling load away from corbel capstones at Palenque.

Sajal: senior noble, subordinate lord, or regional governor within a Classic-period Maya kingdom, at times in charge of a smaller site affiliated with the kingdom's larger seat of government that was ruled by a *k'uhul ajaw*.

Sarcophagus: a large rectangular box, often made of stone, used in funerary contexts to hold an elite person's body and grave offerings. These were plain or carved; the sarcophagus of Pakal at Palenque was carved with elaborate images and texts about the ruler and his ancestors.

Stela (plural stelae): vertical, freestanding stone monument, called *lakamtuun*, which was carved and erected in the Classic period to commemorate period endings in the Maya calendar, usually carved with images of rulers and their family, court officials, and captives, and hieroglyphic texts.

Stucco: plaster, created by mixing water and vegetal gums with lime (crushed, burned limestone). This pliable and durable medium was used to create architectural sculptures, smooth building facades, and cover book pages, ceramic vessels, and walls in preparation for painting.

Sweatbath: called *pib naah* in Classic Mayan, a structure for hygienic and medicinal bathing, comprised of a room (often vaulted) with a firebox that held heated rocks upon which water was poured to create steam. Sweatbaths were constructed in Classic and Post-Classic cities and used for bathing, ritual purification, and for childbirth; sweatbaths and saunas are used today throughout Mesoamerica.

Talud-tablero: an architectural form comprised of a slanted *talus* and a vertical *tablero*, the latter often a surface for painting or sculpture. Originating in Central Mexico, it was widely used at Teotihuacan and was adopted by fourth-century Maya architects.

Tenon: in architectural sculpture, an element projecting from a sculpture's back or bottom, used for insertion into a wall or other architectural form. Plain stone tenons also supported stucco sculpture.

Tollan: "Place of Cattail Reeds," mentioned in 16th-century Nahuatl and K'iche' texts, as a place of great learning and artistry, referring to earlier cities, such as Tula and Teotihuacan, or places of myth and legend. Some Classic-period Mayan texts and images include a cattail-reed glyph that reads PUH and may refer to Teotihuacan.

Tuun: stone or year; this word can appear as an isolated glyph meaning "stone" or within images as a marker for stone material.

Wahy: companion or "dreaming" spirits, portrayed as hybridized animals, skeletons, or other fantastic anthropomorphic and zoomorphic entities; these often malevolent supernatural figures may have been connected to latter-day concepts of sorcery.

Witz: mountain, frequently shown to be animate, and with vegetation such as maize or flowers growing from it (*below*); also the name used for pyramids and funerary mounds.

World Tree: a foliated tree perceived to be at the center of the Maya cosmos, connecting sky, earth and underworld (*below*). It is depicted in Maya art as an animate tree, at times with ripened maize ears sprouting from it, with the Principal Bird Deity at the top. Maya rulers may show themselves along this axis or as embodiments of the World Tree.

Xibalba: the K'iche' name for the underworld, inhabited by forces of darkness and illness, as recounted in the colonial-period *Popol Vuh*.

Select Bibliography

Abbreviations

ACM Acta Mesoamericana
AA American Anthropologist
AM Arqueología Mexicana
AncM Ancient Mesoamerica
BAEB Bureau of American Ethnology, Bulletin
CAJ Cambridge Archaeological Journal
CIW Carnegie Institution of Washington
DOAKS Dumbarton Oaks
HMAI Handbook of Middle American Indians
ICA International Conference of Americanists
INAH Instituto Nacional de Antropología e Historia
LAA Latin American Antiquity
LACMA Los Angeles County Museum of Art
MRP Mesa Redonda de Palenque/ Palenque Round Table
MARI Middle American Research Institute, Tulane University
PARI Pre-Columbian Art Research Institute, San Francisco
PMM Peabody Museum, Harvard University, Memoirs
PMP Peabody Museum, Harvard University, Papers
PNAS Proceedings of the National Academy of Sciences
PUAM Princeton University Art Museum
RRAMW Research Reports on Ancient Maya Writing
SAR School of American Research Press
T&H Thames & Hudson
UNAM Universidad Nacional Autónoma de México
YUAGB Yale University Art Gallery Bulletin

GENERAL SOURCES

Students often start with a digital search; Wikipedia tends to be informative, but provides no novel study. There are, however, excellent, specialized digital resources: mesoweb.com, famsi.org, ARTstor.org, mayavase.com, archaeology.org, nationalgeographic.com, arqueomex.com, www.peabody.harvard.edu/CMHI/, and INAH.gob.mx, among them. Many journals are available online through university libraries and JStor.org, but much of what has been published in this field can only be found in books, in English and Spanish, and will require library visits. The bibliographic search tool at www.famsi.org indexes articles and books and is the best for ancient Maya research in English and Spanish. For images, ARTstor.org and museum databases provide access to thousands of works, and Justin Kerr's mayavase.com offers large numbers of photographs of Maya vessels and iconographic identifications.

Survey books
The best archaeological surveys are M. Coe, The Maya (8th ed., T&H, 2011) and R. Sharer & L. Traxler, The Ancient Maya (6th ed., Stanford, 2006); new entries are S. Houston

& T. Inomata, The Classic Maya (Cambridge, 2009); H. McKillop, The Ancient Maya: New Perspectives (Santa Barbara, 2004), and N. Grube (ed.), Maya: Divine Kings of the Rain Forest (H.F. Ullmann, 2012). Archaeological sourcebooks include S. Evans, Ancient Mexico and Central America: Archaeology and Culture History (3rd ed, T&H, 2013), and D. Nichols & C. Pool, The Oxford Handbook of Mesoamerican Archaeology (Oxford, 2012). L. Schele & P. Mathews, The Code of Kings (Scribner, 1998), offers a historical overview.

G. Kubler, The Art and Architecture of the Ancient Americas (Pelican, 1984) provided a pioneering art historical treatment of Mesoamerican and Andean arts. M. Miller discusses the Maya in two chapters of The Art of Mesoamerica (5th ed., T&H, 2012). Older art historical surveys have sharp insights into particular works of art, even if archaeological data are now out of date: P. Kelemen, Medieval American Art (Macmillan, 1943); E. Easby & J. Scott, Before Cortés (Metropolitan Museum of Art, 1970); M. Covarrubias, Indian Art of Mexico and Central America (Knopf, 1957); J. Pijoán, Historia del arte precolombino (Summa Artis X) (Salvat, 1952); I. Marquina, Arquitectura prehispánica (INAH, 1951); and E. Seler, Gesammelte abhandlungen (Berlin, 1902–23).

Journals and serials
Journals, including most listed above, serve as up-to-date sources, as does the lavishly illustrated National Geographic Magazine. ACM publishes diverse papers presented at the annual European Maya Conference. Smart perceptions have been filed at the International Congress of Americanists since 1875. Since 1993, Arqueología Mexicana has transformed publication of Mesoamerican materials, with recent discoveries and thoughtful considerations of well-known materials. The Centro de Estudios Mayas at UNAM has published Estudios de Cultura Maya most years since 1960. Guatemala publishes Simposio de Investigaciones Arqueológicas en Guatemala (Ministerio de Cultura y Deportes / Instituto de Antropología e Historia); Belize publishes Research Reports in Belizean Archaeology. J. Skidmore launched a new series, Maya Archaeology, in 2009. The Instituto de Investigaciones Estéticas at UNAM has published Anales since 1937.

Exhibitions
Museum exhibition catalogues offer accessible essays about ancient Maya topics; these advance research and provide excellent visual resources. Examples are L. Schele & M. Miller, The Blood of Kings (Kimbell Art Museum, 1986); I Maya, published in English as Maya (Rizzoli, 1998); M. Miller & S. Martin, Courtly Art of the Ancient Maya (T&H, 2004); V. Fields & D. Reents-Budet, The Lords of Creation (LACMA, 2005); D. Finamore & S. Houston (eds), The Fiery Pool (Peabody Essex Museum, 2010); S. Martínez del Campo Lanz, Rostros de la divinidad (INAH, 2010); and D. Magaloni

Kerpel et al., Seis ciudades antiguas de Mesoamérica (INAH, 2011). The catalogues of the DOAKS permanent collections, especially J. Pillsbury et al. (eds), Ancient Maya Art at Dumbarton Oaks (DOAKS, 2012), include masterful essays.

Other guides
Several publications have changed the course of Maya art history: The Blood of Kings; L. Schele & D. Freidel, A Forest of Kings (Morrow, 1990); and S. Houston & D. Stuart, "The Ancient Maya Self," RES: 33 (1998).
Maya religion is considered in K. Taube, The Major Gods of Ancient Yucatan (DOAKS, 1992) M. Miller & K. Taube, The Gods and Symbols of Ancient Mexico and the Maya (T&H, 1992), and D. Carrasco, Religions of Mesoamerica (2nd ed., Waveland, 2013). The reader should consult Bishop Diego de Landa's account of sixteenth-century Yucatan; the least cumbersome translation is W. Gates, Yucatan Before and After the Conquest (Dover reprint, 1980); compare A. Tozzer's annotated version, Landa's Relación de las cosas de Yucatán (PMP 18, 1941). For Popol Vuh translations, consult D. Tedlock, The Popol Vuh (Simon & Schuster, 1996); A. Christenson, The Sacred Book of the Maya (Oklahoma, 2007); and M.S. Edmonson, The Book of Counsel (MARI Pub. 35, 1971). For religious iconography, see E. Benson & G. Griffin (eds), Maya Iconography (Princeton, 1988); O. Chinchilla, Imágenes de la mitología Maya (Museo Popol Vuh, 2011); and articles in M.G. Robertson (gen. ed.), MRP (PARI), vols 1–10 (1973–93), including K. Taube, "The Classic Maya Maize God," from 1985.

Dating and chronology
Maya chronology has been recalibrated by T. Inomata et al., "Early Ceremonial Constructions at Ceibal, Guatemala, and the Origins of Lowland Maya Civilization," Science 340 (6131): 467–71 (2013). On the correlation, see S. Martin & J. Skidmore, "Exploring the 584286 Correlation Between the Maya and European Calendars," PARI Journal 13 (2): 3–16 (2012).

Epigraphy
Indispensable to studying Maya art are reliable guides to hieroglyphics and decipherment. See S. Martin & N. Grube, Chronicle of the Maya Kings and Queens (2nd ed., T&H, 2008). D. Stuart's blog, www.decipherment.wordpress.com, reports on new discoveries and readings. H. Kettunen & C. Helmke's useful Workbook can be accessed at www.mesoweb.com.
For early inscriptions, see S. Houston (ed.), The First Writing (Cambridge, 2004). Houston et al. collected key articles for The Decipherment of Ancient Maya Writing (Oklahoma, 2001). Stuart's "Ten Phonetic Syllables," RRAMW 14 (1987), remains a model of decipherment, and the larger narrative is recounted in M. Coe's Breaking the Maya Code (3rd ed., T&H, 2012).

Publications elucidating epigraphy and iconography include A. Stone & M. Zender, *Reading Maya Art* (T&H, 2011); S. Houston et al., *The Memory of Bones* (Texas, 2006); S. Houston, "Into the Minds of Ancients," *Journal of World Prehistory* 14 (2): 121–201 (2000); and S. Houston, *The Life Within: Classic Maya and the Longing for Permanence* (Yale, 2014). See also: A. Tokovinine, *Place and Identity in Classic Maya Narratives* (DOAKS, 2013); A. Tokovinine & M. Zender, "Lords of Windy Water," in A.E. Foias & K.F. Emery (eds), *Motul de San José* (Florida, 2012), 30–66.

Thematic studies
See S. Houston et al., *Veiled Brightness* (Texas, 2009); C. Mcneil (ed.), *Chocolate in Mesoamerica* (Florida, 2006); R. Koontz et al. (eds), *Landscape and Power in Ancient Mesoamerica* (Westview, 2001); J. Brady & K. Prufer (eds), *In the Maw of the Earth Monster* (Texas, 2010). For dance and performance, see T. Inomata & L. Coben (eds), *Archaeology of Performance* (AltaMira, 2006); and M. Looper, *To Be Like Gods* (Texas, 2009). On the body: V. Tiesler, *Decoraciones dentales entre los antiguos Mayas* (INAH, 2003); and S. Whittington & D. Reed (eds), *Bones of the Maya* (Smithsonian, 1997).

On archaeoastronomy, see A. Aveni, *Skywatchers of Ancient Mexico* (Texas, 1981). On the calendar and counting: D. Earle & D. Snow, "The Origin of the 260-day Calendar," in M.G. Robertson et al. (eds), *Fifth MRP, 1983* (PARI, 1985), 241–44; and A. Blume, "Maya Concepts of Zero," *Proceedings of the APS* 155 (1): 51–88 (2011). The best of the books published in anticipation of the so-called Maya "apocalypse" is D. Stuart, *The Order of Days* (Three Rivers Press, 2012).

On gender: R. Joyce, *Gender and Power in Prehispanic Mesoamerica* (Texas, 2000); T. Ardren (ed.), *Ancient Maya Women* (Altamira, 2002); L. Gustafson & A. Trevelyan (eds), *Ancient Maya Gender Identity and Relations* (Bergin & Garvey, 2002); S. Houston, "A Splendid Predicament," *CAJ* 19 (2): 149–78 (2009); and A. Stone, "Keeping Abreast of the Maya," *AncM* 22 (1): 167–83 (2011).

Regarding death and ancestors: P. McAnany, *Living with the Ancestors* (Texas, 1995); J. Fitzsimmons, *Death and the Classic Maya Kings* (Texas, 2009); A. Ciudad Ruiz et al. (eds), *Antropología de la eternidad* (UNAM, 2003); and A. Cucina & V. Tiesler, *New Perspectives on Human Sacrifice and Ritual Body Treatments in Ancient Maya Society* (New York, 2007). For the ballgame: E. Taladoire, *Terrains de jeu de balle* (Mission francaise, 1981); E. Whittington, *The Sport of Life and Death* (T&H, 2001); and M. Uriarte, *El juego de pelota en mesoamérica* (Mexico, 1992).

On the Maya and Teotihuacan: D. Stuart, "'The Arrival of Strangers'," in D. Carrasco et al. (eds), *Mesoamerica's Classic Heritage* (Colorado, 2000), 465–513; and G.E. Braswell (ed.), *The Maya and Teotihuacan* (Texas, 2003).

For the Terminal Classic period and the collapse: A. Demarest et al. (eds), *The Terminal Classic in the Maya Lowlands* (Colorado, 2004); D. Webster, *The Fall of the Ancient Maya* (T&H, 2002); and A. Demarest, *The Ancient Maya: The Rise and Fall of a Rainforest Civilization* (Cambridge, 2003).

Historiography
Of all early travelers, John Lloyd Stephens's accounts remain the most interesting today: *Incidents of Travel in Central America, Chiapas, and Yucatán*, 2 vols (Harper, 1841), and *Incidents of Travel in Yucatán*, 2 vols (Harper, 1843). C. Baudez & S. Picasso, in *Lost Cities of the Maya* (Abrams, 1992), offer a brief historiography. In J. Pillsbury (ed.), *Past Presented* (DOAKS, 2012), see Fash, Houston, Just, and Villela. See also R. Evans, *Romancing the Maya* (Texas, 2004); S. Giles & J. Stewart, *The Art of Ruins* (Bristol, 1989); and E. Boone (ed.), *Collecting the Pre-Columbian Past* (DOAKS, 1993).

MATERIALS
For building materials and technical observations, see L. Roys, "The Engineering Knowledge of the Maya," *CIW Contributions*, II (1934); E. Abrams, *How the Maya Built Their World* (Texas, 1994); and I. Villaseñor, *Building Materials of the Ancient Maya* (Lambert, 2010). For stone tools, see J. Woods & G. Titmus, "Stone on Stone," in M.G. Robertson et al. (eds), *Eighth MRP, 1993* (PARI, 1996), 479–89. On jades, A. Smith & A. Kidder, *Excavations at Nebaj, Guatemala*, CIW Pub. 594 (1951); T. Proskouriakoff, *Jades from the Cenote of Sacrifice, Chichen Itzá, Yucatán*, AncM 10 (1) (1974); K. Taube, "The Symbolism of Jade in Classic Maya Religion," *AncM* 16: 23–50 (2005). For turquoise, see P. Weigand & A. García de Weigand, "A Macroeconomic Study of the Relationships Between the Ancient Cultures of the American Southwest and Mesoamerica," in V. Fields and V. Zamudio-Taylor (eds), *The Road to Aztlán* (LACMA, 2001), 184–95. Also J. King, C. Cartwright & C. McEwan (eds), *Turquoise in Mexico and North America* (Archetype, 2012).

For marine material: H. Moholy-Nagy, "Shell and Other Marine Material from Tikal," *Estudios de cultura maya* 3: 65–83 (1963). On bones, see A. Herring, "After Life: A Carved Maya Bone from Xcalumkin," YUAGB 1995–96, 48–50; and M. O'Neil. "Bone into Body, Manatee into Man," YUAGB 2002, 92–97. On speleothems, see J. Brady et al., "Speleothem Breakage, Movement, Removal, and Caching," in *Geoarchaeology* 12 (6): 725–50 (1997).

For Maya mirrors: P. Healy & M. Blainey, "Ancient Maya Mosaic Mirrors," *AncM* 22 (2): 229–44 (2011); also N. Saunders, "Stealers of light, traders in brilliance," *RES* 33: 225–52 (1998). Metals: E. Paris, "Metallurgy, Mayapan, and the Postclassic Mesoamerican World System," *AncM* 19: 43–66 (2012); and S. Simmons & A. Shugar, "The Context, Significance and Technology of Copper Metallurgy at Late Postclassic Spanish Colonial Period Lamanai, Belize," *Research Reports in Belizean Archaeology* 5: 125–34. (2008).

SOUTHERN LOWLANDS

Architecture
See W. Fash & L. Lopez Lujan (eds), *The Art of Urbanism* (DOAKS, 2012); J. Kowalski (ed.), *Mesoamerican Architecture as Cultural Symbol* (Oxford, 1999); and M. Uriarte (ed.), *Pre-Columbian Architecture of Mesoamerica* (Abbeville, 2010). Also T. Inomata & S. Houston (eds), *Royal Courts of the Ancient Maya* (Westview, 2001); S. Houston (ed.), *Function and Meaning in Classic Maya Architecture* (DOAKS, 1998); and M. Coe, *Royal Cities of the Ancient Maya* (Vendome, 2012). T. Proskouriakoff based reconstructions for *An Album of Maya Architecture*, CIW Pub. 558 (1946), on archaeological reports.

Late Preclassic
On early Maya religion: D. Freidel et al. in *Maya Cosmos* (Morrow, 1993). For Izapa, Takalik Abaj, and Kaminaljuyu, see J. Guernsey et al. (eds), *The Place of Stone Monuments* (DOAKS, 2010); J. Guernsey, *Ritual and Power in Stone* (Texas, 2006) and *Sculpture and Social Dynamics in Preclassic Mesoamerica* (Cambridge, 2012); A. Kidder et al., *Excavations at Kaminaljuyu* (CIW, 1946); and J. Kaplan & M. Love, *The Southern Maya in the Late Preclassic* (Colorado, 2011). See also K. Reese-Taylor & D. Walker, "The Passage of the Late Preclassic into the Early Classic," in M. Masson & D. Freidel (eds), *Ancient Maya Political Economies* (Altamira 2002). For Late Preclassic architecture: F. Estrada-Belli, *The First Maya Civilization* (Routledge, 2011); and R. Hansen, "The First Cities – The Beginnings of Urbanization and State Formation in the Maya Lowlands," in N. Grube (ed.), *Maya: Divine Kings of the Rain Forest* (H.F. Ullmann, 2012), 50–65. See J. Doyle & S. Houston, in "A Watery Tableau at El Mirador, Guatemala," "at decipherment. wordpress.com (9 April 2012). For the "E-Group," see T. Guderjan, "E-Groups, Pseudo–E-Groups, and the Development of the Classic Maya Identity in the Eastern Peten," *AncM* 17 (1): 97–104 (2006). For a rounded arch: H. Hohmann, "A Maya keystone vault at La Muñeca," *Mexicon* 27 (4): 73–77 (2005).

Sculpture and painting
For sculpture, see S. Morley, *Inscriptions of Petén*, 5 vols, CIW Pub. 437 (1937–38); A. Maudslay, *Biologia Centrali-Americana: Archaeology*, 5 vols (London 1899–1902); *Corpus of Maya Hieroglyphic Inscriptions*, vols 1–9, 1977–. Proskouriakoff's *Classic Maya Sculpture*, CIW Pub. 593 (1950) retains key insights. See also F. Clancy, *Sculpture in the Ancient Maya Plaza* (New Mexico, 1999); A. Herring, *Art and Writing in the Maya Cities*, AD 600–800 (Cambridge, 2005); and D. Stuart, "Kings of Stone," *RES* 29/30: 148–71 (1996).

For figurines, see M. Miller, *Jaina Figurines* (PUAM, 1975); R. Piña Chan, *Jaina, la casa en el agua* (INAH, 1968); L. Schele, *Hidden Faces of the Maya* (Impetus, 1998); M. O'Neil, "Jaina-Style Figurines," in *Ancient Maya Art at Dumbarton Oaks* (DOAKS, 2012); and D. McVicker, "Figurines are us?," *AncM* 23 (2): 211–34 (2012). For the El Perú-Waka' cache, see M. Rich, *Ritual, Royalty and Classic Period Politics* (PhD dissertation, SMU, 2011). See also C. Halperin et al. (eds), *Mesoamerican figurines* (Florida, 2009). For Jaina archaeology: A. Benavides Castillo, "Jaina, Campeche: Temporada 2003 los hallazgos y el futuro próximo," in E. Vargas & A. Benavides Castillo (eds), *El patrimonio arqueológico maya en Campeche* (UNAM, 2007), 47–82. See also S. Ekholm, "Significance of an extraordinary Maya ceremonial refuse deposit at Lagartero, Chiapas," in *ICA* 8: 147–59 (1976).

By site and region
Belize: D. Pendergast, *Altun Ha, British Honduras (Belize): The Sun God's Tomb*, Royal Ontario Museum OP 19, Toronto (1969); D. Pendergast, *Excavations at Altun Ha, Belize, 1964–1970*, vols 1–3 (Royal Ontario Museum, 1979–82); A. Chase & D. Chase, *Investigations at the Classic Maya City of Caracol, Belize: 1985–87* (PARI, 1987); D. Chase & A. Chase, "Maya Multiples," *LAA* 7 (1): 61–79 (1996); and their website, www.caracol.org.

Calakmul and the Kaan (Snake) Dynasty: K. Delvendahl, *Calakmul in Sight* (Merida, 2008). For recent discoveries: R. Carrasco & M. Colón, "El reino de Kaan y la antigua ciudad de Calakmul," *AM* 13 (75): 40–47. For epigraphy: S. Martin, "Of Snakes and Bats," in *The PARI Journal* 6 (2): 5–15 (2005); and "Wives and Daughters on the Dallas Altar," at www.mesoweb.com/articles/martin/Wives&Daughters.pdf. On **Dzibanche**: E. Nalda (ed.), *Los cautivos de Dzibanché* (INAH, 2005), especially E. Velásquez García, "Los escalones jeroglíficos de Dzibanché."

Copan and **Quirigua**: E. Boone & G. Willey (eds), *The Southeast Classic Maya Zone* (DOAKS, 1988); W. Fash, *Scribes, Warriors, and Kings* (2nd ed., T&H, 2001); D. Webster (ed.), *The House of the Bacabs* (DOAKS, 1989); E. Schortman & P. Urban (eds), *Quiriguá Reports II*, Papers 6–14 (Penn Museum, 1983); S.G. Morley, *Inscriptions at Copán*, CIW Pub. 219 (1920); *Introducción a la Arqueología de Copán, Honduras*, 3 vols (Proyecto Arqueológico de Copan, 1983); E. Newsome, *Trees of Paradise and Pillars of the World* (Texas, 2001); M. Looper, *Lightning Warrior* (Texas, 2003). A. Herring's "A Borderland Colloquy," *Art Bulletin* 87 (2) (2005), and J. von Schwerin's "The Sacred Mountain in Social Context," *AncM* 22 (2): 271–300 (2011), offer keen insights. See also: E. Bell, M. Canuto, & R. Sharer (eds), *Understanding Early Classic Copan* (Penn Museum, 2004), especially R. Sharer's essay, and E. Andrews & W. Fash (eds), *Copan: The History of an Ancient Maya Kingdom* (SAR Press, 2005).

El Zotz/El Diablo: S. Houston et al. (eds), *Death Comes to the King: The Maya Royal Tomb of El Diablo, Guatemala* (Mesoweb, in preparation). **Holmul**: F. Estrada-Belli et al., "A Maya Palace at Holmul, Peten, Guatemala and the Teotihuacan 'Entrada'," *LAA* 20 (1): 228–59 (2009).

For new discoveries at **La Corona** (previously Site Q): M. Canuto & T. Barrientos, "La Corona: un acercamiento a las políticas del reino Kaan desde un centro secundario del noroeste del Petén," in *Estudios de Cultura Maya* 37: 11–43 (2011); and M. Canuto & T. Barrientos, "The Importance of La Corona," in *La Corona Notes* 1 (2013). For nearby **El Perú-Waka'**, see K. Eppich, "Feast and sacrifice at El Peru-Waka'," *PARI Journal* 10 (2): 1–19; D. Freidel et al., "Resurrecting the Maize King," *Archaeology* 63 (5): 42–45 (2010).

Palenque: P. Mathews & L. Schele deciphered the Palenque dynastic sequence: "Lords of Palenque: the glyphic evidence," in M.G. Robertson (ed.), *Primera MRP, Part 1, 1973* (1974), 63–75. See: M.G. Robertson, *The Sculpture of Palenque*, 4 vols (Princeton, 1983–92); D. Stuart & G. Stuart, *Palenque, Eternal City of the Maya* (T&H, 2009); D. Stuart, *The Inscriptions from Temple XIX at Palenque* (PARI, 2005). E. Barnhart, *The Palenque Mapping Project* (PhD dissertation, Texas, 2001), and K. French, *Palenque Hydro-Archaeology Project, 2006–2007 Season Report* (2008), at famsi.org study ancient waterways and settlement. See also: G. Aldana, *The Apotheosis of Janaab' Pakal* (Colorado, 2007); D. Marken (ed.), *Palenque, Recent Investigations at the Classic Maya Center* (AltaMira, 2007); A. González Cruz & G. Bernal Romero, "The discovery of the Temple XXI monument at Palenque," in *Maya Archaeology* 2 (Mesoweb, 2012), 82–102; D. Stuart, "Longer Live the King," *The PARI Journal* 4 (1) (2003); and A. Herring, "Sculptural Representation and Self-reference in a Carved Maya Panel from the Region of Tabasco, Mexico," *RES* 33: 102–14 (1998). Architecture and epigraphy: S. Houston, "Symbolic Sweatbaths of the Maya," *LAA* 7: 132–51 (1996). New technical insights: V. Tiesler & A. Cucina (eds), *Janaab' Pakal of Palenque* (Tucson, 2006); L. Filloy Nadal (ed.), *Misterios de un rostro maya* (INAH, 2010).

Petexbatun region: I. Graham conducted reconnaissance: *Archaeological Explorations in El Petén, Guatemala* (MARI, 1967). For archaeology: S. Houston, *Hieroglyphs and History at Dos Pilas* (Texas, 1993); A. Demarest, *The Petexbatun Regional Archaeological Project* (Vanderbilt, 2006); T. Inomata, *Warfare and the Fall of a Fortified Center* (Vanderbilt, 2006); and T. Inomata & D. Triadan (eds), *Burned Palaces and Elite Residences of Aguateca* (Utah, 2010).

Piedras Negras: A. Stone, "Disconnection, Foreign Insignia, and Political Expansion," in R. Diehl & J. Berlo (eds), *Mesoamerica After the Decline of Teotihuacan AD 700–900* (DOAKS, 1989), 153–72; F. Clancy, *The Monuments of Piedras Negras,*

an Ancient Maya City (New Mexico, 2009); M. O'Neil, *Engaging Ancient Maya Sculpture at Piedras Negras, Guatemala* (Oklahoma, 2012); H. Escobedo & S. Houston (eds), *Proyecto Arqueológico Piedras Negras: Informe preliminar* (1997, 1998, 1999, 2001); M. Child, *The Archaeology of Religious Movements* (PhD dissertation, Yale, 2006); and J. Weeks et al. (eds), *Piedras Negras Archaeology, 1931–1939* (Penn Museum, 2005).

Plan de Ayutla: L. Martos López, "The Discovery of Plan de Ayutla, Mexico," in *Maya Archaeology* 1 (Mesoweb, 2009), 60–75.

Tikal and **Uaxactun**: W. Coe, *Excavations in the Great Plaza, North Terrace, and North Acropolis of Tikal*, Tikal Report 14 (Penn Museum, 1990); P. Harrison, *The Lords of Tikal* (T&H, 1999); J. Sabloff (ed.), *Tikal: Dynasties, Foreigners, and Affairs of State* (Santa Fe, 2003); and C. Jones, "Cycles of Growth at Tikal," in T. Culbert (ed.), *Classic Maya Political History* (Cambridge, 1991), 102–27; C. Coggins, *Painting and Drawing Styles at Tikal* (PhD dissertation, Harvard, 1975). The archaeology of Uaxactun took place in the 1930s: A. Smith, *Uaxactun, Guatemala: Excavations of 1931–37* (CIW, 1950). S. Martin has offered numerous insights into Tikal epigraphy: "Tikal's 'Star War' Against Naranjo," in M.G. Robertson et al. (eds), *Eighth MRP, 1993* (PARI, 1996); "At the periphery," in P. Colas et al. (eds), *The Sacred and the Profane*, ACM 10 (2000), 51–61; "In the Line of the Founder," in J. Sabloff (ed.), *Tikal: Dynasties, Foreigners, and Affairs of State* (SAR, 2003), 3–45; and "Caracol Altar 21 Revisited," *The PARI Journal* 6 (1): 1–9 (2005). See also: E. Weiss-Krejci, "Reordering the Universe during Tikal's Dark Age," in C. Isendahl & B.L. Persson (eds), *Ecology, Power, and Religion in Maya Landscapes*, ACM 23 (2011): 107–20; H. Trik, & M. Kampen, *The Graffiti of Tikal*, Tikal Report 31 (Penn Museum, 1983); M. O'Neil, "Ancient Maya Sculptures of Tikal, Seen and Unseen," *RES* 55/56 (2009): 119–34.

Tonina: P. Becquelin & C. Baudez, *Tonina, une cité maya du Chiapas (Mexique)*, 3 Vols (1979–1984, Paris); J. Yadeun, *Toniná* (Chiapas, 1992); P. Mathews & C. Baudez, "Capture and Sacrifice at Palenque," in M.G. Robertson et al. (eds), *Third MRP, 1978* (PARI, 1979), 31–40.

Yaxchilan: C. Tate, *Yaxchilán* (Texas, 1992); S. Plank, *Maya Dwellings in Hieroglyphs and Archaeology* (Oxford, 2004); M. O'Neil, "Object, Memory, and Materiality at Yaxchilán," *AncM* 22 (2): 245–69 (2011); C. Golden et al., "Piedras Negras and Yaxchilán," in *LAA* 19 (3): 249–74 (2008); and M. Miller, "A Design for Meaning in Maya Architecture," in S. Houston (ed.), *Function and Meaning in Classic Maya Architecture* (DOAKS, 1998), 187–222.

THE NORTH
For Early Classic **Acanceh**, see V. Miller, *The Frieze of the Palace of the Stuccoes, Acanceh, Yucatán, Mexico* (DOAKS, 1991). Regarding **Oxkintok**: Proyecto Oxkintok publications (Misión Arqueológica de España

México ([1988]–1992). On **Ek' Balam**:
Vargas & V. Castillo, "Hallazgos recientes
Ek' Balam," *AM* 13 (76): 56–63 (2006);
d G. Bey et al., "Classic to Postclassic at
Balam, Yucatan," *LAA* 8: 237–54 (1997).
n Puuc architecture: H. Pollock, *The Puuc*
MM, 1980), and J. Kowalski, *The House*
the Governor (Oklahoma, 1986).
Chichen Itza: The most important
mmaries of CIW archaeology are:
Ruppert, *Chichen Itzá*, CIW Pub. 595
952); A. Tozzer, *Chichen Itzá and its Cenote*
Sacrifice, PMM 12 (1957); and E. Morris
al., *The Temple of the Warriors at Chichen*
zá, *Yucatán*, CIW Pub. 406 (1931). Dating
sputes rage: R. Cobos, "Concordancias
discrepancias en las interpretaciones
quológicas, epigráficas e históricas de
nes del Clásico en las Tierras Bajas Mayas
el Norte," *Mayab* 20: 161–66 (2008), and
, Lincoln, "Chronology of Chichén Itzá," in
Sabloff & E. Andrews V (eds), *Late Lowland*
aya Civilization (New Mexico, 1986), 141–96.
ee also: E. Pérez de Heredia Puente, "The
abnal-Motul Ceramic Complex of the Late
lassic Period at Chichen Itza," *AncM* 23
): 379–402 (2012). For laser scan data
d reconstructions of Chichen Itza, see
ISIGHT's www.mayaskies.net.
 D. Charnay noted resemblances with
ula: *Ancient Cities of the New World* (New
ork, 1888). On Toltec art forms: G. Kubler,
Serpent and Atlantean Columns," *Journal*
the Society of Architectural Historians 41
982); M. Miller, "A Re-examination of
esoamerican Chacmool," *Art Bulletin* 67
): 7–17 (1985); C. Coggins & O. Shane
ds), *Cenote of Sacrifice* (Texas, 1984);
d P. Schmidt in *Mexico: Splendors of Thirty*
enturies (New York, 1990).
 See also: J. Kowalski et al. (eds), *Twin*
ollans (DOAKS, 2008); L. Wren et al., *The*
reat Ball Court Stone of Chichén Itzá, RRAMW
5 (1989); W. Ringle, "Who was who in
nth-century Chichen Itza?" *AncM* 1 (2):
33–43 (1990); W. Ringle et al., "Return of
uetzalcoatl," *AncM* 9 (2): 183–232 (1998);
nd D. Graña-Behrens, "Emblem Glyphs
nd Political Organization in Northwestern
ucatan in the Classic Period (AD 300–1000)," *
ncM* 17 (1): 105–23 (2006).
 The final Carnegie project was carried out
 Mayapan: H. Pollock et al., *Mayapán*, CIW
ub. 619 (1962). More recent publications
clude K. Taube, "A Prehispanic Maya
atun Wheel," in *Journal of Anthropological*
esearch 44 (2): 183–203 (1988); S. Milbrath
 C. Peraza, "Revisiting Mayapan," in *AncM*
4 (1): 1–46 (2003); and M. Masson, T. Hare,
 C. Peraza, "Postclassic Maya Society
egenerated at Mayapán," in G. Schwartz
 J. Nichols (eds), *After Collapse* (Arizona,
006), 188–207.
 Santa Rita Corozal: T. Gann, "Mounds
 Northern Honduras," 19th Annual Report
900). D. Chase & A. Chase, *Offerings to*
he Gods (Florida, 1986); and D. Chase,
The Maya Postclassic at Santa Rita Corozal,"
 Archaeology 34 (1): 25–33 (1981).

Tulum: S. Lothrop, *Tulum: An Archaeological*
Study of the East Coast of Yucatán, CIW Pub.
335 (1924); and A. Miller, *On the Edge of the*
Sea (DOAKS, 1982). A. Smith, *Archaeological*
Reconnaissance in Central Guatemala, CIW Pub.
608 (1955), presents Postclassic architecture
of the Guatemalan highlands.

CERAMICS
A baseline chronology comes from Uaxactun:
R. Smith, *Ceramic Sequence at Uaxactún*,
Guatemala, 2 vols, MARI Pub. 20 (1955).
M. Coe transformed studies of ceramics:
The Maya Scribe and His World (Grolier Club,
1973); and *Lords of the Underworld* (PUAM,
1978). Regarding Preclassic cacao: T. Powis
et al., "Spouted Vessels and Cacao Use among
the Preclassic Maya," *LAA* 13 (1): 85–106
(2002). J. Kerr published much of the corpus:
The Maya Vase Book, vols 1–7, 1989–; and
www.mayavase.com. See also: D. Reents-
Budet, *Painting the Maya Universe* (Duke,
1994); M. Coe & J. Kerr, *The Art of the Maya*
Scribe (Abrams/T&H, 1998); R. Adams,
The Ceramics of Altar de Sacrificios, PMM 63
(1) (1971); and N. Hellmuth, *Mönster und*
Menschen (Graz, 1987). For the Ik' site:
A.E. Foias & K.F. Emery (eds), *Motul de San*
José (Florida, 2012); and B. Just, *Dancing into*
Dreams (PUAM, 2012).
 On technology, see: P. Rice, "Late
Classic Maya Pottery Production," *Journal*
of Archaeological Method and Theory 16:
117–56 (2009); D. Reents-Budet & R. Bishop,
"Classic Maya Painted Ceramics," in J.
Pillsbury et al. (eds), *Ancient Maya Art at*
Dumbarton Oaks (DOAKS, 2012), 289–99;
D. Reents-Budet et al., "Out of the Palace
Dumps," *AncM* 11: 99–121 (2000); S. López
Varela et al., "Ceramics Technology at
Late Classic K'axob, Belize," *Journal of Field*
Archaeology, 28 (1/2): 177–91 (2001); and
H. Neff, *Production and Distribution of Plumbate*
Pottery (FAMSI, 2001).

PAINTED MURALS AND BOOKS
New reconstructions are key, especially those
of H. Hurst and L. Ashby. D. Magaloni-Kerpel
has provided essential technical studies,
especially in *La Pintura Mural Prehispánica*
en México, which UNAM has published in
large folio volumes: *Area Maya*, v. II (UNAM,
1998–2001).
 Bonampak: M. Miller, "Maya Masterpiece
Revealed at Bonampak," *National Geographic*
Magazine, Feb 1995: 50–69; M. Miller, "The
Willfulness of Art: The Case of Bonampak,"
RES 42 (2002); M. Miller & C. Brittenham,
The Spectacle of the Late Maya Court (Texas,
2013); and S. Houston, "The Good Prince,"
CAJ 22 (2): 153–75 (2012).
 Calakmul: R. Carrasco & M. Cordeiro,
"The Murals of Chiik Nahb, Calakmul,
Mexico," in C. Golden et al. (eds), *Maya*
Archaeology 2 (Mesoweb, 2012), 8–59;
S. Boucher & L. Quiñones, "Entre mercados,
ferias y festines," *Mayab* 19: 27–50 (2007);
S. Martin, "Hieroglyphs from the Painted
Pyramid," also in *Maya Archaeology* 2.

San Bartolo: The wall paintings have
been partly published in *National Geographic*
Magazine. Major publications are W. Saturno
et al., "The Murals of San Bartolo, El Petén,
Guatemala. Part 1: The North Wall," *Ancient*
America 7 (2005); and K. Taube et al., "The
Murals of San Bartolo, El Petén, Guatemala.
Part 2: The West Wall," *Ancient America* 10
(2010). See also: W. Saturno et al., "Early
Maya Writing at San Bartolo Guatemala,"
Science 311 (5765): 1281–83 (2006).
 Xultun: W. Saturno et al., "Ancient Maya
Astronomical Tables from Xultun, Guatemala,"
Science 336 (6082): 714–17 (2012); and
M. Zender & J. Skidmore. "Unearthing
the Heavens." *Mesoweb Reports* (2012):
www.mesoweb.com/reports/Xultun.pdf
 Codices: On pre- and post-Conquest
books, see J. Thompson, *The Dresden Codex*
(American Philosophical Society, 1972);
J. Villacorta & C. Villacorta, *Códices Maya*,
Guatemala, 1930); and G. Vail, "The Maya
Codices," *Annual Review of Anthropology*
35: 497–519 (2006). The Grolier Codex is
illustrated in M. Coe, *The Maya Scribe and*
his World (Grolier, 1973). For the Madrid
Codex, see A. Ciudad Ruiz & A. Lacadena,
"El Códice Tro-Cortesiano de Madrid en
el contexto de la tradición escrita Maya,"
in J. Laporte & H. Escobedo (eds), *En Simposio*
de Investigaciones Arqueológicas en Guatemala,
1998 (MUNAE, 1999), 876–88; and G. Vail
& A. Aveni (eds), *The Madrid Codex*
(Colorado, 2009).

A MODERN WORLD OF MAYA ART
F. Columbus wrote his father's biography:
The Life of the Admiral Christopher Columbus
by his Son Ferdinand, trans./ed. B. Keen
(Rutgers, 1959). J. de Grijalva, as recorded
in *The Discovery of New Spain in 1518*, trans./
ed. H. Wagner (Cortés Society, 1942),
collected Maya objects. On the invasion,
see: I. Clendinnen, *Ambivalent Conquests*
(2nd ed., Cambridge, 2003). New studies
include: F. Asselbergs, "La Conquista de
Guatemala: Nuevas Perspectivas del Lienzo
de Quauhquecholan en Puebla, México,"
Mesoamérica 14: 1–53 (2002); S. Edgerton,
Theaters of Conversion (New Mexico, 2001);
and C. Cortez,"New Dance, Old Xius," in
A. Stone (ed.), *Heart of Creation* (Alabama,
2002). M. Restall, *The Maya World* (Stanford, 1999); and J. Chuchiak IV, "Writing
as Resistance," *Ethnohistory* 57 (1) (2010).
Regarding continuity and change:
E. Vogt, "Persistence of Maya Tradition in
Zinacantan," in R. Townsend (ed.), *Ancient*
Americas (Art Institute of Chicago, 1992),
60–69; and D. Graña Behrens et al. (eds),
Continuity and Change (Anton Saurwein,
2004). On calendars: B. Tedlock, *Time and*
the Highland Maya (rev. ed., New Mexico,
1993); and J. Weeks et al., *Maya Daykeeping*
(Colorado, 2009). For 20th-century textiles:
W. Morris Jr, *Living Maya* (Abrams, 1987);
and W. Morris Jr. et al., *Guia Textil de los Altos*
de Chiapas: A Textile Guide to the Highlands of
Chiapas (Thrums, 2012).

Sources of Illustrations

1 Panel 1a, La Corona. Photo by David Stuart, courtesy the Proyecto Regional Arqueológico La Corona; 2 Olmec-style head, Ceibal. Courtesy Ceibal-Petexbatun Archaeological Project; 3 Map of Maya Sites. Drawn by Philip Winton; 4 Facade from Holmul. Photo Alexandre Tokovinine, courtesy CMMI/Proyecto Arqueológico Holmul; 5 Frederick Catherwood, *Broken Idol at Copan*. Photo SuperStock/Alamy; 6 Architectural casts, Chicago World's Columbian Exposition, 1893. Photo Field Museum Library/Getty Images; 7 Carved vessel, Peto. PM; 8 Stand with incense burner, Palenque. Photo Javier Hinojosa; 9 Detail of Stela C, Quirigua. Drawing Matthew Looper; 10 Captive, Tonina. Museo de Sitio de Tonina, Chiapas. INAH, Mexico; 11 Carved bones, Burial 116, Tikal. Photo Linda Schele. Top: Drawing by Mark Van Stone. Bottom: Drawing after A. Trik; 12 Emiliano Zapata Panel. Museo Emiliano Zapata, Tabasco. INAH, Mexico; 13 Carved human head, Chichen Itza. PM; 14 Jade Maize God in spondylus shell, Copan. Photo Kenneth Garrett; 15 Jade plaque, Nebaj. MNAE. Photo JK (K4889); 16 Jade head, Altun Ha Tomb 1. Institute of Archaeology, Belmopan, Belize; 17 Mosaic disc, Chichen Itza. MNA. INAH, Mexico; 18 Ear flares, Santa Rita Corozal. National Institute of Culture and History, Belize; 19 Gold mask, Chichen Itza. PM; 20 Death god mosaic, Topoxte. Photo Ricky López Bruni; 21 Human skull censer, Chichen Itza. PM; 22 Incised peccary skull, Copan. PM; 23 K'awiil effigy, Tikal. Sylvanus G. Morley Museum, Tikal, Guatemala. Photo The Art Archive/Alamy; 24 Seated wooden figure. Metropolitan Museum of Art, New York, Michael C. Rockefeller Memorial Collection, Bequest of Nelson A. Rockefeller, 1979; 25 Stela 9, Calakmul. Museo del Fuerte de San Miguel, Campeche. Photo JPL; 26 Ballplayer lintel, Tonina. MNA. Photo JPL; 27 Stela 22 and Altar 10, Tikal. Photo Interfoto/Alamy; 28 Quarry, Palenque. Photo Merle Green Robertson; 29 Eccentric flint, Copan. Instituto Hondureño de Antropología e Historia, Tegucigalpa; 30 Pyrite mirror,

Bonampak. Centro INAH, Tuxtla Gutiérrez, Chiapas, Mexico. INAH, Mexico; 31 Room 2, warrior, Bonampak. Photograph by JK. Courtesy the Bonampak Documentation Project; 32 Incensario lid portraying Yax K'uk' Mo', Copan. IHAH, Museo Arqueológico de Copán; 33 Brick with graffito, Comalcalco. Museo de Sitio de la Zona Arqueológia de Comalcalco, Tabasco, Mexico. INAH, Mexico; 34 Polychrome vessel, Tikal. MNAE. Photo JK (K2695); 35 Figurine from El Perú-Waka'. Photo Ricky López Bruni, courtesy the El Perú-Waka' Regional Archaeological Project; 36 Carved bones from Tomb 2, Structure 23, Yaxchilan. Direccion de Estudios Arqueológicos. INAH, Mexico; 37 Cylinder vessel. The Nasher Museum of Art at Duke University, Durham, NC. Gift of Mr Ray Bagiotti. Photo JK (K5345); 38 Structure 13, Plan de Ayutla. Photo Patricia Carrillo, courtesy Joel Skidmore; 39 Reconstruction of Groups A and B, Uaxactun. Drawing TP; 40 Graffito of building from Structure 5D-65, Tikal. Courtesy UPM; 41 Plan of Tikal. Drawing after Peter Harrison; 42 Temple I and North Acropolis, Tikal. Photo Robert Harding World Imagery/Alamy; 43 Facade, El Zotz. Photo Edwin Román, courtesy the Proyecto Arqueológico El Zotz; 44 Structure E-VII, Uaxactun. Photo American Museum of Natural History, New York; 45 E-VII solar alignments, Uaxactun. Drawing after Renfrew & Bahn; 46 Evolution of Group A buildings, Uaxactun. Drawing G. Kubler; 47 Carved blackware vessel, Tikal. Drawing William R. Coe, courtesy UPM; 48 Structure 49, Tikal. Photo Mary Ellen Miller; 49 Twin pyramid complex, Tikal. Drawing after Peter Harrison, *The Lords Of Tikal*, 1999; 50 Dos Pilas reconstruction. Rendering National Geographic Image Collection/Alamy; 51 Aerial view of Palenque. Photo Michael Calderwood; 52 Corbel vaults, Palace House F, Palenque. Photo Mary Ellen Miller, YVRC; 53 Keyhole arches, Palace House A, Palenque. Photo Amanda Hankerson/Maya Portrait Project; 54 Temple of Inscriptions, Palenque. Drawing Philip Winton; 55 Temple of the Sun, Palenque. Photo LatitudeStock/Alamy; 56 Model of the Temple of the Cross, Palenque. After Ignacio Marquina; 57 View of Tonina. Photo Bryan Just; 58 Death god frieze, Tonina. Photo Kenneth Garrett/National Geographic Creative; 59 Structure 33, Yaxchilan. Drawing Philip Winton; 60 Reconstruction of West Acropolis, Piedras Negras. Drawing TP; 61 Reconstruction of Sweatbath P-7, Piedras Negras. Drawing TP; 62 Caana, Caracol. Photo Jon Arnold Images Ltd/Alamy; 63 Plan of the Principal Group, Copan. Drawing after William Fash; 64 Ballcourt, Copan. Photo YVRC; 65 Margarita facade, Copan. Photo courtesy the Early Copan Acropolis Program, UPM; 66 Reconstruction of Structure 22, Copan.

Drawing TP; 67 Reconstruction of Hieroglyphic Stairway, Copan. Drawing TP; 68 Graffito, Chicanna. Drawing after Jose Antonio Oliveros, *Mexican* 1981; 69 Doorway, Chicanna. Photo age fotostock/ Alamy; 70 Reconstruction of Xpuhil. Drawing TP; 71 Stucco frieze, Ek' Balam. Photo JPL; 72 Pyramid of the Magician, Uxmal. Photo Massimo Borchi/Archivio Whitestar; 73 Nunnery detail, Uxmal. Photo YVRC; 74 Nunnery, Uxmal. Photo Massimo Borchi/Archivio Whitestar; 75 House of the Governor, Uxmal. Photo Ken Welsh/Alamy; 76 Arch, Labna. Photo age fotostock/Alamy; 77 Visualization of Chichen Itza by Kevin Cain, insightdigital.org; 78 Caracol, Chichen Itza. Photo iStockphoto.com; 79 Castillo, Chichen Itza. Photo Mary Ellen Miller, YVRC; 80 Section of Castillo, Chichen Itza. Drawing after Maria Longhena; 81 Great Ballcourt, Chichen Itza. Photo Visual Resources Collection, Yale University, New Haven, CT; 82 Tzompantli, Chichen Itza. Photo The Art Archive/Manuel Cohen; 83 Temple of Warriors, Chichen Itza. Photo Ferguson/ Royce Archive, University of Texas Libraries, the University of Texas at Austin; 84 Mercado plan and elevation, Chichen Itza. After Karl Ruppert; 85 Castillo, Tulum Photo Massimo Borchi/Archivio Whitestar; 86 Monkey Scribes vase. New Orleans Museum of Art. Photo JK (K1225); 87 Codex-style vase. Museum of Fine Arts, Boston. Photo JK (K1004); 88 Stela 1, Tikal. Photo YVRC. Drawing of Stela 1 courtesy UPM; 89 Whistle figurine, Tomb 23, Río Azul. Photo George F. Mobley/National Geographic Creative; 90 Sculptured Stone Bonampak. Drawing Linda Schele; 91 Carved panel. Kimbell Art Museum, Fort Worth; 92 Captive, Room 2, Bonampak. Photo UNESCO 1964; 93 Polychrome vase. Photo JK (K1208); 94 Black Background Vase. Museum of Fine Arts, Boston. Photo JK (K688); 95 Figurines from Burial 39, El Perú-Waka'. Photo Ricky López Bruni, courtesy the El Perú-Waka' Regional Archaeological Project; 96 Censer from Group C, Palenque. Museo de Sitio de Palenque. INAH, Mexico; 97 Chak Chel figurine. Princeton University Art Museum. Photo JPL; 98 Jaina-style figurines. (Left) Dumbarton Oaks Research Library and Collection, Washington, D.C. (Right) Detroit Institute of Arts, Founders Society Purchase, Katherine Margaret Kay Bequest Fund and New Endowment Fund; 99 Lintel, Halakal. Drawing Alexander Voss; 100 Monkey scribe, Copan. Photo JK (K2870); 101 Maize God, Copan. British Museum, London; 102 Monument 27, Tonina. MNA. INAH, Mexico; 103 Bone with incised captive, Burial 116, Tikal. Drawing after A. Trik; 104 Mosaic mask of Pakal, Palenque. MNA. Photo Kenneth Garrett; 105 Head of Pakal, Temple of Inscriptions, Palenque.

NA. INAH, Mexico; **106** Stucco head, alenque. MNA. INAH, Mexico; **107** Carved one, Burial 116, Tikal. Drawing after A. Trik; **08** Carved vessel, Copan. Photo JK **<**2873**)**; **109** Frieze, Tecolote Structure, El Mirador. Photo AFP/Getty Images; **110** Stela **1**, Kaminaljuyu. MNAE. Photo JPL; **111** Stela Izapa. MNA. Photo JPL; **112** Stela 29, Tikal. rawing William R. Coe; **113** Leiden Plaque. jksmuseum Volkenkunde, Leiden; **114** ectoral, Dzibanche. CNCA-INAH, MNA; **15** Hombre de Tikal. Photo Ricky López runi; **116** "Ballcourt Marker," Tikal. MNAE. hoto JPL; **117** Stela 4, Tikal. Photo YVRC; **18** Stela 31, Tikal. Photo Edith Hadamard, VRC; **119** Stela 31, Tikal. Drawings William . Coe, courtesy UPM. 3D rendering Kevin ain, insightdigital.org; **120** Lintel 48, axchilan. MNA. Photo JPL; **121** Panel 12, iedras Negras. MNAE. Photo Megan E.)'Neil; **122** Stela 26, Quirigua. Photo Wendy Ashmore/Quirigua Archaeological roject. Drawing Matthew Looper; **123** eramic vessel, Peten. Photo Peter David oralemon; **124** Motmot Marker, Copan. hoto Kenneth Garrett; **125** Yehnal, opan. Photo Robert Sharer, courtesy PM; **126** Monument 168, Tonina. Museo e Sitio de Tonina. INAH, Mexico; **127** Stela , Dos Pilas. Photo Ricky López Bruni; **28** Oval Palace Tablet, Palenque. Photo enneth Garrett; **129** Sarcophagus lid, alenque. Photo Merle Greene Robertson; **30** Reconstruction of the Temple of the .ross, Palenque. Drawing TP; **131** Tablet f the Sun, Palenque. Drawing Linda Schele; **32** Palace Tablet, Palenque. Photo JPL; **133** emple 19, stuccoed pier, Palenque. Photo **>**L; **134** Temple 19, stone panel from pier, alenque. Photo JPL; **135** Temple 19, stone latform, Palenque. Photo Jorge Pérez de ara; **136** Tablet of the 96 Glyphs, Palenque. hoto Michael D. Coe; **137** Monument 122, onina, 711. Museo Regional de Chiapas. hoto Javier Hinojosa; **138** Stela 14, Piedras legras. Photo David Lebrun/NightFire ilms; **139** Stela 35, Piedras Negras. heinisches Bildarchiv, Cologne; **140** Stela 3, iedras Negras. PM; **141** Panel 2, Piedras legras. PM; **142** Panel 3, Piedras Negras. hoto JK (K4892); **143** Stela 12, Piedras legras. MNAE. Drawing David Stuart, MHI; **144** Panel 1, Pomona. Museo de Sitio e Pomoná. INAH, Mexico; **145** Lintel 24, axchilan. British Museum, London; **146** intel 25, Yaxchilan. British Museum, ondon; **147** Lintel 26, Yaxchilan. MNA. hoto Jorge Pérez de Lara; **148** Lintel 15, axchilan. British Museum, London; **149** tela 35, Yaxchilan. Photo Jorge Pérez de ara; **150** Lintel 8, Yaxchilan. Drawing Ian iraham, CMHI; **151** Altar 3, Caracol.)rawing courtesy UPM; **152** Altar 5, Tikal.)rawing courtesy UPM; **153** Stela 16, Tikal.)rawing courtesy UPM; **154** Altar 8, Tikal. hoto Mary Ellen Miller; **155** Graffito, Ialer's Palace, Tikal. Drawing courtesy **1**PM; **156** Lintel 3, Temple IV, Tikal. Museum r Volkerkunde, Basel; **157** Stele 11, Tikal.

Drawing William R. Coe, courtesy UPM; **158** Stela 51, Calakmul. MNA. Photo Jorge Pérez de Lara; **159** Stela C, Copan. Photo YVRC; **160** Chahk from Hijole structure, Copan. Museo de Escultura Maya, Copan, Honduras. Photo Jorge Pérez de Lara; **161** Detail of Stela 15, Nim Li Punit. Photo Nicholas Hellmuth; **162** Stela J, Copan. Drawing Linda Schele; **163** Seated figure, Hieroglyphic Stairway, Copan. PM. Photo Kenneth Garrett; **164** Zoomorph P, Quirigua. Photo Daniel Mennerich; **165** Stela E, Quirigua. Photo A.P. Maudslay. British Museum, London; **166** Altar Q, Copan. Photo Kenneth Garrett; **167** Stela 1, Ceibal. Photo YVRC; **168** Stela 3, Ceibal. Photo Mary Ellen Miller, YVRC; **169** Palace of the Stuccoes, Acanceh. Watercolour Adela C. Breton. Bristol Museums, Galleries & Archives; **170** Jambs and lintel, Xcalumkin. Drawing Harry Pollock; **171** Sculpture of captive, Cumpich. MNA. Photo Jorge Pérez de Lara; **172** Painted stucco head, Uxmal. National Museum of the American Indian, Smithsonian Institution. Photo Walter Larrimore; **173** Stela 14, Uxmal. Drawing Karl Taube; **174** Stela 21, Oxkintok. Drawing by Harry Pollock; **175** Jamb, Kabah. Photo Barry Brukoff; **176** Stone head, Kabah. MNA. Photo Jorge Pérez de Lara; **177** Column, Tunkuyi, Campeche. Photo Karl-Herbert Mayer. Drawing Matthew Looper; **178** Gold disk, Chichen Itza. Drawing TP. Photo PM; **179** Ballcourt panel, Chichen Itza. Rendering Kevin Cain, insightdigital.org; **180** Mercado sculptured altar, Chichen Itza. Photo President and Fellows of Harvard College, PM; **181** Fossil temple, Chichen Itza. Photo Massimo Borchi/Archivio Whitestar; **182** Stone turtle, Mayapan. Drawing Karl Taube; **183** Stela 1, Mayapan. Drawing TP; **184** Detail from cylindrical vessel. The Cleveland Museum of Art, Gift of Edgar A. Hahn 1967.203; **185** Mundo Perdido plate, Tikal. MNAE; **186** Basal flange bowl. Photo JK (K4876); **187** Lidded bowl, Becan. Museo Fuerte de San Miguel, Campeche, Mexico. Photo Jorge Pérez de Lara; **188** Tetrapod vessel. Dallas Museum of Art. Photo JK (K3249); **189** "Screw-top" vessel, Río Azul. MNAE; **190** Tripod cylinder vessel, Burial 10, Tikal. Photo Michael D. Coe; **191** Incised tripod bowl. Photo Gerald Berjonneau; **192** Cylinder vessel. Photo JK (K5060); **193** Cylinder vessels, Burial 196, Tikal. Photo Nicholas Hellmuth; **194** Buenavista Vase. Department of Anthropology, Belize. Photo JK (K4464); **195** Cylinder vessel. Art Institute of Chicago, Ethel Scarborough Fund; **196** "Bunny Pot." Photo JK (K1374); **197** Dancing Maize God vessel. Art Institute of Chicago. Photo JK (K1374); **198** Vase of the Seven Gods. Photo JK (K2796); **199** Princeton Vase. Princeton University Art Museum, Princeton, NJ. Photo JK (K511); **200** Codex-style vase. Photo JK (K1185); **201** Codex-style plate. Museum of Fine Arts, Boston. Photo JK (K1892); **202** Altar de Sacrificios Vase. MNAE. Photo Michael

D. Coe; **203** Chama-style vase. UPM. Photo JK (K593); **204** Fenton Vase. British Museum, London; **205** Chochola-style vessel. Photo JK (K4547); **206** Plumbate vessel. Yale University Art Gallery, Gift of Mr and Mrs Fred Olsen; **207** Ring-stand vessel. Yale University Art Gallery, Gift of the Olsen Foundation; **208** Detail of Las Pinturas West Wall Mural, San Bartolo. Photo Kenneth Garrett; **209** Las Pinturas North Wall Mural, San Bartolo. Rendering Heather Hurst; **210** Burial 48, Tikal. Photo courtesy UPM; **211** Burial 12, Rio Azul. Photo George F. Mobley/National Geographic Creative; **212** Structure B-XIII, Room 7 Mural, Uaxactun. Rendering Antonio Tejeda. President and Fellows of Harvard College, PM; **213, 214** Murals, Calakmul. Photo Simon Martin, used with permission of Ramón Carrasco and the Proyecto Arqueológico Calakmul; **215, 217, 218** Structure I Murals, Bonampak. Rendering Heather Hurst and Leonard Ashby, Courtesy Bonampak Documentation Project; **216** Room 2, south wall, Bonampak. Photo JK. Courtesy the Bonampak Documentation Project; **219** Drawing 21, Naj Tunich. Photo W.E. Garrett/National Geographic Creative; **220** Mural, Xultun. Photo Tyrone Turner/National Geographic Creative; **221** Capstone 15, Ek' Balam. Museo del Mundo Maya, Mérida, Mexico. Photo Javier Hinojosa; **222, 223** Upper Temple of the Jaguars, Chichen Itza. Watercolours by Adela C. Breton. Bristol Museums, Galleries & Archives; **224** Reconstruction of mural from the Temple of Warriors, Chichen Itza. Rendering Ann Axtell Morris. President and Fellows of Harvard College, PM; **225** Chahk impersonators, Mural 1, Tancah. Reconstruction by Felipe Dávalos; **226** Mural, Mayapan. Photo Joel Skidmore; **227** Madrid Codex. Museo de las Américas, Madrid; **228** Dresden Codex. Sächsisches Landesbibliothek-Staats-und Universitätsbibliothek Dresden; **229** Detail from *Lienzo de Quauhquechollan*. Photo Bob Schalkwijk; **230** Casa de Montejo, Merida. Photo Manuel Cohen; **231** Open chapel, Dzibilchaltun. Photo Kevin Collins; **232** Xiu Family Tree. Tozzer Library Special Collections, Harvard University, Cambridge, MA; **233** Mary Magdalene statue with textiles, Magdalenas Aldama, Chiapas, Mexico. Photo Alfredo Martínez; **234** *Huipil*, Magdalenas Aldama, Chiapas, Mexico. Coleccion FCB-CHIAPAS de Fomento Cultural Banamex, A.C. Photo Edgar Espinoza; **235** Maya woman weaving. Photo Janet Schwarz.

Glossary. All drawings by Linda Schele except: Chahk (Simon Martin); Emblem glyph (Tracy Wellman); God L (Simon Martin); Itzamnaaj (Simon Martin); Jaguar God of the Underworld (Simon Martin); K'awiil (Simon Martin); K'in (Aman Phull); K'inich Ajaw (Simon Martin); Talud-tablero (Aman Phull).

253

Index